− Parting The Veil −
The Art Of
Nene Thomas

CHIMERA PUBLISHING

HAMILTON, NEW JERSEY
2005

Parting the Veil: The Art of Nene Thomas

Art: Copyright ©Nene Thomas 2005
Introduction: Copyright ©Bruce Coville 2005
First Edition: Copyright ©Chimera Publishing, 2005. All Rights Reserved

Editors: Norman Hood and E. Leta Davis
Design and Layout: McNabb Studios for
Chikara Entertainment, Inc.

Limited Edition
ISBN 0-9744612-790000
Hard Cover
ISBN 0-9744612-890000
Paperback
ISBN 0-9744612-990000

Chimera Publishing
—Hamilton, New Jersey

Visit our website at
www.chimerapublishing.com
E-mail: norm@chimerapublishing.com

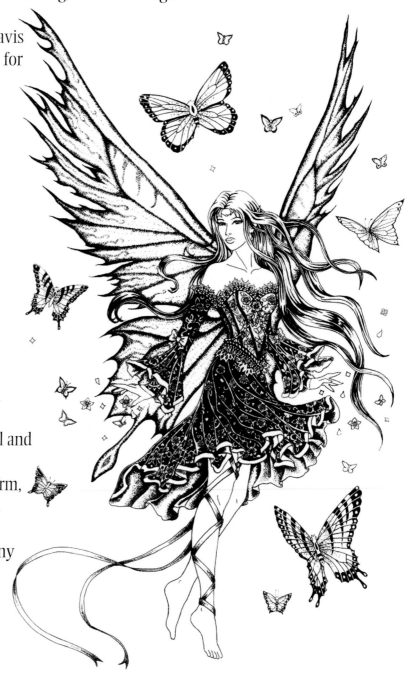

First Printing: July 2005
10 9 8 7 6 5 4 3 2 1

Printed in China by
Regent Publishing
Services Limited.

Contact RegentNY2@aol.com
for additional information.

Dedication

I dedicate this book to my husband, Steven C. Plagman.
Your unswerving faith and love has helped me grow not only as an
artist but as a person. I would be remiss in not acknowledging that you
are an integral part of every painting I create.

You are everything to me.

Artist's Foreword

I have loved art for as long as I can remember. I can think of no greater gift than to take an image or an idea and express it in a fashion that others can appreciate and understand--even love. Whether that expression takes the form of the music that you hear on the radio, or as a book that you can't put down, or as a movie that you never get tired of seeing no matter how many times you watch it, artistic expression is a gift that the creator gives to his or her audience. When I was younger, I used to look at books of art by the masters, and wish that I too could create something of such sublime beauty that others would view my art as a gift as well, and would draw inspiration from it the way I did with the masters. I am a long, long way from achieving this goal, but even today it is my fervent hope that someone, somewhere, will be inspired by my work—inadequate as it is--and will use that inspiration to create art of their own.

It is a rare thing to be able to make a living doing the thing you love the most. I didn't start out as a professional artist; I started out as an art lover who wanted to be an artist. I had to work at it. I didn't have a lot of talent, nor was I exceptionally gifted. Almost everyone around me, including other artists, warned me that I would most likely end up a stereotype: a starving artist. And the truth is, sometimes I did live the stereotype. But the thing that kept me going was the desire to succeed. To show the world what I saw, and to give the world the gift that others had given to me.

Perfection is an ideal that can never be truly realized. It is a goal that can never be obtained, no matter how hard you strive for it. Yet it is this striving that makes us better than we are, and forces us to create beyond our ability. Achieving perfection is impossible, but sometimes--just sometimes--we can reach excellence. Looking at the images in this book reminds me of the triumph and the agony that each of these paintings has brought to me. They remind me that no matter how much I draw--how much I paint--I still have a long way to go before I can truly consider myself an artist. But I am striving. I'm setting aside my successes and failures alike, and reaching for that spot within me that exists within everyone: that indescribable place that allows such beauty to be expressed. I've been there a precious few times before, and believe me when I say that it is a wonderful place to be.

This book is my gift to you, fellow art lover. May you draw inspiration from it, and may you use that inspiration as fuel for achieving dreams of your own. You have it in you: all you have to do is strive for it.

Nene Thomas

A GLIMPSE BEYOND THE VEIL . . .

I know a little about beautiful, detail-obsessed, cat-dominated painters of exquisitely rendered fantasy images, mostly because I'm married to one.

Not, I hasten to add, Nene Tina Thomas.

But as I studied Nene's art and began to learn more about her, I experienced an eerie sense of familiarity. Writing in her live journal (to be found at her excellent website, www.nenethomas.com), Nene once described spending an entire day painting the details on thousands of tiny feathers. Reading that, I immediately had a flashback to a sequence of conversations I had with my wife, Kathy, when she was working on an illustration for our first book. The picture showed a giant holding a "bouquet" of apple trees.

"You're not going to draw in all the separate leaves, are you?" I asked somewhat nervously, concerned about both her well being and the deadline.

"Of course not," she replied.

When I came back to the studio a few hours later she was patiently and happily outlining each leaf.

"Um you're not going to shade them all, are you?"

"Of course not!"

It will probably come as no surprise to you that by the time the picture was finished, the leaves had all been carefully, individually shaded.

Certainly I would not be surprised to discover that Nene's husband, Steve, has had an occasional conversation like this with his wife, at least until he learned better. People like Nene—and thank the powers that we have them!—work in a kind of hyper-focused state that lets them live inside the image they are creating. It's as if they are visiting another world in order to bring back reports to those of us not privileged to go there ourselves.

And what a world it is. As a child of the northern forests, I recognize the bare winter branches that form the background of so many of Nene's images—recognize them for the clarity and fidelity with which she has rendered them. What she has added is what I never saw myself but always suspected was there and longed to see, namely the ethereal and fantastic beings that populate those woodlands.

One of the things I love about Nene's paintings is that there is so much to see. These are pictures you can spend time with—and, having spent time, you can revisit them and still find new things. Take Chance Encounter, one of the images in this book. First, of course, you see the central figure and the small black dragon hovering above her. You note the sense of connection between them, and your mind starts to ask questions, to build a story. What kind of dragon is it? Will this be but the meeting of a moment or will they form a bond? Is the dragon merely curious or is it bringing a message, perhaps even seeking her help? What more might be in store for these two? Some pictures are worth a thousand words. This one could easily spin its way into being a full novel.

As you continue to look, or when you return for another visit—for these are paintings that you can visit, not merely look at—you begin to note the details: the extraordinary delicacy of the horse's bridle, so real that you can imagine the feel of it beneath your fingertips, or the finely rendered feathering of the hairs on its legs. And always, behind it all, the winter forest, which stretches into a misty distance that makes you long to enter it, to discover what else is back there (though, of course, it could be that little dragon's mother).

It's only when you put it all together and step back from the magic for a moment that you begin to realize the time (not to mention the obsession with detail) it must have taken to create such an image. And then when you consider the number of images in this book . . . well, the mind boggles. Nene's statement, "I HAVE to paint—it's a compulsion." helps to make sense of it all. How else could this wealth of detail have come to be?

Nene got her start as a professional by painting cards for the Magic gaming system. It was a good training ground, I suspect, but hardly a large enough canvas for her vision and energy. You can also see in her work, sometimes quite obviously, Nene's love of anime. I suspect, too, that she has a fondness for the work of Kay Nielsen, though that is only conjecture.

To continue with the conjecture—Nene must, one thinks, be light of spirit. Only consider how much of her work is filled with things in flight, with butterflies and swirling leaves, owls and dragons, and the faeries themselves, often happily suspended in midair, especially in her anime styled paintings. Her sense of play and whimsy comes out in some of these, and it is clear that her inner child is alive and well. But her vision stretches to the heroic, the romantic, and even the starkly ferocious. (You know, for example, that the dragon in "Omen" would eat your heart without a qualm).

Of all the images in this book, my personal favorite is Moon Dreamer, a work that is filled with pensive magic. The background seems more simple than those found in many of the other paintings (though in reality its expanse is infinite), yet somehow it's a picture you can get lost in and can become, if you let yourself fall into it, as contemplative as the central figure.

You may well find a different favorite. It will take you a while to do so, for there are enough images waiting in the pages that follow to sate even the hungriest imagination.

Those of us who love fantasy often have the sense that there is a magical world waiting just beyond the veil. Nene Thomas has very kindly parted that veil for us and given us a glimpse of the wonders waiting for us on the other side.

Just turn the page and you'll see what I mean . . .

Bruce Coville
Syracuse
February, 2005

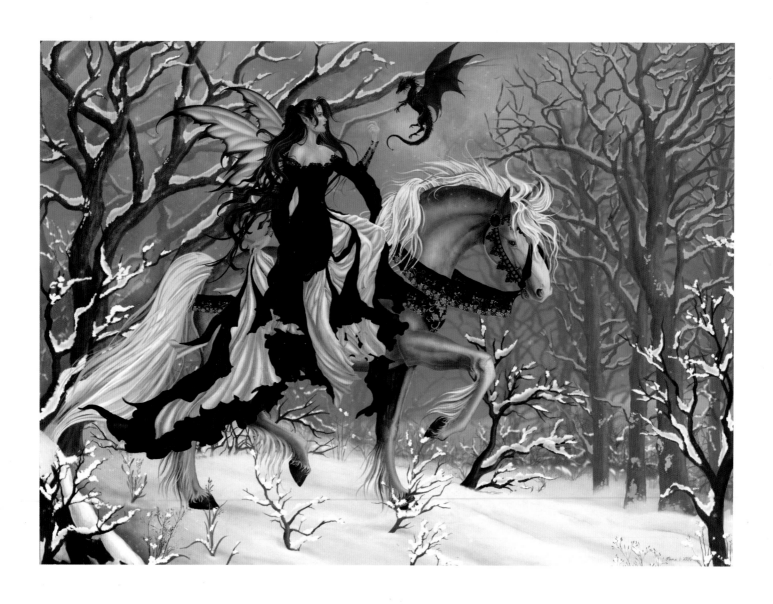

A Chance Encounter

When I started painting *A Chance Encounter*, I didn't realize how difficult it would be to complete. The problem wasn't the intricate six-sided cloth: it was the background. I wanted to convey a sense of isolation, deep in a snowy forest, and I think I achieved the effect I was looking for, but it took much longer than I expected. As you look at the images in this book, you may notice I also used this character in *Hope*, *Gathering Storm*, and *Storm Runes*. I love this character's design very much, and I often find myself imagining new paintings in which I can place her.

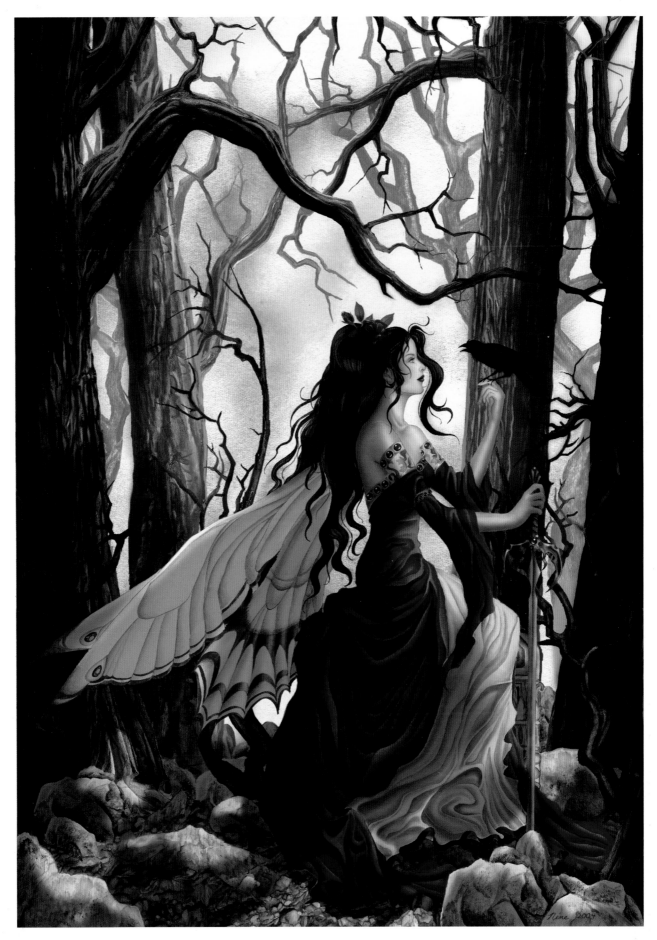

Always

When I finished the original sketch for *Memento*, the woman I had fashioned had black angel wings and was sitting in a graveyard. While I loved the finished painting, I decided that it was too dark to appeal to the general public, so I repainted it. I turned the angel into a faery sitting in a forest and renamed the piece.

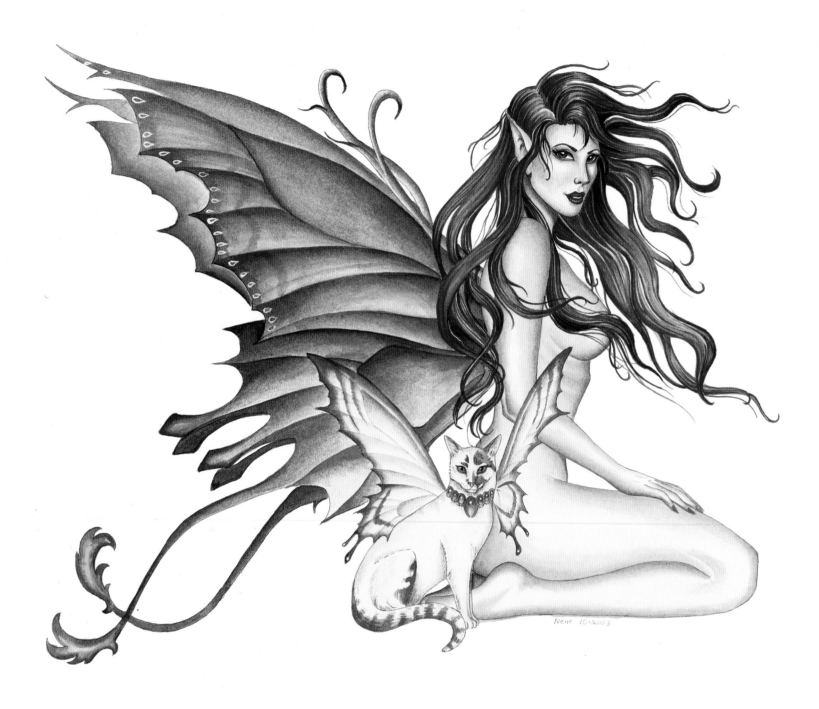

Amber

The cat in this picture is one of my six cats. His name (oddly enough!) is Amber. Amber was a stray cat that had had enough of sowing his wild oats. He decided it was time to settle down, so one day, when I was checking the mail, he ran into my house, through the open door, stopped, and took a good look around. Once he was sure the house was up to his standards, he gave me a look that said, "This will do. Now show me to my room."

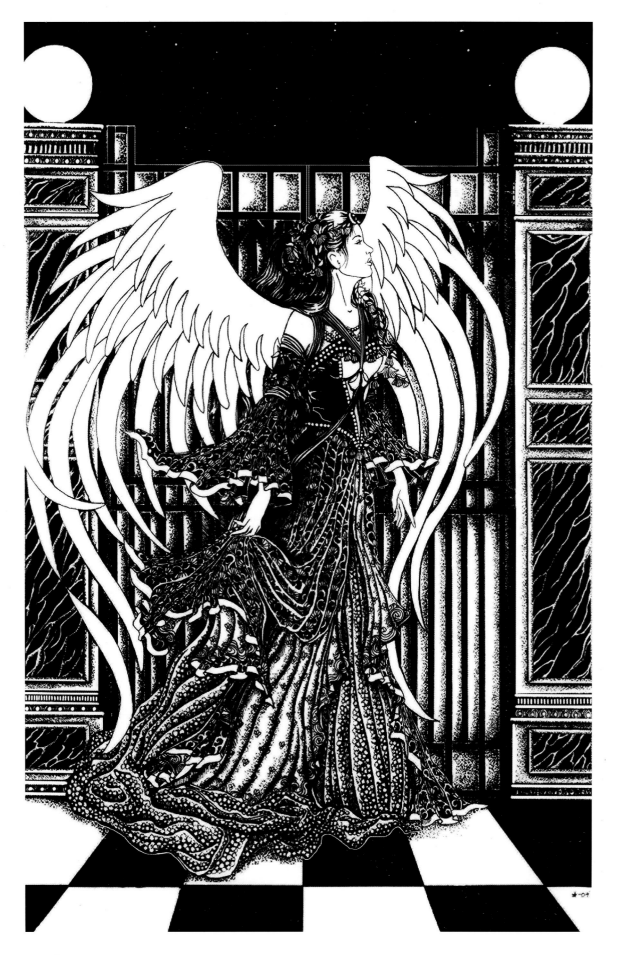

Angel's Gate
I had high hopes for *Angel's Gate* when I finished the sketch, but the finished version didn't live up to my vision. So I placed it on a shelf and forgot about it until Ann-Juliette took it down one day and tightened the original sketch into a very nice pen-and-ink drawing.

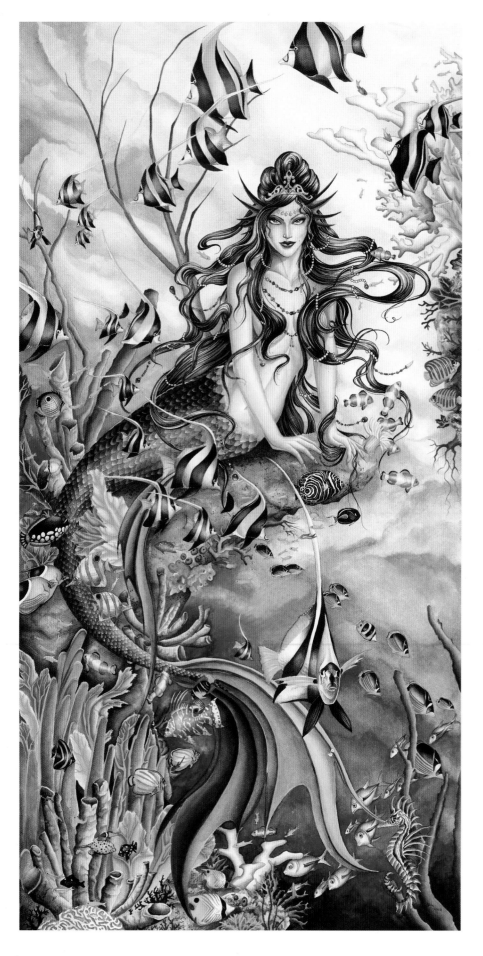

Aquamarine

The fish in this picture are all real salt-water, tropical breed. They aren't all from the same region, but they are real fish, and when I painted this picture, I learned all of their names, just to see if I could.

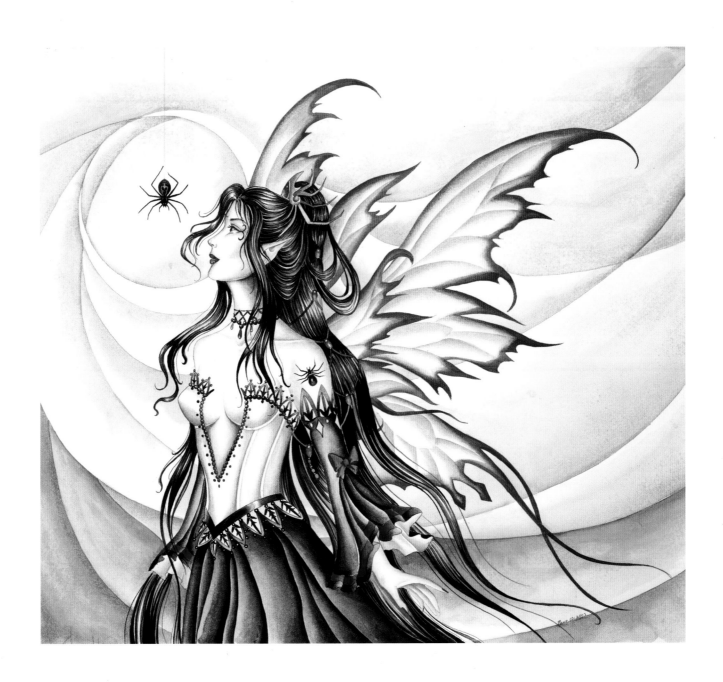

Arachne

For those of you who aren't familiar with Greek Mythology, Arachne was a weaver who boasted that she could weave better than Pallas Athena, the goddess of wisdom. Athena took exception to this boast and transformed Arachne into a spider, dooming her to spend eternity weaving webs and contemplating the folly of angering the gods.

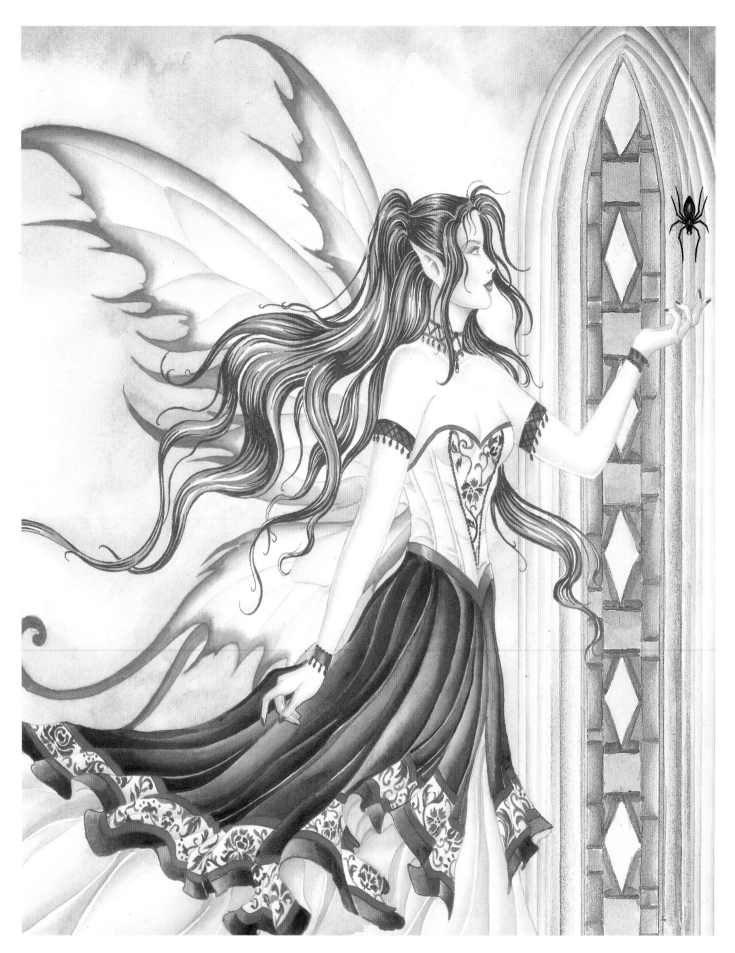

Arachne II: Dark Spider

I have to admit that when I paint an image I'm never quite sure if it will be popular or not. *Arachne* was one of the pieces that I enjoyed doing, but I didn't expect it to be particularly successful. Some time after I painted it, one of the companies that carries my art asked me to paint a companion piece, using the same character. *Dark Spider* is my response.

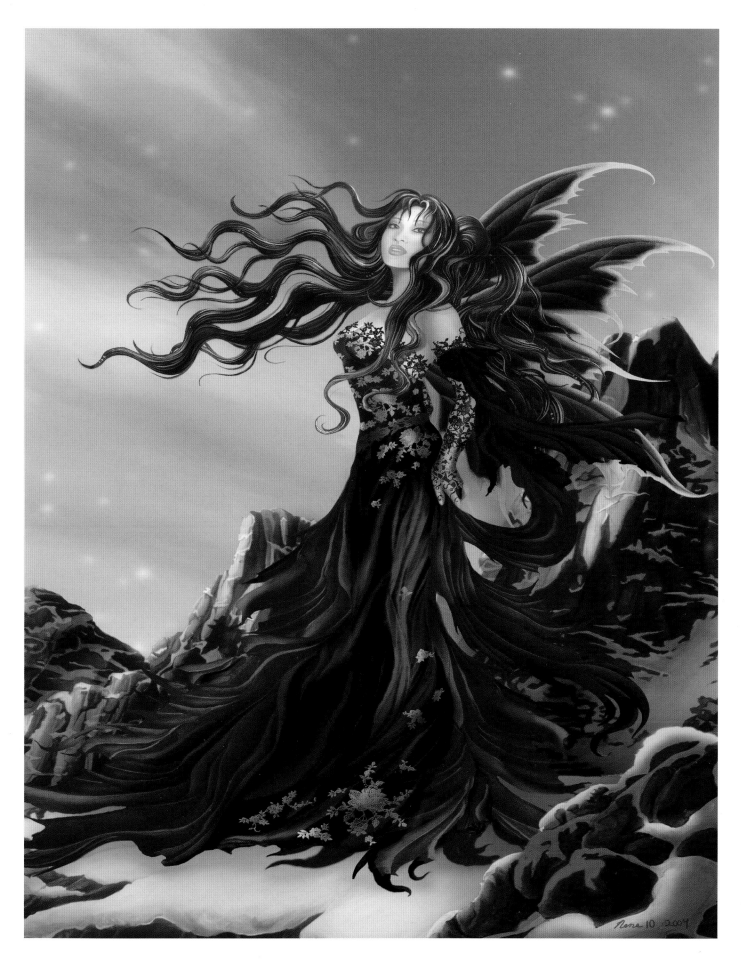

Aria

Normally I don't like to do portrait pieces because it is extremely difficult to get the painting to look like the model. I made an exception for *Aria*. The girl in the picture is a very good friend and fellow artist named Yaya Han, and she is so beautiful that I had to paint her. I was a bit nervous when I showed it to her, but she loved it!

13

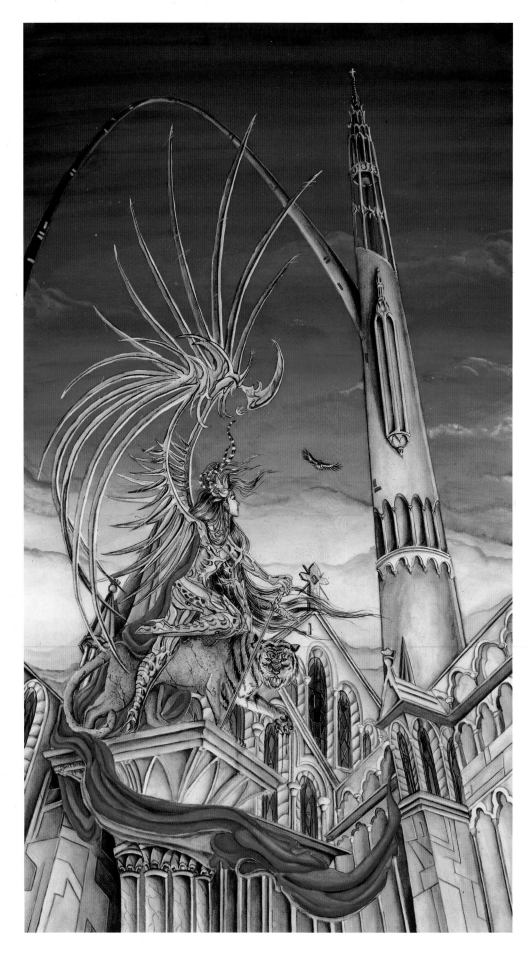

Bird of Prey

I painted *Bird of Prey* shortly after *Knight of Winter.* While I was sketching it, I played around with perspective, trying to find an angle that would make the tower seem like it soared and give the arch a truly vaulted look. This piece was featured on the cover of *Cryptych* magazine, but I never actually released prints of it.

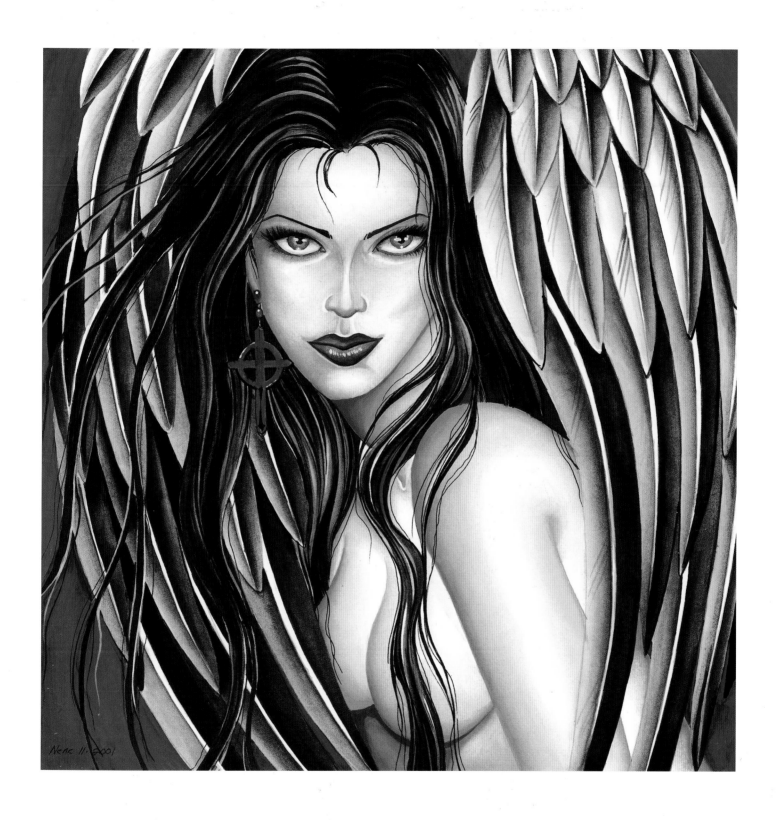

Blood Angel

In the majority of my paintings, I give the central figure an elegant look. I keep the poses demure and the facial expressions soft. This piece was designed to be different. The central figure has a very direct gaze, and there is nothing demure about her.

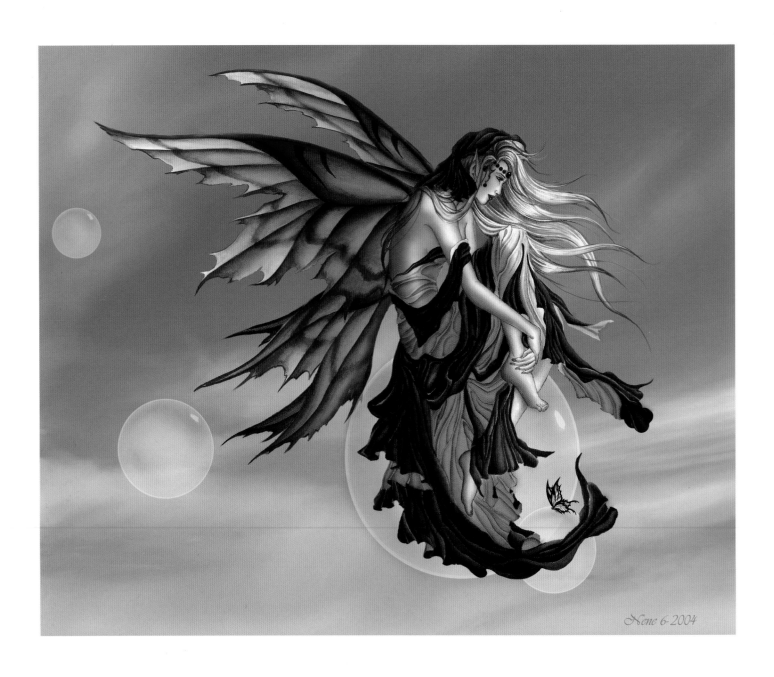

Bubbles and Butterflies #1: Blue Dream

When I develop a painting, I usually try to envision it as part of a series rather than as a single piece. *Bubbles and Butterflies* was designed as a series of figures sitting on bubbles that had very simple backgrounds and a lot of cloth. In *Blue Dream* I wanted to display strength through simplicity, so I deliberately kept the background simple. The figure really seems to be floating along, daydreaming.

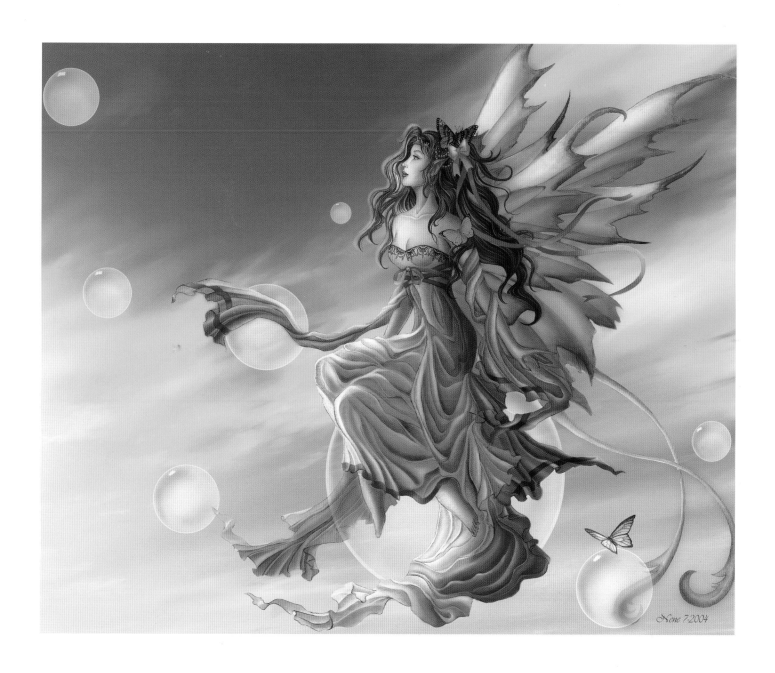

Bubbles and Butterflies #2: Daybreak

This painting is the second in the *Bubbles and Butterflies* series, and I got a little more aggressive with the lighting while I was painting it. I wanted the background to be a little more elaborate than the one in *Blue Dream*, but I still wanted to convey a feeling of simplicity.

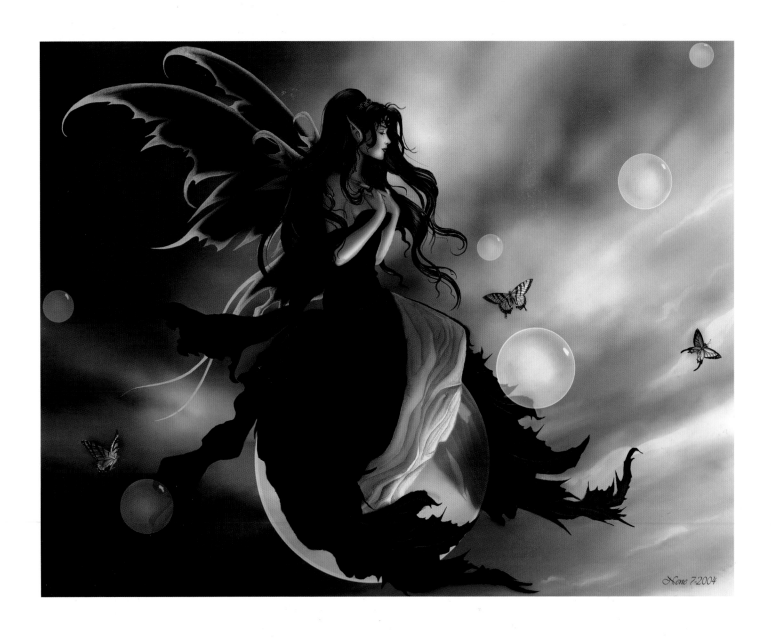

Bubbles and Butterflies #3: Gathering Storm

Gathering Storm, like the first two paintings in the *Bubbles and Butterflies* series, employs a simple background, dominated by an elaborate figure. The black and beige dress compliments the figure's warm gray skin very well, and the wings are as near to perfection as I could hope to get them. I also love her hairstyle. The effect created by the topknot, held in place by a jeweled hairpiece, greatly improves the image.

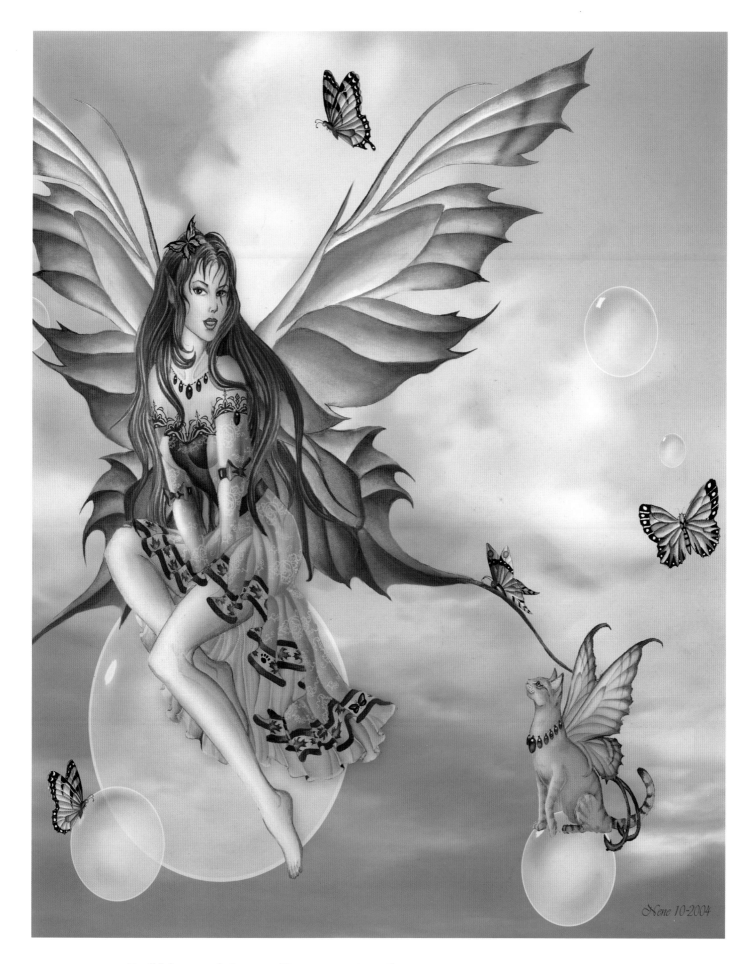

Bubbles and Butterflies #4: Purple Lace

Sometimes a series will take on a life of its own, and I end up adding more and more images to it. *Bubbles and Butterflies* has become that kind of series. Every time I think I am finished, inspiration hits, and I'm suddenly working on another piece for it. Luckily, this series is a genuine pleasure to paint.

19

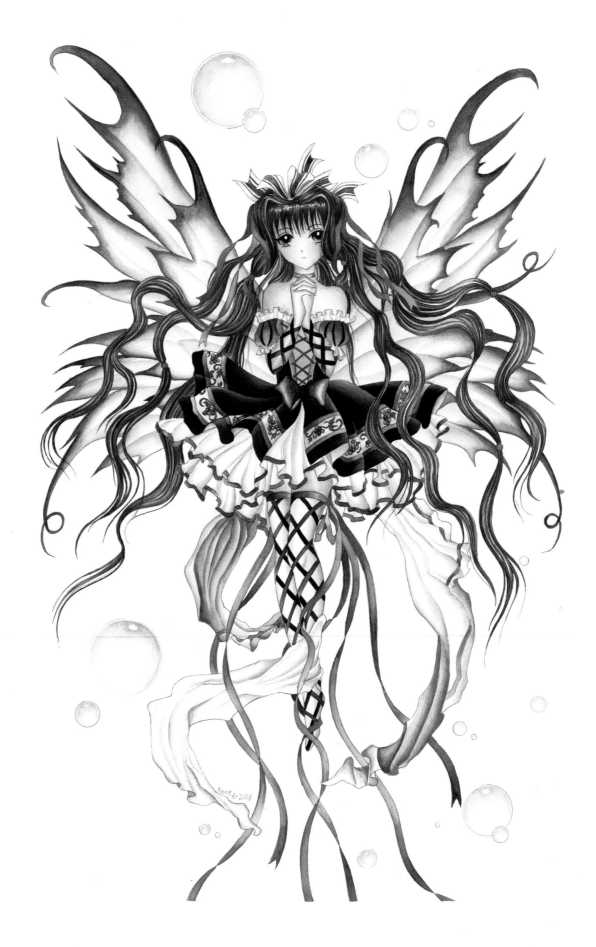

Burgundy Wine

This image is from my series of Japanese Anime inspired faeries. My anime faeries tend to be cuter and more lighthearted than my regular faeries, and I emphasize this by giving their dresses more frills and flourishes. I also love to paint long, very elaborate stockings, and cute stockings are perfect for these faeries.

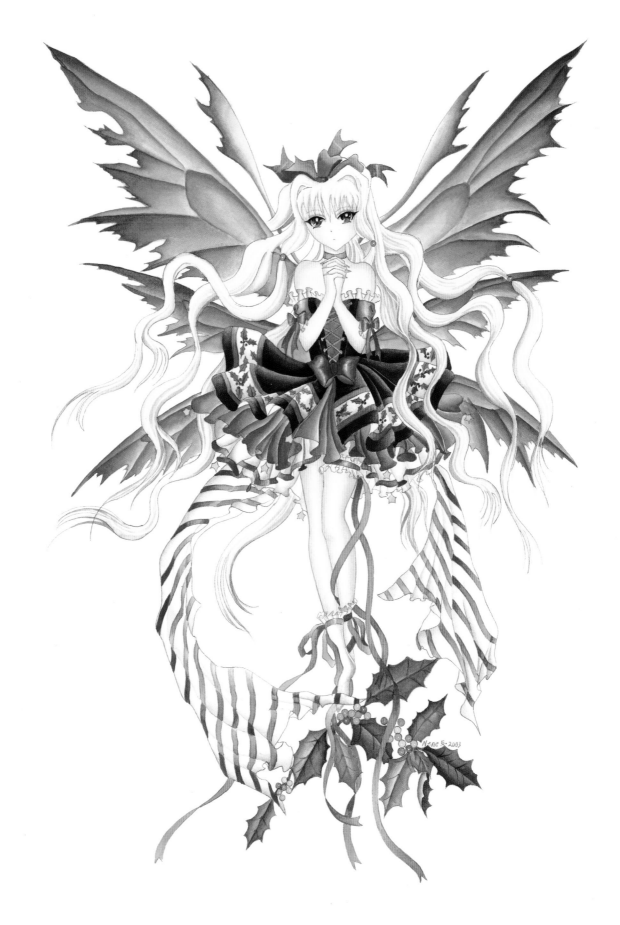

Candy Cane

I usually don't paint holiday-specific designs, but I made an exception in this case. The idea of *Candy Cane* was so incredibly cute that it just had to be painted. Don't look at this painting too long! You'll get cavities!

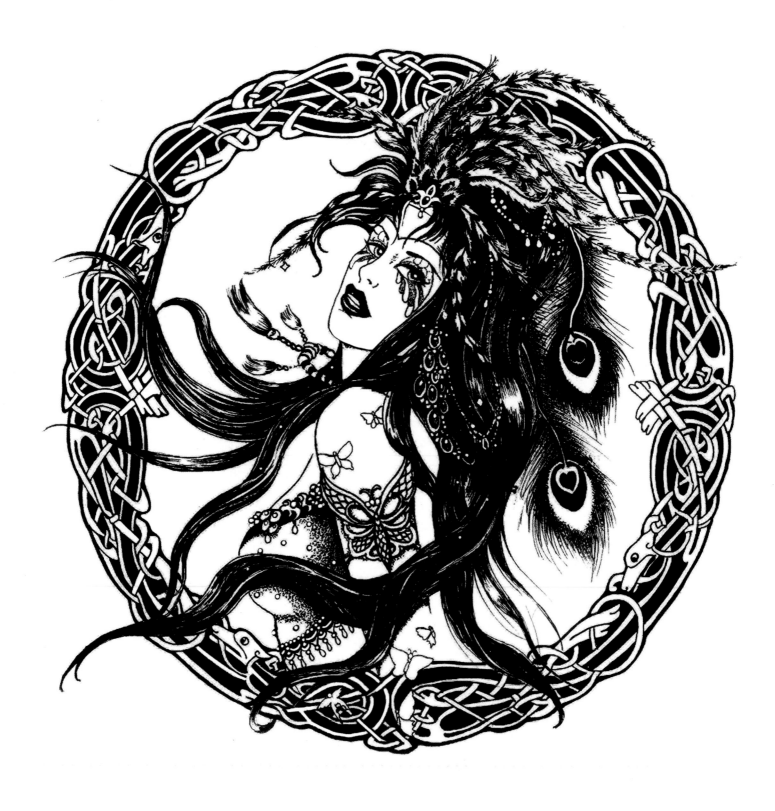

Carnevale I

Not every piece that I sketch becomes a finished painting. In fact, most of my sketches sit on a shelf and are doomed to sit there waiting, unloved and unremembered. When I hired my sister, Ann-Juliette, as my art assistant, I needed to find a way to allow her to practice converting my sketches into a form ready for me to paint. So I pulled out a stack of old sketches and asked her to turn them into pen and ink originals. All of the black-and-white images in this book were penned by Ann-Juliette, and as you can see, she has quite an eye for detail.

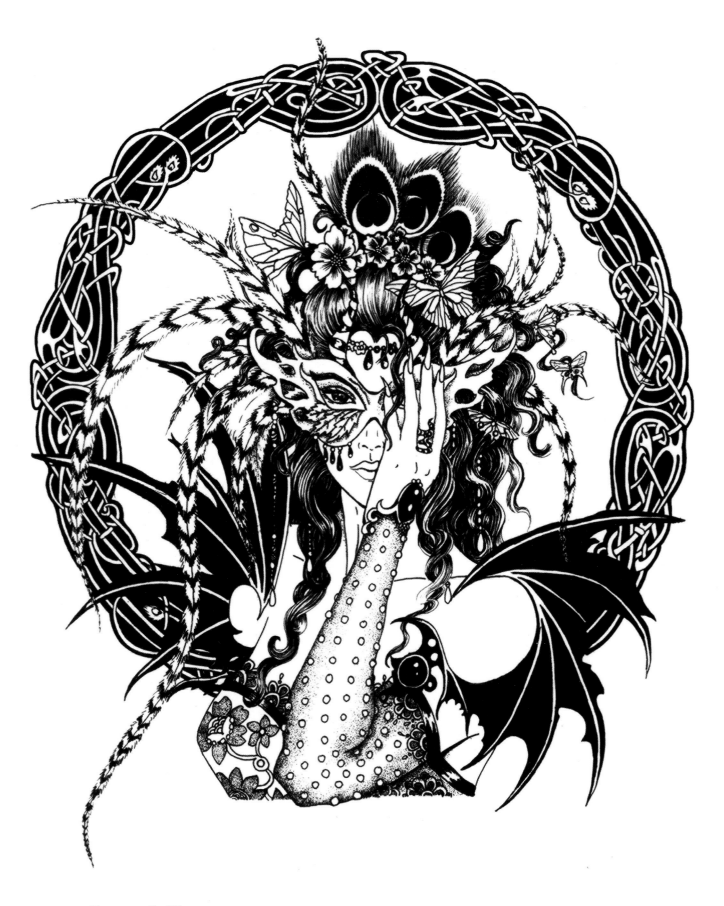

Carnevale II

The *Carnevale* series was something I had planned to do a while ago, but as I looked at the paintings I had completed, I saw that too many of them were simply faces and torsos on stylized backgrounds. So I reluctantly set the *Carnevale* series to the side and began working on large pieces with full backgrounds again. I still like these pictures and am glad that I have a chance to share them, but I still think I made the right decision when I set them aside.

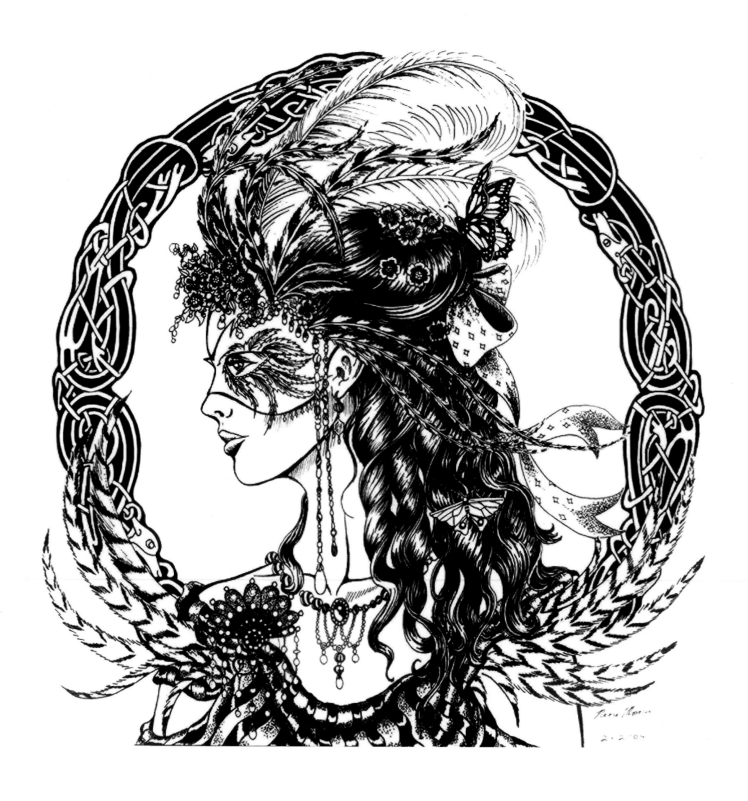

Carnevale III

Of the three images in the *Carnevale* series, this one has the most antique look. The curls, the patterns on the figure's dress, and the feathers are all hallmarks of Victorian styling, and I think that these design elements add up to create a very regal whole. I have to admit, I absolutely adore Victorian styles, and they mesh well when they are spiced up with a fantasy element.

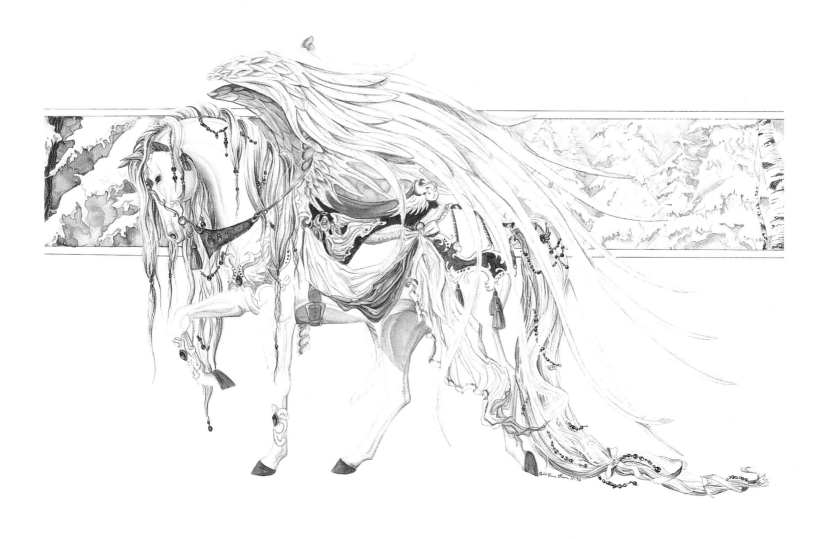

Carousel Horse #1: Angel White

Carousel Horse #1: Angel White is the first in a series of paintings designed to work together to achieve a special effect. When the series is completed, there will be twelve horses in all, one for every month of the year. *Angel White* is the carousel horse designed for January. If everything goes as planned, each subsequent image in the series will fit side-by-side in order, the colors running from white to black, the horses moving up and down like a carousel, and the backgrounds changing with the seasons. If you collect all twelve of the images and line them up in the proper order, you will have a continuous picture of a forest changing through the season.

If you look at the saddle, you will see an angel: the final part of the imagery. Each horse will have a saddle device that incorporates the title.

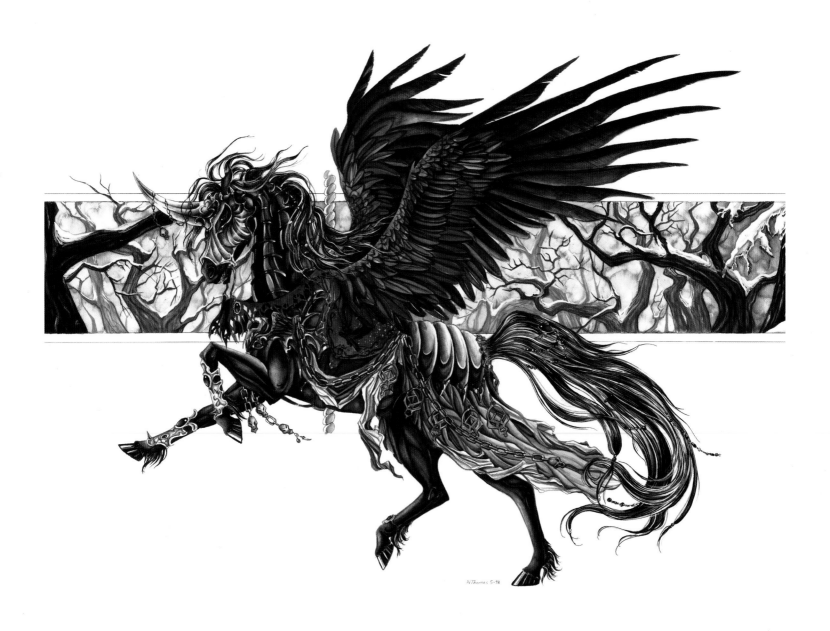

Carousel Horse #2: Raven Black

Raven Black represents December, but it was the second image that I painted for the series. The reason I paint these images out of order is that I prefer winter and autumn scenes to spring and summer scenes, so I'll paint the seasons that I like first, then go back later and finish the series.

If you look closely at this horse, it will become apparent that this isn't a nice horse. His teeth are pointed, the chains around his neck have skulls on them, and the chamfron protecting his head is bladed. The saddle device is a raven.

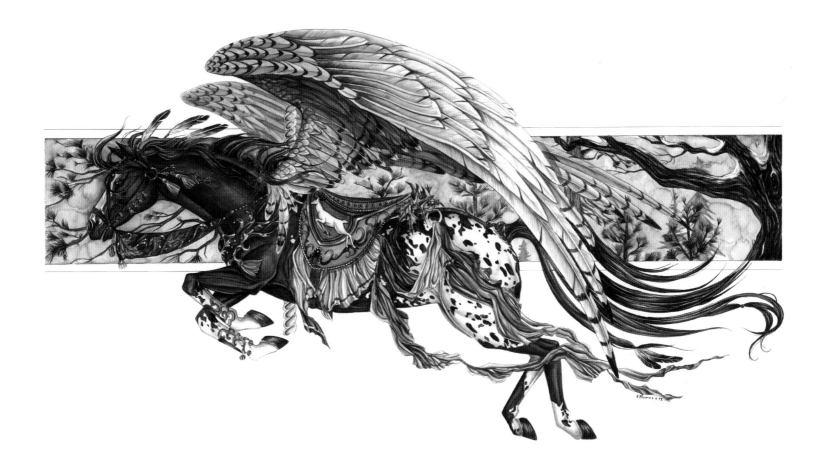

Carousel Horse #3: Hunter Brown

This is the third carousel horse. Hunter Brown represents the month of November and fits to the left of *Raven Black*. The horse is in full flight, and its pose mirrors that of the stag on his saddle.

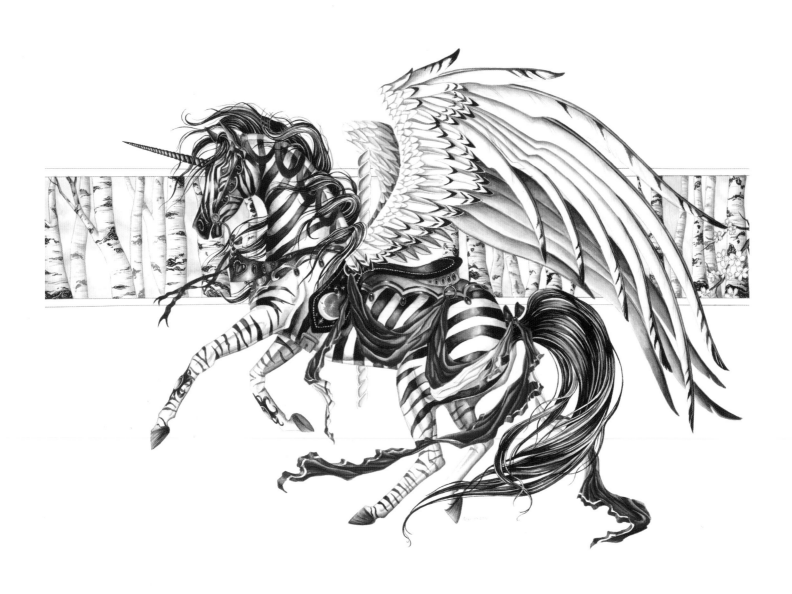

Carousel Horse #4: Moonlight Silver

For those of you who watch Animal Planet, you may notice that this isn't actually a zebra. I think zebras are extremely ugly, so I painted a stallion with zebra colors and hoped no one would notice. *Moonlight Silver* represents the month of February and fits to the right of *Angel White.* Here's a bit of trivia: someone once asked my husband what kind of fantasy creature was this, a Pegasus or a unicorn? Neither. It's a Pegaunizebracornasus was his answer.

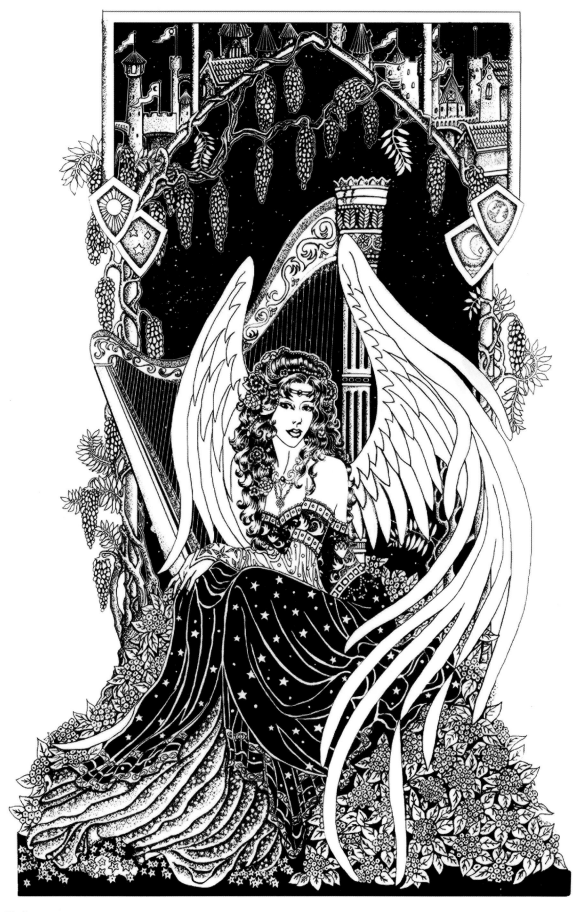

Celesta

I drew *Celesta* years ago, when I was thinking about adding a second set of images to the *Virtues* series. While I liked the way this image turned out, I felt uncomfortable with the idea of continuing an already completed series. Too long much time had passed since I completed *Introspection*. After Ann-Juliette finished the pen-and-ink version of the image, I decided to use the figure in a different painting and created *Interlude*.

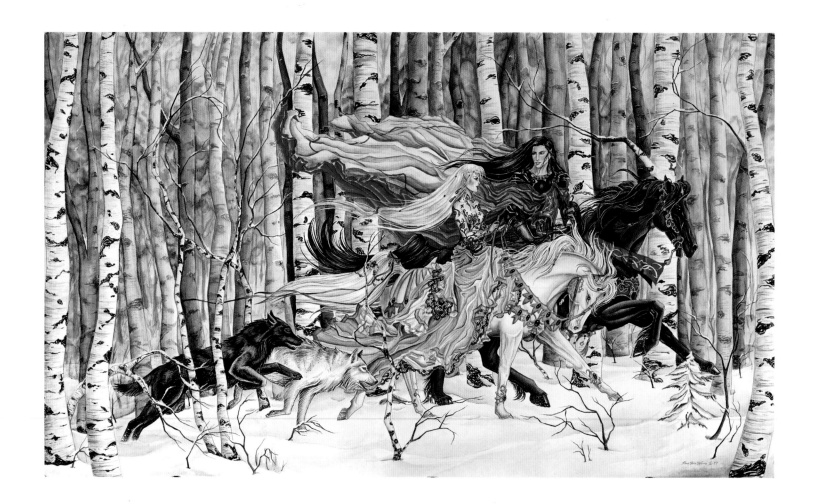

Counterpoint

Counterpoint is my tribute to Bev Doolittle, one of my favorite artists. The horizontal format, the birch forest, and the movement through the trees are all hallmarks of her work, and I tried to capture the same feel in this image. Don't bother looking for any hidden elves in the trees though! That would be over the top, even for an homage.

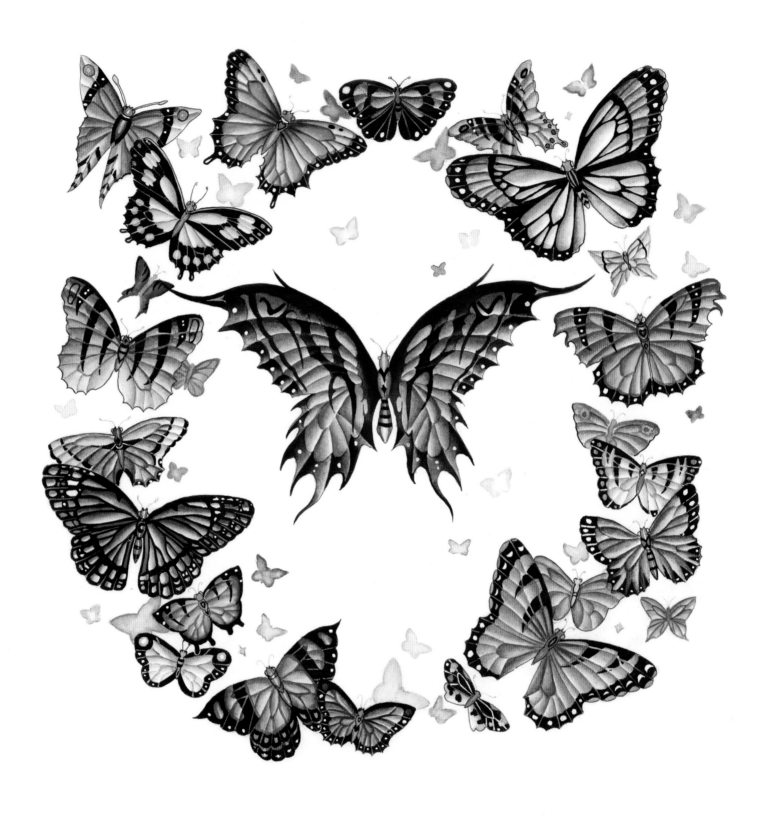

Dark Butterfly Ring

Can you think of anything more beautiful than a sky full of butterflies? This image was created as a sticker design for one of the companies that I work with, but I liked it so much that we actually ran prints of it. One of my fans asked me why I paint butterflies as if they were pinned to a board. Silly person! They aren't pinned down: They're just well-trained!

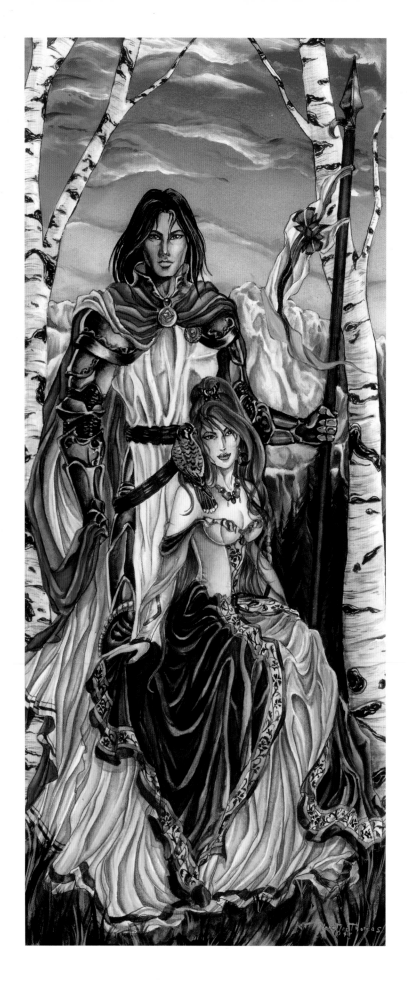

Devotion

I was really happy with the way this painting came out. The colors of the dress are very vibrant, and the knight's armor actually looks like armor. But the outstanding part of this image is the decorative border on the dress. I had played with borders before, but this one really came together, and it set the standard for all of the other frilly dresses that I've painted since.

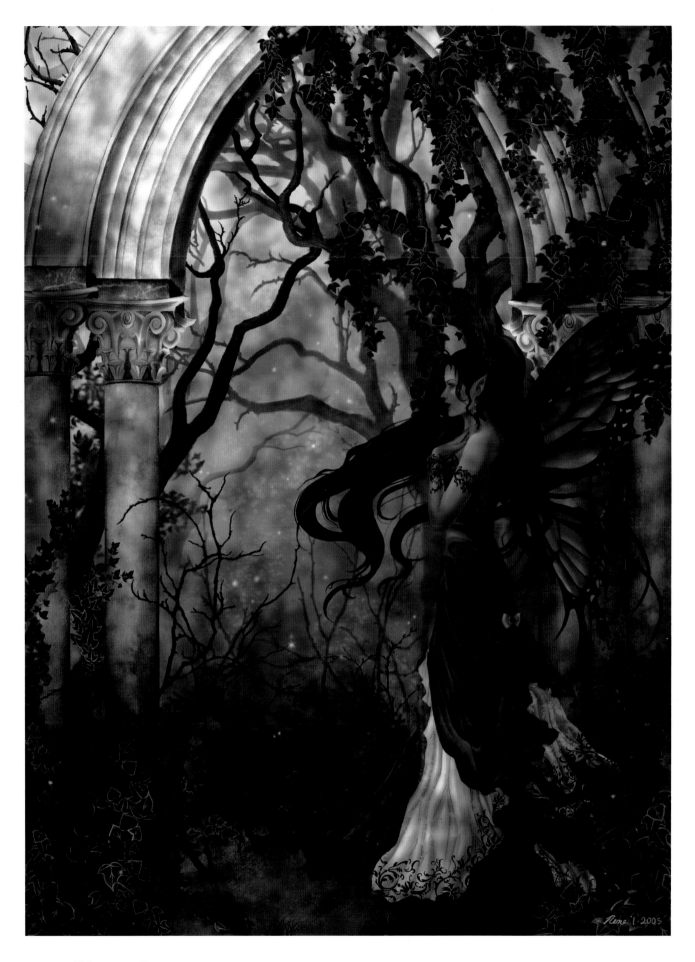

Direwood

Inspiration comes from the most unlikely places at times. My husband loves video games, and I got addicted to watching him play one particular game. One of the areas in this game is a beautiful forest that succumbs to a malevolent influence, and its beautiful foliage has been turned into a twisted mockery itself. The imagery of this setting stuck with me and inspired *Direwood*.

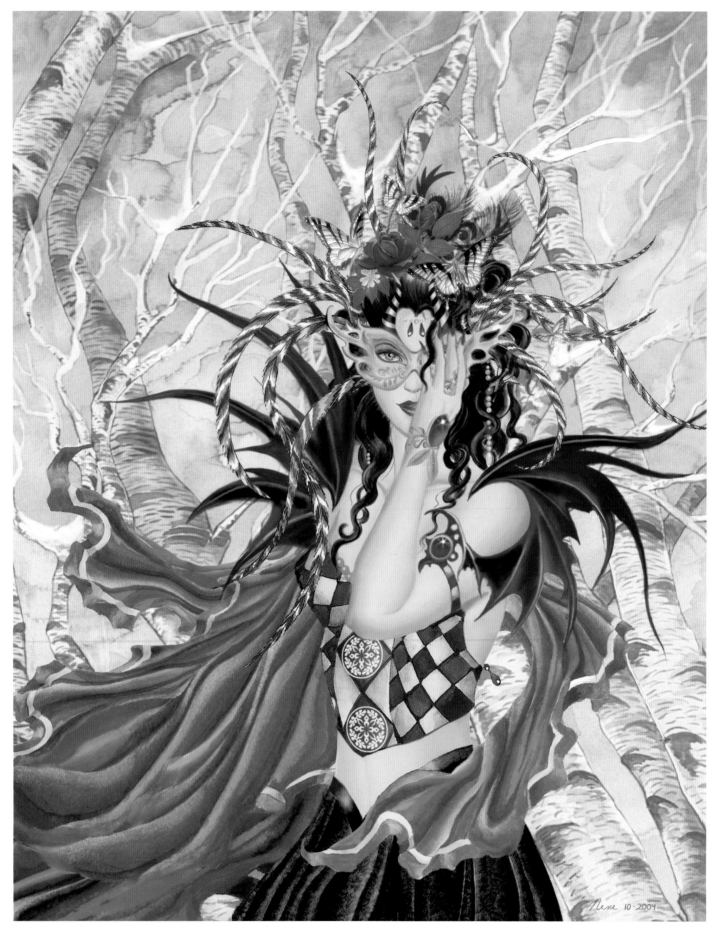

Domino

The original sketch of *Domino* was much smaller than the finished painting, as all I had originally intended to paint was the figure's face and the mask. As I was working on it, however, I decided that I wanted to see more of the figure, so I started over, using the original design as the starting point. The character is from a story that I have been working on for most of my life. The character's name is Aveliad.

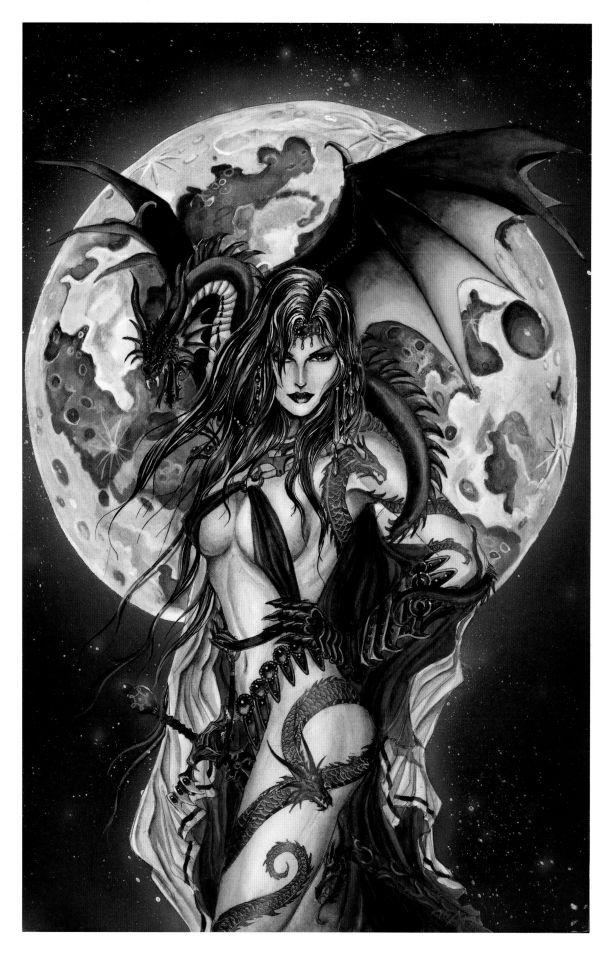

Dragon Witch #1: Dragon Moon

Dragon Moon was the prototype for the *Dragon Witch* series, and the figure is still one of the most popular of my images. The dragon witches are pure pin-up. I really hadn't explored that direction in my art before. I really admire the work of Olivia and Vargas, and this series is an homage to them.

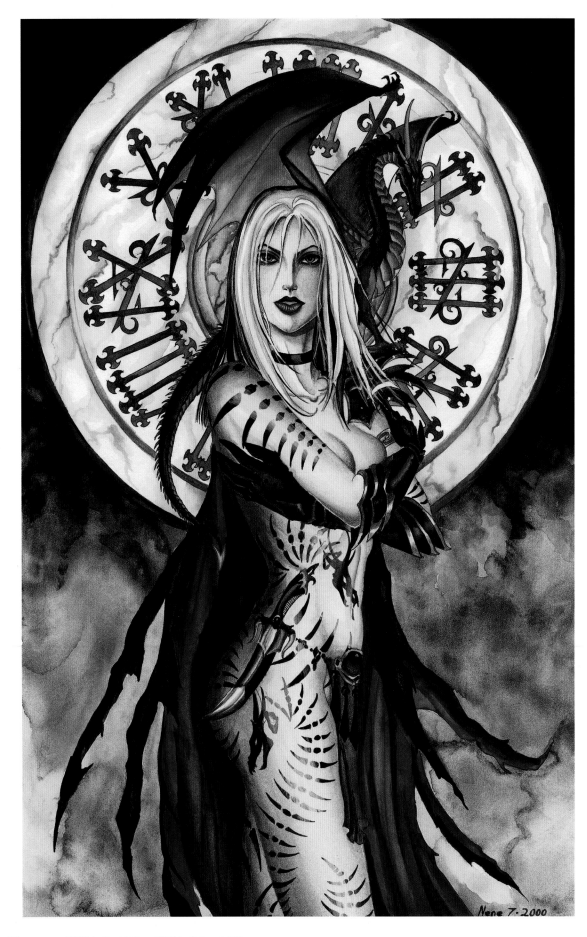

Dragon Witch #2: Witching Hour

The clock in the background is missing a key feature:

It doesn't have hands. Midnight is the witching hour, but no matter how I tried to paint the hands, they looked like big spikes growing out of the top of the figure's head, and I couldn't fashion a digital clocks, for it just wouldn't have that gothic feel.

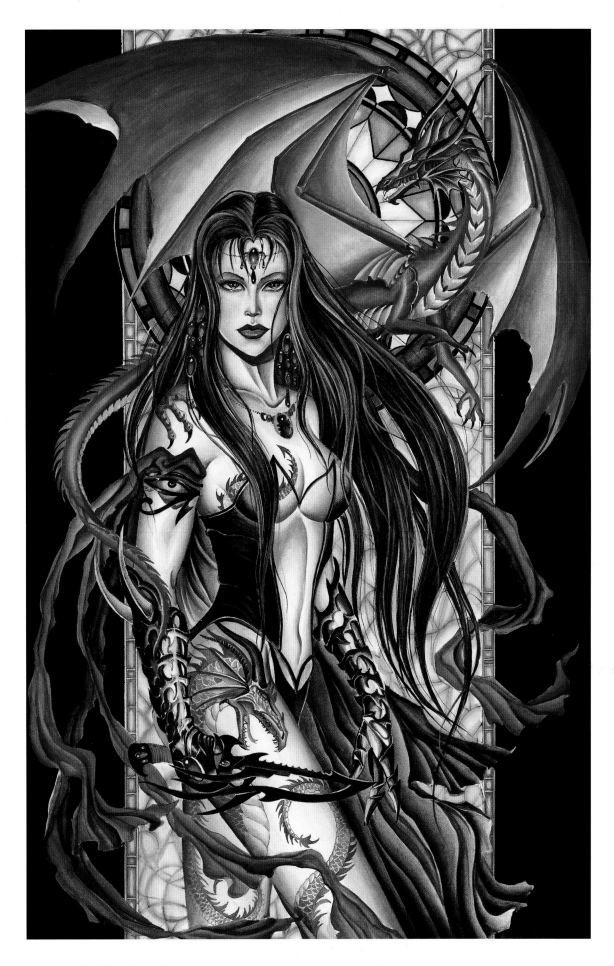

Dragon Witch #3: Corona

Corona is the third in the *Dragon Witch* series and is designed to stand beside *Halo*, the fourth in the series. The arm band that the figure is wearing is a solar eye, taken from Egyptian imagery.

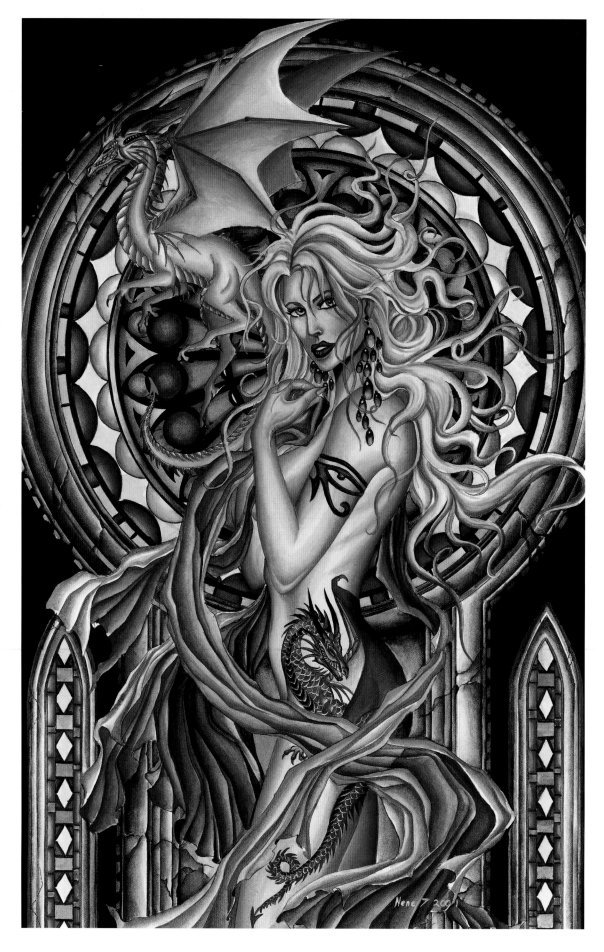

Dragon Witch #4: Halo

Halo is another Dragon Witch painting, but I moved away from the warrior motif when I was making it. I wanted the woman to be a little more vulnerable. *Halo* is the only figure in the series that doesn't carry a weapon.

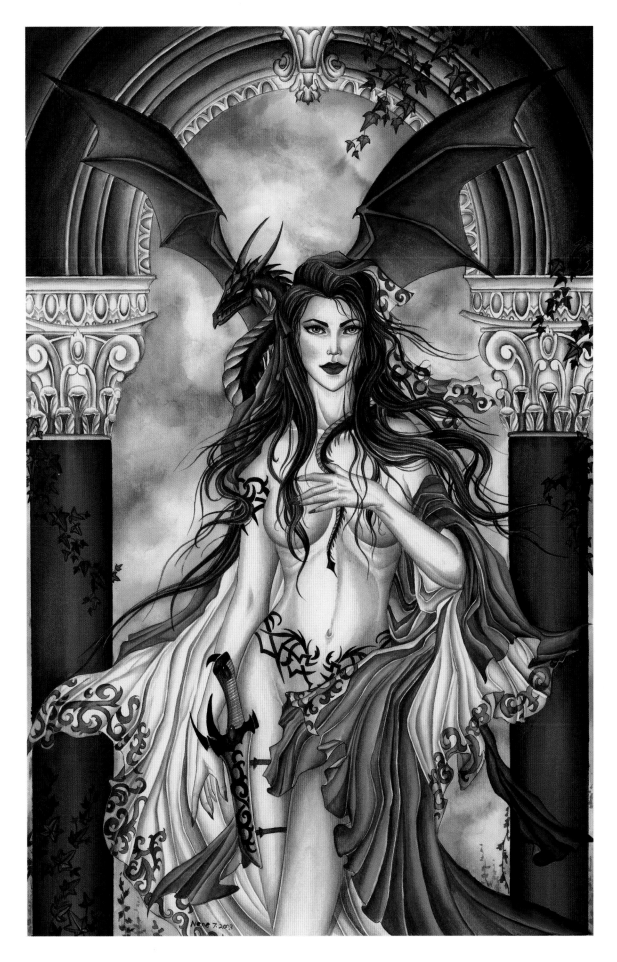

Dragon Witch #5: Oracle

Oracle is a very direct piece. And while the figure is practically naked, she doesn't exactly look vulnerable. The large knife may help to give her an air of boldness, but I think it has more to do with her direct gaze and confident stance.

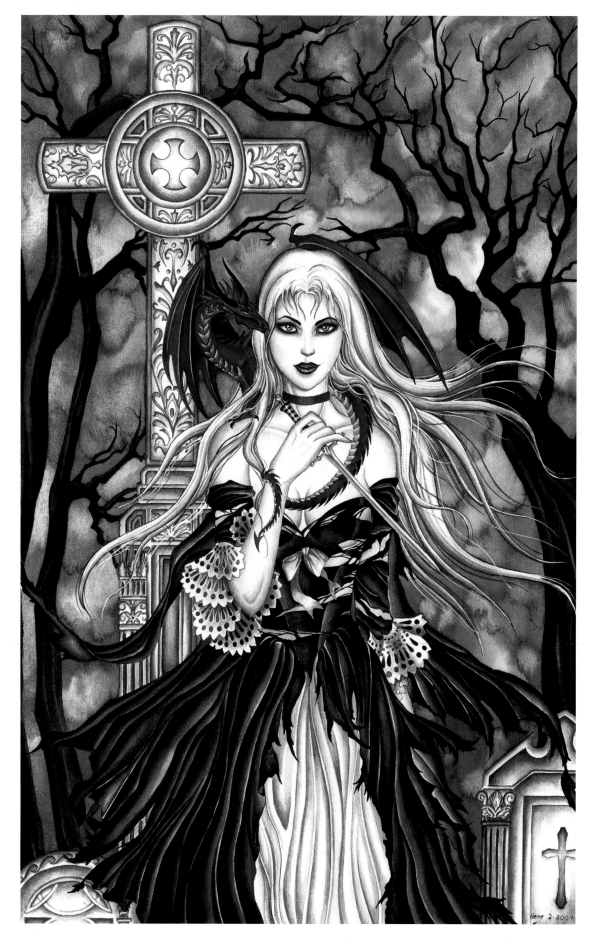

Dragon Witch #6: La Victime

I love French History! After the French Revolution and the Reign of Terror, people that had lost relatives to the guillotine would throw lavish parties at which they wore red ribbons around their necks to signify their loss. It became the cool thing to do: if you weren't a victim, then you weren't allowed to attend the parties.

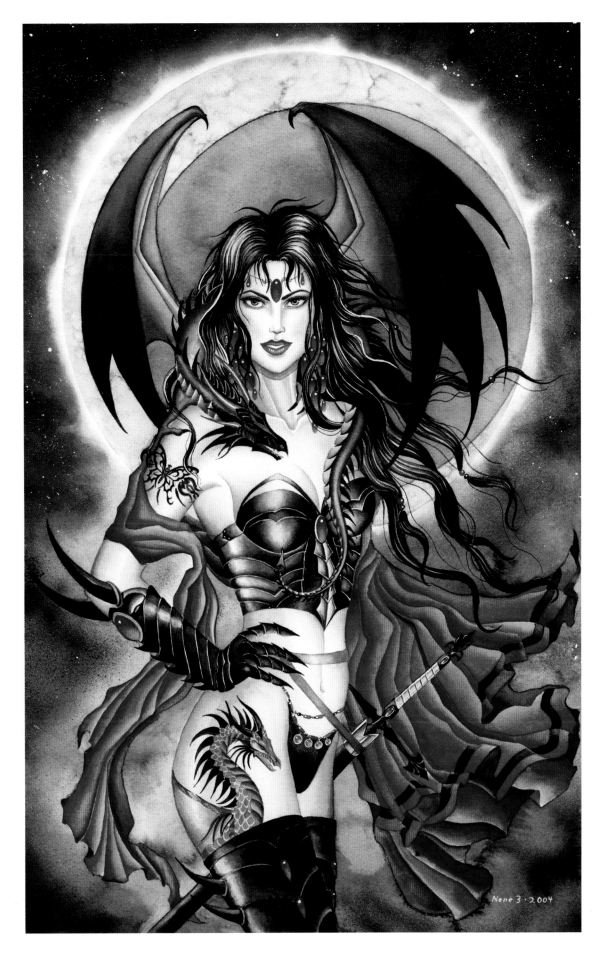

Dragon Witch #7: Guardian

Guardian is the quintessential Dragon Witch: scantily clad, armed to the teeth, and tattooed. While *La Victime* has a gothic feel, *Guardian* is pure, unadulterated fantasy.

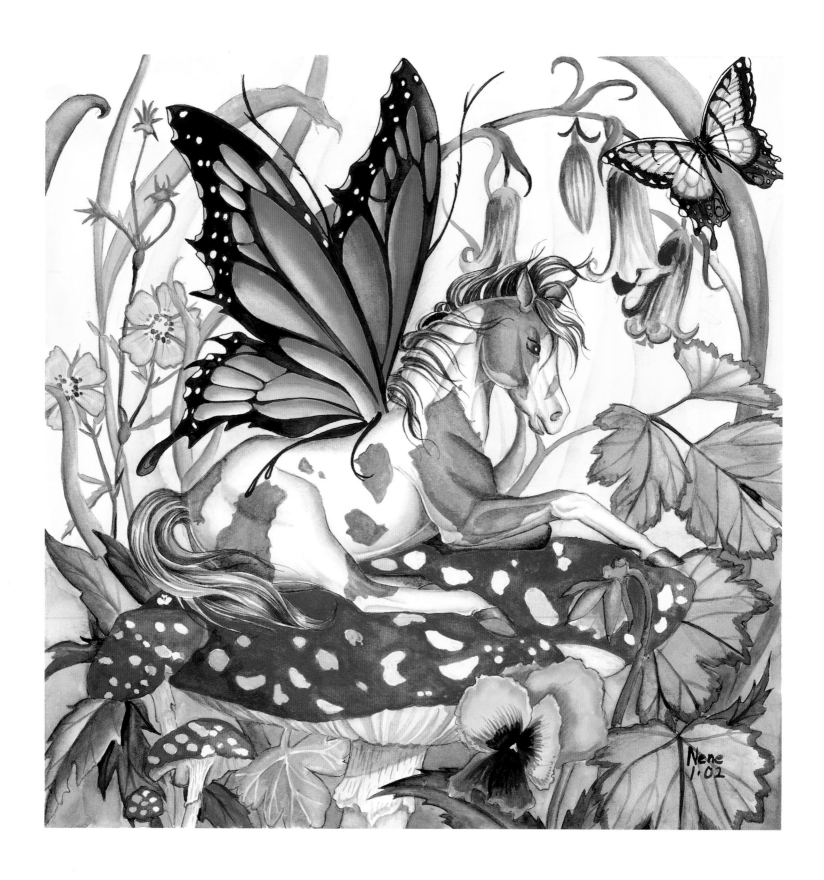

Faery Foal

This piece is just about as cute as it can be, rivaling *Candy Cane* for pure saccharin sweetness. I love horses, but this was the first time that I had ever painted a foal. I think it came out pretty well!

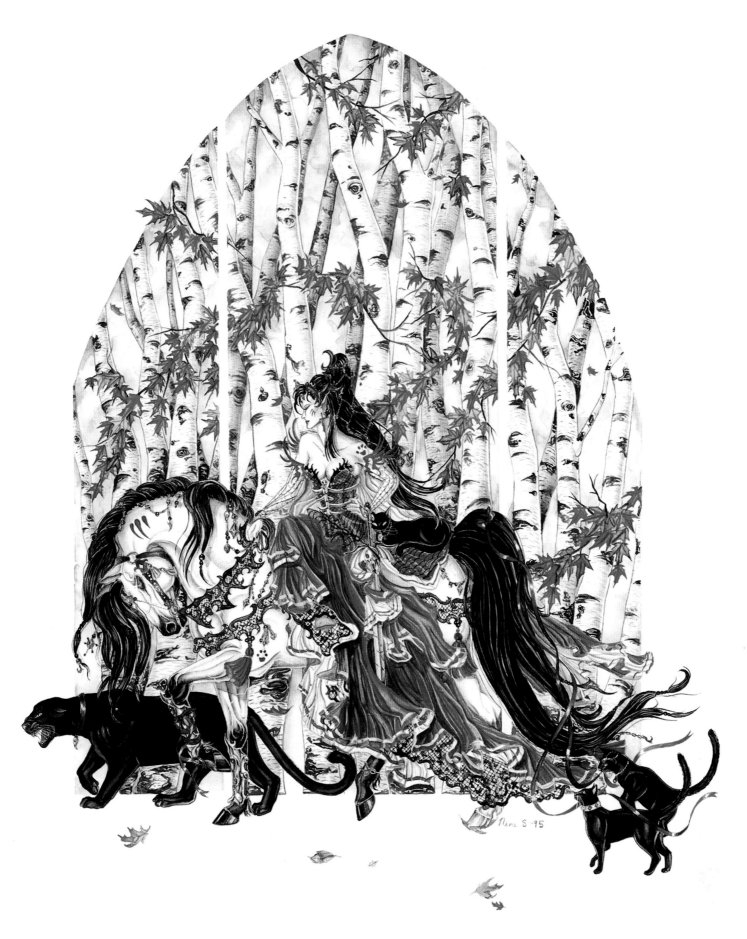

Faery of Black Cats

Knight of Winter and *Faery of Black Cats* marked the first real growth of my art. Before I painted them, I had been working almost exclusively on Collectible Card Game art for several different companies. At that time everything that I painted was a commission, but I painted *Faery of Black* for myself. Once I completed it, I knew that I had to become my own boss and paint only the things that I wanted to.

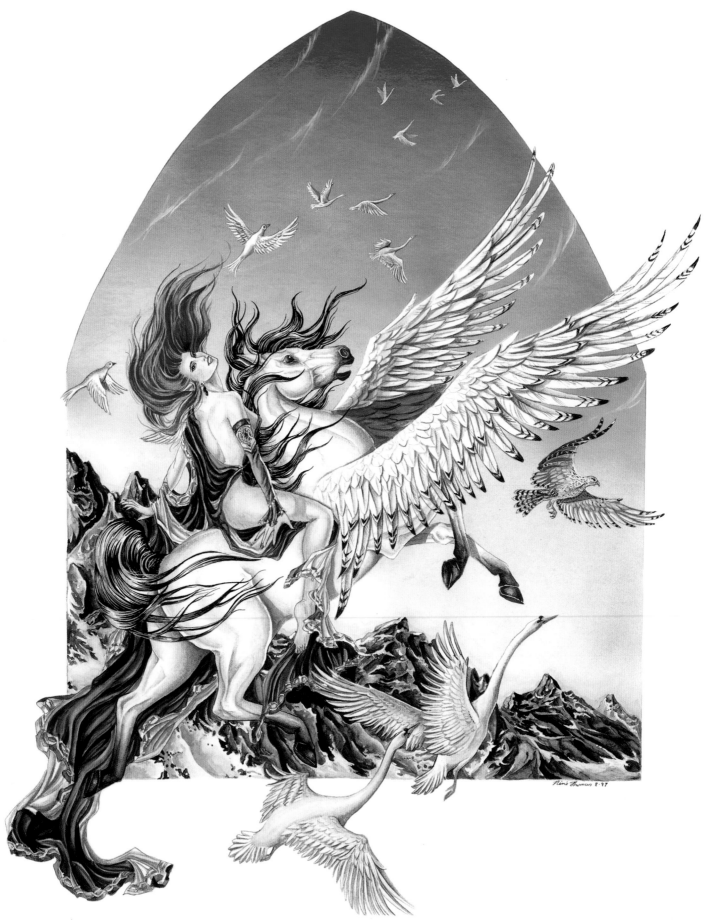

Faery of Flight

Faery of Flight is the third print in the Faery series, and one of the first pieces in which I attempted to paint mountains. The blue sky was also a departure. I normally paint skies using Payne's gray washes to create a mist-like effect.

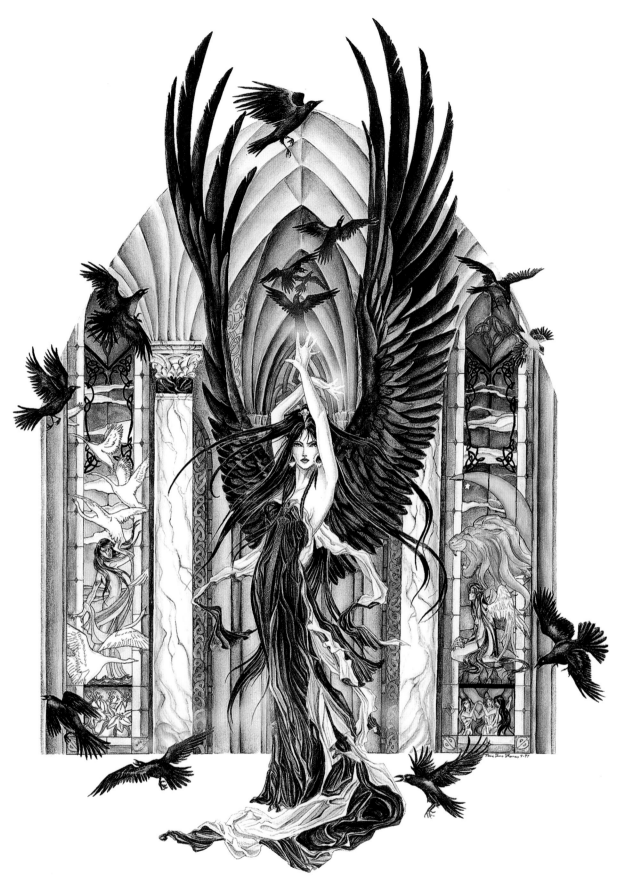

Faery of Ravens

Faery of Ravens is one of my most popular pieces. Normally I don't mess with symbolism, preferring instead to leave interpretation to the viewer, but I added quite a bit to this piece. The faery is actually creating the ravens, and the picture has 12 ravens flying in a counter-clockwise circle, with the thirteenth bird having actually been created as a goldfinch by mistake. The idea here is that magic is never predictable, and that sometime things can go awry. If you look carefully, you'll see that the stained glass windows tell their own stories as well.

Faery Princess

Designed as a set with Le Fay, Faery Princess is a young, demure faery compared to the older and more seductive Le Fay. Even though she is supposed to be demure, the expression on her face is very sexy…sort of a come hither look.

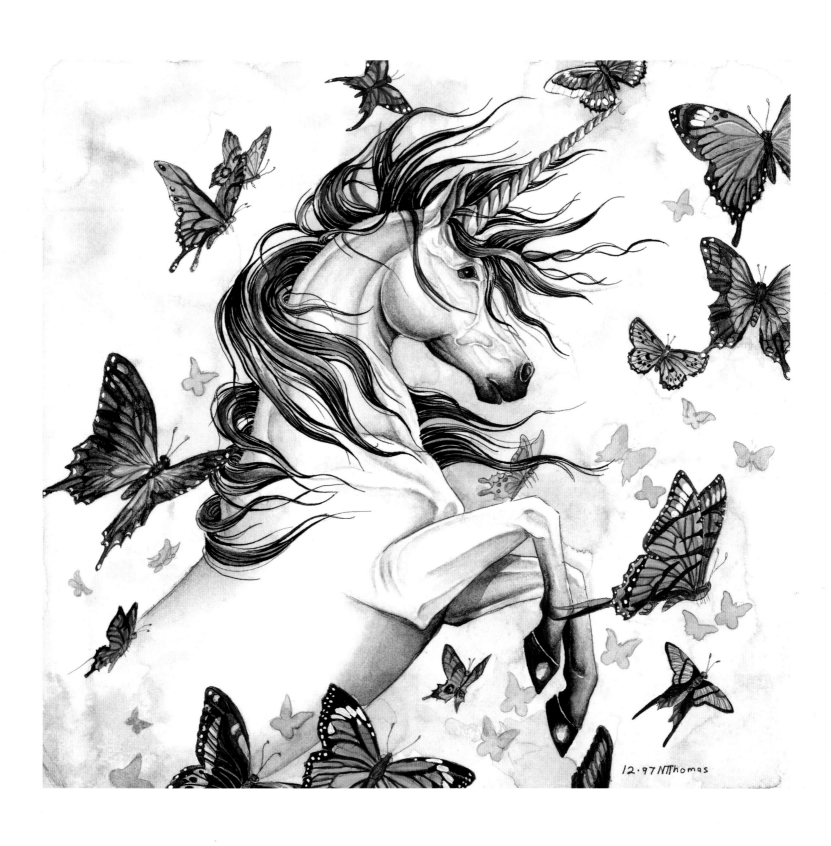

Faery Ring

This picture marks the beginning of my love for butterflies. Unlike the two Butterfly Ring images, this picture shows butterflies in flight, and not just pinned to a board. I am very happy with the way the unicorn came out as well. The shading on the horn and the shadowing on the horse came out better than I'd hoped.

Fall

Before I became a professional artist, I tested the waters by releasing a few hand-colored prints. My earliest works were small editions shown at local conventions, and several of them bore striking resemblances to the anime fan art that I started with. This is Chesare, the same character featured in *Birds of Prey*, *Memento*, and *Absinthe*. As you can see, the character design has changed somewhat over the past decade.

Fallen Angel

Fallen Angel was the prototype for *Blood Angel*, and as you can see, it is a lot darker. After I painted *Blood Angel*, I had to decide if I wanted to take one extra step further and put dark eye shadow and blood on her face. Ultimately, I decided against it, the changes wouldn't have added all that much to the overall effect. So I left it the way it way it was, and renamed it *Blood Angel*.

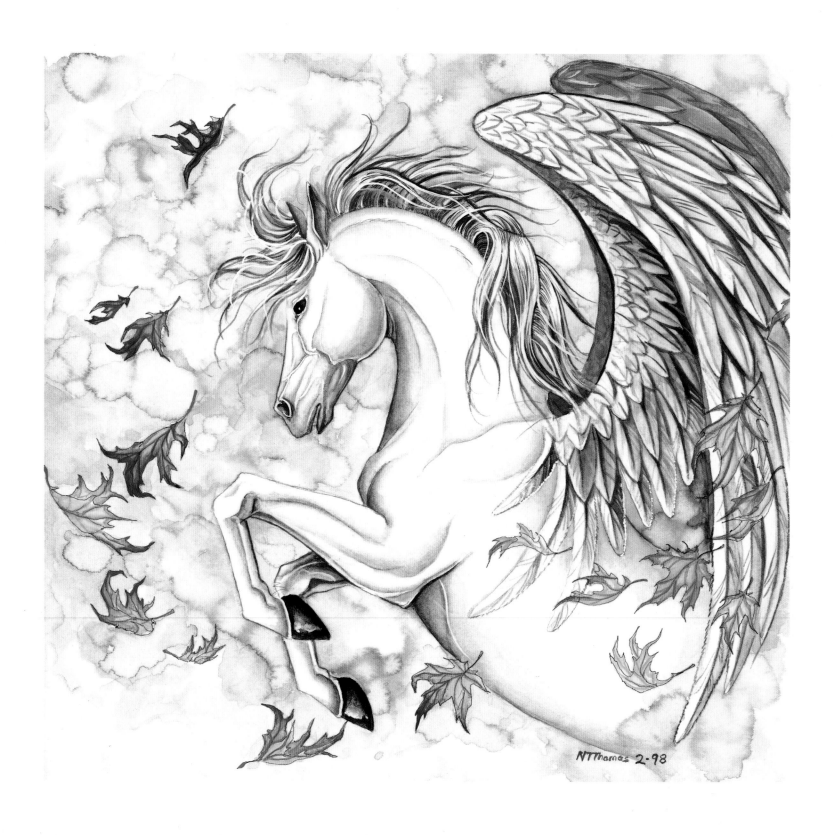

Fire Dance

Fire Dance is the companion to *Faery Ring*, and is a stereotypical Pegasus. The thing I like best about this picture is the flow of the leaves. They look as if a sudden wind has lifted them up and swept them aside. Autumn leaves are stunningly beautiful and, next to birch trees, are my absolute favorite things to paint. In fact, since I think birch trees have ugly leaves, I often paint oak or maple leaves on them, instead of their real leaves.

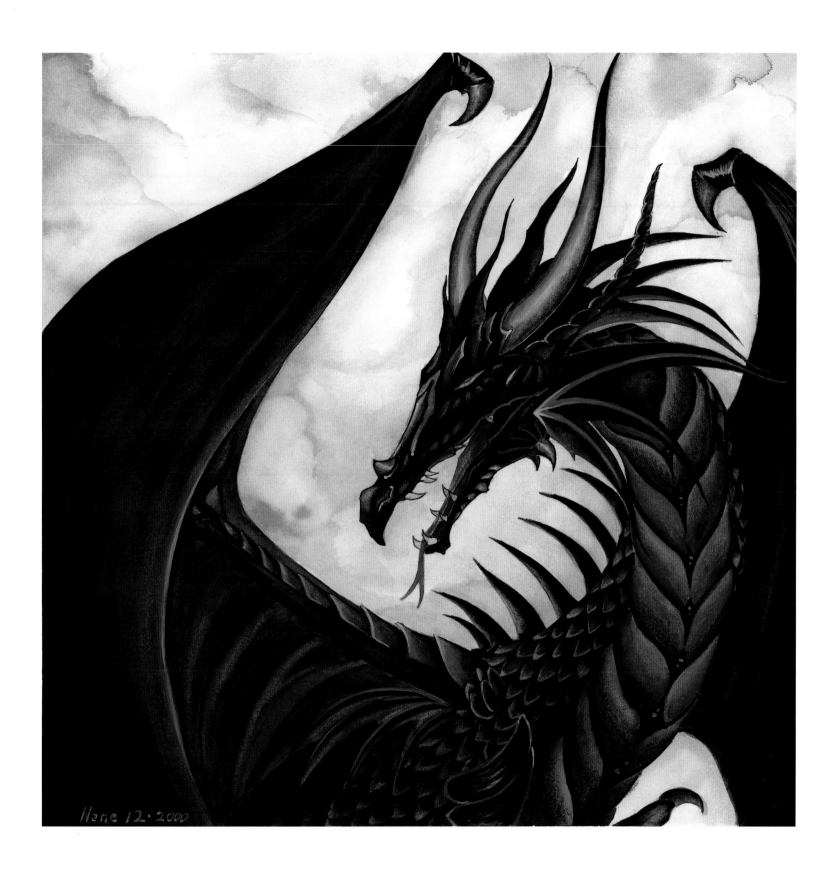

Fireheart

In the world of Dungeons and Dragons, good dragons are signified by precious metals, and evil dragons are signified by colors. Therefore, black dragons are evil, while gold dragons are good. *Fireheart* and *Sundancer* are a set, one evil, one good, but I like black dragons better. They just look cool!

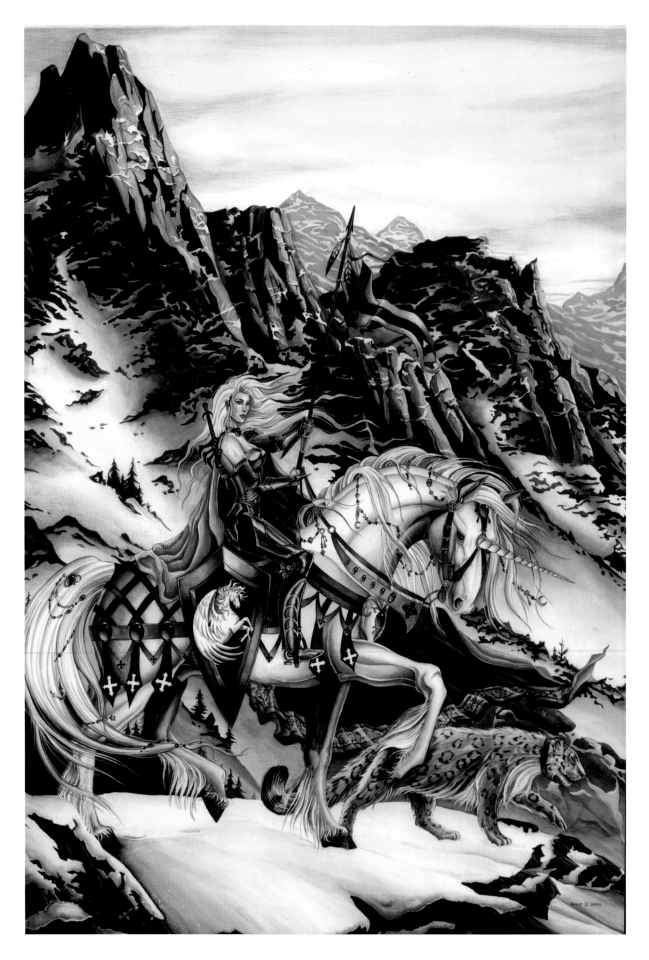

Fortitude

The original name for this image was *Bradamante*, but I really got tired of answering the question, "Who is Bradamante?" So I renamed it. Bradamante, by the way, was the niece of King Charlemagne, the legendary French ruler. She was a female paladin and an exceptional warrior. She eventually married a Saracen warrior named Rogero, but only after, she forced him to convert to Christianity.

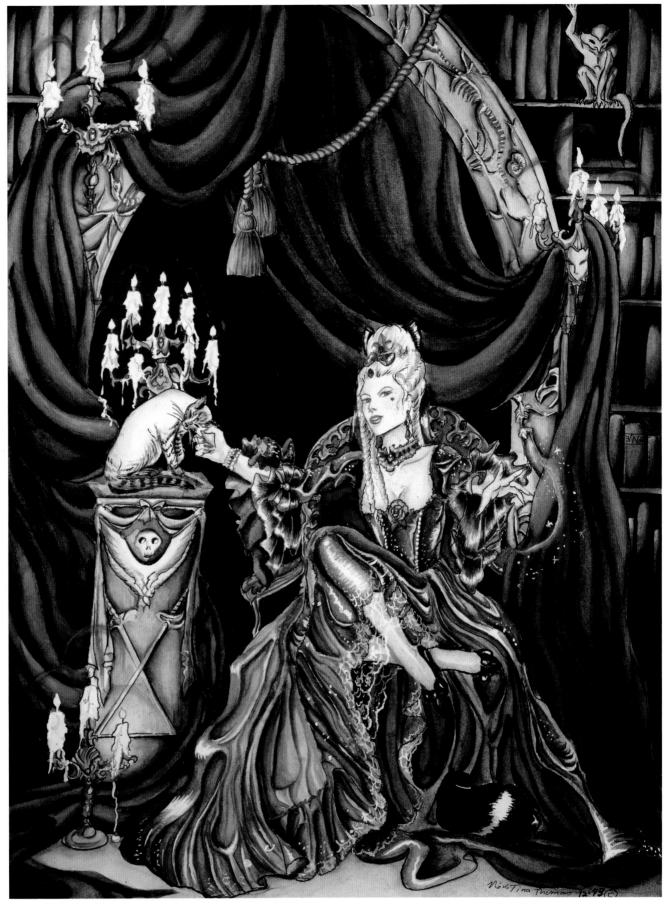

Greensleeves

Greensleeves holds the distinction of being the oldest true painting in this book. I painted this one in 1993, five months before *Knight of Winter*. My style was just starting to take shape, and for all of its relative crudity, this piece contains many elements that I still use today. After all, some things never change, such as my love of elaborate dresses and elegant hair styles. On a personal note, the cats featured in this picture are named Nirvana and Cowser, and they belong to two of my dearest friends, Beth and Sue. Sadly, Cowser has since passed away.

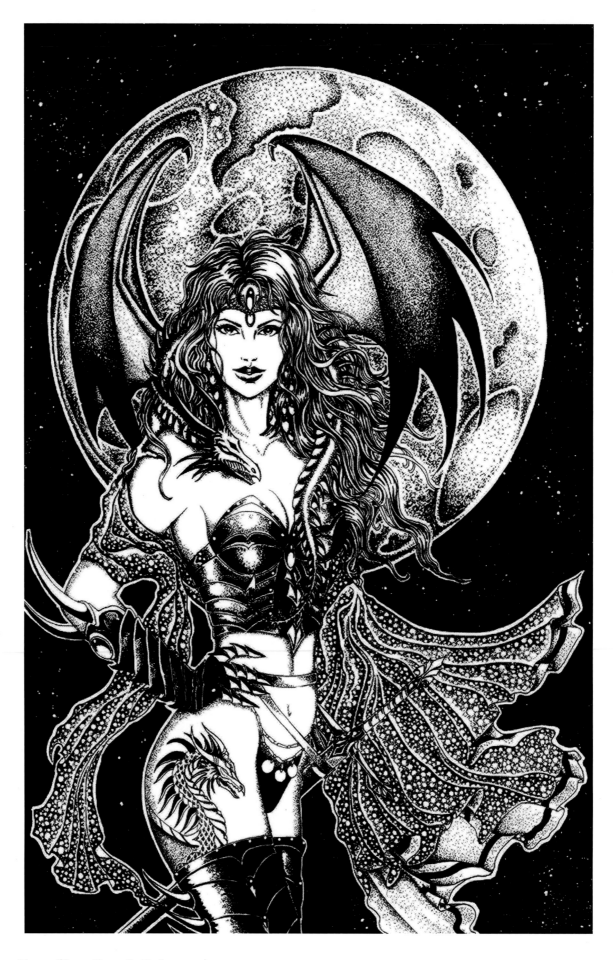

Guardian Pen & Ink

Guardian belongs to the *Dragon Witch* series, which can be seen in its completed form in this book. Ann-Juliette did the ink work, and really made this piece stand out. In particular, the pointillism work she did on the moon and the dragon's wings really make the image pop out, and that isn't easy to achieve in black and white.

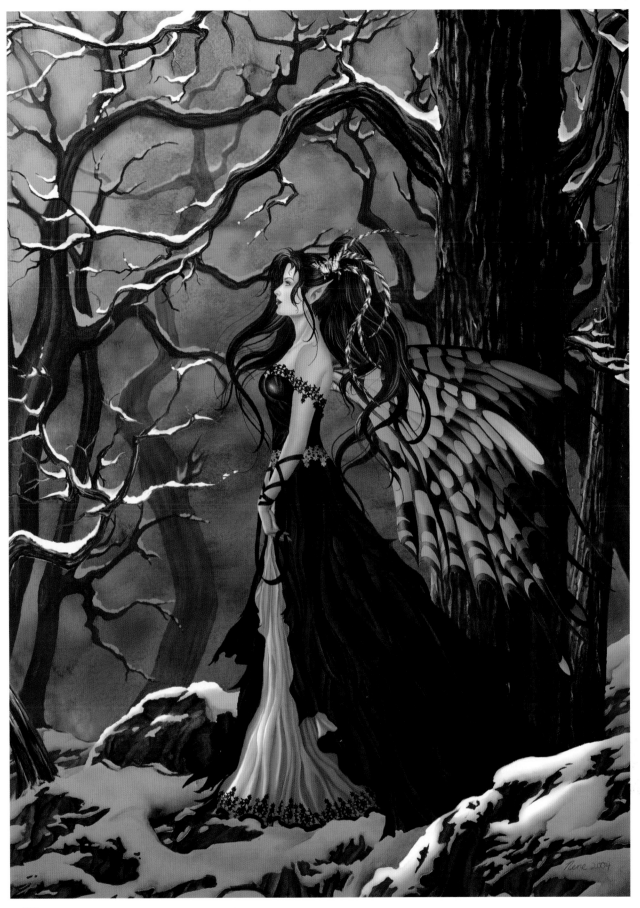

Hope

Every now and then, an artist can actually see the improvement in his or her work. Generally speaking, improvements in technique are very gradual, and usually you don't even realize that you are getting better. *Hope* is the beginning of the new direction that my art is taking, and I couldn't be more pleased with it. When I finished painting it, I couldn't believe how well it came out or that I was the one who painted it! When you create a piece like this, it re-energizes you because you want to repeat your achievement again and again.

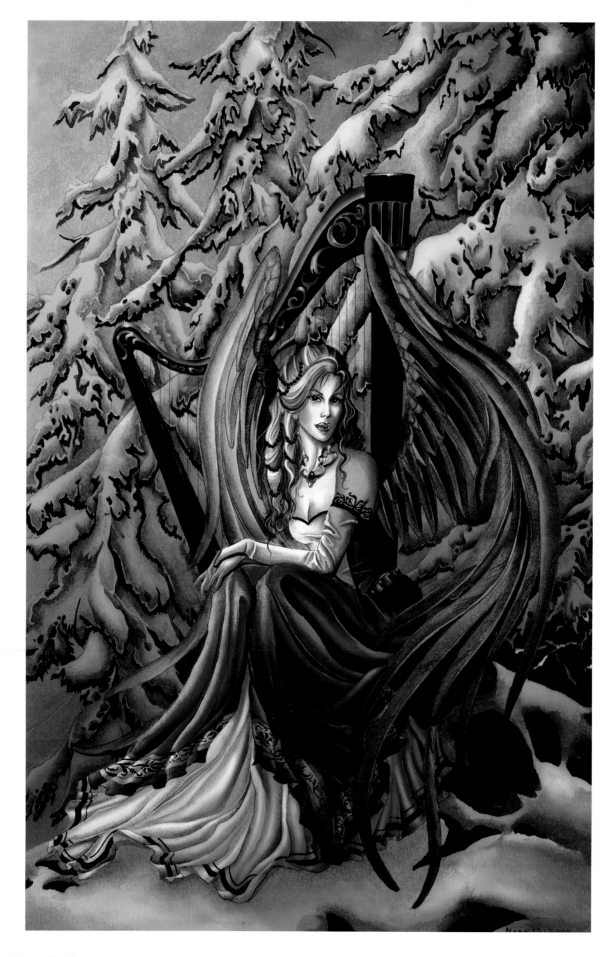

Interlude

This piece was completely inspired by my sister, Ann-Juliette. While Angie is developing into a very good artist, she is also a very accomplished musician. Her instrument of choice is the harp, and she plays it beautifully. The harp is an elegant instrument, and I felt it would fit perfectly in a painting.

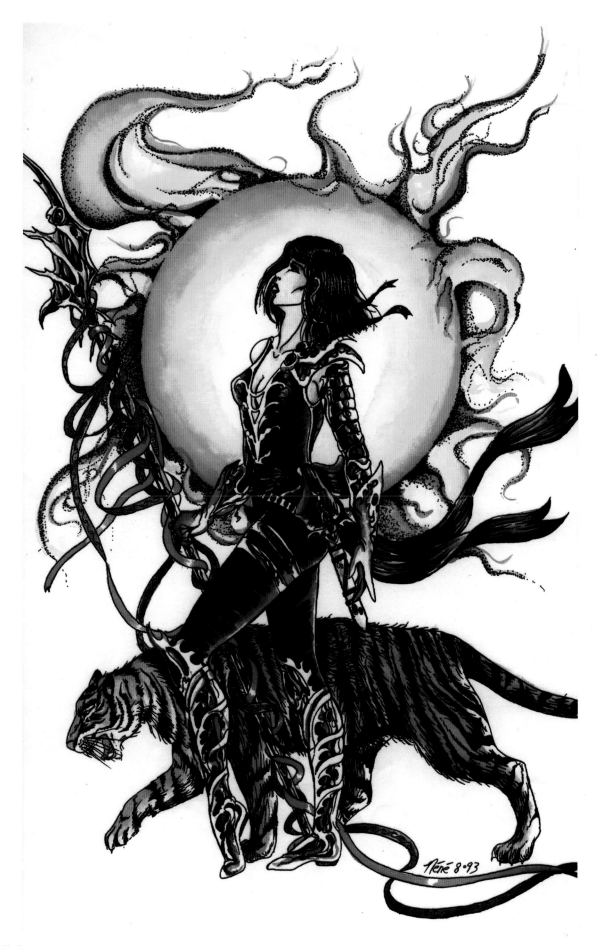

Iris

Iris is a hand-colored print that I did very early in my career. The sun in the background does a good job of focusing your eye on the center of the piece. In fact, the effect is so successful that I used it in the *Dragon Witch* series: each print in that series features a round object of one type or another in the background.

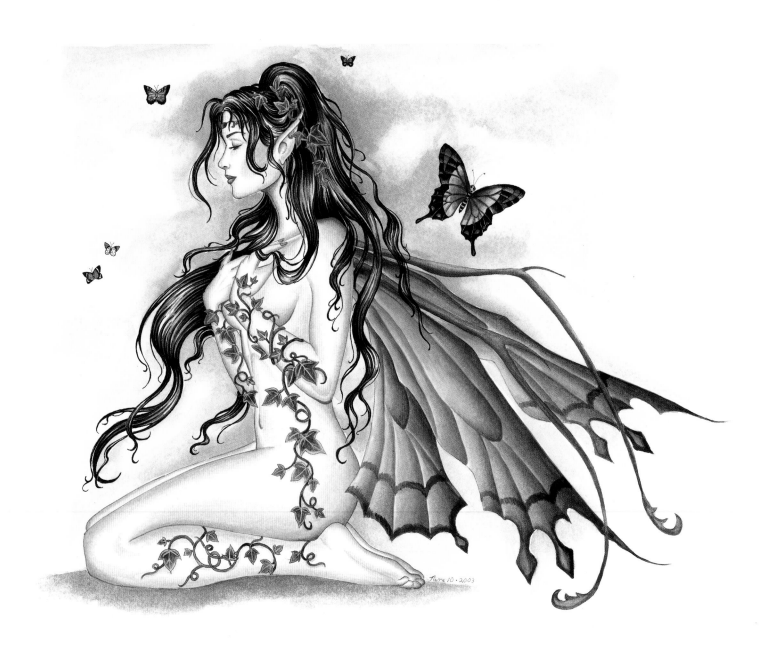

Ivy

My artwork conforms to a certain number of self-imposed rules. The first of which is that I never paint true nudes. So if you look closely at any of my paintings, you will see that while I may hint at nudity, I never show it. *Ivy* is no exception.

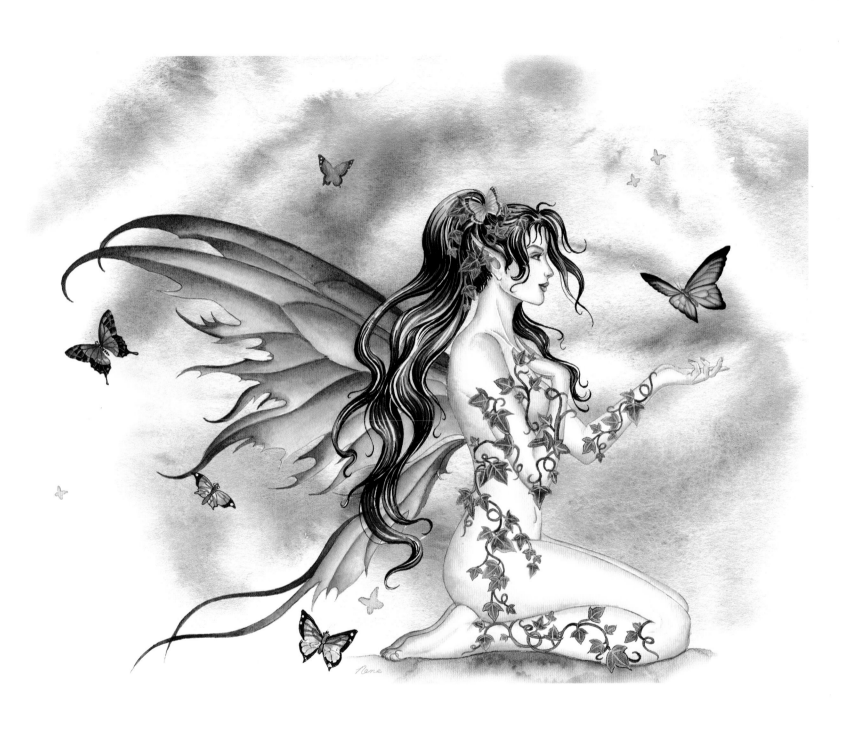

Ivy 2: Vines

Ivy 2 was commissioned by the same company that asked for a second version of *Arachne*. They wanted me to capture the same feel as I captured in Ivy, but make it different enough to be noticeable. Normally, this wouldn't be a problem, for I can usually just change the way a figures clothes look, but with *Ivy*, that wasn't an option.

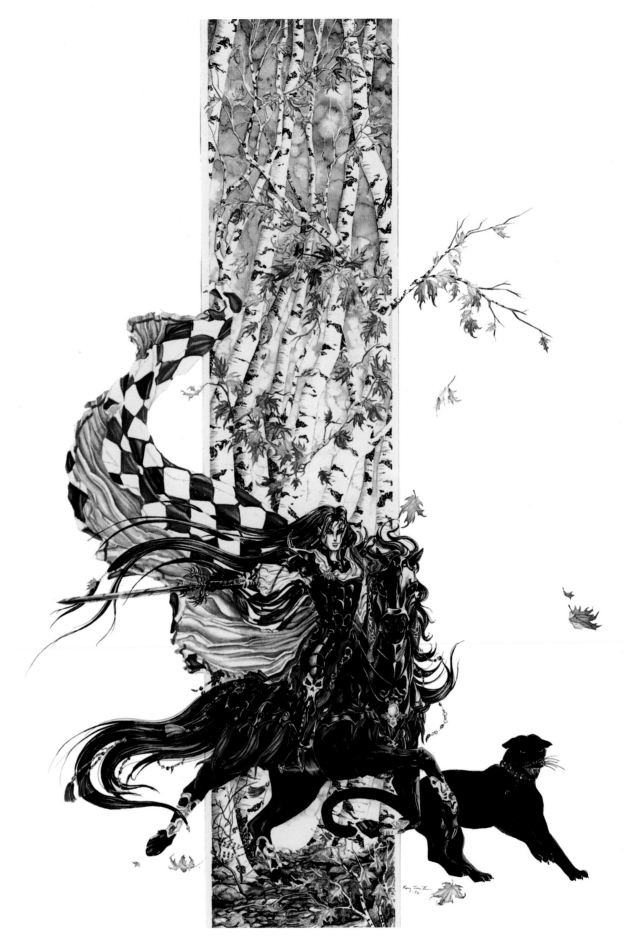

Knight of Fall

This painting was a companion to *Knight of Winter and* was intended to be the second of four paintings in a seasonal series. Unfortunately, I lost my nerve and decided not to finish the series. At the time I was very confident with winter and fall scenes but had never attempted a spring or summer scene.

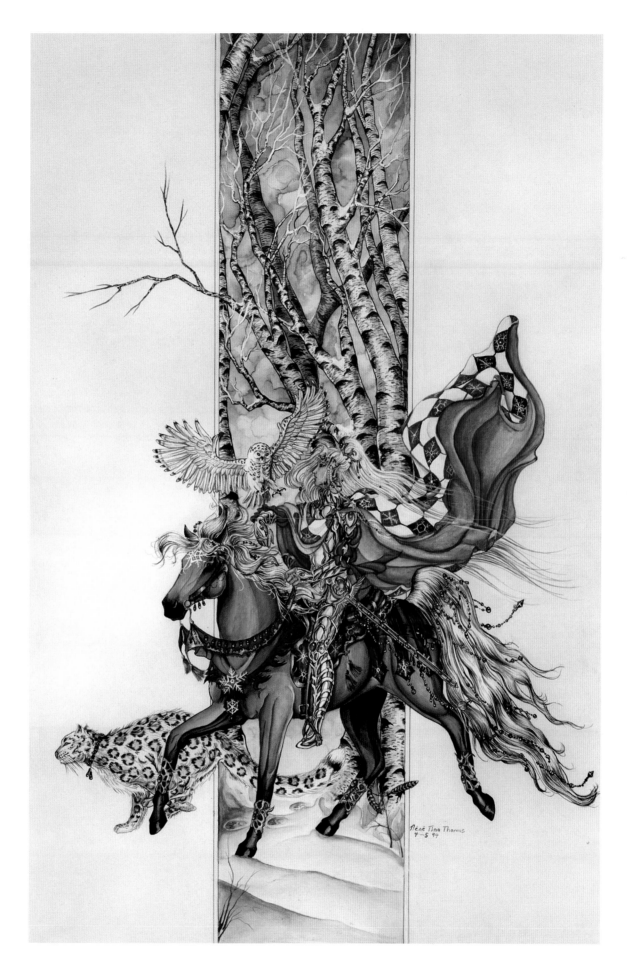

Knight of Winter

In a very real sense, this is the piece that started it all. *Knight of Winter* holds the distinction of being the first professional quality painting that I painted for myself. The success of this piece convinced me that I could make a living outside of contract art. Shortly after I finished it, I left that world and went into business for myself.

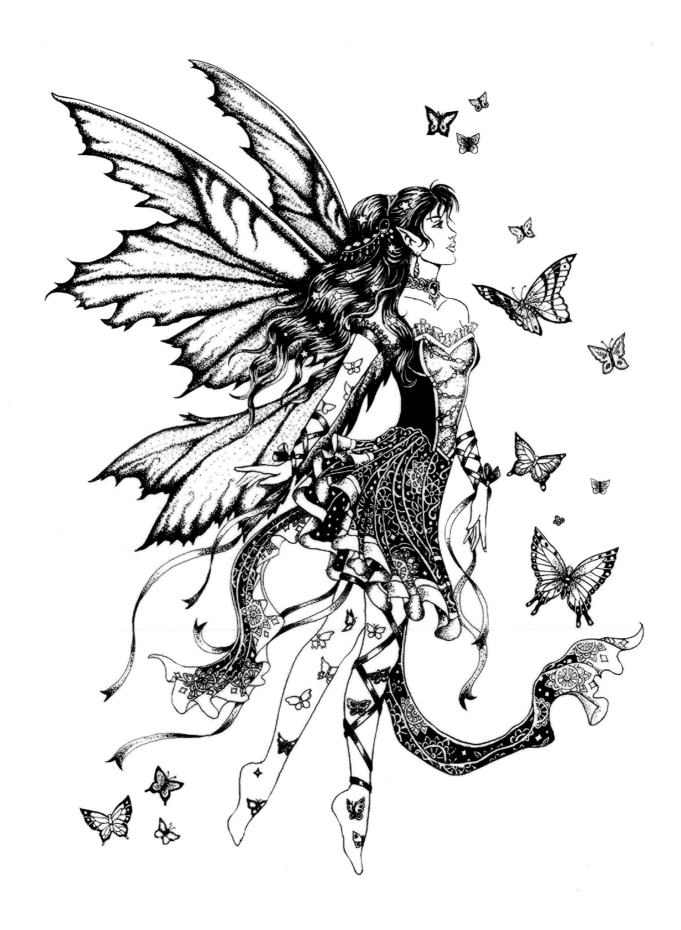

Lavender Serenade Pen & Ink
When I first designed the *Orchestral* series, I had no idea just how popular it would become. I feel that the designs of the images in that series are very simplistic. But I think the simplicity adds to their charm, and although the individual images will never attain the status that *Wisdom* has, they are nonetheless very well regarded.

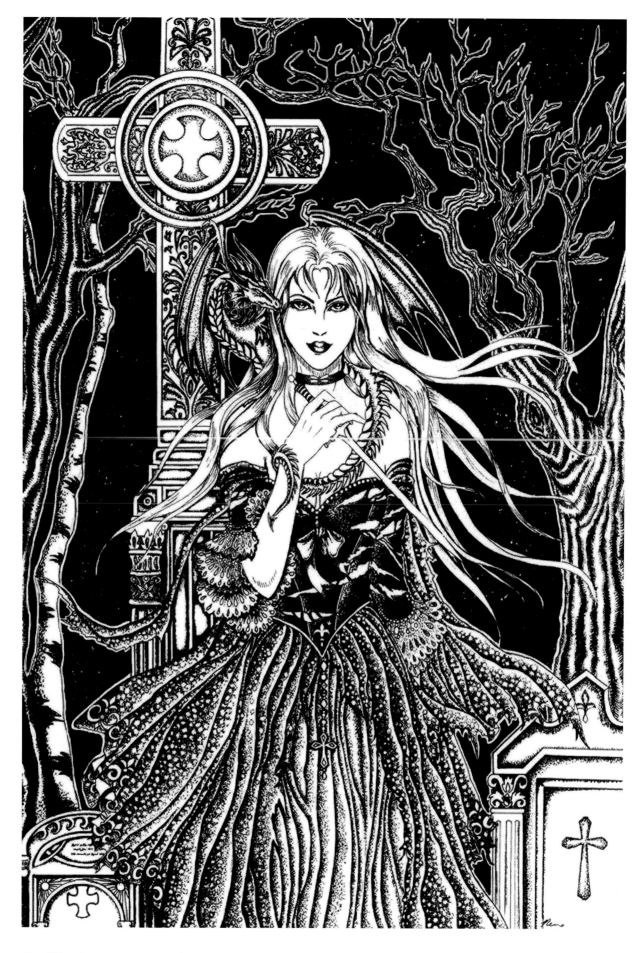

La Victime Pen & Ink

La Victime is part of the *Dragon Witch* series and can be seen in its completed form in this book. I had always envisioned *La Victime* as being a dark piece, but a lot of the elements that I had used on *La Victime* couldn't be translated into a black-and-white image. For example, there could be no dead grey skin in a black and white image.

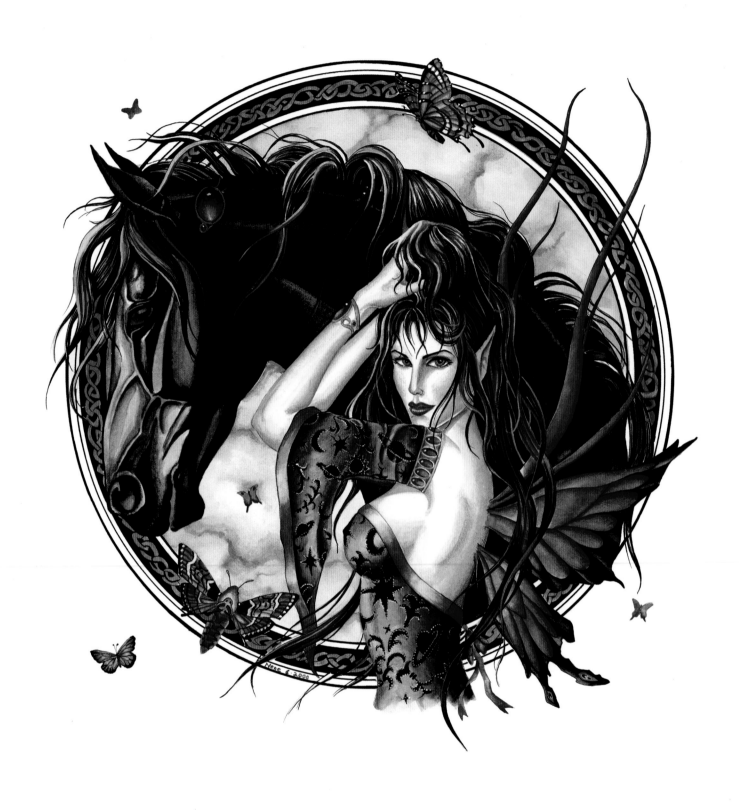

Le Fay

While the faery in *Faery Princess* had an innocent come-hither look, *Le Fay* has eschewed subtlety and is instead giving us a come-and-get-it-big-boy cheesecake pose. I guess the older you get, the harder it becomes to play the ingénue!

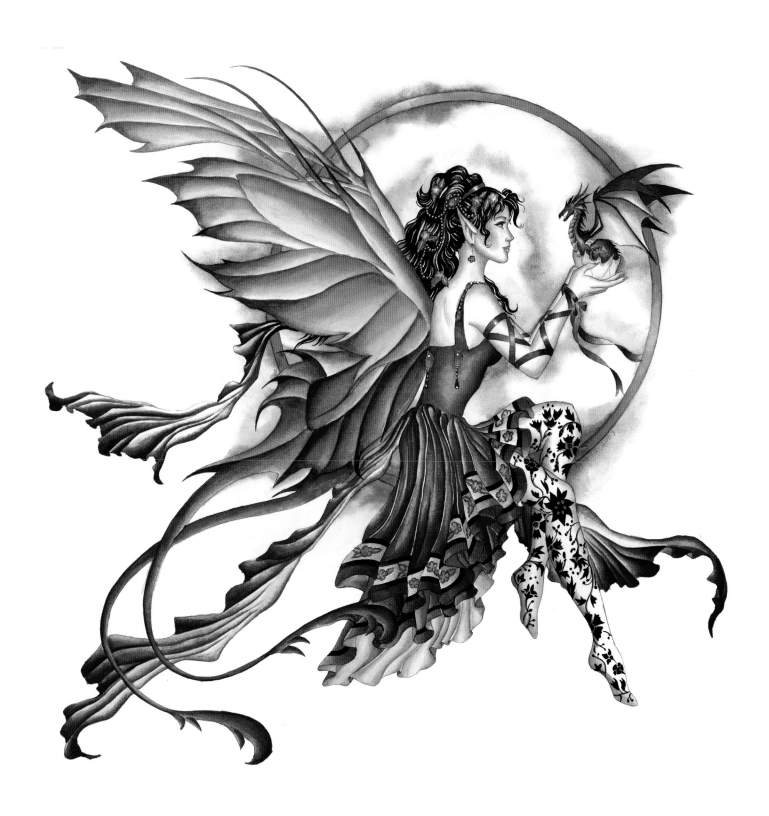

Little Dragon

Little Dragon and *The Gift* were painted around the same time as the *Orchestrals*. I really wanted to work on simpler pieces, and I didn't want to spend a lot of time on any one piece. *Little Dragon* marked the end of my striving for simplicity, and after I finished it, I decided to start working on more elaborate pieces again.

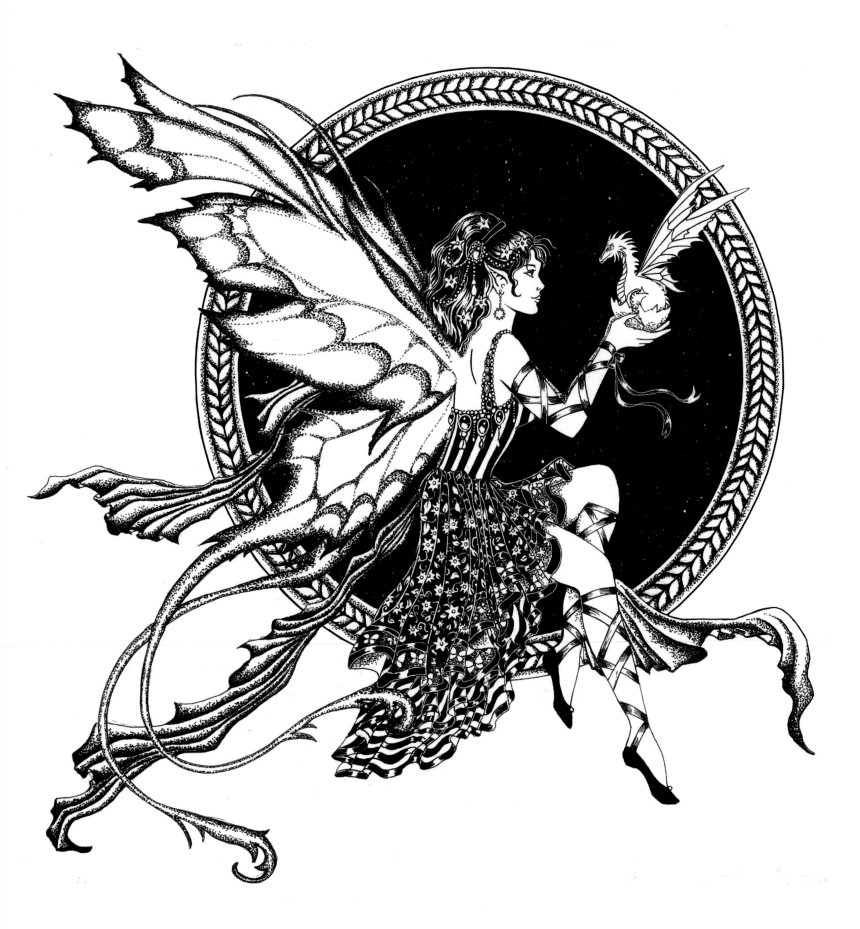

Little Dragon Pen & Ink

Pen-and ink pieces like this one are very challenging to complete, for the simplicity of their design makes it difficult to turn the sketches into worthwhile pen-and-ink. For the *Little Dragon Pen and Ink*, Ann-Juliette added all of the patterning that you can see on the dress herself. Such patterning has become a staple for all of her designs. While I like dresses to be plain with an elaborate fringe or lace trim, she like her dresses to have elaborate patterns. You can see that preference very well in this piece.

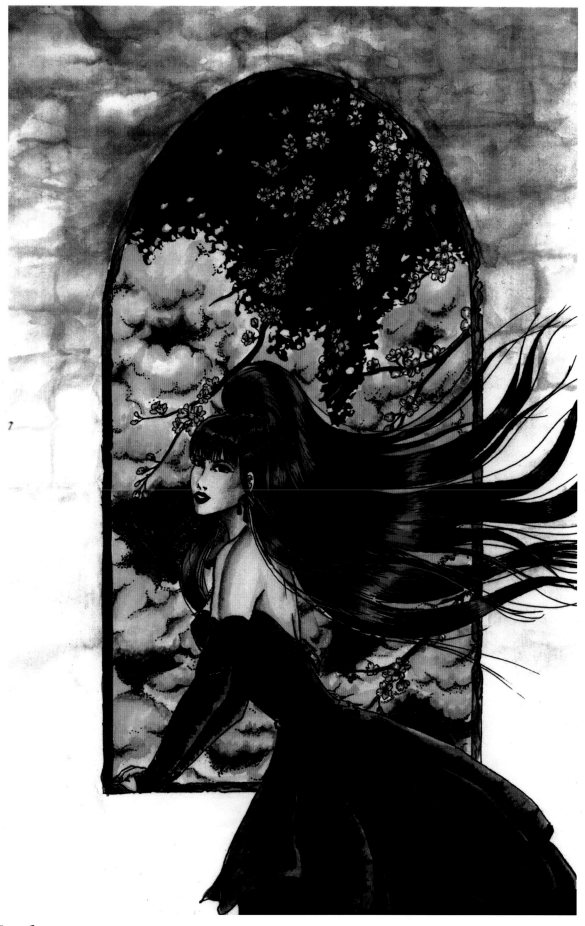

Lyrahe

Lyrahe is another character portrait from the story that I've been working on. She is the older sister of Chesare and was briefly the lover of Valeriad. On a personal note, I really love cherry blossoms. Visually, cherry blossoms are almost as good as birch trees. Unfortunately, it is very difficult to work a pink background into the dark paintings that I tend to prefer, so I haven't used them in a very long time.

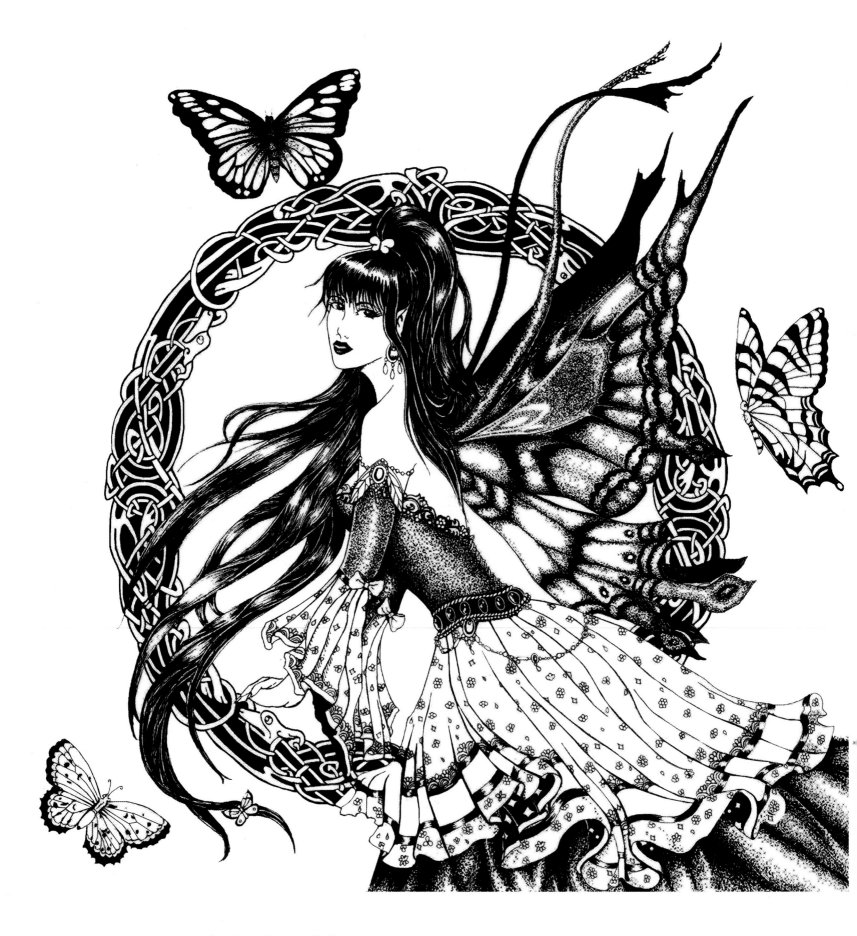

Lyrahe Fae Pen & Ink

Of all of the pen and ink originals that Ann-Juliette has made from my work, this one is the oldest image she's used so far. The design was simple enough to allow her to the freedom to use her imagination, yet elegant enough to make it appealing. The finished product is so good that even I can't tell that it was created from an older image.

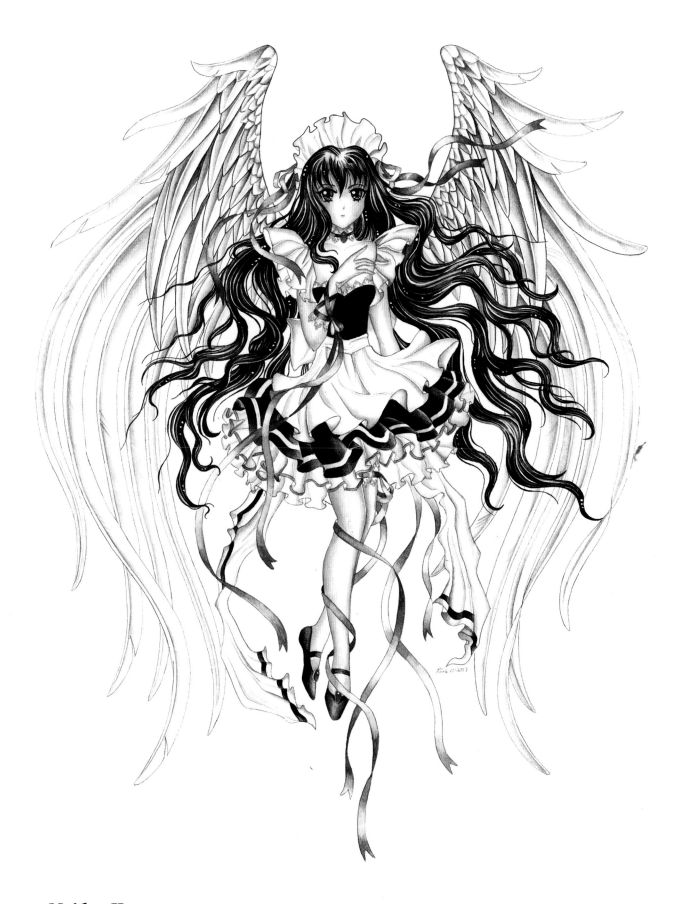

Maiden Heaven
In Japan, frilly maid costumes on anime characters are a really popular theme. When I saw a book filled with picture after picture of incredibly cute maids, I knew I had to do one, just to see if I could!

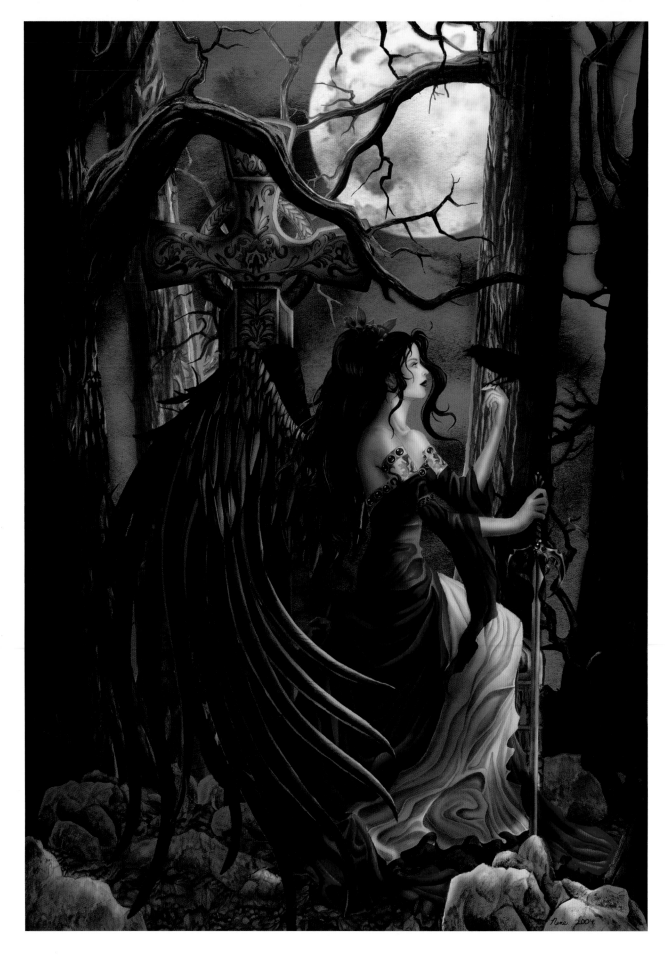

Memento

When I envisioned this piece, I pictured the woman with black wings, sitting in front of a tombstone. After I finished it, I decided that it was really too dark, so I did a second version that eventually became *Always*. While the women in both pieces are exactly the same, the difference between them is as clear as the difference between night and day.

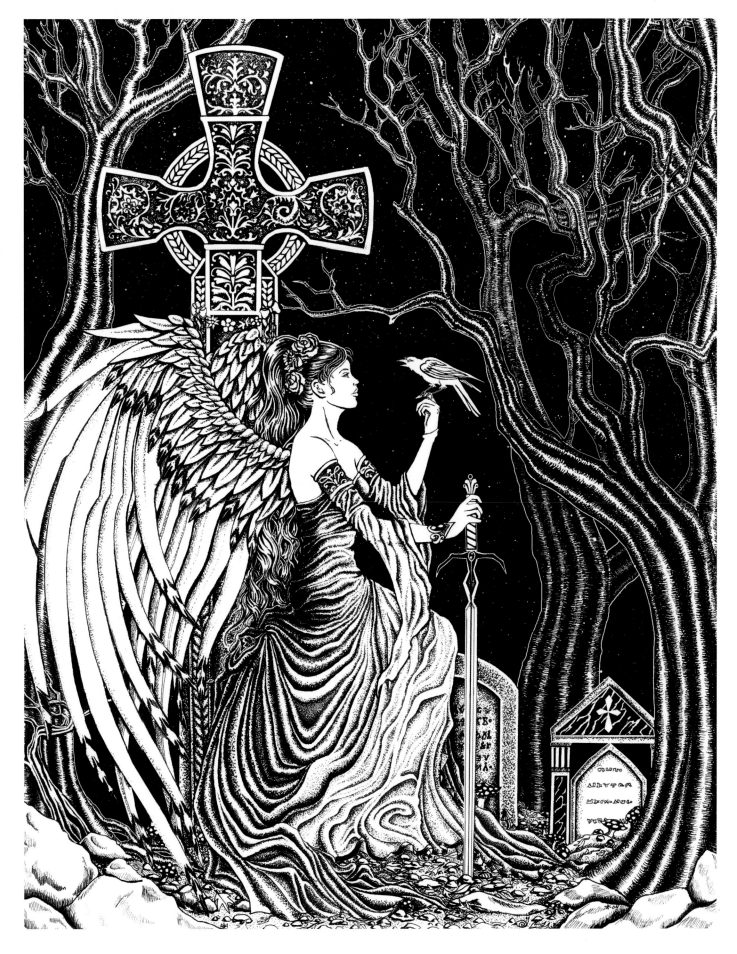

Memento Pen & Ink

While the detail work on this pen and ink is superb, I think the piece loses a little of its power without the color. That seems strange to me. Color, I feel, actually softens a dark piece, but in this case, color has the opposite effect. I do like one aspect of this image though: the gravestones.

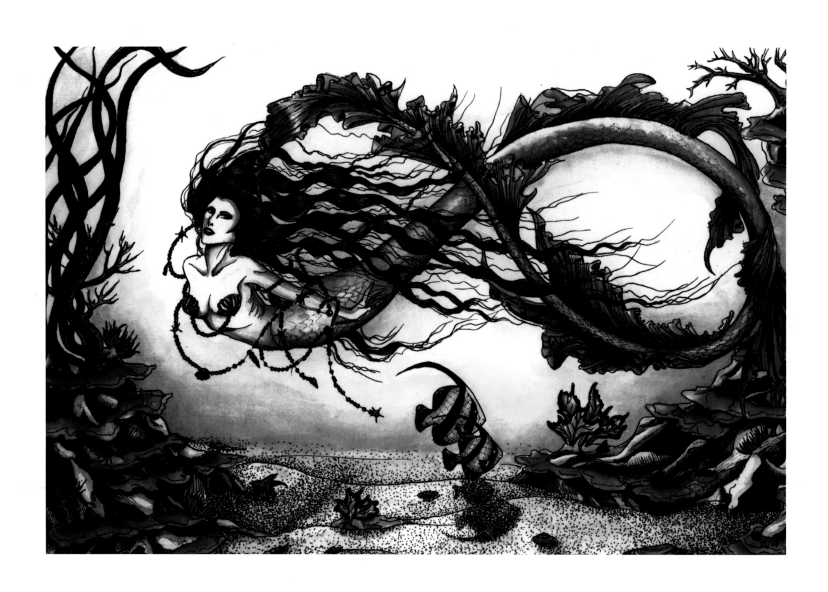

Mermaid

No matter what my subject is, I almost always prefer to use intricate, elaborate designs instead of simple ones. When I painted *Mermaid*, I wanted her to have a soft flow, with tendrils of hair that resembled a kelp forest. If you paint hair correctly, it can often tell just as much of a story as a good expression. This image was hand-colored print that I did early in my career, but it heavily influenced *Aquamarine*, a mermaid I painted years later.

Midnight Blue

I decided to try something a little different on this piece. While *Midnight Blue* is still an anime faery, I made the faery a little less frilly and a little more edgy. She's still really cute, though! Traditionally, the hair color on anime characters is very colorful, with shades and hues that have nothing to do with reality. As you can probably tell from my anime pieces, I'm definitely a traditionalist!

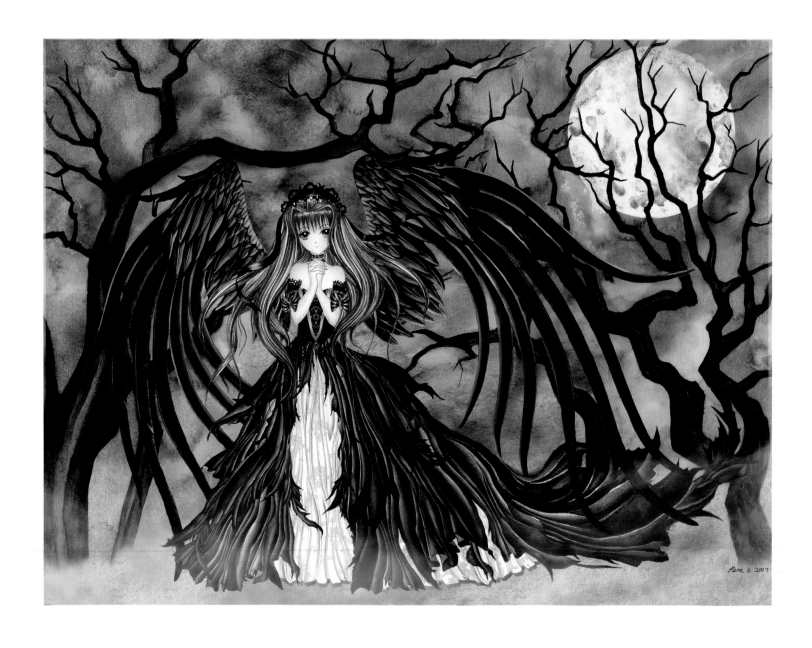

Midnight Wings

This is another anime piece, but with a darker feel. Despite its darkness, it still retains the cuteness inherent in my anime work. YaYa Han, the model for Aria, made a costume of this particular piece, and she wore it at *DragonCon* in 2004. Her costume was stunning and absolutely perfect in every detail, right down to the flow of the wings. Creating a work like this is wonderful, but seeing a living, breathing interpretation of it was truly something special.

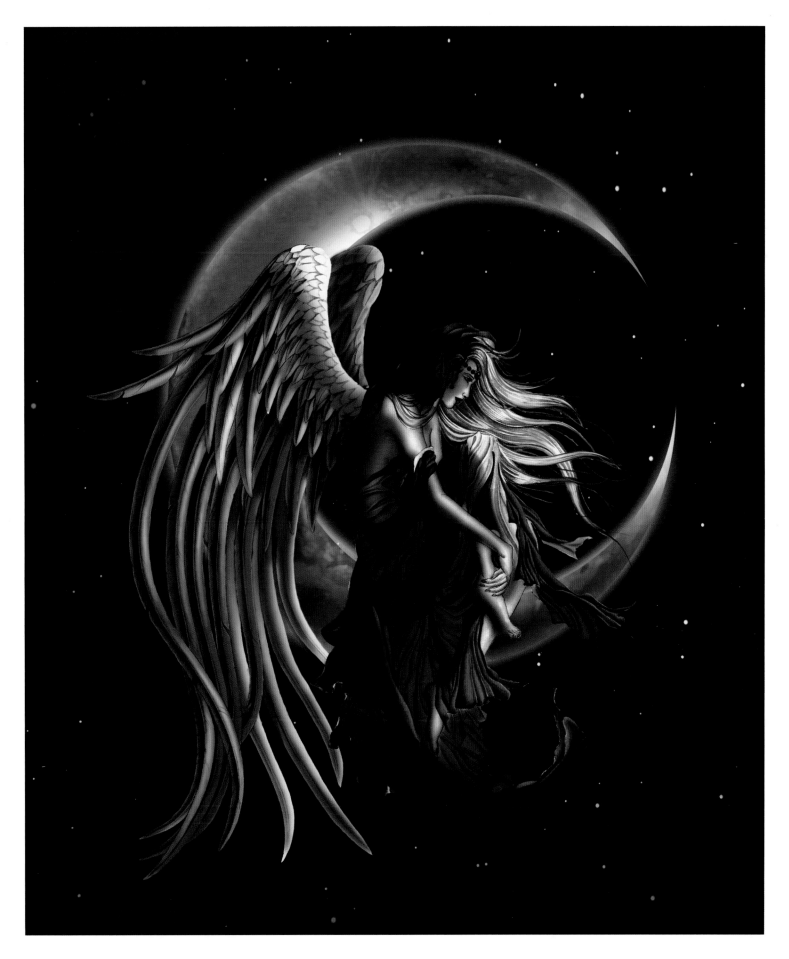

Moon Dreamer

This is a design based on the figure from Introspection that I did for a commission. The soft lighting and the more dramatic shading really works to separate *Moon Dreamer* from *Introspection*. One of the biggest differences is that Introspection had faery wings rather than angel wings, but I thought angel wings were more appropriate for *Moon Dreamer*, considering the subject matter.

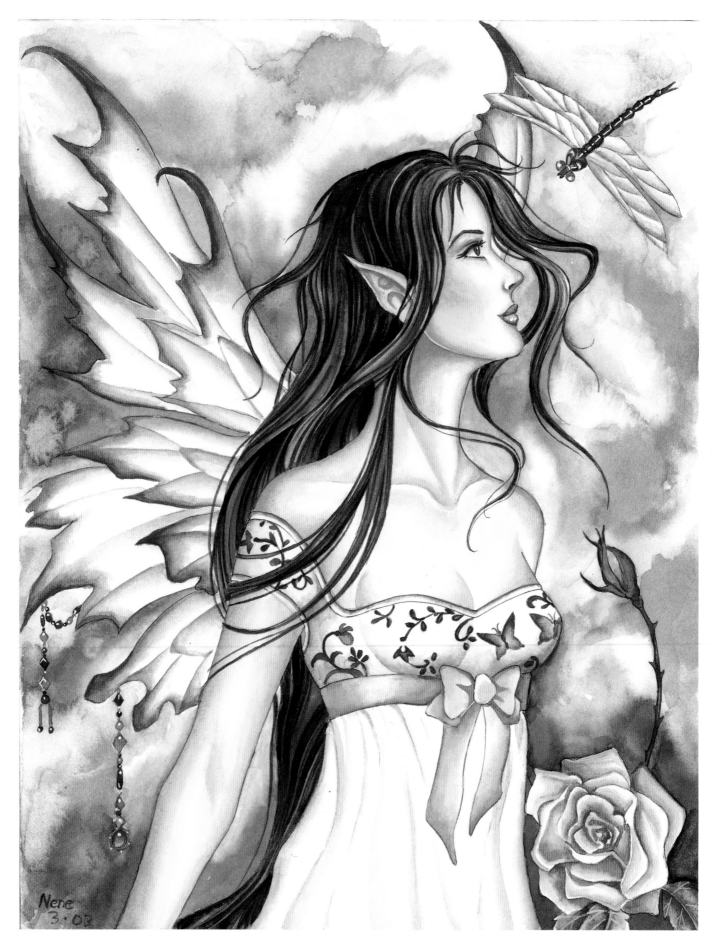

Morning Dew

When I work in sets, it's very important to make sure the images are complementary. Evening *Mist* and *Morning Dew* are a little like bookends, two pictures that look good alone but are meant to be together.

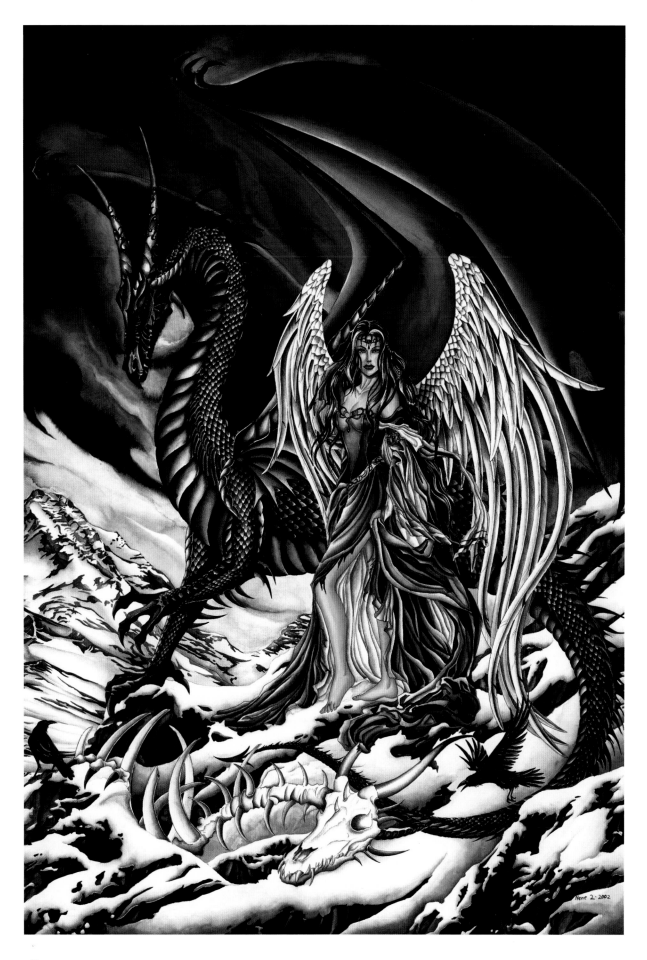

Omen

Omen is a redo of Strength. As I've said before, I love painting winter and autumn scenes, but I have a serious problem with spring and summer. *Strength* was a good idea, but I was really unhappy with the execution. So I took the figure, painted a proper winter background, and then added a dragon for good measure.

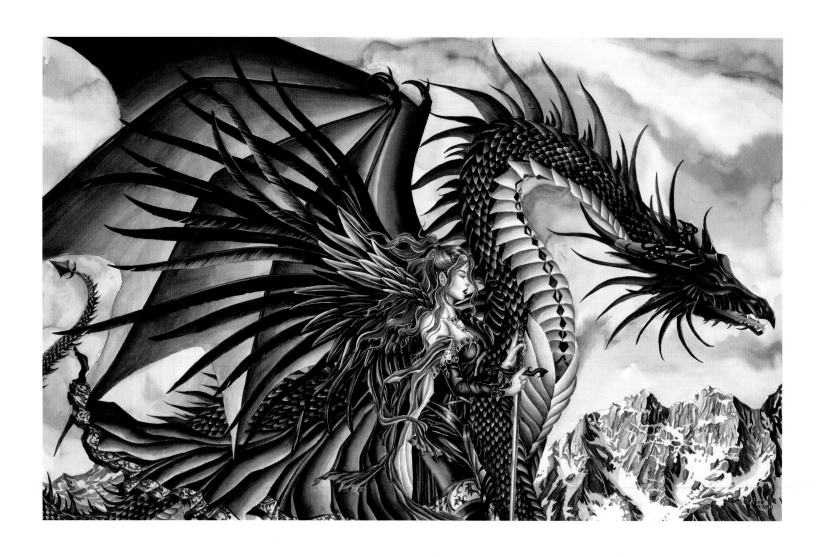

On Ebon Wings #1: Absinthe

The character in this image is a recurring one in my art. Her name is Chesare, and she is one of the main characters in the story that I discussed earlier. The character in *Sapphire*, whose name is Valeriad, is from the same story. These two characters are not a couple. In fact, for all his beauty, Valeriad, as I envision him, is as cold and heartless as Chesare is warm and caring. The two of them find themselves in opposition to each other as the story progresses. These paintings were done originally as character sketches for my story, but they came out so well that I released them as prints.

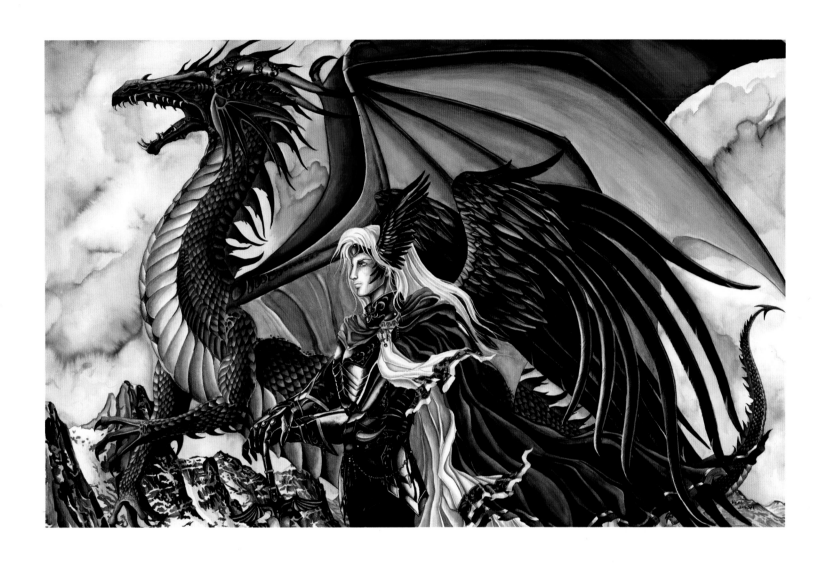

On Ebon Wings #2: Sapphire

The man in this picture actually has a name. His name is Valeriad, and he is a character that I've been working on for most of my life. I hope that one day I'll be able to write about him and the world he lives in, but my writing isn't as good as my painting. Fortunately, the exchange rate is very favorable to artists: if one picture is worth a thousand words, then all I have to do is paint another 150 pictures of him and I'll have a novel!

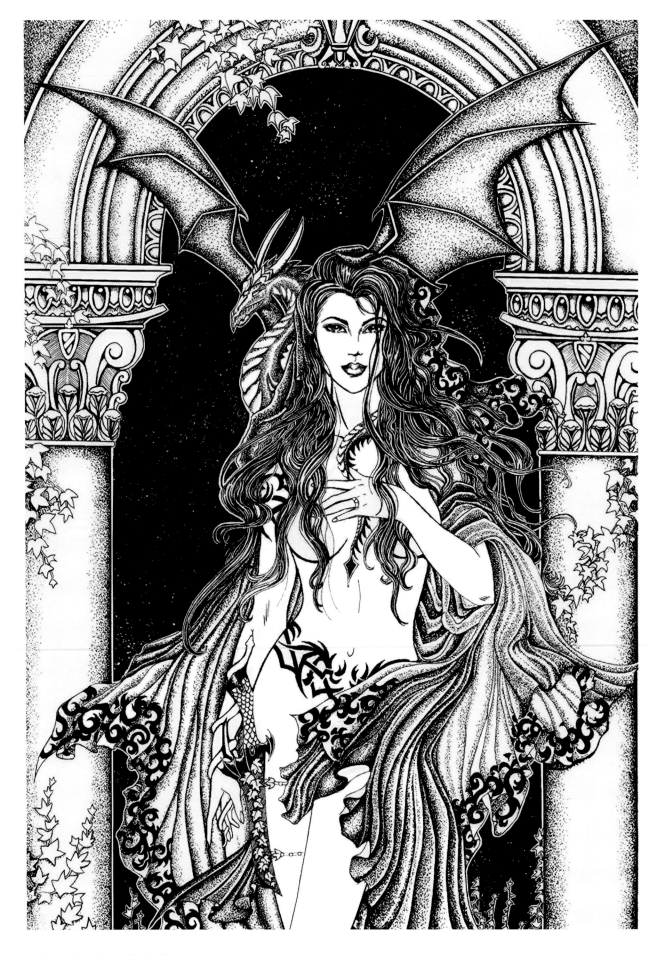

Oracle Pen & Ink

This is far and away my favorite pen-and-ink image. I liked it so much that I had an edition of 100 prints made to see if it would sell, and it did. Sometimes an artist is able to reach beyond his or her skill level and pull out a piece that really stands out. Ann-Juliette accomplished that with *Oracle*, and I couldn't have been more proud of her when it was completed.

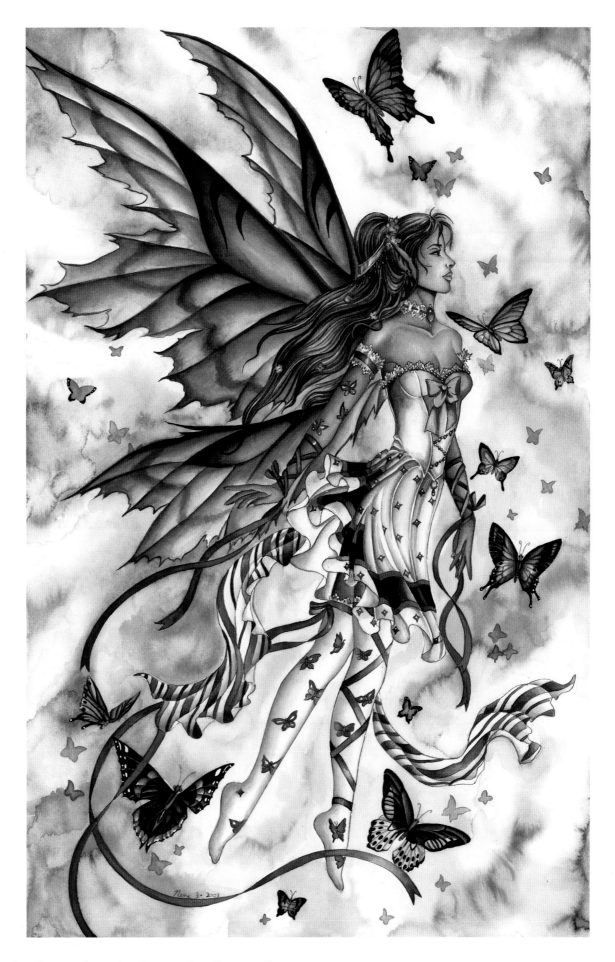

Orchestrals #1: Lavender Serenade

When I designed this piece, I wanted two things: cute and quick. I had been designing really elaborate works for so long that I needed a change of pace. After a little bit of sketching, I came up with the idea for the *Orchestrals*: a series of faeries wearing cute dresses (instead of the formal gowns I normally paint) surrounded by butterflies and nothing else.

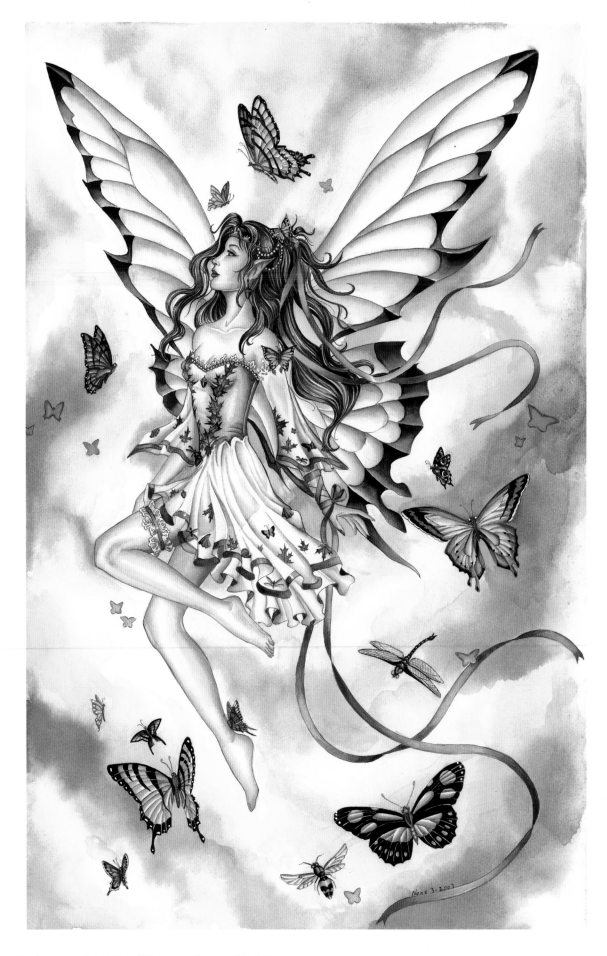

Orchestrals #2: Rhapsody in Gold

This painting is of another whimsical faery, painted with very warm tones to balance the cooler tones that I used in *Lavender Serenade*. I also made her skirt a little more translucent to show off a little more of her legs without being indecent.

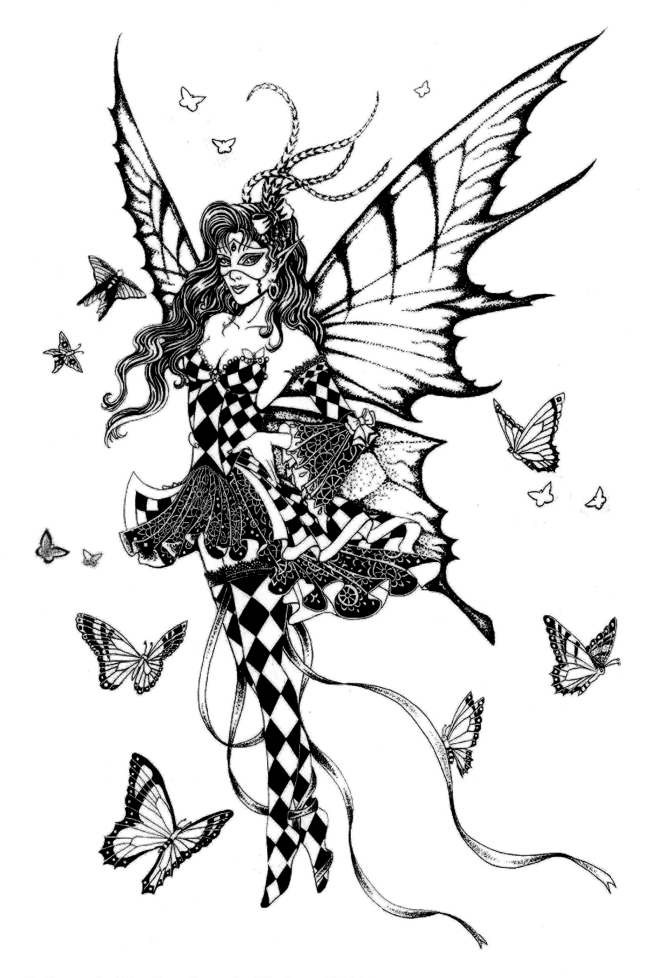

Orchestrals #3: Symphony in Black and White

No matter how colorful I intend a series to be, somehow I always find a way to work the color black into it. This piece just came together. The mask gives the figure a mischievous look, and the rest of the outfit makes her look very playful. Even her hair has a dashing sweep to it, and the jaunty feathers in it complete the look.

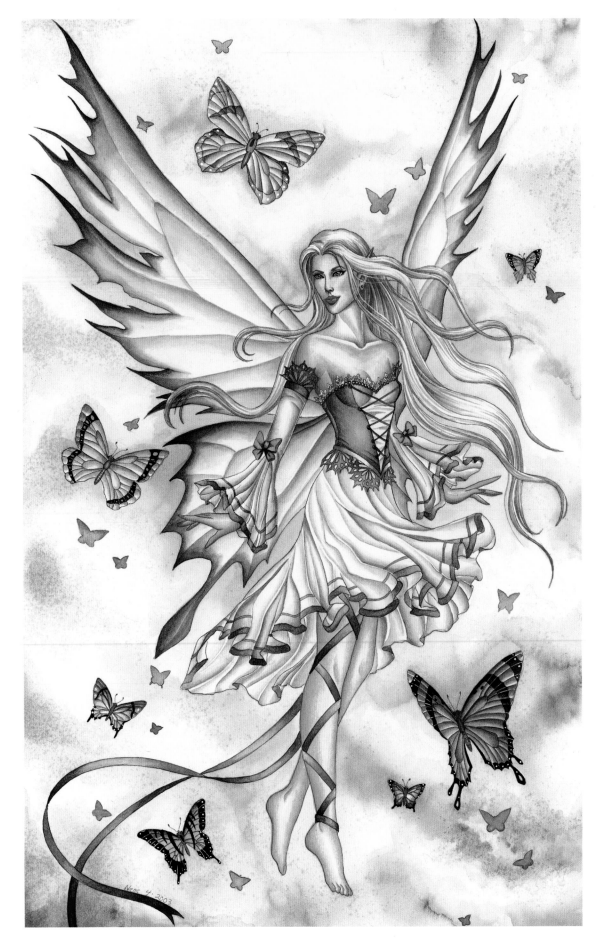

Orchestrals #4: Prelude in Blue

Coming up with interesting titles for pieces can sometimes be almost as difficult as actually painting them in the first place. I wish I could say that the title for this series just popped into my head, but it really didn't. It took days for me to come up with a catchy title that served to tie the images together.

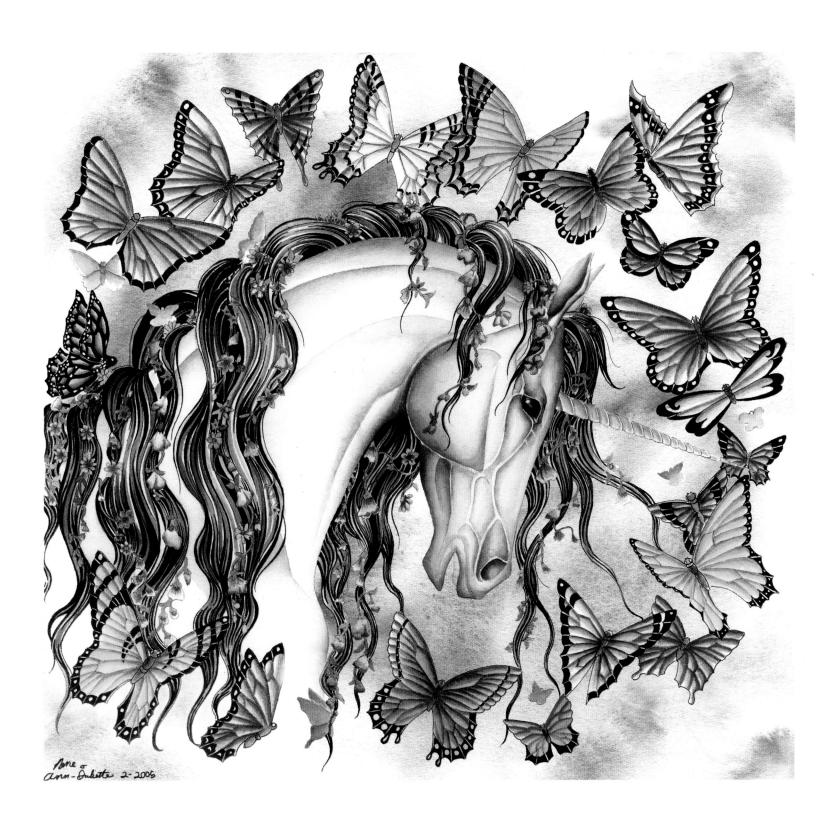

Petal

Up until this piece, Ann-Juliette had been doing very well on pen and inks and color studies, so I felt it was time to push her a bit. *Petal*, and its companion piece *Treasure*, had been sitting on my shelf half-painted for a while, and after careful consideration, I pulled them down and told her to finish them. They took her a while, and I know she sweated bullets over them, but in the end she pulled them off flawlessly.

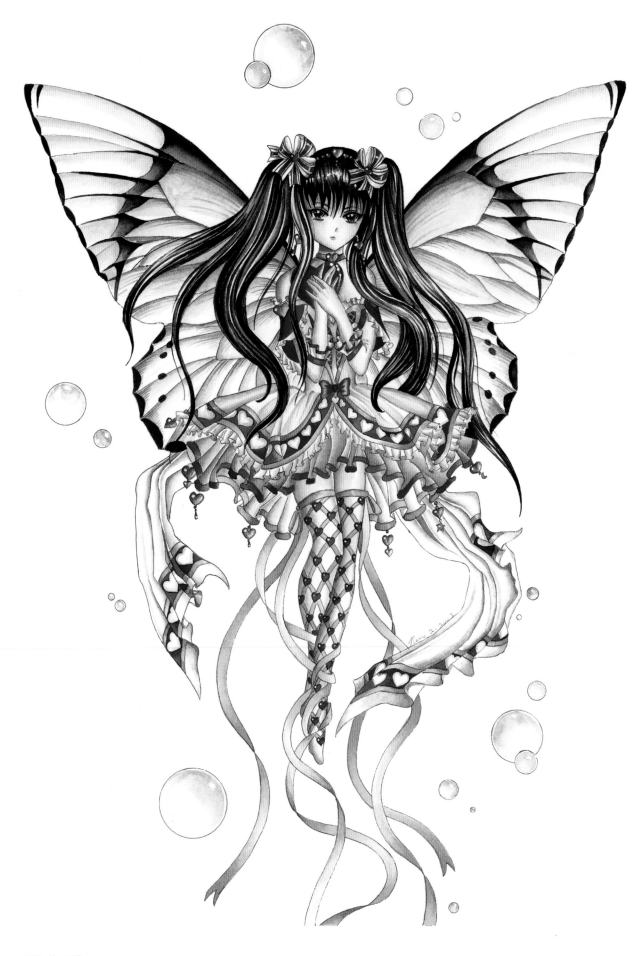

Pink Champagne

Next to *Candy Cane*, *Pink Champagne* takes the prize for being the most adorable faery. While the dress has a very definite Valentine motif, it isn't a true holiday image like *Candy Cane*. My sister Ann-Juliette helped me create the dress design for this image and for *Red Hearts*.

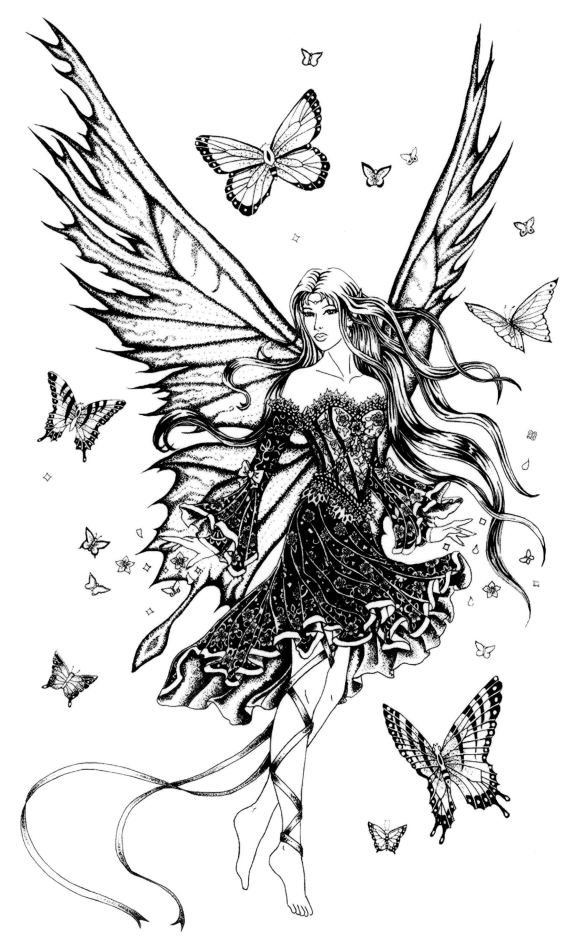

Prelude in Blue Pen & Ink

By the time Ann-Juliette did this one, she had become an old hand at doing the *Orchestrals* as pen and inks. This design follows the groundwork she laid in the other three designs, and the four together forms a cohesive whole. It's interesting to see that the heavy pen work doesn't extend to the skin on any of her inks. She puts the heavy detail on cloth and other elements but lets the drawing speak for itself when it comes to flesh.

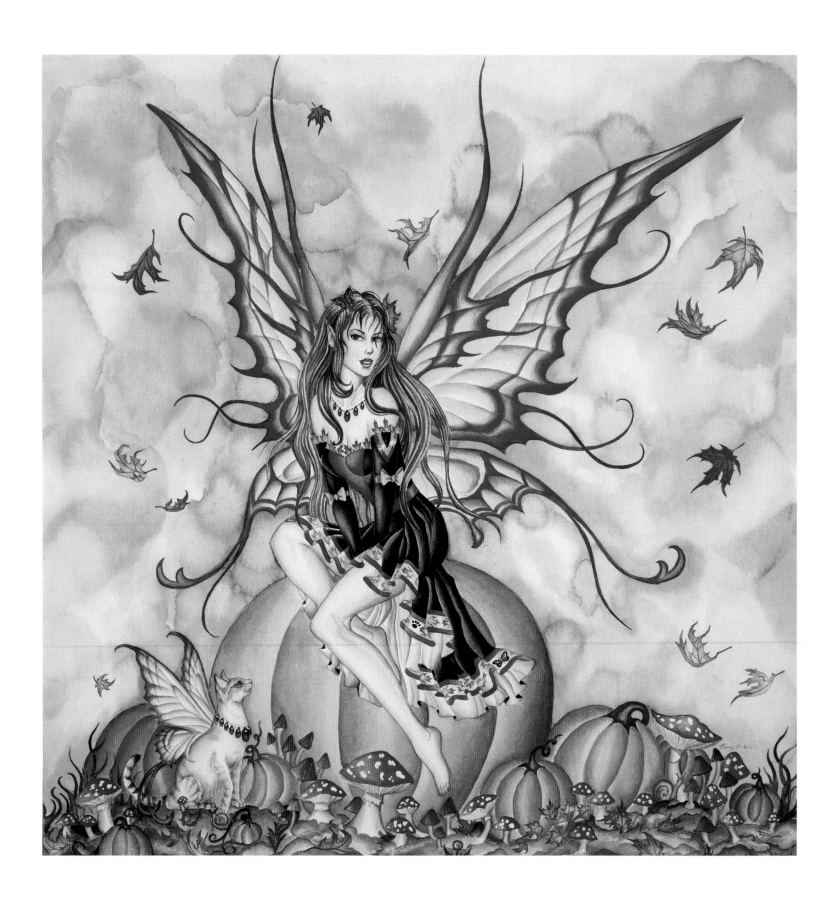

Pumpkin Patch

Much like *Pink Champagne*, *Pumpkin Patch* isn't actually meant to be a holiday-specific painting.
Pumpkins just seem to represent Halloween or Thanksgiving. I simply wanted to paint some bright
orange wings and I needed a design element that would work with that color. Having the figure sit in a
grove of orange trees wouldn't have produced the same feel. Ann-Juliette did a lot of the design work
on this image, including laying out the pumpkins!

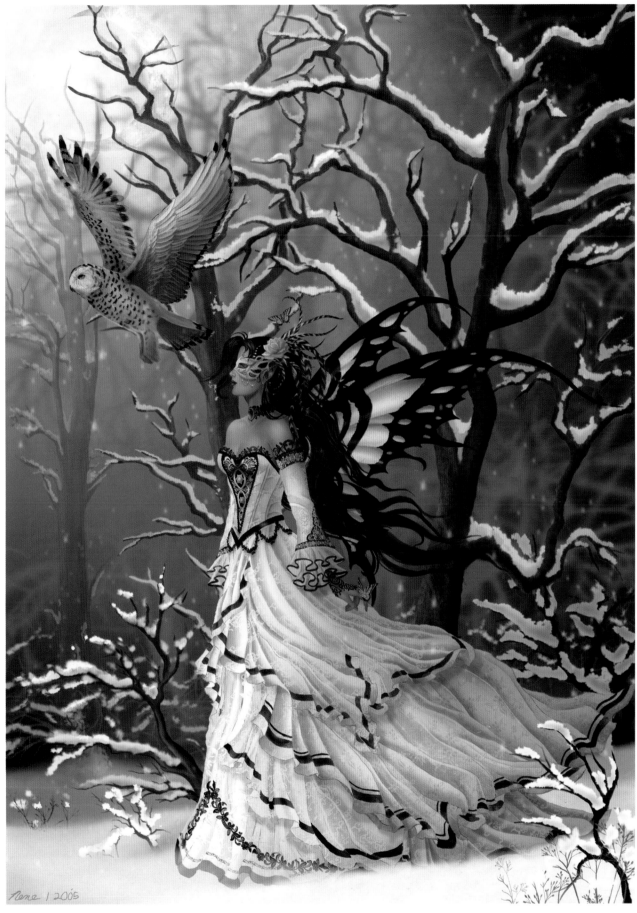

Queen of Owls

As my style continues to develop, I find that I am able to capture more and more of the image that I seen in my head on the drawing board. This is very satisfying to me, for one of the great heartbreaks of being an artist is the constant need to compromise or settle. Time and again, I look at a painting and think to myself this isn't how I imagined it or this isn't how I pictured it in my head. *Queen of Owls* has come closer to matching the image in my head than any other piece I've painted so far.

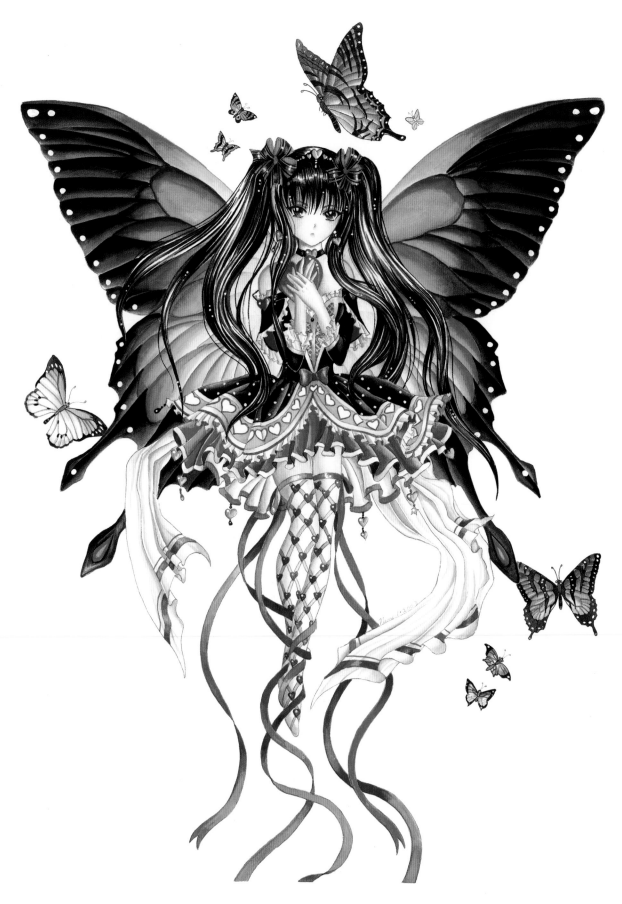

Red Hearts

Long before I decided to become a professional artist, I was a fan of Japanese animation. I used to draw my favorite characters and submit them to various fan publications, and eventually people began to ask me if I had any prints available. People wanted to pay me to draw? I couldn't believe it. Years later, anime has become one of the fastest growing segments of the fantasy industry. While traditional conventions are faltering or dying, anime conventions are growing like wildfire. So I decided to try my hand at Anime again, to see if I still could do it well.

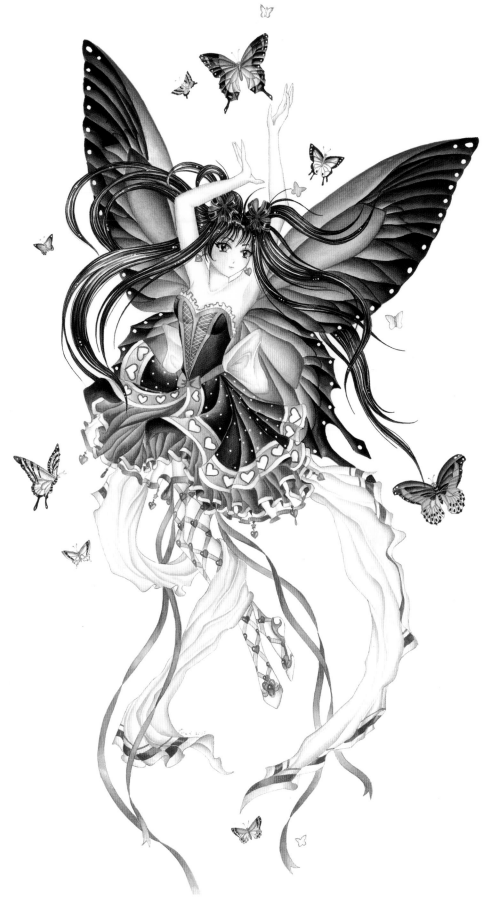

Red Hearts II

Red Hearts did very well as a print, but it also did very well in the realm of merchandising. It seems that after all these years, anime is becoming mainstream, and major corporations are picking up on that. *Red Hearts 2* was commissioned by a company that wanted me to do a version of *Red Hearts* with a more dynamic pose. I was more than happy to oblige, for I really liked the way *Red Hearts* came out in the first place.

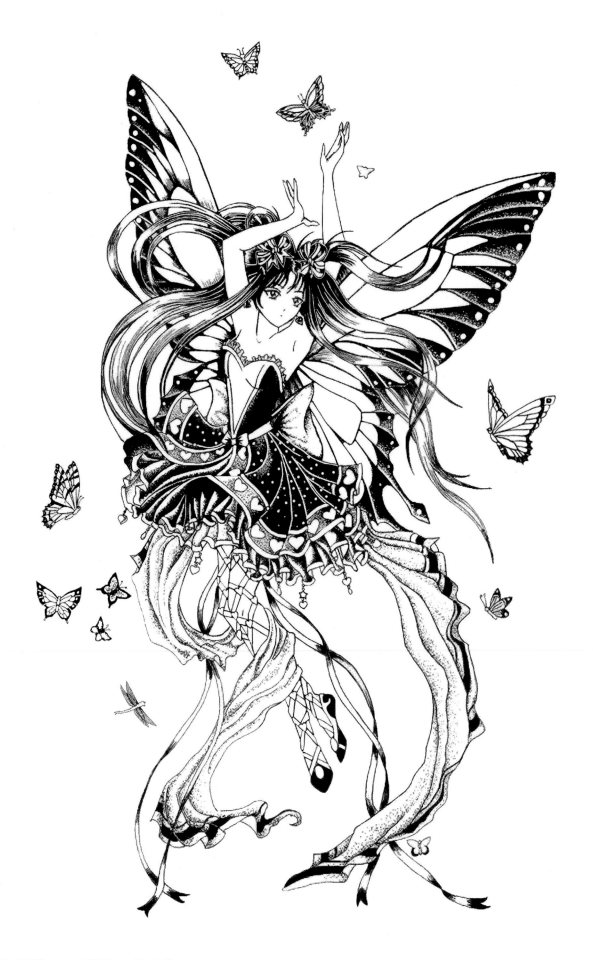

Red Hearts II Pen & Ink

Normally, Ann-Juliette takes any opportunity to turn plain cloth into elaborate patterns and intricate designs. When she set to work on *Red Hearts II*, she decided against that and instead kept the pen and ink as close to the original painting as she could get it. I think she made the right decision, as heavy detail looks out of place on anime art.

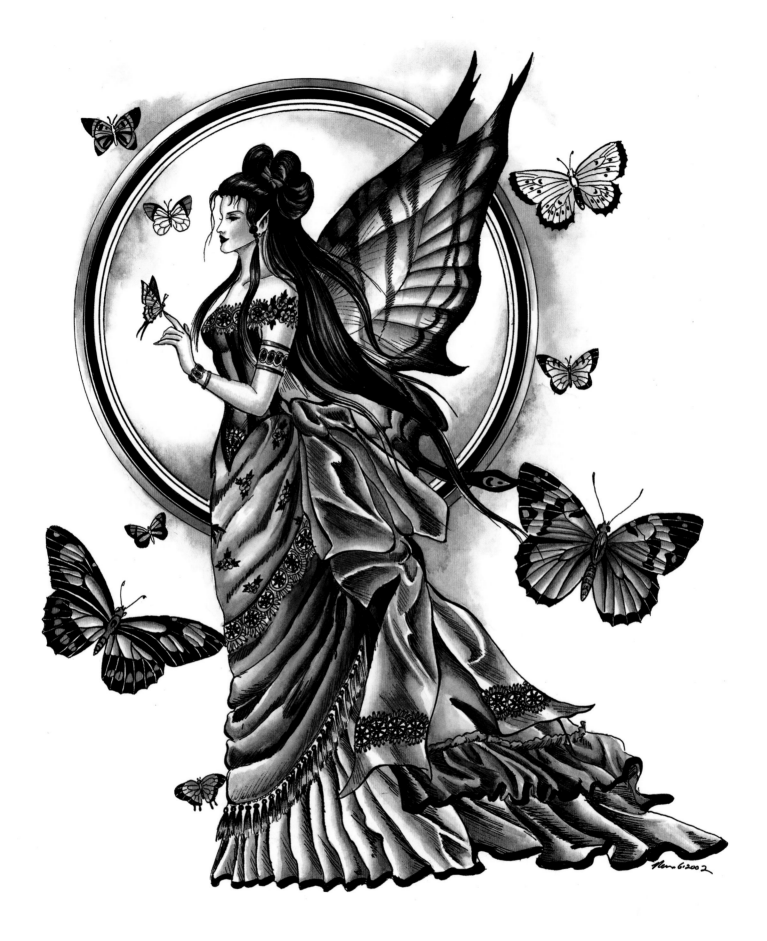

Regal Beauty: Emeralds

This painting is of a faery wearing a Victorian day dress. When I finished this drawing, I knew it wouldn't really have a mass appeal, so I released it as a series of ten hand-colored prints.

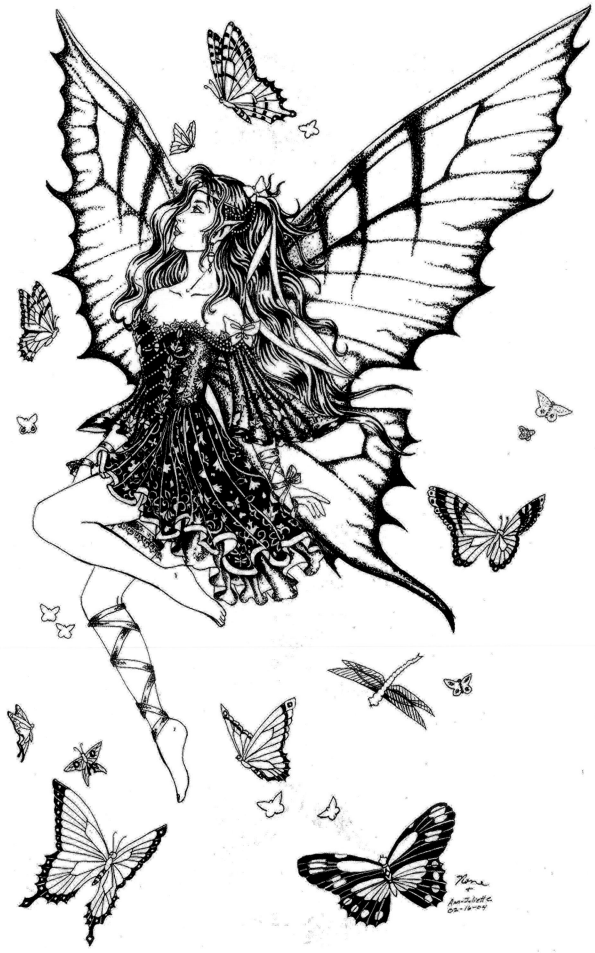

Rhapsody in Gold Pen & Ink

Rhapsody in Gold is one of the *Orchestrals*, and you can see the color version of the figure in this book, but the pen and ink came out so well that I thought it should be added for posterity. As with all of the pen-and-ink images in this book, the original sketch was done by me, but all of the ink work was done by my sister Ann-Juliette.

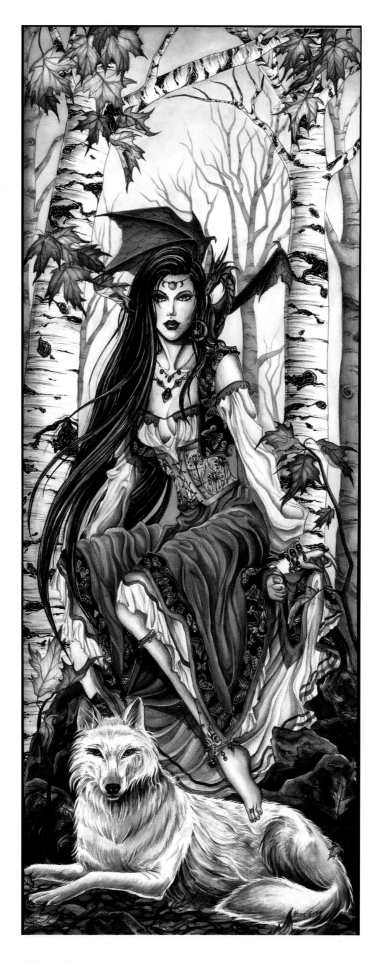

Sisters #1: Misty Morning

This gypsy is the first in the *Sisters* set and is designed to stand beside *Corsair*. When I painted this piece, I wanted to show two sisters whose lives had taken radically different paths. On a side note, if you look at this sister's foot, you will see that she is missing her big toe. My husband keeps saying that the wolf ate it.

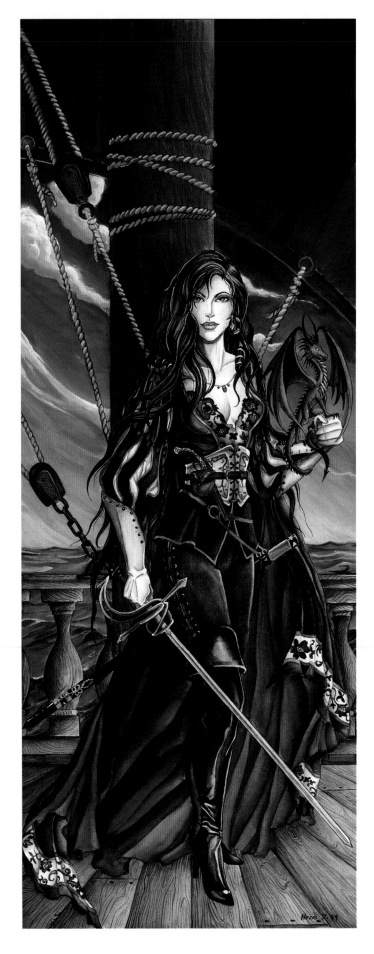

Sisters #2: Corsair

Corsair is the second part of the *Sisters* series, which was designed to show two sisters who had lived very different lives. The only problem with this picture is the figure's skin tones. A true sailor would be deeply tanned, not milky white.

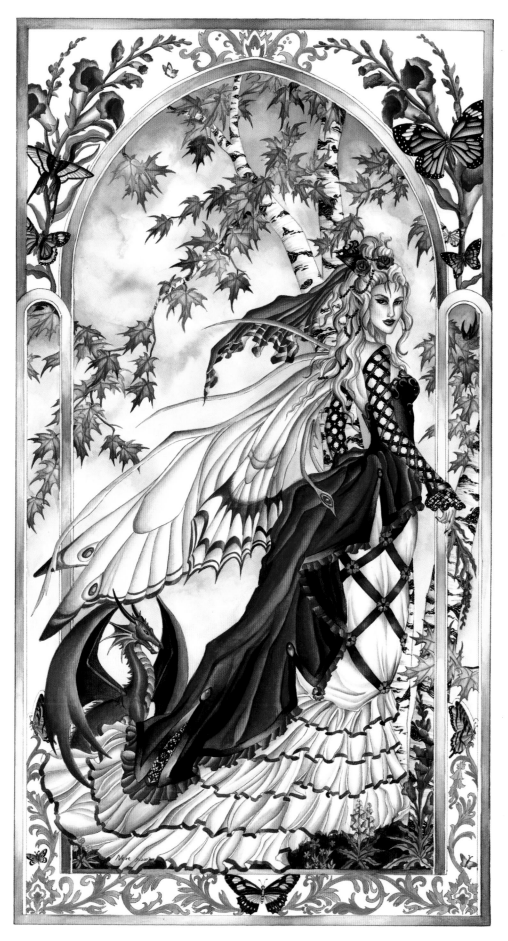

Snapdragon

The sleeves on this figure's dress were inspired by a costume worn by one of my favorite ice skaters, Irina Slutskaya, at the 2001 World Championships. Irina only took second, but she looked incredible. The rest of the dress has a Victorian design with lots of flowing cloth, just the way I like it!

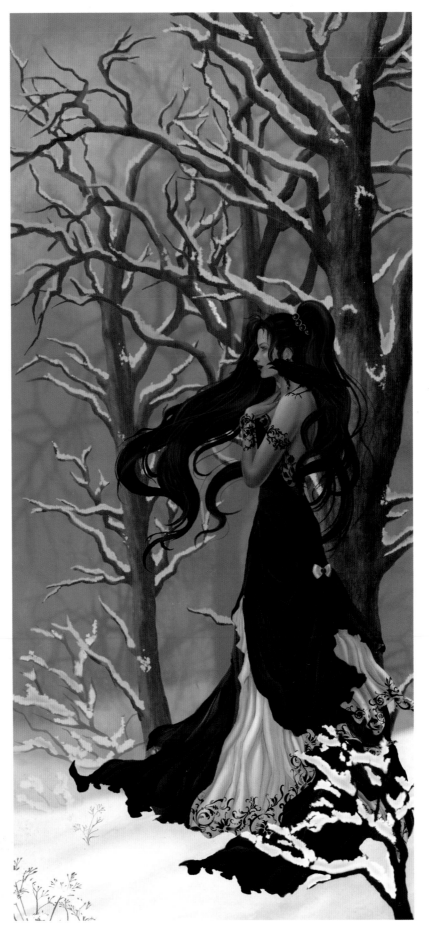

Solitair

The red hair color of the figure in *Solitaire* is the only true color in the entire piece. It serves to draw the eye straight to the center of the painting. The rest of the painting is a study in monochromatic lighting, and it isolates the character very well, making her a solitary figure, not just in the drawing, but in the painting as well. This is another painting of Chesare Dar, the character in *Absinthe, Memento, Bird of Prey*, and *Fall*.

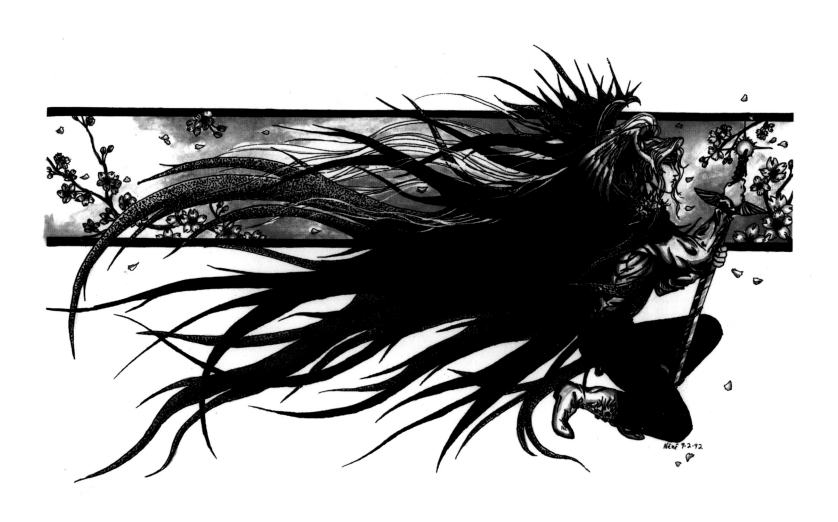

Spring

Much of my earliest work tended to feature characters from my story. This is another picture of Valeriad, the character that I painted in *Sapphire*. A lot of these early pieces also featured artistically tattered (usually black!) cloth. I moved away from the motif for a while, but I've since been experimenting with it again. *La Victime*, *Hope*, and *Storm Runes* are some of my latest pieces, and all of them feature clothing that has been artfully torn.

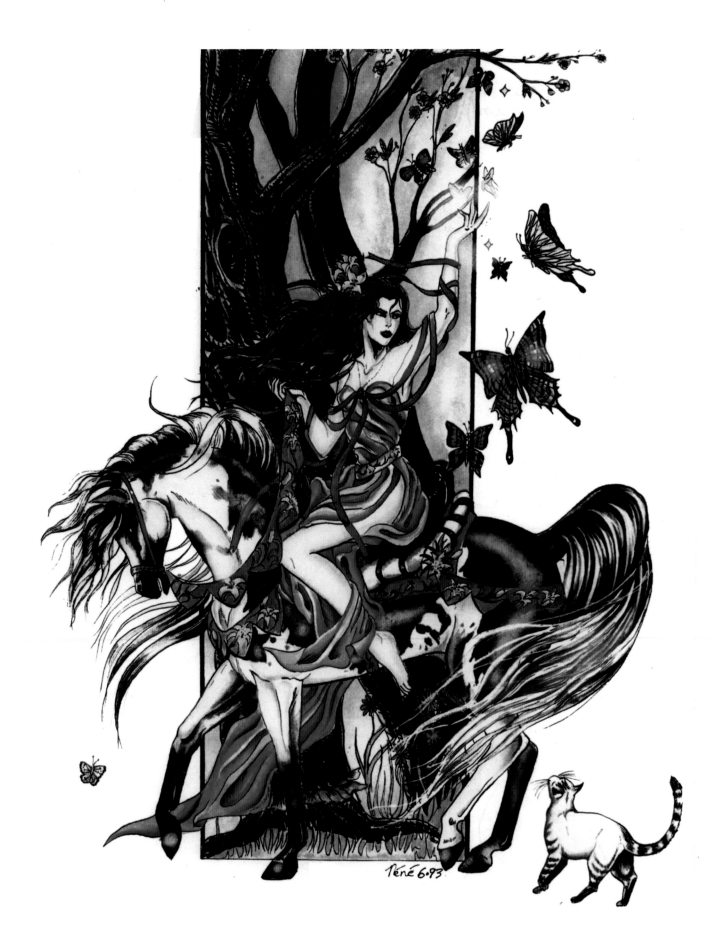

Spring Faery

I've used the idea in this piece several times throughout my career, but this is one of my earliest examples of a faery sitting on a horse. For purely aesthetic reasons, I really prefer to paint women sitting sidesaddle, as in Faery of Black Cats, rather than sitting astride as the faery in this piece is doing. Having a faery sitting sidesaddle just seems more elegant to me.

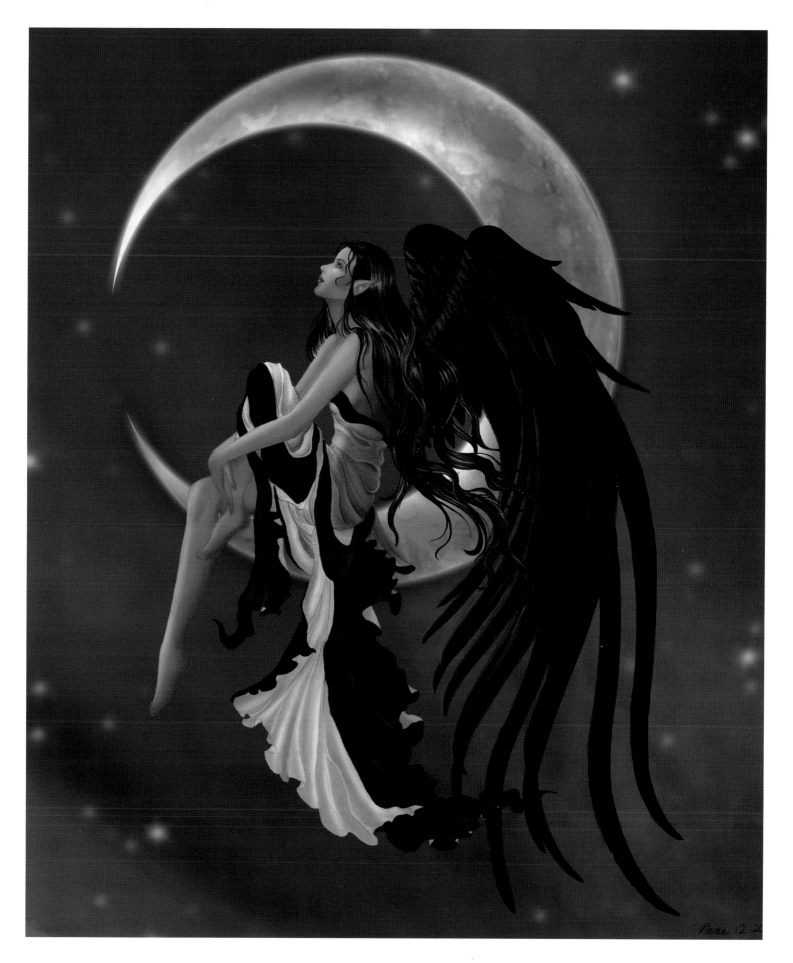

Stargazer

Stargazer was designed as a companion to *Moon Dreamer*. I worked a long time on this painting and believe the end result is good, but it didn't come out as I imagined it would. I can't put my finger on it, but something about this one strikes me as odd. Still, I really like the dreamy look on the figure's face and the fact that she is staring at the stars as if she is imagining what is out there.

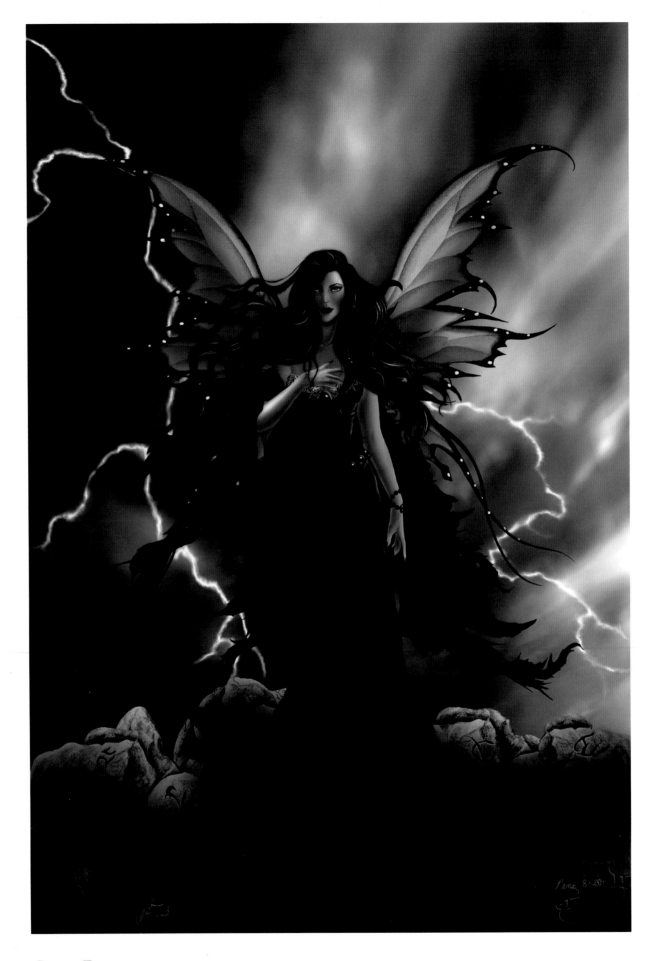

Storm Runes

Storm Runes is a very dramatic piece. I really went out of my way to make the lighting as intense as possible without overpowering the piece, and I really like the results. I couldn't decide between faery wings and large black feathery wings, but I eventually decided that feathery wings would be a little too much for an already dark piece. The purple wings really work with the lightning too!

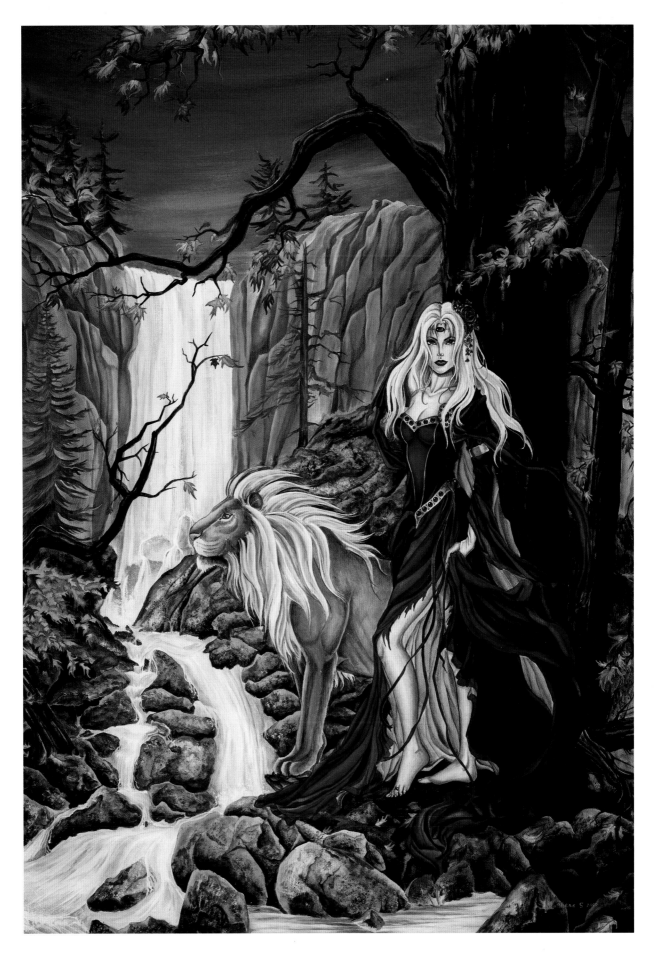

Strength

This piece looked really good as a sketch, but the execution came up a bit short. The woman, the dress she's wearing, and the rocks in the foreground came out great, but the lion and the background needed some work. Unfortunately, the more I worked on it, the worse it seemed to get. Out of sheer frustration, I went back to the drawing board and created *Omen* instead.

Summer

The figure in this piece is a very early incarnation of a character from my story named Derentain. Long hair is great, but I think I went a bit overboard here. The manly chest and the too-small shirt might also be a bit much.

104

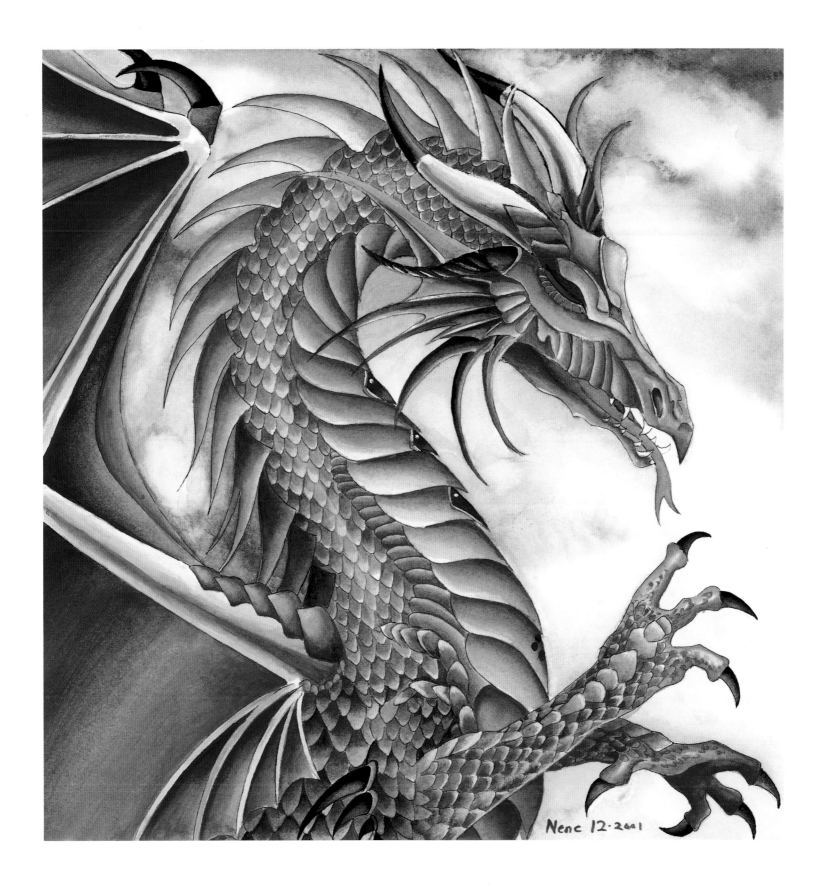

Sundancer

A good percentage of my fan base is made up of gamers (people who play role-playing games such as Dungeons and Dragons), so I often get asked to paint specifically colored dragons. *Fireheart*, the companion piece to *Sundancer*, was tailored for my fans who are gamers. Golden dragons are amongst the most noble and most revered creatures in the fantasy world. As such, they make an excellent opposite to vile black dragons. And for the gamers reading this right now: Yes, I know the true match for a golden dragon is actually a red dragon and NOT a black dragon, but black dragons are much prettier!

105

Symphony in Black and White Pen & Ink

You would think that a piece entitled *Symphony in Black and White* could be easily converted into a pen-and-ink original, but you'd be wrong. As with almost all of her pieces, Ann-Juliette takes special care to flesh out all of the plain cloth with elaborate designs to make them more visually stimulating. The patterns actually serve to tone down the visual cacophony that a stark black-and-white image creates.

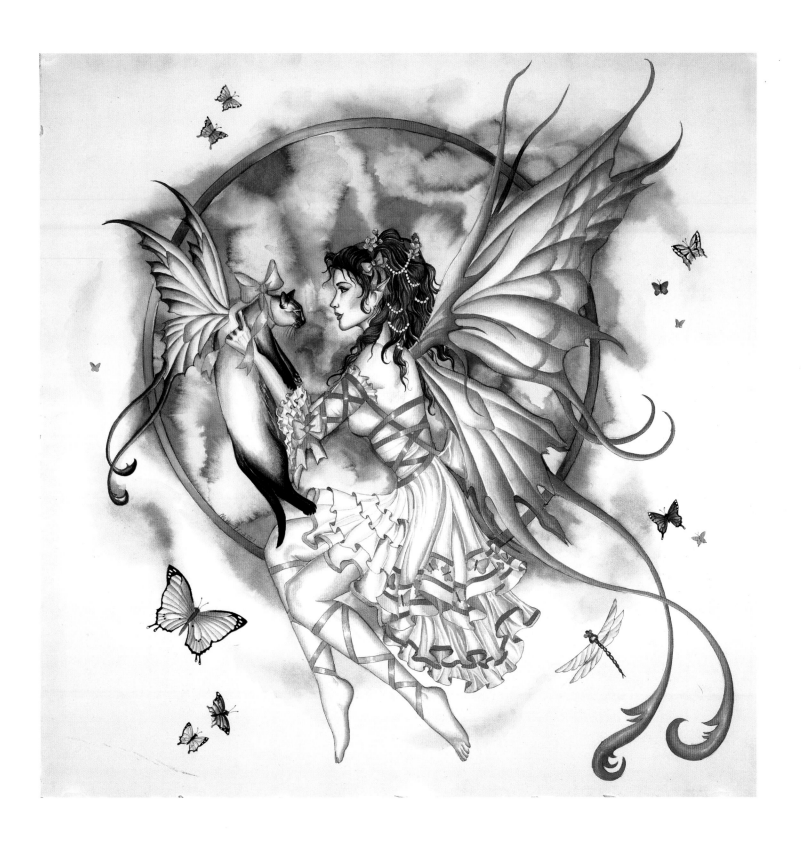

The Gift

Siamese cats are absolutely adorable, which makes them the perfect breed to feature in a piece called *The Gift*. Unfortunately, while they may look great, they have a reputation for being noisy, destructive, and very, very high maintenance. My mom had a Siamese cat named Coco-chin, and she was a right terror, though she was very beautiful. And of my six cats, one is a blue-point Siamese, and another is a Siamese/Himalayan/Persian mix. Both cats are beautiful, but sadly, they go out of their way to perpetuate the stereotype.

107

The Gift Pen & Ink

The dress in the original painting was pink, plain and pink. Sadly, pink doesn't translate to black and white so, to compensate, Ann-Juliette came up with one of her most elaborate designs.

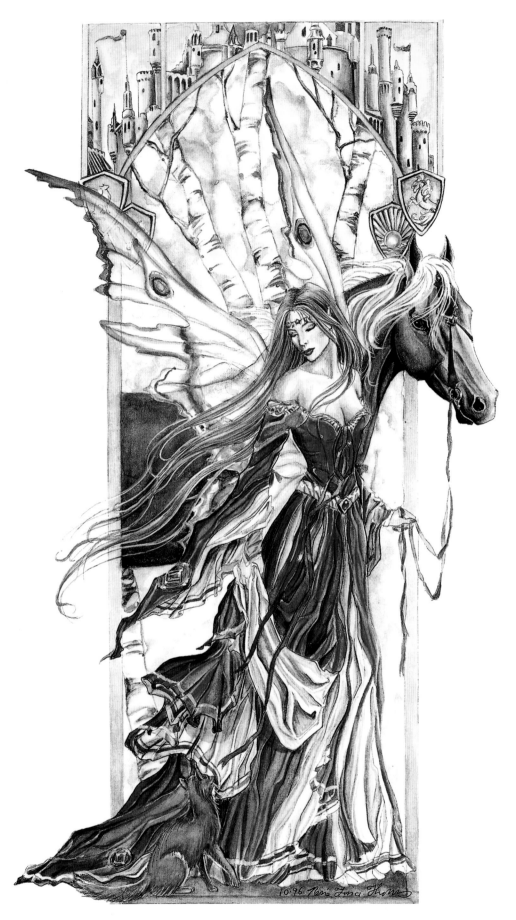

The Virtues #1: Serenity

I really didn't like this piece when I completed it. Most artists know what I mean when I say that sometimes a picture just doesn't come out the way you imagined it would. *The Virtues* was only supposed to be a series of four, but I was so disappointed with *Serenity* that I set it aside and painted four stronger images. For some reason, everyone else loved this one. Sometimes an artist just isn't the best judge of his or her own work.

109

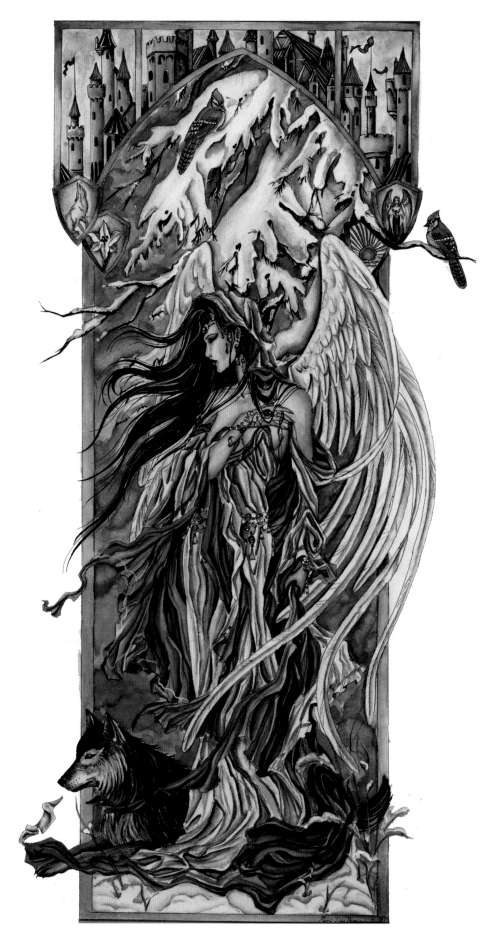

The Virtues #2: Peace

Peace represents winter. *Serenity* was the prototype, for I actually intended for the *Virtues* to be a series of four—containing an image for each season.

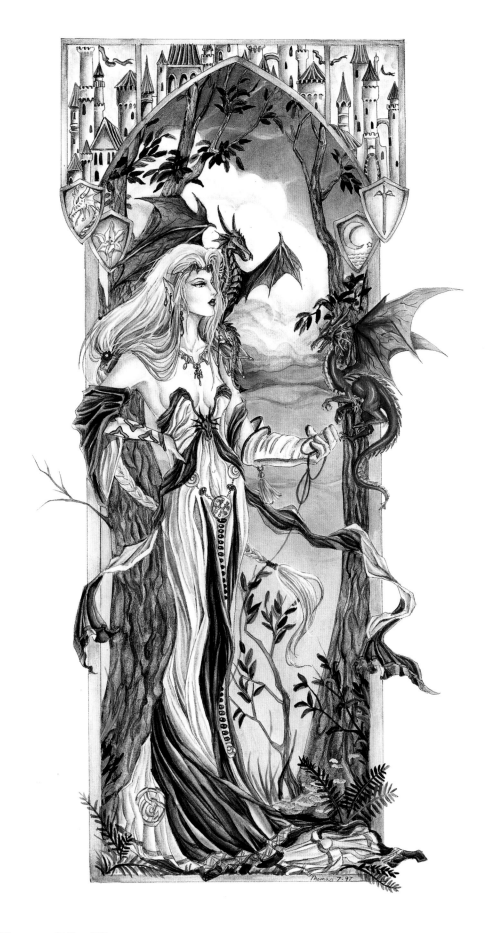

The Virtues #3: Elegance

Elegance represents summer. The thing I like best about this image is the arrogance that the figure radiates. In popular fantasy, elves are the most arrogant creatures, and I think I captured that arrogance with this figure's pose and expression.

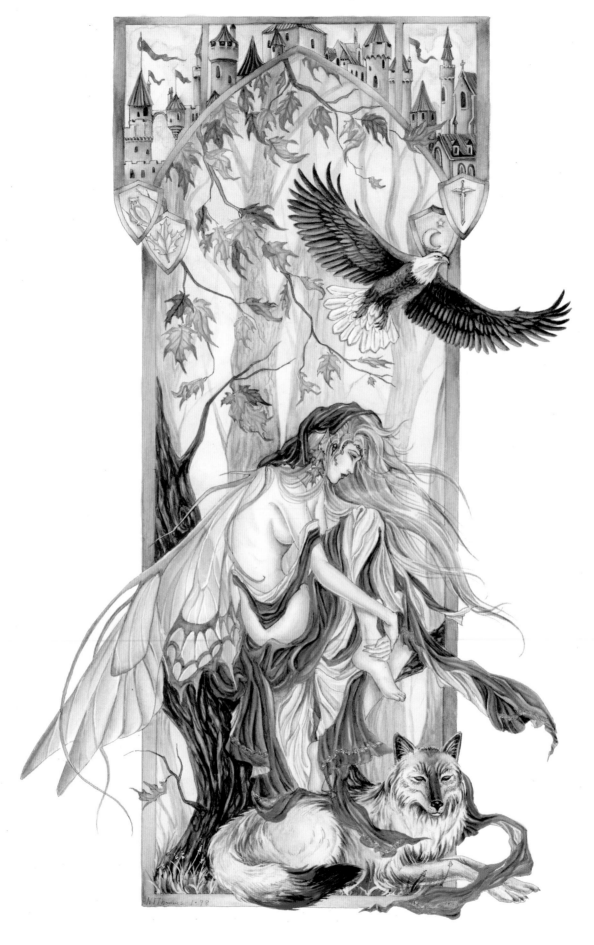

The Virtues #4: Introspection

Introspection represents fall. I have used the figure in this piece several times, because it is one of the most evocative figures I've ever created, and several companies have asked me to modify it for them.

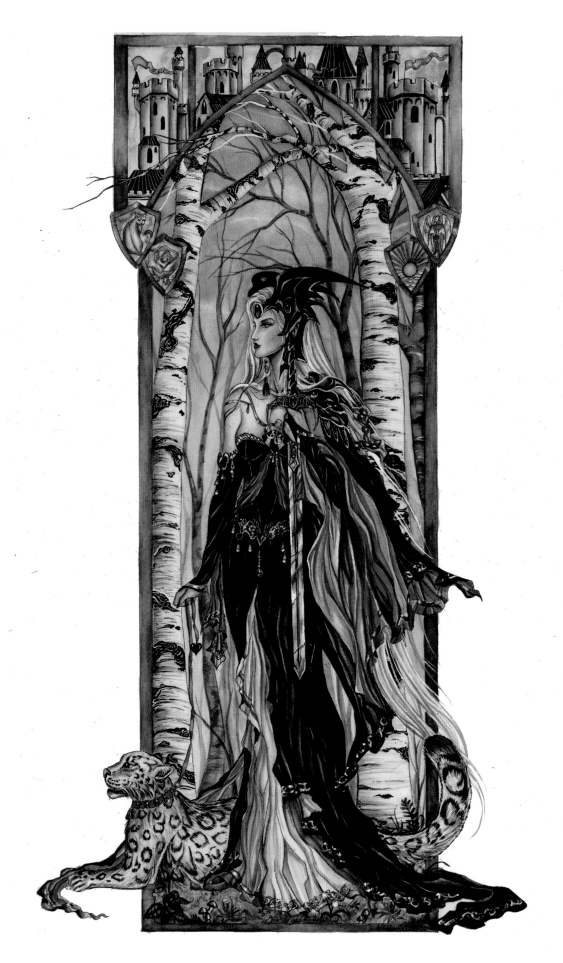

The Virtues #5: Patience

Patience represents spring and was the last of the *Virtues* to be painted. The figure has the same cool expression that *Elegance* has, but it is not quite as pronounced. I drew her holding the sword as if it didn't actually belong to her. I wanted her to look as if she were simply holding it in trust for someone else.

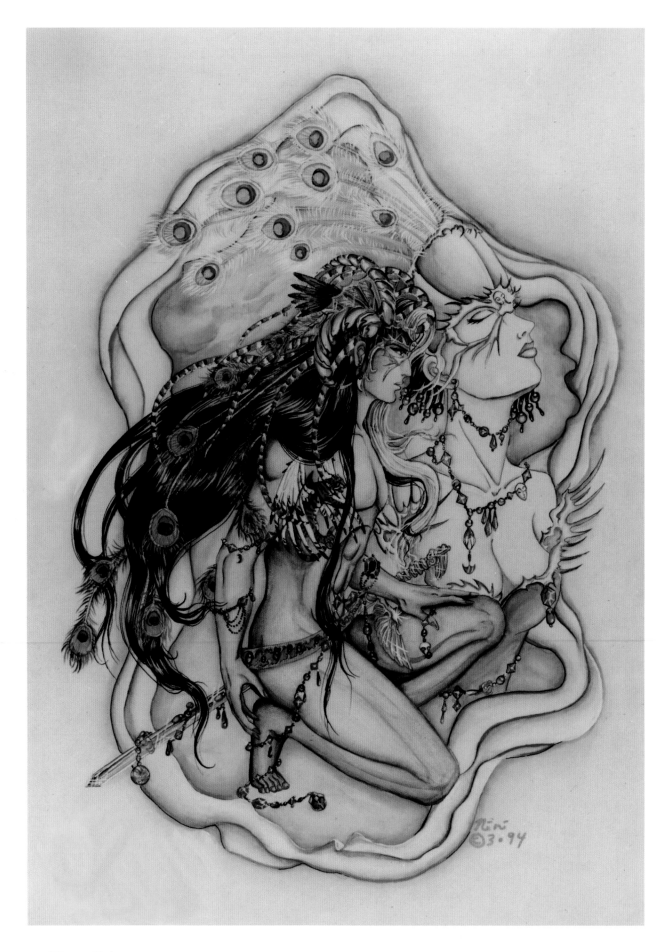

Tiger Prince

This is Phaedron, another character from my story. He's Valeriad's brother and Chesare's lover. While he is a major character in the story, I haven't really used him much in my art. I prefer the cold look of Valeriad to the warm look of Phaedron when I paint men.

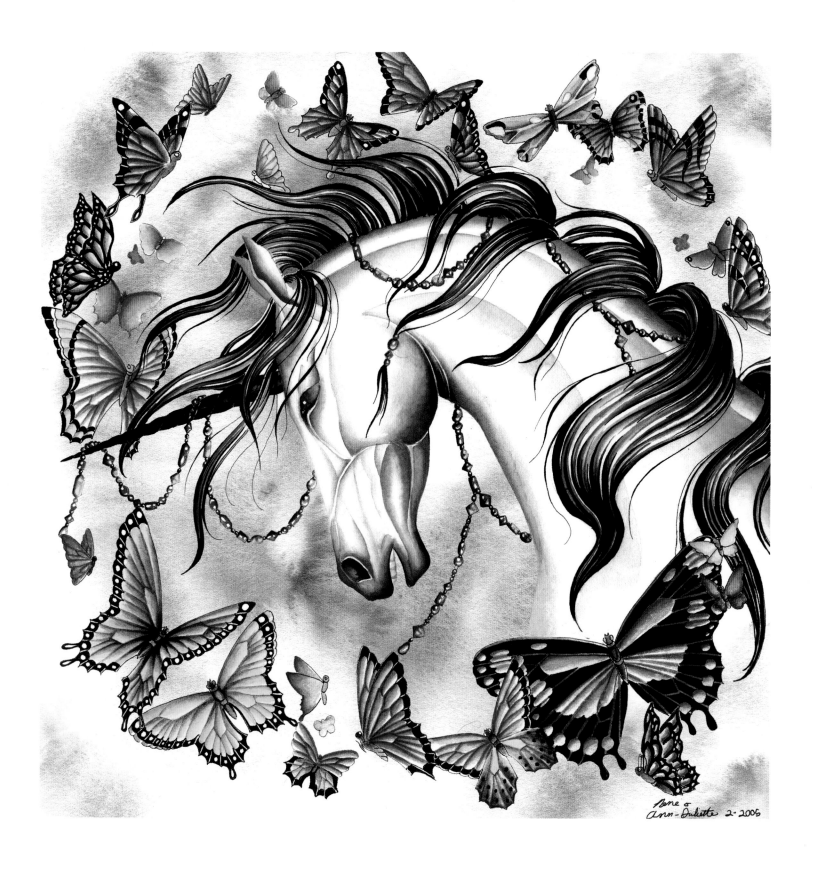

Treasure

As with *Petal*, this piece was set aside after I had started it because I didn't like the direction it was taking. When it came time to train Ann-Juliette on color work, I immediately thought of this piece and *Petal*. The myriad butterflies gave Ann-Juliette the perfect chance to use all of the colors on her palette, and she took excellent advantage of the opportunity.

115

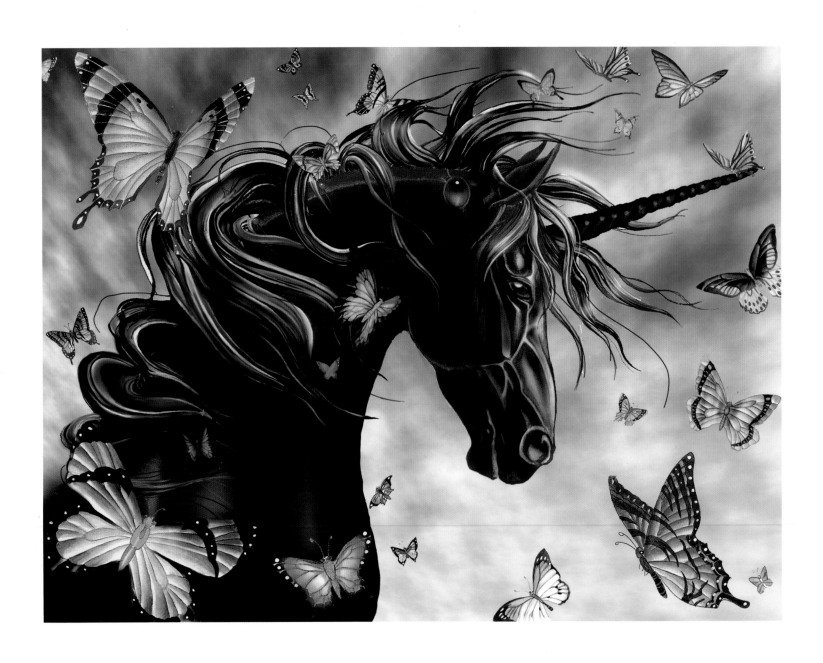

Unicorn Butterflies

This piece was designed as a postcard, but it took me almost as long to finish it as a full-sized piece would have. I had a lot of trouble getting the horse's head in the proper position, and blue skies have never been my strongest suit.

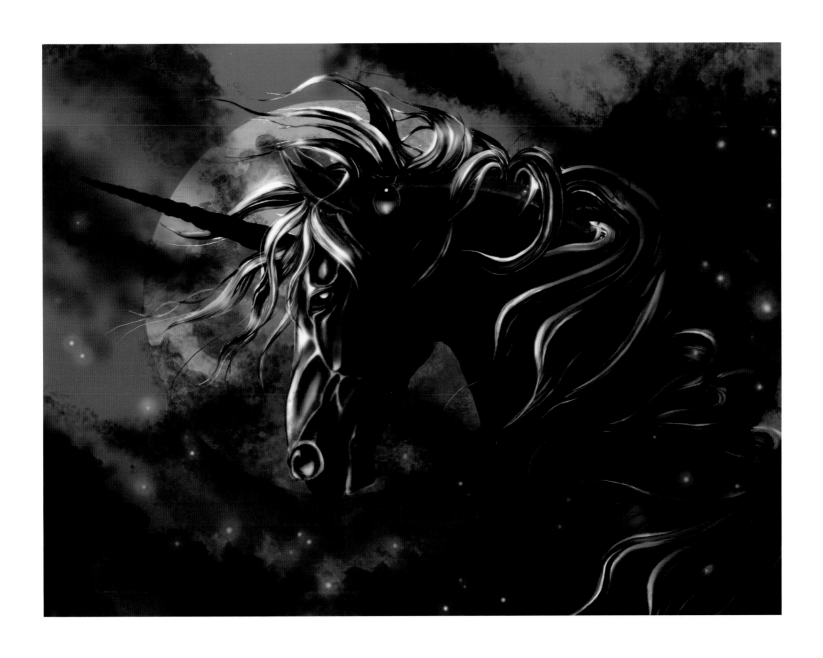

Unicorn Moon

This piece, like *Unicorn Butterflies*, was designed as a postcard, but this one didn't take as long as *Butterflies* to complete because I am used to painting dark backgrounds. The little sparklies were difficult, however. Painting bright touches on a dark background isn't as easy as you might think!

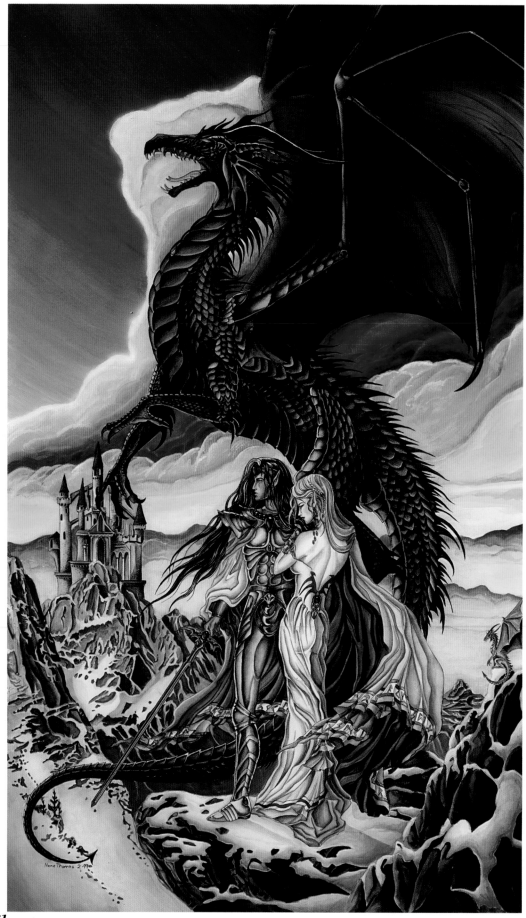

Vigilance

I had to restart this piece seven times, and it was the cause of the only temper tantrum that I'll ever admit to. Nothing on this piece seemed to work right, and during one of the attempts, my cat *Shadowfax* actually spilled my paint water all over it. Eventually everything did come together, and after it was finished, I was able to forgive my evil, evil cat. Every scale on the dragon is hand painted, one by one. It's enough to drive anyone crazy.

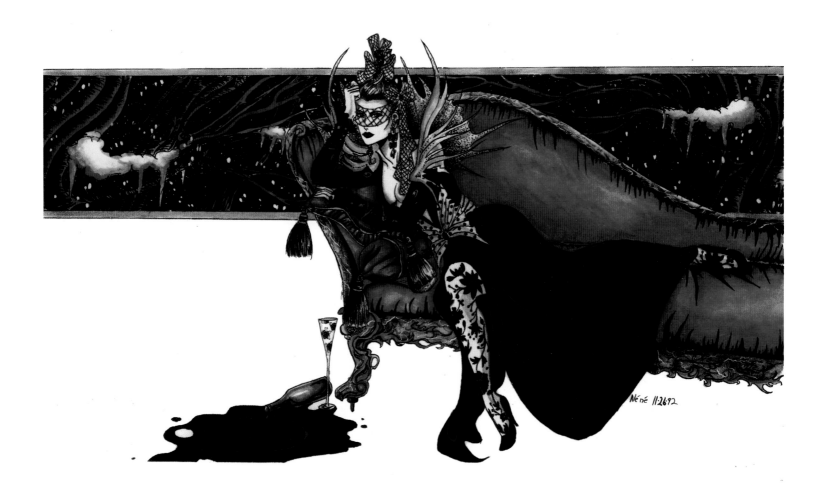

Winter

Gray skin isn't the easiest thing in the world to paint correctly. Achieving a cold look without making the figure look dead requires a very delicate balance. This was the first piece that I had ever painted with grey skin, though I have done it several times since, for example, in *Faery of Ravens*, *La Victime*, and *Hope*. The figure in this piece is named Edaria, and she is another character from my story.

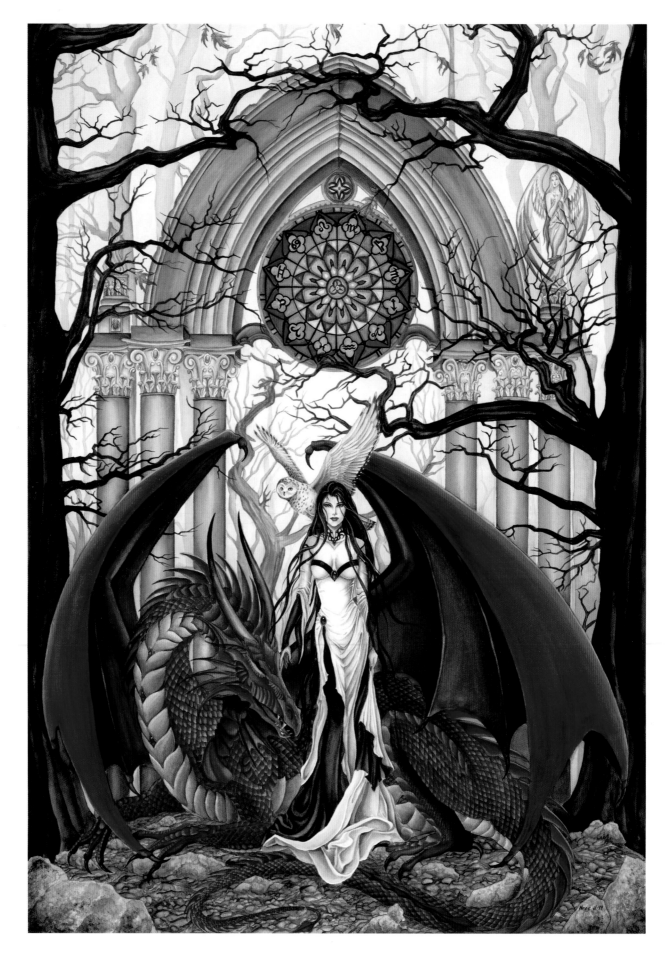

Wisdom

The background for this piece was inspired by the painting *Cloister Cemetery* in the *Snow* by Caspar David Friedrich. I love that painting, and I used it as a reference as I painted this piece. This is one of the largest paintings that I have ever done. It took me over six weeks to finish it.

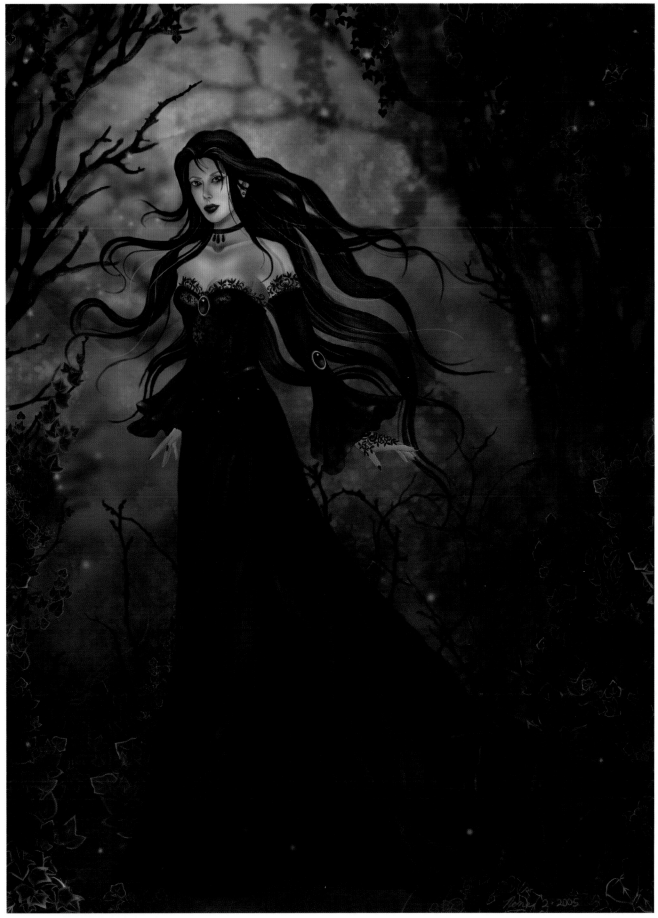

Witchwood

I finished this piece just as the deadline for this book approached, and I was feeling pretty good about it, until I called Steven in to take a look at it. He said, "I really like it, but it reminds me of the cover of a V.C. Andrews book." I took a second look and darn if he wasn't right! It's the lighting that gives it that look. Lighting a face from underneath gives it a distinctive look that you usually see on the cover of gothic horror novels.

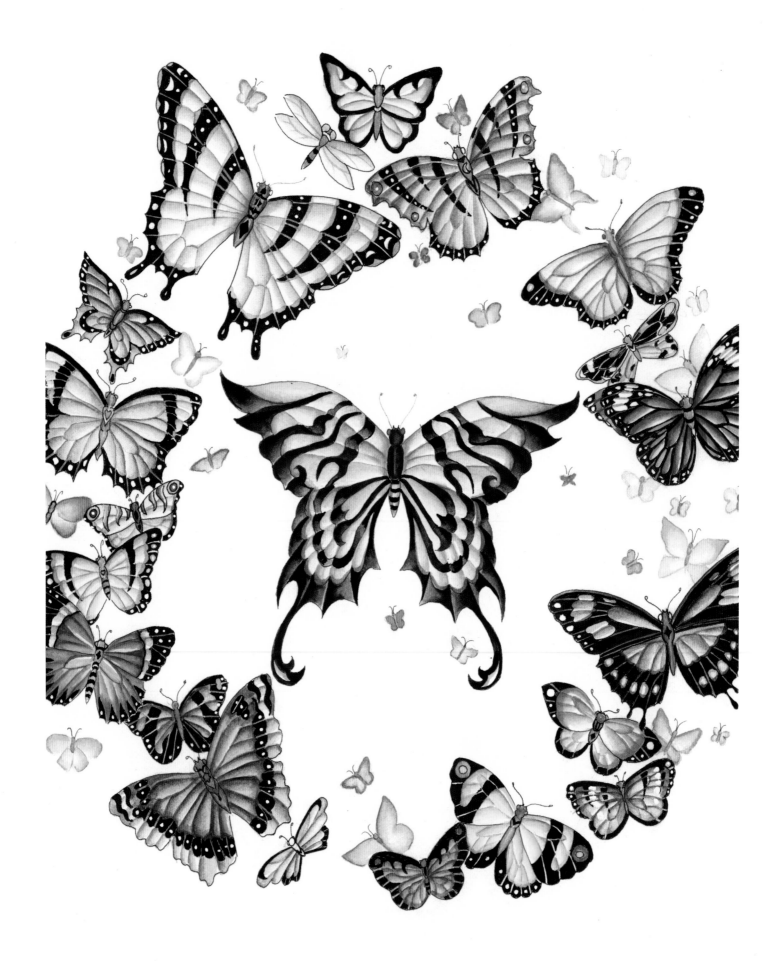

Yellow Butterfly Ring
Both the *Yellow* and *Dark Butterfly Rings* were collaborations that I did with my sister, Ann-Juliette. She drew the original sketch, and I painted it. Then we released the images as stickers. Ann-Juliette has such a great eye for detail that I hired her as my art assistant, and many of my current works incorporate her ideas and designs.

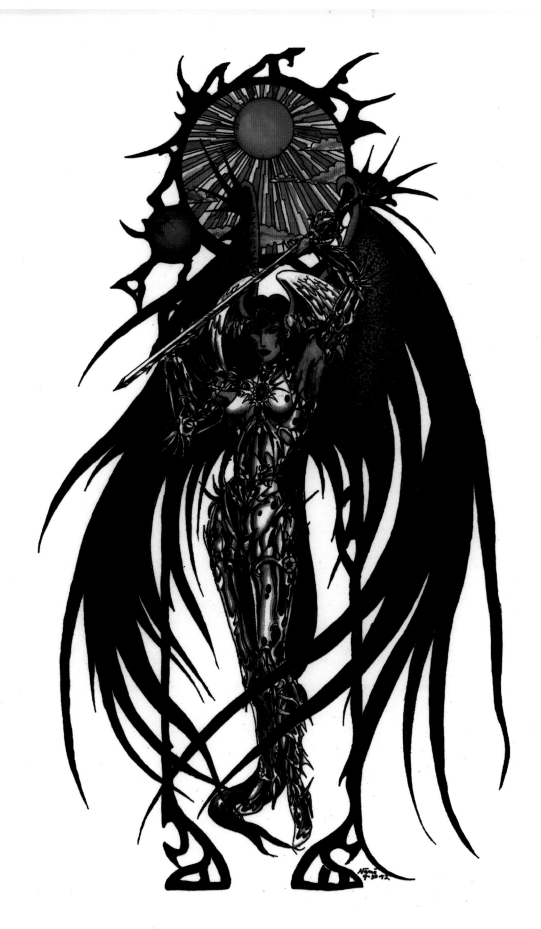

Zarryiosiad

Zarryiosiad is a hand-colored print of a character from my story. This character is the one that begins the epic, thousands of years before the events in my story take place. She created an empire by conquering an entire continent and bending it to her will. Thousands of years later, every noble bloodline in the empire originates from her.

Some General Advice for Aspiring Print Artists

At almost every show I attend, people ask me for advice. Some questions I can't answer, as I decided a long time ago not to pursue contract work. But some advice I can give...specifically, how to make your work appeal to the broadest audience possible. The tips that I have written aren't a magic formula and in no way guarantee success! But, if you follow them as much as possible, you will find that your work will reach a larger audience...and that can translate directly into sales.

1) Avoid nudity in your artwork as much as possible.

Hint at sexuality, make the people in the piece tease, but don't show anything. Intellectually, people understand that nudity in art is a time-honored tradition, and that just because a piece features nudity in it, that doesn't make it smut. Unfortunately, people are also sensitive to what their friends and family will think, and most will err on the side of caution. So while they may appreciate artwork that features nudity, they won't hang it on their walls for fear of offending someone. Simply put, that means you lost a sale. Even worse, some art shows will not even allow you to display your art if you feature nudity. Some will, but will place your work in a closed-off area! The object is to display your art to the maximum number of people possible, not to be placed in a closet for fear of offending people! If you absolutely MUST have nudity in your work, try to make it as tasteful as possible. The more graphic or shocking the work gets, the smaller your audience becomes.

2) Make your characters as generic as possible.

In order to sell as many prints as possible, you have to make your image appeal to as many people as you can. People are more likely to buy a print from you if they can see themselves or their character in the image you have created. That means you have to paint generic characters. Say you draw a beautiful woman that appeals to everyone. The more specific you make the character, the more it will appeal to a specific crowd and the less it will appeal to a general crowd. This is absolutely impossible to avoid! Simply choosing a hair color will lose a percentage of your audience. For example, people that are partial to redheads won't buy pictures of brunettes or blondes etc. You can't avoid that! But don't compound the problem by giving her a tattoo and a nose ring, and putting her on a motorcycle. Motorcycle enthusiasts will love the piece: the

rest of the audience won't.

3) Ugly doesn't sell!

When you create a character, make him or her as beautiful as possible, and pay special attention to anatomy! In fantasy art, people are looking for an ideal representation of the things that they like, especially Roleplaying gamers. People never think of their characters as being ugly or fat or the like. Every character out there is a supermodel or bodybuilder by day, gypsy sorceress with wolf or raven familiar by night. That means that they want perfect representations and it is up to you to provide them. The single most import feature to get right is the face...and more specifically the eyes. The first place people look when seeing a print for the first time is directly in the eyes. After that they will take in the rest of the work, but if the face is flawed then most likely people will remember it and not buy the print. So take time in creating a face. A beautiful face can hide a multitude of sins.

4) Display your work in as professional a manner as possible.

I asked my husband to address this particular point, as he is not only the one responsible for matting and framing my work, but he also arranges my displays at every show we attend. Here is what he said:

Presentation can be vital in the way people perceive your work, and first impressions are everything. If a person approaches your display and sees loose prints hung by bulldog clips, more often than not they are going to walk away. The same thing applies to matted prints: if you mat your prints, make sure that the mat work compliments the piece and doesn't detract from it. You don't have to do fancy cuts, but putting a lime-green mat on a red painting is not good. And make sure your cuts are clean! Ragged mats detract from a display just as much as using bad color selection!

Three people go to a job interview. All three have the exact same qualifications, from the amount of experience, to the amount of schooling. All three of them look exactly alike, except for one thing; the way they dress. The first person is wearing mismatched clothes that haven't seen a washing machine for weeks, let alone an iron. This person has taken no pride whatsoever in his own appearance, relying on his personal experience to get him the job.

The second person arrives for the interview wearing

a full tuxedo (including tails and a top hat) that is glittering with rhinestones. He is immaculately dressed, but looks like a ringmaster at a circus, or at the very least, an ice skater. His qualifications are great, but he just looks gaudy.

The third person arrives for the interview looking like a model in GQ. He is stylishly dressed, but not overwhelmingly so. He has broad shoulders, and the cut of the jacket emphasizes this, without screaming it. Overall, he is the most professional looking interviewee of the group.

Who would you hire? In a perfect world, you can hire any of them and you would be fine. Unfortunately, this is not a perfect world, and image is everything. Who would you want to represent you to the public; the dirtbag, the peacock, or the professional?

The art world is exactly the same way. Artwork that is presented in a ragged, dog-eared mat that uses uncomplimentary colors just looks unprofessional, no matter how good the print itself may be. I have seen very good artists get overlooked at convention after convention, simply because their displays look sloppy.

However, going to the opposite extreme is also bad. Cutting a fancy mat that uses the finest materials is great, unless it overpowers the piece to the point that all you can see is the mat, not the art. People will not pay out their hard-earned money for something that looks horrible on the wall, no matter how well it may be cut

.
The best mat is tastefully cut without being too plain. Ideally, you should use the artwork itself to plan out the mat. For example, look at the general flow of the piece. Does the action flow from one side of the piece to another? If so, perhaps a ray pattern or a diagonal cut might bring it out a little more. Is the action centered? If so, maybe a centered pattern might be in order. Is the piece elegant or flashy? Elegant needs a plain cut - perhaps a 3-D Double Bevel - while a flashy piece could use zigzag offset corners. The possibilities are endless. There are other rules for displaying your art in a professional manner. Make sure that you don't crowd your display. If you have a lot of pieces to sell, pay for the extra panels. Crowded displays are very difficult to look at, and most people won't take the time.

5) If you are painting mythological creatures, stick to the ones that everyone knows.

Fantasy creatures are very popular with the buying crowd. However, certain creatures are more popular than others, and you have to cater to the buying public. Dragons are perennial favorites, as are fairies, mermaids, pegasi and unicorns. Less popular are griffons and hippogriffs. Western dragons (like the ones Elmore paints) are more popular than Eastern Dragons (Chinese Dragons.) This rule applies to animals as well. The most popular creatures among fantasy art collectors are ravens, wolves, falcons and hawks, horses, and dolphins. For some odd reason, giant cats are not as popular, unless you go for the really exotic breeds: white tigers, snow leopards, black panthers etc.

Keep this in mind when you are painting your main figure as well. Elves and humans sell quite well, dwarves and halflings don't. Centaurs and other half human figures (or anthropomorphic creatures, i.e. "fuzzies") have a market, but the vast majority of buyers aren't interested.

6) You can't fool the buying public. They are smarter than you think.

The average buyer knows at first sight whether or not they like a print well enough to pay good money for it. You can tell them all about the inherent symbolism and mysticism and the like that you have placed in the image, but all they are really concerned with is whether or not the print will look good in their house. The fact is, almost every single print that you sell is an impulse buy. A potential customer already knows if they are interested in buying a print of your work. If they are hesitant about buying from you, usually it is because they are wondering if they have the money or the room to display it or a way to get it home…etc. It normally has nothing to do with the print itself. If a print isn't selling, then YOU did something wrong and it is up to you to correct it.

7) Paint in bright colors. It makes your display stand out.

Sometimes, people can be like crows. They are attracted to shiny objects and are naturally drawn to them, so if you paint in bright colors they will naturally be drawn to your display. If you normally do paintings with darker themes, a single bright painting can be enough to bring people in to your display. But when you hang your work, make sure that the brightest piece is hung as close to the center as possible and the rest arranged around it. Bold colors make a statement about your work, and people will respond.

8) If you advertise a print run as a limited edition, keep it that way. Reprinting will cost you customers. Of all of these bits of advice, this is the one that I have the hardest time mentioning, simply because so many people in our career field are guilty of it. It takes a long time to build up a good clientele. Once you have "regulars" you will find that they tend to spend more money than other people. The problem is trust is a very difficult thing to earn, and you can lose it forever in an instant. If you tell people that there are only going to be so many prints in an edition, then stick to that, even if doing so will cost you money. If you think an image is going to be popular, there are ways to have your cake and eat it too. As long as you tell people UP FRONT that you reserve the right to reprint an image or have an open edition, then there is nothing wrong with reprinting a sold-out edition. If one of your customers finds out that you have reprinted a sold-out edition dishonestly however, you will lose not only his trust but all of his future business as well. "Prefer a loss to a dishonest gain; the one brings pain at the moment, the other for all time."

9) Find ways to cut costs, and keep your prints as cheap as possible. No matter how good your art may be, if it is too expensive for people to buy, they won't buy it. "Quantity has a quality all it's own" is very true when it comes to art: selling ten prints at $10 each is much easier than selling one print for $100. In order to keep the price of your prints from becoming too high for people to afford, you need to learn how to cut costs. Buy a mat
cutter and learn how to mat your own work. Buy your supplies (frames, glass, matboard, tape, EVERYTHING) from wholesalers whenever possible. Ship things via U.S. Post a couple weeks in advance to save shipping. Anything you can do to bring down your costs is savings that you can pass on to your customers. Don't lose your shirt over it though! If you have to charge more for a print, then do it and don't think twice about it. You are in this to make money after all, and taking a loss is defeating the purpose.

10) Never fall in love with your own work. Criticism is the best way to learn where the strengths and weaknesses in your work are. So don't take it personally if someone criticizes your art. You will learn wrong in the others. As I mentioned earlier, you can't fool the buying public. THEY will tell you where your work is good and where it isn't. There is a caveat to this rule: more from people that point out the flaws in your work than you will from those who compli-
ment it. Also, if you are mailing 10 pieces of art to shows and only one piece is selling consistently, try to figure out what you did right in that one piece, and what you did wrong.

10-a) Artists are not the best judges of their own work. You will find that prints that you think are perfect don't sell as well as you think they should, and prints that you think are utter crap sell as fast as you can mat them. Don't get discouraged by this! Do your own thing and let the sales take care of themselves.

11) Size matters. People equate size with value. The larger a print is, the more you can charge for it. So no matter how good and detailed a print is, if it is smaller charge less, if it is larger, charge more. There are exceptions of course! A small original is worth more than a large print to the buying public. A large open-edition print isn't worth as much as a small, limited edition print.

I hope that this information can help those of you who are wondering what it takes to become a print artist. It took me a long time to learn some of the lessons that I have posted here. So I hope you can profit from them! Good luck!

**Nene Tina Thomas &
Steven Plagman**

SPECIAL THANKS TO:

My wonderful husband Steven who has always believed in me even when I doubted myself. The employees of Nene Thomas Illustrations Inc.: Ann-Juliette Thomas, Jan-Annette Johnson, and Darlene Bryant. In particular, I would like to thank Ann-Juliette for the beautiful inks that you will see throughout this book. She has become an indispensable part of the artistic process, and without her this book would be greatly lessened. I would like to thank all of my other brothers and sisters, Chance, George, and Yvette, as well as my parents, John and Patricia Thomas. I would also like to thank Harold and Supattra Plagman, my in-laws, for giving us all the support that we could have asked for throughout my career. I would like to thank the many artists that have inspired and befriended me over the years. Time and again the examples you've set have made me challenge my ideas of what can and can't be done.

AND VERY SPECIAL THANKS TO:

Norm and Leta Hood. By supporting me and publishing this book, you have made a lifelong ambition a reality. Your valuable insights and steady encouragement has made this book better than I imagined it could be. For that you will always have my gratitude.

INDEX

My Island Home

MY BOOKS

KITCHENER'S MOB, 1916

HIGH ADVENTURE, 1918

ON THE STREAM OF TRAVEL, 1926

MID-PACIFIC, 1928

MOTHER GOOSE LAND, 1930

FLYING WITH CHAUCER, 1930

TALE OF A SHIPWRECK, 1934

THE FRIENDS, 1939

DOCTOR DOGBODY'S LEG, 1940

O, MILLERSVILLE!, 1940

UNDER A THATCHED ROOF, 1942

LOST ISLAND, 1944

A WORD FOR HIS SPONSOR, 1949

THE FAR LANDS, 1950

THE FORGOTTEN ONE
 AND OTHER TRUE TALES OF THE SOUTH SEAS, 1952

MY ISLAND HOME, 1952

In Collaboration with Charles Nordhoff

HISTORY OF THE LAFAYETTE FLYING CORPS, 1920

FAERY LANDS OF THE SOUTH SEAS, 1921

FALCONS OF FRANCE, 1929

MUTINY ON THE BOUNTY, 1932

MEN AGAINST THE SEA, 1934

PITCAIRN'S ISLAND, 1934

THE HURRICANE, 1936

THE DARK RIVER, 1938

NO MORE GAS, 1940

BOTANY BAY, 1941

MEN WITHOUT COUNTRY, 1942

THE HIGH BARBAREE, 1945

My Island Home

AN AUTOBIOGRAPHY

"This small island is, for me,
Everything a home should be."

by
J A M E S N O R M A N H A L L

WITH ILLUSTRATIONS

Mutual Publishing

LIBRARY OF CONGRESS CATALOG CARD NO. 52-9089

Published October 1952
Reprinted October 1952 (three times)
Reprinted November 1952
Reprinted December 1952 (twice)

Reprinted by Mutual Publishing in mass market format 2001
ISBN 1-56647-448-5

In the latter part of this narrative the author has included some material from
books written earlier and long out of print. The publishers wish to thank
Houghton, Mifflin & Company and Harper & Brothers for their kind permis-
sion to do so. The publishers also wish to thank the following: The *Atlantic
Monthly* for permission to reprint the selections originally published by them
and for Mr. Ellery Sedgwick's eulogy of James Norman Hall; Coward-McCann,
Inc., for eight lines from *The Complete Poems of Francis Ledwidge*, copy-
right 1928 by Coward-McCann, Inc.; Dodd, Mead & Company and Sidgwick
& Jackson, Ltd., for eight lines from "Peace" by Rupert Brooke, copyright 1915
by Dodd, Mead & Company; Henry Holt & Company, Inc., for nineteen lines
from *Complete Poems of Robert Frost*, copyright 1930, 1949 by Henry Holt
& Company, Inc.; Charles Scribner's Sons for twenty-six lines from "Contem-
plation" and "The Cloud's Swan Song" by Francis Thompson and for a brief
quotation from *The World Crisis* by Winston S. Churchill, copyright 1923 by
Charles Scribner's Sons, 1951 by Winston S. Churchill.

PRINTED IN AUSTRALIA

*To the Memory of
my Father and Mother*

A Starry Night at Arué

These are my beliefs, in eight and twenty lines:
That men are nobler than their actions show;
That "Beauty is Truth" defined and still defines
As much of ultimate truth as we shall know;
That ever-questing Science yet may bare
Much that is strange and new, and after all
Her farthest flights, that Man will stand and stare,
Awed and humbled, at the self-same wall
That hemmed him round when once he lived in trees;
That littleness makes still the happiest nation;
That states do wrong to emulate the bees
In industry, the ants in population;
That of men's crimes against themselves, the latest,
Distance conquered, is among the greatest;

That Reason is a rock no more than Feeling
(Intuition is a safer guide);
That those who make a god of Reason, kneeling
Devout, are not the wholly sane, clear-eyed
Beings they fondly think; that cocks will crow
At dawn, as now, in twice ten thousand years,
Changelessness a changing world to show;
That men will still shed blood and women tears
As long as there are tears and blood to shed;

That joy has lunar months as well as grief.
When everything is said that can be said,
This is my sure, my very firm belief:
That life, to one born whole, is worth the living,
Well worth the taking, having, and the giving.

Contents

LIST OF ILLUSTRATIONS

My Island Home

i. The Woodshed Poet

Look to the northward, Stranger,
Just over the barn roof, there.
Have you in your travels seen
A land more passing fair?

THOSE LINES were written fifty years ago by a woodshed poet who lived in the little town of Colfax, Iowa — population 1749 — in the heart of the prairie country. He was twelve years old and little knew, then, that the Stranger appealed to would, in the course of time, prove to be himself, looking to the northward toward the days of his boyhood and youth from his home on the island of Tahiti, in the South Pacific. But so it is, and, despite the distance of time and space, I am happy to find that some of the memories of those days stand out as clearly as though the events of them had happened last week.

The Hall-family woodshed stood a little way back of the house on the northern slope of a hill that gave a wide view of the country in that direction. Both woodshed and barn have long since vanished, but I still see them in the mind's eye, their walls covered with the early compositions of the woodshed poet. "Look to the Northward," of four stanzas, was penciled by the woodshed window, overlooking the barn which was farther down the hill. The Stranger's attention was called to particular points of beauty in the landscape stretching away to the hills that bound it north and west.

Colfax, in the days before the arrival of motorcars, was one of those small country towns healthy, commercially, because the farmers living around them within a radius of from six to ten miles did their trading in them; and "trading" it was, in a real sense, for the farmers' wives brought with them fowls and eggs and homemade butter to be exchanged for various articles which the combined dry-goods-and-grocery stores of those days had to sell. The town had a reason for being that was later to be partly lost. As motorcars increased and dirt roads vanished the farmers' custom went to larger towns. Colfax, like many another small town, is now only the ghost of what it was in the eighteen-nineties and early nineteen-hundreds. There were no wealthy residents in the town, nor were there any poor. Modern conveniences were few. During my boyhood I remember only two houses furnished with bathrooms and indoor toilets. All dwellings were heated either by wood stoves, potbellied stoves that burned soft coal, or those glorious bringers of indoor cheer, "hard-coal burners." Furnaces were then unknown except for a few in store buildings. As for house furnishings, most of them came, I believe, from Grand Rapids, Michigan, and a few other emporiums in or near Chicago. It was all in atrocious taste, and rocking chairs in particular were monstrosities that would have to be seen to be believed.

Our house, on its exposed hilltop where it took the buffetings of the bitter midwinter winds sweeping down from Canada, was a story-and-a-half frame building with a porch eight feet wide, trimmed with gingerbread scrollwork, fronting the dining room. The only water faucet in the house was in the cellar, for this was believed to lessen the risk of the pipe freezing in winter, but it froze nevertheless. All water was carried up to the kitchen. On a small back porch we had an icebox; but Iowa summers were as hot as the winters were cold, and those precious blocks of ice would vanish before the day was done.

But that old frame house was a home in the best sense of the word. Comforts and conveniences there were none, but they were not

missed because we had never known them. What amazes me now, as I think of boyhood days, is how our mother managed to raise five children, three boys and two younger girls, doing practically all of the work herself when we were little. Only the family washing was sent out. Everything else she did, with the help of an occasional "hired girl." We children helped, of course, when we were old enough, but I still wonder how Mother managed when we were too young to be of use.

Around my tenth year when I began my literary career, my model was James Whitcomb Riley, the Hoosier Poet, and my secret ambition was to be called, some day, the Hawkeye Poet. Despite my admiration for James Whitcomb Riley, I had no desire to follow him in writing dialect poems. I wished to write of real people and real events, and a typical example written at the close of the Spanish-American War, when I was eleven, was preserved on the flyleaf of my school geography. *Cuba Librey*, I supposed, was the way *Cuba Libre* was pronounced.

> Cuba Librey! Cuba Librey!
> Ring the bells, a glad refrain!
> Noble Dewey, fearless Teddy
> Have defeated haughty Spain.
>
> Now the volunteers from Colfax
> Have returned home from the war.
> Only one of them was wounded;
> On his shoulder is a scar
>
> Where a Mawser bullet hit him.
> Barney Winpiggler his name.
> Some got sick, but only Barney
> Will be known to future fame,
>
> For he shed his blood in battle
> So the Cubans could be free,
> And they are, for Spain is conquered
> On the land and on the sea.

A kind of melancholy seizes me as I travel back in thought from the grim uncertainties of today to the deep tranquility of 1899, the time when these verses were written. How little war, or the threat of it, intruded upon the lives of Americans in the nineties! To boys of my day it meant the American Revolution, the War of 1812, and the Civil War: battles of long ago, forever past and done with. Except for the half-dozen volunteers from Colfax who took part in the Spanish-American War, throughout the entire period of boyhood we never saw a man in uniform save the aging veterans of the Civil War who assembled at one of the churches for the Memorial Day service and then marched to the cemetery to the music of the fife-and-drum corps. War was no threat of the future but a fading memory of the past. It was something one read about in illustrated school histories: Paul Revere's ride and the battles of Lexington and Concord and Bunker Hill. It was Ethan Allen shouting: "In the name of the great Jehovah and the Continental Congress!"; it was Lincoln at Gettysburg; General Grant at the surrender of Lee's armies. War, to us, was associated with Iowa in May, with the fragrance of lilacs and appleblossoms in the air, when our beloved and revered school superintendent, Dennis M. Kelley, standing in the local cemetery by the grave of a Civil War veteran, reminded us of the sorrow that had been and would never be again. As for the Spanish-American War, it was not a real war; Teddy Roosevelt had won it almost singlehanded, at San Juan Hill. We Colfax boys were proud of Barney Winpiggler who had shared a little of Teddy's fame by getting wounded in the shoulder.

Of all the haunts of boyhood, the Hill was the one I most deeply loved. It was the highest of the wooded hills east of town. The Chicago-to-Denver branch of the Chicago, Rock Island and Pacific Railroad wound around the bases of the hills and just beyond was the "deep tangled wildwood" bordering the river: a paradise for boys but no more so than the hills themselves. The view from my Hill was even more beautiful than that from the one where our house stood,

and from the middle of April the forest floor was carpeted, first with hepaticas whose fragrance is the very breath of spring; then came violets, Dutchman's-breeches, dogtooth violets, jack-in-the-pulpits, cowslips, bloodroots and May-apple blossoms. And, in the autumn when the hills were ablaze with color, there were hickory nut, black walnut and butternut trees and hazelnut bushes loaded with spoil.

Whenever, during later years, I have returned home, I have always planned to arrive in mid-April, if possible, so as to be in time for the hepaticas, and within half an hour of my arrival I head for the woods. At the crest of the highest hill there is, or was, a great linden tree where I loved to sit looking out to the north over the bottom lands of the Skunk River.

Many boys of my generation, like the boys of Tom Sawyer's and Huck Finn's generation, went to bed betimes on summer nights, but not always to sleep. And we were quite as skillful at making exits through upstairs windows; or we could creep downstairs, shoes in hand, as noiseless as cats. Alas! Having emerged from our parents' dwellings, we found no Mississippi River flowing past our dooryards, majestic, mysterious, under the light of the moon. In summer the Skunk River was little more than a prairie slough filled with sandbanks, mudbanks, and the trunks and branches of dead trees that had been swept into the channel during the spring rains. But we were not without adventure. Our Stream of Travel was of a different kind but none the less romantic: the C.R.I. & P. Railroad.

Number Six was due at Colfax at 10:45 P.M., but a good five minutes before that time it appeared around the curve westward, at the top of the Mitchellville grade, six miles away. The headlight proclaimed the glory of its coming, and the first faraway whistle was like a call to adventure in the summer night, sending shivers of delight up and down the spines of three of us more than ready to respond to it — Buller Sharpe, "Preacher" Stahl, son of the Methodist minister, and myself. Number Six took water at Colfax, and we waited beneath the water tank about fifty yards past the east end of the sta-

tion. We would hear the fireman climb onto the tender and pull down the iron spout with the canvas nozzle attached; then silence, save for the plash of water pouring in and the gentle yet powerful breathing of the engine. Presently up went the spout, spilling the water remaining in it onto the ground just beyond where we were concealed. Then came the "high-ball" — that most stirring of signals — two short sharp blasts of the whistle. Peering out from behind the posts supporting the water tank we would see the conductor swinging his lantern from the station platform. The fireman gave a pull at the bell rope; the great wheels began to move, and at the first mighty "hough!" of the engine we skipped out, leaped on the pilot — or "cowcatcher" as it was called by the uninitiated — and vanished into the pool of darkness just beneath the headlight.

What were the adventures of later years, compared with those summer-night rides on the pilot of Number Six? There was happiness almost too great for the hearts of boyhood to contain. The deep-toned whistle echoed among the wooded hills east of town. The great engine, rounding the sharp curves along the serpentine stretch of track skirting the hills, communicated the keen thrill of excitement from its own huge body to those of the twelve- and thirteen-year-olds who felt themselves a part of it. The headlight threw shafts of glory into the wooded land along the river; then, the curves passed, we felt sharp nudges from behind as the train gathered speed, and the long shaft of brilliant light now reached far ahead along the right-of-way.

A great part of our enjoyment came from being so close to the bosom of Mother Earth, which gave us the keen sense of traveling at enormous speed and with effortless power. All the odors of the summer night were ours: the cool dank fragrance of bottom lands along the river, mingled with that of skunk, one of the healthiest of all smells; the perfume of drying clover hay; the pungent odors of weeds and field flowers lying in swathes along the right-of-way as the scythes of the section hands had left them; the mingled odors of manure, horse sweat and harness coming from barns. And, best of

all, the deep-toned whistle of Number Six, and we traveling with it! It was splendid compensation for the many times when we heard train whistles from afar, the sound growing fainter and fainter until heard no more.

Grinnell, thirty-two miles from Colfax, was our usual destination. In the horse-and-buggy days a town thirty or forty miles distant was unknown territory to most small boys, with the romantic appeal that distance lends it, and this was enhanced with the hour approaching midnight, the strange streets empty, and most of the houses dark. The three of us would hasten away from the station and the business part of town, for the night constable would be making his rounds in that neighborhood and we had no desire to be questioned by him. In those days when trains carried all the traffic of the nation we could be sure of catching a westbound freight that would take us home before daylight. And so, carefree and curious, we wandered at ease along broad residential streets where maple trees and overarching elms were "chandeliers of darkness" against the starry sky. On one of the earliest of these journeys I had my first view of Grinnell College, or Iowa College as it was then called.

I have often thought of the importance of the effect those midnight rambles over the Grinnell College campus were to have on the events of my later life. I had the feeling of being in another world, as remote from that I knew as though it had been a thousand miles away. The beautiful lawns and the trees that shaded them; the buildings that looked so august and venerable compared with the mean little churches of Colfax, which, together with the schoolhouse, were the only public buildings in town — all of this stirred in me a vague longing.

The nocturnal visits of Sharpe, Stahl and me had all been summer ones when the College was closed; but upon one never-to-be-forgotten occasion we saw the campus on a night in early October, shortly after the students had returned. This must have been in the autumn of 1902 or 1903. We witnessed a torchlight procession coming along

the street bordering the west side of the campus. Thirty or forty
men were singing what I afterward learned was called "The Glee
Club Marching Song":

> A band of brothers from old Grinnell,
> We march along tonight,
> Two — by — two, our arms linked firm and tight.
> Our songs arouse the sleepy town
> As we go marching on,
> Singing the love that binds our hearts in one.

On they went, their bodies casting huge shadows in the torchlight,
the singing dying away far in the distance. At the time I remembered
only fragments of the song, but having been born an idealist, a ro-
manticist, even in boyhood anything beautiful heard or seen was
immediately enhanced in the imagination and formed dream pictures
in my mind. So it was on this occasion: the street bordering the
campus was no ordinary street, nor the houses ordinary houses.

The whistle of a westbound freight would hurry us back to the
railway yards. On the homeward journey we usually rode on top
of a boxcar to have a better view of the countryside. Often the train
was a fast freight that went thundering through Colfax, gathering
speed for the long Mitchellville grade; but there was no need for
concern: the grade conquered the best of them. When halfway up,
the freight would be traveling no faster than a boy could trot. Sharpe,
"Preacher" and I would hop off there, walk the three miles back and
be safely in bed and asleep well before daylight.

ii. The Store

SATURDAY NIGHT was bath night in the Hall family. We bathed in turn by the kitchen stove, the bathtub being an enameled dishpan; then, in clean nightgowns, the boys of the family — the girls were still too young — would gather in the sitting room around the hard-coal burner while Mother read to us from Dickens and Cooper, and the serial stories of *The Youth's Companion*. *The Old Curiosity Shop*, *Nicholas Nickleby*, *Oliver Twist* and *David Copperfield* were my Dickens favorites, and *The Last of the Mohicans*, *The Deerslayer* and *The Pathfinder*, of Cooper's works. Recently, glancing through *The Old Curiosity Shop* once more, I wondered whether Mother had not done some judicious skipping in reading Dickens to us in the old days.

Even before I had learned to read there were two books in my father's library that I often lugged out to the floor and studied with absorbed interest: *Paradise Lost* and *The Ancient Mariner*, both superbly illustrated by Gustave Doré. I doubt whether there could be a better preschool preparation for a child than to expose him to Milton and Coleridge, the text illustrated by Doré. He may be frightened by some of the pictures, but the stirring and quickening of his imagination is well worth the price of occasional moments of terror. It was not until years later that I realized the deep and lasting impression these poems made upon me by means of the illustrations alone, and when I had learned to read the text beneath, my awesome delight was greatly increased. I still remember nearly all of the illustrations in *Paradise Lost* and the lines beneath them:

> Before the gates there sat on either side
> A formidable shape . . .

> Forthwith upright he rears from off the pool
> His mighty stature . . .

As for *The Ancient Mariner,* I still have the identical volume I pored over in childhood days: the Altemus Edition published in 1889 by Henry Altemus, in Philadelphia. The pleasure it gave me to expose my own children to it at the age when I first entered that incomparable world, still glows reminiscently in my heart. I see their faces as they examined Doré's illustrations while I read:

> About, about, in reel and rout
> The death-fires danced at night . . .

> Beyond the shadow of the ship,
> I watched the water-snakes . . .

> They groaned, they stirred, they all uprose,
> Nor spake, nor moved their eyes . . .

One lives again in the hearts of one's children; and I never had a keener sense of reliving a part of my own childhood than when I first introduced my youngsters to *The Ancient Mariner.*

With other boys of my age I moved along through the early grammar school grades, learning the poems that all children learned from the Readers of those days. It seems strange to me that I should not have met Whittier's *Snow-Bound* until I was a pupil in the fifth grade. Our teacher, Miss Lulu Remine, read it to us on two successive Friday afternoons. Miss Remine who had a kind and sympathetic heart was the first of the grade school teachers who gave her pupils "memory gems" to learn for morning and afternoon roll calls. Instead of answering "Present" at these times, each of us rose at his desk and recited a "memory gem": "Order is Heaven's first law"; "A

man of words and not of deeds is like a garden full of weeds";
"They're only truly great who are truly good"; "Oh, what a tangled
web we weave, when first we practice to deceive!" and the like. When
my turn came I would sit with my head in my hands, an expression
of patient suffering upon my face, well knowing that I would not
have to be patient for long. It never failed to work. I would soon feel
a hand upon my shoulder and there would be Miss Remine, looking
concernedly down at me.

"Normie, aren't you feeling well?" I partly salved my conscience
by thinking of "Normie." I hated being called that and Miss Remine
never called me anything else. I needed only to glance up at her in
mute appeal and to shake my head. She never asked for particulars as
to where I was feeling badly or how long I had been suffering. "My
goodness, Normie! Why didn't you tell me? Now you must go
straight home!" And off I went without any further urging, the other
boys giving me knowing glances over the tops of their books as I
made my way to the door.

I had a definite end in view on these occasions: to go to the
C.R.I. & P. "deepo" and sit in the Gents' waiting room, hoping that
an eastbound freight train would come along, one not stopping at
Colfax.

George Myers, ticket agent and telegraph operator, would be in
his office with the glazed ticket windows closed. I would sit by the
potbellied stove, snug and safe, with a feeling of deep content mingled
with hopeful anticipation. Nothing broke the silence save the occa-
sional loud clicking of the telegraph instrument and the comfortable
winter sound of the falling apart of glowing lumps of coal. At the
sound of a far-off whistle to westward I would slip out the side door
of the waiting room and run to the west end of the station where I
could stand unseen, with a clear view of the approach. I might be
shivering with cold but was never aware of it during the brief, awe-
inspiring demonstration of enormous speed and power, there one
moment, gone the next, leaving one small boy in a cloud of dust,

cinders and coal smoke, his back turned to the icy wind of its wake as he watched the caboose dwindle and vanish around the curve to the east.

The first book bought with my own money was a fifty-cent edition of Burns' poems, published by Hurst & Company, in New York. I still have this copy, fragrant with the memories, and the pages marked with the sacred finger grime of boyhood and youth. The earliest of its associations goes back to the time when I wrote "The Skunk River in Spring."

I regretted that our little river was named the Skunk. It deserved a better one, I thought, and later discovered that it had a better one: a beautiful Indian name, the Checaqua, but it was never so marked on the maps. I envied Robert Burns who had rivers so beautifully named to immortalize: "Flow gently, sweet Afton" . . . "Ye banks and braes o' bonny Doon. . . ." Insofar as I knew no one had ever written a poem about the Skunk River. I resolved to do so, slipping the name in as unobtrusively as possible.

I wrote of a tragic event: little Willy King, whose parents lived only two blocks from our house, had been drowned in the river while learning to swim.

> Oh, lovely River! Gentle Skunk!
> Beneath this shining pool was sunk
> The body of a Colfax boy!
> How could the stream we love destroy
> The life of little Willy King
> And leave his parents sorrowing?
> And throw his body on the ground
> Nearly a mile from where he drowned?

Comparing this with —

> Ye banks and braes o' bonnie Doon,
> How can ye bloom sae fresh and fair?

I felt deeply discouraged and wondered whether I could ever become a poet. Curiously enough, it was Burns who, later, gave me new heart and courage to continue the struggle.

During my last two years in high school I worked, evenings and on Saturdays, and during summer vacations, in H. G. Gould's clothing store. Mr. Gould was not a resident of Colfax; he lived in another part of the state, but had bought several clothing stores in Iowa towns. The one in Colfax was managed by two cousins, John and Billy Davis. I was sweeper-out of the store, kept the furnace going in winter, dusted shirt- and collar boxes and was slowly learning to wait on trade. But diffidence, the bane of my life, then and since, was a great handicap, and this was increased by the rebuffs received from farmers and their wives who little trusted a young salesman.

The store, in the Craigan block, extended from the street to the alleyway behind. The Davis boys trained me as well as they could. Often when a customer entered they sent me forward to see what was wanted. The customer was, usually, one of my old enemies before whom I went down to inevitable defeat. With a forlorn attempt at brisk self-confidence I would approach and say: "Is there something, Mrs. Rorabaugh?" or "Well, Mr. Phlaum! What will it be today?" knowing very well what it would be. Mrs. Rorabaugh would fold her arms over her ample stomach and reply, coldly: "I want to see John"; and Mr. Phlaum would scowl and mutter, "Where's Billy?" or walk right past as though he had not even seen me. On rare occasions when both the Davis boys were busy a customer might permit me to sell him half a dozen bone collar buttons or a pair of cornhusking gloves, but that is about as far as their confidence in me went.

There were splendid compensations for this side of the clothing business, particularly on stormy winter days when customers were few. The Davis boys, of Welsh blood, were born singers. John had a superb tenor voice, and when we were busy at routine tasks he could no more keep from singing than from breathing. He could

make spring of winter when he sang, "Every morn I bring thee
violets," or, "I know a bank whereon the wild thyme grows." This
last was identified, for me, with my favorite hill east of town.

My love for male quartet music, aroused early, became a passion
during the years in the clothing store. There were some coal mines
a few miles south and west of town and for this reason we had a
population including both Welsh and Negro families, and all of them
could sing. The store was a rendezvous for the songbirds. Some of my
happiest memories are of winter days when the railway spurs to the
mines were so deeply buried in snow that the miners could not go
to work, nor could farmers reach town to do any trading. The Banks
brothers, Babe and George, colored boys, would saunter in. George,
a strapping fellow with a voice like Paul Robeson's, would say: "Billy,
any objection to a little harmony?" There never was. Then we would
tune up, and once the singing started others would quickly gather,
both white and colored, until, sometimes, we had a full glee club.
We had a large repertoire of songs. "Come Where the Lilies Bloom"
was one of my favorites. The chorus went:

BARITONES AND BASSES:	Oh-oh-oh Come, Come, Come, Come . . .
SECOND TENORS:	Come where the lilies, The sweet fragrant lilies,
FIRST & SECOND TENORS:	Come where the lilies bloom so fair . . .
BASSES:	Bloom so fair, oh come and . . .
FULL CHORUS:	Down in the meadow, The green shady meadow, Come where sweet fragrance fills the air . . .
BASSES:	Sweet

 sum-

 mer

 air.

Thomas Moore was another friend of those days, although I knew only the poems set to music that appeared in our high school song-book. Three of them, "Oft in the Stilly Night," "There's Music in the Air," and "A Canadian Boat-Song," are as intimately connected with Iowa as though I had written them; in fact, it seemed at times that I must have written them. "Oft in the stilly night" . . . after the lapse of forty years this line calls up a picture of my Hill. To this day I love "stilly night" far better than "still night" or "quiet night"; it reaches farther and implies more. There is no such thing as a still night except, perhaps, in the Far North in the dead of winter, and even there one hears the occasional sharp crack of frost and both sees and hears the awe-inspiring music of the Northern Lights. It was never a still night on my Hill. I heard the quavering stilly music of frogs along the river below and the songs of the whippoorwills in the woodland bordering it; the faint hum in so many different keys of night-flying insects. A stilly night is one when silence is made the deeper by such Midsummer Night's Dream music.

I do not mean to give the impression that I did nothing but read verse and attempt to write it during my middle teens. My daily life was like that of the average boy. As permanent reminders of the period I have four bulged knuckles on the fingers of my right hand, mementos of futile but persistent efforts to become an expert catcher behind home plate. The night rides on Number Six continued, and there were longer daylight journeys on freights, both east and west. Parents of those days should have known the value to boys of this kind of education, that "riding the rods" was not as hazardous as it seemed to be, and that a summer's-day journey through beautiful pastoral country viewed from the open door of an empty boxcar, the pupils sitting there swinging their legs as the varying landscapes flowed by, was worth a month of geography lessons. But parents are often deficient in understanding a boy's point of view, and ours were bound to note absences, sometimes overnight because, in our love of travel, we journeyed too far. Furthermore, the great C.R.I. & P.

Railroad System itself took notice of the fact, reported by various train officials, that three boys from a small town in central Iowa had become confirmed pilot jumpers and riders of night trains. A letter was received by "The Mayor, Colfax, Iowa," reporting the matter. The identity of the boys was discovered and reported, in turn, to the parents; and there was an end to those wonderful journeys.

My friend, Elmer Black, had taken no part in the railway journeys because he lived on a farm north of town; but now we began to make other journeys together, including voyages down the Skunk River. The first was made in a flat-bottomed rowboat. Being inland born and ignorant of the boatbuilding craft, neither of us knew the value of lightness in construction; and our boat, although it drew little water, was as heavy as though made of cement. When it was finished we were so eager to be off that we started before the paint was dry. The Skunk empties into the Mississippi in the southeastern corner of the state a little above Fort Madison. Our hoped-for destination was an island in the Mississippi below Hannibal, Missouri; but at Brighton, Iowa, we had to give up. We had dragged our rowboat a distance of almost halfway across the state. The summer chanced to be an unusually dry one and by the time we reached Brighton what water was left would scarcely have floated a twig.

Later Elmer built a small launch from blueprints of the Brooks boatbuilding plans for boys; it was equipped with a 2½-horsepower engine. Knowing the fickleness of the Skunk in summer as to depth of water, our second voyage was down the Des Moines River, and our destination, New Orleans. This time we reached the Mississippi and had the unforgettable thrill of visiting Huck Finn's island; but at St. Louis our funds gave out; and so, alas! home once more, hoofing it and sleeping in the fields at night, crossing our old friend, the Skunk, on several occasions by means of wagon bridges.

In those days the Skunk was a river, or at least a creek. It wandered in great loops and bends, often returning upon itself as though enamored of such beautiful, bird-frequented country and reluctant

to leave it. In later years, when monstrous ditchers and dredgers began improving the country according to their engineers' ideas of what country should be, our meandering little river became a ditch, and those who made it so convinced everyone that a straight line is the shortest distance between two points. Much land was redeemed, temporarily, at least. But on various occasions since, I have stood on the banks of "New Ditch," the modern name for the sleepy old Checaqua, watching the swift current foaming Mississippi-ward, carrying with it hundreds of thousands of tons of rich topsoil. My belief is that Mother Earth knows best how her rivers should flow.

iii. The Eighth Wonder

ON THE NIGHT of June 15, 1904, Elmer Black and I, with our classmates, took part in the graduation exercises of the Colfax High School. I had written my Commencement oration on "The Nineteenth Century: The Eighth Wonder of the World," and a fragment of the opening sentence, "One hundred years ago the morning broke . . ." kept repeating itself like the words on a worn phonograph record with the needle stuck in a groove.

The Methodist church was packed. Elmer Black and I sat with our classmates on the flower-banked platform; our parents were seated a dozen rows back, and on their faces was the expression of worried hopefulness common to the parents of high school graduates upon such occasions. I looked anxiously around the church for my brother, Harvey, but he was nowhere to be seen. I felt easier after that.

I heard vaguely the Reverend Popplewell's Invocation. It was an earnest appeal for blessing upon "these young people just at the threshold of life, and now going out into the world." In those days very few high school graduates went on to college. Commencement meant just that: the period of formal education was now behind them.

My ordeal was slowly approaching. Bessie Wood's violin solo — "Czardas" — gave tremulous voice to the feeling of apprehension of the next-but-one on the program; and Hazel Swihart's recitation, "Modern Lady with the Lamp," lighted the way inexorably toward me and the Eighth Wonder. My oration had nothing to do with the

wonders of invention or mechanical achievement during the century; I was to speak of the growth of tolerance, whether religious, racial, or national, of the new birth of freedom during the century, and development in the arts and sciences (outside the mechanical), with special reference to the art of poetry. It was rather a large assignment for a seventeen-year-old and a ten-minute oration; but I felt that I had covered the field pretty thoroughly if only I could remember the words I'd covered it with.

Hazel Swihart was again in her seat, having sustained the record, unbroken so far by the members of the Class of 1904, for the ease and assurance with which the orations had been delivered. Mr. Mischler, our high school superintendent, rose once more and adjusted his spectacles.

"The next oration is by Norman Hall. His subject is, 'The Eighth Wonder of the World: The Nineteenth Century.'"

As I stepped forward to speak I saw my brother, Harvey, sitting in the front row of pews directly below me. Harvey was familiar with all the works of the woodshed poet that had appeared on the walls of the barn and woodshed and had often quoted them for his own purposes, in the presence of other boys. I had given him two or three bloody noses for this brotherly devotion, and Harvey had treasured up the memory of these affronts, knowing that his day would come. And now, at last, it had. Our mother had promised me that Harvey would be in one of the seats farthest from the platform where I would not be able to see him; nor had I seen him all through the program until just before I rose to orate. How he had managed to sneak up to the first row just before my turn came was more than I could guess, and I had no time for guessing at the moment.

He had a command of facial expression that was, truly, implike. He neither smiled nor giggled, but looked up at me with an innocent air of feigned interest that would have fussed a wooden image. As I stood there, appalled at the sight of him, his lips moved, and I knew

that he was forming the words: "Look to the Northward, Stranger." He then crossed his arms and waited with an air of grave expectancy.

"One hundred years ago the morning broke, and in the light of a dawning era, the remnants of once-mighty hosts: Ignorance, Bigotry and Superstition, were seen scattering in full retreat toward the Night of the Past."

Do what I would, I was forced to glance again at Harvey. He waited with the same air of blandly grave expectancy as though he were saying: "Yes? . . . And then?"

Not one of my classmates had faltered. I had to be the first. The silence in the church was beyond all silence. For a moment my mind was blank; but thought of the shame it would be to go down in defeat before this imp of a kid brother aroused me to a truly heroic effort. I was saved by the sight of Mr. Logston, janitor of the church, whom I saw standing in the rear of the auditorium. I began again, and by keeping my eyes fixed upon him I brought the nineteenth century to a triumphant conclusion.

I had a wonderful revenge upon my brother Harvey. As a graduation gift my father presented me with a week's visit at the St. Louis Exposition, and Elmer Black received the same gift from his father. My brother was so miserable at not being permitted to come with us that I refrained from gloating over him; but a slight return for the moment of agony he had caused me was, certainly, called for.

The following morning as I came up from the barn, Harvey was standing on the back porch, looking more than glum. I grinned, but he made no response. At the kitchen door I turned to favor him with a variation on a theme which came to mind while I was milking Hattie, our cow:

> Look to the northward, Harvey!
> The dear old barn is there.
> All next week you can do my chores
> While I am at the Fair.

At Des Moines Elmer Black and I boarded a Minneapolis & St. Louis train St. Louis bound. We sat in a day coach, our grips on the rack overhead, with an abundance of literature concerning the Fair on the seats beside us: maps of the Exposition grounds, folders showing the separate buildings and the exhibits within them; splendid panoramic views of the Fair as a whole, centered around the main attraction, to me, at least — the beautiful lagoon with its ornamental bridges and groups of statuary, bordered with lawns and promenades; and on the lagoon, gondolas floating above their mirrored reflections, or being propelled smoothly along by gondoliers who actually came from Venice.

The joy of anticipation was increased by reading, while en route to the Fair, of the wonders we were to see. The wheels of our day coach clicked over the rails in perfect cadence with:

> When Louie came home to the flat,
> He hung up his coat and his hat.
> He looked all around but no wifie he found
> And he wondered where Flossie was at.

No need to tell *us* where Flossie was at, or the wording of the message she had left on the table for her husband:

> Meet me in St. Louis, Louie,
> Meet me at the Fair . . .

For memory stirrers, what can compare with popular songs? I have only to hum this one, soundlessly, and the St. Louis Exposition is still open and thronged with visitors, among them two entranced members of the 1904 graduating class of the Colfax High School.

Elmer and I saw everything together; I even stayed with him through miles and hours of wandering past machinery exhibits. Thanks to Elmer's keen interest not one was missed, but the only one I remember with any vividness was that of steam-locomotive engines. I had an inborn distrust of machines, but not of this kind. They

were not machines to me but superb, humanized landships plying along the great Stream of Travel that passed through our home town; as beautiful to me as clipper ships were to the boys of the Atlantic seaboard during the eighteen-fifties and sixties, or Mississippi River steamboats to the youngsters of Mark Twain's day.

Of the exhibits in the Hall of Industry, I think it was called, I best remember a bubble fountain displayed by some soap manufacturer. Millions of bubbles cascaded down sloping walls of glass, through shafts of colored lights. It was pretty, but at the same time, a disappointment; there were too many signs calling attention to the kind of soap from which the bubbles were made. Furthermore, a soap bubble, a single one, is a beautiful thing, a symbol of perfection, and is not to be improved upon by multiplying the number.

The spectacle at the Fair never to be forgotten was that of the lagoon at night, reflecting the light of thousands of lamps, the Venetian gondolas silhouetted against it. Every night Elmer and I sat by the lagoon listening to the songs of the gondoliers, to the accompaniment of guitars and mandolins: "O Sole Mio," "Santa Lucia," the "Miserere" from *Il Trovatore*; we heard them for the first time at the Fair.

Back home we were both members of the Symphony Mandolin Club. We were first mandolins, Hugh Dotson, second, and Dale Hurst, our director, played the guitar. We were called upon to play at various local entertainments: church suppers, Masonic and Odd Fellows' banquets, and the like, and sometimes we gave concerts on our own account. But these were all indoors, under unromantic circumstances. I suggested to Elmer that when we returned home we should give a concert like those we were hearing nightly on the lagoon. The still water of Horseshoe Bend where the wagon bridge north of town crossed the Skunk River could be our lagoon, and a ten-cent admission fee would cover the cost of decorating the bridge with Japanese lanterns. We still had our Colfax-to-Brighton rowboat and that, too, we would decorate with greenery and colored lanterns. It was large enough to contain the four members of the club, with a

fifth occupant to row us over the mirrorlike water of Horseshoe Bend on either side of the bridge where the audience would be leaning over the railing while we gave a complete concert of instrumental and vocal numbers, the latter to be sung by a male quartet consisting of the Davis cousins and the Banks brothers in an accompanying boat. Elmer was quietly noncommittal. He was not romantically inclined, and doubted whether there would be water enough in the river by the time we got home. He admitted, however, that the plan was worth considering.

For Elmer, the week at the Fair was one of the greatest value. He had a practical mind, and I could all but see it expanding under the stimulus received at the Exposition. He collected so many folders and pamphlets given out at the exhibits in Machinery Hall that he had to buy a canvas suitcase to contain them. I brought home some souvenirs for the family and three copies of a book of popular American songs. These were for the Symphony Mandolin Club with the music arranged for first and second mandolins and guitar. I also found similar arrangements for "O Sole Mio" and the "Miserere." In the book of American songs were "Mid the Green Fields of Virginia," "On the Banks of the Wabash," "My Little Georgia Rose," "Goodbye, Dolly Grey," and others of the kind, full of the wistful spirit of the eighteen-nineties.

I returned from the Fair the same dreamy, callow, unawakened youth I had been the week before, and from the moment of arriving at home the feeling of melancholy deepened. The transition from the lagoons and gondolas of the Exposition to the commonplace sights of Colfax had been too sudden. The shock would have been less severe if the hoped-for concert on the river by the Symphony Mandolin Club had been carried through; but the other members of the Club were lukewarm about it. They did not actually refuse to consider it, but I was not able to prod them to action; then the river fell so low that Horseshoe Bend was no more than a mud flat with a few stagnant puddles scattered over it.

I resumed without enthusiasm my customary labors at the clothing

store, and grim dogged effort helped me to conquer some of my diffidence, so that customers began to accept me as a good enough salesman. Saturday night was band-concert night and all the stores were open on that evening until ten thirty. The Colfax Cornet Band was a first-class organization, and formerly I had deeply enjoyed their concerts. But now, as I listened from the clothing store, shoehorn in hand, slipping farmers' feet into $3.50 W. L. Douglas shoes, I would see the great lagoon at the Fair, hear the "Miserere" as sung by the gondoliers, and fall to dreaming sitting on the shoe stool. But even while dreaming I could say, "Stand up in it and see how it feels."

The wooded Hill was now more than ever my refuge. I "brooded" there on many a Sunday afternoon and many a moonlight night. A curious thing happened at this time. Burns, whom I had been reading with such pleasure and profit only a short time before, had done me a great deal of good. His sturdy independence had brought me to the realization that I had veins of it in my own nature. I had been fumbling my way through and trying to emerge from the inner chrysalis of the adolescent period. Then came the week at the Fair, and as a result of it I became more dreamily adolescent than ever. Longfellow in his most sentimental moods now became my favorite companion. This was a prolific period in composition. All of the poems may be summed up in the following, which was written under the linden tree at the top of the Hill:

> When I am dead, here would I be interred
> To sleep in peace, upon this lonely hill;
> Where, from afar, the peewee's call is heard
> As now I hear it, and the whippoorwill,
> Deep in the moonlit glades that lie below,
> Repeats his changeless song of endless woe.

I took a kind of pride in keeping "the burden laid upon me" of I didn't know what, out of public view. Sometimes I forgot to remember that I was bearing it and became quite cheerful.

iv. The Choice

ONE DAY when the Davis boys had gone to lunch and I was alone in the store, Mr. Gould, our boss, came in. As I have mentioned, his home was in another part of the state. Now, having retired from the cattle business, he spent much of his time visiting the towns where he had bought clothing or grocery stores. He greatly enjoyed coming to Colfax, particularly in the wintertime, and would sit in the rear of the store talking with farmers and cattle feeders who made the place a kind of club. He stopped at the Mason House and his visits were anywhere from two to six weeks long.

Whenever I think of this particular visit I think of fleece-lined underwear, for I was unpacking a case of this merchandise when Mr. Gould came in. It was a stormy February day in 1906 and I had a good fire going in the furnace. Mr. Gould took a chair by the hot-air register and questioned me in his kindly way about one thing and another while I went on with my work. Then he picked up the morning Des Moines paper and laid it on his lap while he took a cigar from his vest pocket. I enjoyed watching him light a cigar, he did it with such deliberation, to prolong the anticipatory pleasure. He would lean back, worm his big brown hand into his trousers pocket for his penknife; then with the greatest care he would clip off the end of the cigar and replace the penknife. He made a rite of lighting the cigar and the glow of deep sensual satisfaction as he did so was that of a man who knows how to make the most of the

small amenities of life. In these days when I see editors, literary agents, motion-picture directors or business executives of whatever kind lighting cigarettes while answering several sets of telephones, taking a drag or two, pressing out the fire in an ash tray, then immediately lighting another until the tray is heaped with mangled cigarettes, I think of Mr. Gould and his way of smoking. It is an indication of the vast change in the tempo of life from the early nineteen-hundreds to the nineteen-fifties. His was pure enjoyment; theirs is an unconscious display of tension and nervous strain.

He now read for half an hour or so. I was marking price tags for the underwear when he laid the paper aside.

"Norman, knock off for a bit," he said. "Want to have a little talk with you. Come over here and sit down."

I took a chair on the opposite side of the register, waiting while he gazed meditatively at his cigar as though estimating the amount of enjoyment there was left in it.

"Been lookin' around up north," he said. "Met a man in Belle Fourche, South Dakota. He's sellin' out his clothing business and goin' to California. Good many Iowa people doin' the same thing. Lot of sissies! Can't stand Iowa winters."

He spat disgustedly down the hot-air register and the sizzling sound that followed seemed to indicate the frying of the renegades who would choose California as a place to live.

"What'll they do out in California — sit around in the sun all day, whittlin' sticks? They're no good, that kind of people. Don't belong in Iowa; didn't belong in the first place. No pioneer blood in *their* veins. Good riddance if they *all* go to California. Get 'em cleared out and we'll have Iowa the way it ought to be."

The California trek of Iowans, then just beginning, filled Mr. Gould with contempt. He died before the great migration was under way. I wonder what he would have thought of the huge annual picnics of later years, held in the vicinity of Long Beach, where the migrants gather by counties to talk of "home," to sing:

We're from I — o — way, I — o — way,
That's where the tall corn grows!

But I myself am one of those exiles, although it was not to escape
Iowa winters that I became one, and I did not follow my fellow
Iowans to Long Beach.

I was puzzled as to why Mr. Gould should be discussing this mat-
ter with me when he broke off and was silent for a moment. Then
he added: "I bought that clothing store in Belle Fourche. How would
you like to run it for me?"

I was so taken aback that, for a moment, I could only stare at him.
I was not yet eighteen, and the prospect of going to another town
in another state, not as a clerk, but to manage a clothing store, out-
topped any that I could have dreamed for myself.

"John and Billy tell me you're getting to be a good clothing sales-
man," he said. "I like to give a young fellow a start in life, and here's
yours if you want it."

He went on to say that the former proprietor of the clothing store
had agreed to manage it for him until the next autumn when he
planned to leave for the West Coast. I would take over then and
have the intervening months for further training with the Davis boys.

"I'm not so young as I was, Norman. Before long I'll want to take
things easier; not have so many irons in the fire. Well, if you dig in
and work hard and save your money, you'll end up by being pro-
prietor of that store. I'll sell out to you on terms you'll be able to
meet without any trouble. You'll be wanting to get married a few
years from now; and there you'll be, settled for life, with a nice
thrivin' business in a fine little town. How does that strike you as an
end to work toward?"

At first I was so dazzled by the offer that I found it hard to express
my gratitude to Mr. Gould; but as the weeks passed I began to feel
troubled, uneasy, about this end to work toward. It seemed too near
the beginning, and "settled for life" perturbed rather than comforted

me. The phrase kept repeating itself like the tolling of a bell. My father, the Davis boys, and other friends thought this a splendid opportunity and took it for granted that I would accept. As I have said, it was not customary in those days, at least, in Colfax, for a young man to go on to college. The Invocation of the Reverend Popplewell at our high school Commencement exercises expressed the general attitude as to where schooling should end. Thereafter, education was a part of experience, earning a living, and so I had thought of it.

In a notebook of those days I find this entry: "Growth in poetic power. Compare 'Look to the Northward, Stranger,' with 'The Peewee's Call.'" The woodshed poet was, evidently, trying to convince his old enemy, Diffidence, that if he had faith in his wings and continued to use them, they would carry him farther than to Belle Fourche, South Dakota. I realized that I was approaching a crossroad and would be standing there in the autumn, regarding crossed signboards: one pointing toward Belle Fourche, and the other . . . I didn't know where. One thing was certain: if I was to hold to the Muse it was time to seek some unbiased opinions: the thing to do was to seek confirmation of my hopes from the editors of magazines.

One morning I "rode the blind" of the local westbound passenger train (just to keep my hand in) to Des Moines, and spent a full day in the public library reading the poetry in the magazines received there. I returned home with the addresses of the *Atlantic Monthly*, *Harper's Magazine*, and half a dozen more.

From that time on I lived a double life. By day I was a clothing salesman; by night a would-be poetry salesman. In the latter occupation I received such courteous rebuffs that I was encouraged rather than disheartened. The letters received were all of the same kind:

> The Editor regrets that your manuscript is not available for publication at this time. He thanks you for your courtesy in offering it.

But what greater thrill, save an acceptance of a manuscript, could a woodshed poet have than that which comes with the taking-out, handling and reading of these printed cards that actually came from an editor's office and which may have been slipped into the envelopes by his very hands? The returned manuscript gains both dignity and merit because it has been read, he hopes, by the editor himself.

Although the unbiased editorial opinions were all of a kind, I was not discouraged. With the coming of spring I went as usual to my Hill. The hepaticas were in glorious abundance. Their perfume alone convinced me that life was too precious to be spent in a clothing store, and that a young man who made the mistake of underestimating its value would have only himself to blame for the disillusionment of later years. I considered more and more seriously the prospect of going to college, and that meant Grinnell and no other place.

> A band of brothers from old Grinnell,
> We march along tonight,
> Two — by — two, our arms linked firm and tight. . . .

It is strange how a small event will be seized by a youngster and molded to his unconscious needs. I have long since realized the importance of the part the chance meeting with that band of brothers played in shaping the course of my life. The fragrance of hepaticas, of the woods in early spring, influenced my decision to go to college, but it might not have been Grinnell except for the night rides on Number Six, and the Glee Club Marching Song heard at just the right moment. It gave me an ideal conception of comradeship that I have never lost.

Early in the summer I wrote to the Registrar's office in Grinnell for information about college entrance requirements. A week or two later a young man several years my senior came into the store. I did not know him, but supposing him a chance customer passing through Colfax, I went forward to wait on him.

"Are you Norman Hall?" he asked. He then introduced himself.

He was Benjamin Dehaan, of Pella, Iowa, a member of the senior class (1906) at Grinnell, and had been asked to call in response to my letter to the Registrar. He explained that he was employed by the College during the summer vacation to call upon prospective students. The last thing I had expected was a personal call from anyone connected with the College. The experience taught me the importance of such calls by upperclassman upon high school boys, particularly those affected with shyness. I had scores of questions to ask, about entrance requirements, curricula, student life in general. Ben Dehaan answered them all. He did not try to "sell" me the college — to use the expression that was to become current years later; I could not have bought it even if he had. But his love for Grinnell was apparent in all that he said, and confirmed my own feeling about it, gained from my night prowls over the campus with my two friends, or as we lay in the grass, keeping our ears cocked all the while for the whistle of a westbound freight.

That was a memorable meeting, and "the burden laid upon me" of being settled for life dropped from my spirit somewhere between the Gould clothing store and the C.R.I. & P. depot as I accompanied Ben Dehaan to his train. He stood on the car platform during the two minutes the train was at the station, answering further questions; then as it started to move he gave me a friendly nod. "So long," he said. "Hope we'll see you in the fall."

v. The Potato Peeler

ON A MORNING in late September of 1906 I boarded the train for Grinnell with the feeling of having burned my bridges behind me. I was in a sober mood and my father's parting words kept repeating themselves in my mind. He was disappointed that I had not accepted Mr. Gould's offer but made no attempt to dissuade me from going to college. As we stood on the station platform watching the train coming down the Mitchellville grade, he said: "Well, son, I hope you are doing the right thing. Only time can tell."

The train was filled with students, some for Grinnell, but most of them for the state university at Iowa City. Across the aisle from me sat a young fellow who looked as though he, too, were going to college for the first time. We glanced at each other in a speculative way and presently he crossed over to sit with me.

"Where to — Grinnell?" he asked.

The fact that we were both bound there as freshmen made an immediate bond between us, and this was strengthened when we learned that we were in the same fix with respect to money. He came from Westside, Iowa, and his name was Chester C. Davis. Chester was on the first leg of a journey that was to take him to Washington, D.C., a generation later as head of the AAA in President Roosevelt's administration, and later to St. Louis where he is now president of the Federal Reserve Bank.

On that September day Chester's reserves in cash were like my own — a bit scanty. Each of us had enough money to pay our tuition,

$65, with two or three spare five-dollar bills for immediate expenses. Chester's heart was as light as his pocketbook; it was reassuring to meet a man so completely certain of the rightness of going to college, and my own small misgivings melted away before we had talked five minutes.

We were both naturally concerned about the prospects of getting immediate employment. As it proved we need not have worried. There was a Student Reception Committee on the station platform; from this we were passed on to the Student Employment Committee, and that same afternoon I was raking autumn leaves from the lawn of a house on Park Street, bordering the west side of the campus and within a block of the place where I had first heard the Glee Club Marching Song. I found enough work doing odd jobs to pay my room rent — $3.50 per week — and another job peeling potatoes at the Grinnell Kitchen, a rather small restaurant in town, provided board. Chester, with more foresight and enterprise, started a student laundry agency and had the further resource of being made janitor of one of the College buildings.

In those days Grinnell had no dormitories except Mears Cottage, a small one which housed some of the women. Nine-tenths of the students roomed in private houses and organized their own boarding-clubs. Chester and I roomed at the Chapin house. At the head of our stairs lived Charles E. Payne, from Terre Haute, Indiana, who had just come to Grinnell as an instructor in history; later he became a full professor and head of the department. Mr. Payne was as tough and fine in spirit as he was frail of body. He had lost both legs above the knee in a train accident and walked with artificial limbs. The expression on his face in repose was one of quiet melancholy. I never heard him laugh, and when he smiled, the effect was like that of a gleam of late autumn sunshine. He had a genius for friendship. I doubt whether any member of the faculty had more devoted friends among the students, particularly the men, than Professor Payne. He was quiet and reserved in manner and it was some time before

I ventured more than a polite "Good morning" when I met him on the stairway slowly clumping his way up or down. My first real meeting with him took place some months later.

On Friday evenings two of Mr. Payne's faculty friends, Professor Smiley, head of the Latin Department, and J. P. Ryan, Professor of Public Speaking, often came to his room to spend the evening in talk or in reading aloud. While passing the door I discovered that they often read poetry together, and presently, instead of passing I would halt to listen. One evening while eavesdropping in this way, I heard Professor Ryan read the following lines. He had a clear resonant voice that easily pierced the thin door paneling.

> Like some young cypress, tall, and dark, and straight,
> Which in a queen's secluded garden throws
> Its slight dark shadow on the moonlit turf,
> By midnight, to a bubbling fountain's sound —
> So slender Sohrab seemed, so softly reared.

The last line was the only one I remembered. At first I thought it very beautiful; then it rather annoyed me because I was not able to forget it. When meeting Professor Payne on the stairway I was tempted to ask about it, but I would have to begin by apologizing for eavesdropping and the hallway was not an appropriate place. Finally I summoned up the courage to knock at his door.

"Come in!" he called. In I went and he gave me a friendly welcome that broke the ice between us once and for all. After a little preliminary talk I confessed and apologized as planned. Mr. Payne smiled in his autumnal fashion and said, "You're forgiven if you promise not to do it any more. We don't always read poetry. Sometimes we talk." I assured him that I had listened only when they were reading. Then I quoted the remembered line and asked who wrote it.

"It's from Matthew Arnold's 'Sohrab and Rustum,' " he replied. "I

wonder that such a soapy line should have stuck in your mind. You're not familiar with Arnold's poetry?"

He indicated where the volume stood on one of the bookshelves and asked me to hand it to him.

"You may be a bit young to read Arnold just now," he said, "but the time will come when you will read no one else, for some months at least." He opened the volume and glanced through the pages for a moment or two. "I'm going to try to put you off him for the present," he added, with another faint smile. "Perhaps I had better say, to prepare you for the Arnold least worth reading: 'Sohrab and Rustum' is a good example of Arnold fulfilling his destiny as a poet; it's the kind of thing he felt that he should write. Later, you will see for yourself the poems he truly wanted to write; you can pick them out without a moment's hesitation."

Mr. Payne then questioned me about the poetry I had read. He could not have helped remarking how limited my knowledge of it was but he gave no indication of this; on the contrary, he listened with interest and attention so encouraging to a young man. Glancing at my watch I was amazed to find that my ten-minute visit had lengthened to nearly an hour. I sprang from my chair and Mr. Payne rose slowly from his, going with me to the door. He spoke apologetically of his criticism of Arnold. "When I think of the pleasure he has given me . . . Nevertheless, it's a mistake to let your bump of veneration for whatever poet get oversized. Be most wary when one of them tries to convince you that he is writing at the top of his form."

But there are certain bumps of veneration acquired in youth that one never loses, but cherishes and protects from all adverse criticism. One of mine is for Tennyson, including the *Idylls of the King*. If I could have one day of my reading life over again, I think I would choose that upon which I first read —

> So all day long the noise of battle rolled
> Among the mountains by the winter sea

and on to the end. This happened the week before we were to discuss the poem in class. From that evening on I was lost to the world of reality.

Strangely enough, "The Passing of Arthur" is associated with the Grinnell Kitchen, the eating house where I earned my board by peeling potatoes. The proprietor, who was also the cook, was a big potbellied man with close-set eyes, and always with two or three days' growth of beard on his greasy face. My kitchen companion was a dried-up little woman around sixty, with no teeth and no voice. When she spoke it was in a whisper and she was scared stiff of our boss. Her name was Abbie.

It was all but incredible to me that anyone could peel potatoes so fast; she could do four to my one. What annoyed me was to have the proprietor stand by, with his big greasy hands on his hips, watching me at work with Abbie; naturally, that did not make me any more efficient. Steaks and French fried potatoes were the specialty of the house. Luckily, the boss was so busy at the stove most of the time that he could not watch over me; nevertheless, he managed to give me a few words of encouragement now and then.

Sitting on a stool beside Abbie, each of us with two pans, one for unpeeled and one for peeled potatoes, I would be working with grim earnestness and suddenly become aware that the boss was standing between and behind us. I wondered why he didn't have us peel into the same pan and decided that he enjoyed shaming me, a college student, so much slower than Abbie, who had never had even a grammar school education. He would yell to the assistant cook to watch his steak while he, in turn, was watching me but saying not a word for a moment. Then he would remark, as though to the world at large, and with an inflection of voice indicating amazement and unbelief: "I'll be son-of-a-bitched!" Then he would hasten back to the stove.

I could not flatter myself that this was an expression of astonishment at my peeling speed, and Abbie had worked there so long that

her skill could be taken for granted. My conclusion was that the comment was critical and referred to my lack of virtuosity with a paring knife. Abbie had a good heart. She wanted to help me and would try to slow down a little when the boss was standing by. But she couldn't; she had been peeling vegetables most of her life. Every now and then when she dared risk it, three or four peeled potatoes would come flying into my pan. Knowing her terror of the boss I was able to value this act of courage and kindliness as it deserved to be valued. But I had nothing but contempt for the boss, and would toss Abbie's gifts back into her pan, sometimes with one or two of my own, and heaven knows, I had none to spare. Abbie would glance at me so pleadingly that, sometimes, I pretended not to notice her contributions to my pan.

Another implied criticism — for the boss never spoke to me direct — was of this kind: He would take up a handful of Abbie's peelings, as thin as wood shavings, and a handful of mine, more potato than peeling, and examine them, I suppose, for I never glanced up to see just what he did. But a moment later the two kinds, both the fat and the lean, would come spilling slowly down into my pan, and with the usual comment.

The strange thing was his never cursing me out, direct. He was the kind of man you would expect to say: "You're fired! Get the hell out of here!" I would have greatly preferred the direct criticism, but it never came. The only way I could make sense of such odd behavior was that he enjoyed having a college student to haze in this manner. I expected every day to be my last, but weeks passed, then months, and I was still peeling. I came to have a kind of left-handed liking for my boss. It was as though there were an unspoken compact between us. He was to be son-of-a-bitched without protest on my part, and in return, I was to keep my job as long as the peeled potatoes were still big enough for French fries.

In time I became a fairly good potato peeler, leaving more and more of the potato intact. Abbie was a first-rate teacher, and instead

of four to one it became two to one. I might not have been fired at all except for my reading of "The Passing of Arthur." During the week that followed, although I went as usual to the Kitchen, I was not really there, but in —

> the place of tombs,
> Where lay the mighty bones of ancient men,
> Old knights, and over them the sea-wind sang
> Shrill, chill, with flakes of foam. . . .

I could not explain to Boss Kay the reason for my absent-mindedness, and so ended my potato-peeling job. It was some satisfaction to know that I lasted longer at the Kitchen than two other students, my time counted against the sum of theirs. But it is only fair to say that they fired themselves. They couldn't, or wouldn't, take what I took.

In the year 1853, a New Englander from New Haven, Vermont, was considering his future, how it should be spent, and where. He consulted Horace Greeley, editor of the New York *Tribune,* about the matter, and Greeley said: "Go West, young man, go West. There is health in that country, and room, away from our crowds of idlers and imbeciles." And west the young man went, as far as the State of Iowa, formed from the Iowa Territory only eight years earlier. His name was Josiah B. Grinnell, and in 1854, with several associates he founded the little settlement that was to bear his name. Meanwhile, six years earlier, twelve young men known as the Iowa Band, graduates of Andover Theological Seminary, had established Iowa College in the frontier settlement of Davenport. It was moved to Grinnell in 1859.

Only forty-seven years lay between that event and the arrival at Grinnell, in the autumn of 1906, of the Class of 1910. One's sense of far-away-and-long-ago is so deeply affected by the character of the changes that take place within one's own lifetime, that, to me, the founding of Grinnell College and its removal from Davenport to

the town of Grinnell seem events of remote antiquity. I can scarcely believe that Grinnell students of my day should have been so close to the era of the pioneers in Iowa.

The streams of migration flowing westward through Iowa Territory during the thirties and forties of the last century came largely from New England. Grinnell's founding fathers were of that stock, and their first concern, after getting temporary roofs over their heads, was to establish a college. The families attracted by it gave the town a character of its own, as I realized from the day when I first went there as a student. In passing back and forth between Grinnell and my home town I was aware of the difference in climate between the two places; of the stimulating nature of the Grinnell atmosphere as compared with that only thirty-two miles farther west. The one was ozone, the other just common air.

Looking back to those days I now see how large a part of the benefits I received from college came indirectly, merely by my being exposed to such influences as that of Professor George L. Pierce, head of the School of Music. It was thanks largely to him that our lives were so filled with music, absorbed unconsciously, through the pores of our skin, so to speak. Most of us came from small towns where our knowledge of music had been confined to school songs, church and Sunday school hymns, and Saturday night band concerts. I say nothing in disparagement of such music, for I am still fond of it — just as I am of barbershop quartets, developed in Iowa to their highest perfection; but young men and women, often without realizing the fact, are ready and eager to go on from there. At Grinnell I heard orchestral music for the first time. There was a college orchestra, directed by Professor Pierce, and a string quartet in which he played the cello; both gave concerts throughout the year, and I must by no means forget the pipe-organ music of Professors Scheve and Matlack, heard daily at chapel and the Sunday vesper service. The vesper service came at five in the afternoon, and I doubt whether, at any college in the U.S.A., a more beautiful one could have been heard.

Then, in the spring of every year was held the May Festival, when members of the Chicago or the Minnèapolis Symphony Orchestra visited the College for a series of concerts, and what these meant to the students of my day could not be measured in terms of words. It was at one of these, held in the open air on the south campus, that I first heard Mendelssohn's *Midsummer Night's Dream* music.

It was my new friend, Roy Ray Roberts, who suggested that we should enter the glee club tryouts. Although I loved singing in chorus with other men, it would not have occurred to me that I had a chance of becoming a member of the glee club. I have Roberts to thank for deciding to make the attempt with him. He had an excellent bass voice and bubbled over with self-confidence for the pair of us; and so we were among the thirty or more hopefuls who gathered in the chapel for the first tryout.

Professor Pierce, who directed the men's glee club, was of medium stature, quiet in speech, and his nose-glasses gave him an air of good will. I felt *en rapport* with him at once, and when my turn came to stand at the piano while he tried out the range of my voice, I "ah-ed" up and down the scale with a semblance, at least, of Roy Roberts' ease of manner. When Professor Pierce had thoroughly tested my range he glanced up with an encouraging smile. "A quite good second-tenor voice," he remarked to the other members of the club who were listening, grouped around the piano. Then came the test at sight-reading, and as the club librarian was passing out copies of the song we were to sing with the old members, I had the same feeling of panic as when, rising to orate on the Eighth Wonder, I saw my brother Harvey sitting in the row of pews directly in front of me. However, with Roy I survived the second and third tryouts and eventually I received a little formal note on glee club stationery which read:

Dear Mr. Hall: —

I am happy to inform you that you have been elected to fill one of the second-tenor vacancies on the glee club. Please re-

port for practice at the chapel on Friday afternoon at four-fifteen.

RALPH GARNER
Secretary

The members of the glee club came from all four classes, and owing to their close association I found here an epitome of the Band of Brothers I had so often dreamed of. Furthermore, the men's and the women's glee clubs made up the vesper choir, with the result that we were always present at the Sunday vesper service. This service was something to be looked forward to from week to week. I was not a devout young man, in the accepted meaning of the term. I did not belong to the College Y.M.C.A. and attended none of the Bible-study classes. But the vesper service seemed to me true spontaneous worship. I never had the least doubt of the sincerity of President Main, or Professor Emeritus L. F. Parker, or Professor Norris or Dr. Steiner, when one of them led the service. And how different were the hymns sung in chapel to those I had been accustomed to hear in the churches of my home town! All through boyhood I had heard such hymns as, "When the roll is called up Yonder," "At the Cross, at the Cross, where I first saw the Light," "Leaning on Jesus," and the like. Those sung at Grinnell were of a different order: "O, Love that wilt not let me go," "Dear Lord and Father of mankind," "O, Master let me walk with Thee," "By cool Siloam's shady rill," expressing, as I thought, the very spirit of worship, words and music written by men who were deeply reverent and sincere. Who could hear such hymns in youth and not be affected by them?

Gounod's *St. Cecilia Mass* was liked so well by the student body that two or three times yearly it took the place of the regular vesper service. I have never heard it since those days. Why the *Messe Solennelle*, as it is usually called, has never appeared in any of the libraries of music recorded for phonograph remains a mystery to me. There was a partial recording made by the Columbia Phonograph

Company, but so poorly done that it might better not have been recorded at all.

My second-tenor part in the glee club was exactly suited to my abilities. I enjoyed it with all my heart, particularly when, during the Christmas and spring vacations, we set out for the usual concert tours through Iowa and the adjoining states. The Grinnell College Glee Club had a deservedly high reputation throughout the Middle West, and, under the direction of Professor Pierce, this was further enhanced. We sang in small towns and large towns, and during the spring vacation of 1909 we made a tour as far as the Pacific Coast, giving concerts all the way along, both going and coming. But the greatest pleasure, to me at least, came when we sang in towns in our own part of the country. The concerts were usually given in churches always packed to the doors, with additional seats placed in the aisles. It was wonderful being able to assist in giving such evident pleasure to so many people. Belonging to the glee club was my heaven on earth at this time.

vi. The Bristol House

Having been fired as a potato peeler I had to find a new job without delay. Luckily, Mrs. Silver, who owned the Bristol House, gave me employment as one of her student waiters. Learning to be a waiter was a far easier task than mastering the art of potato peeling. My first duties at the Bristol House were to fill glasses with ice water and set one at each place, along with a pat of butter, as the guests entered the dining room; then to act as bus boy when they had finished their meals. I soon became expert at this job and could hoist on one hand a large tray stacked high with dirty dishes, kick my way through the swinging doors to the kitchen, and slide the dishes across the come-back table within easy reach of the claws of Grandma Ridder who presided there. From this job I soon graduated to waiting on table.

The Bristol House served excellent meals — nothing fancy, but good country fare of the first quality. Mrs. Silver did her own marketing and would have nothing but the best cuts of meat and the finest and freshest of fruits and vegetables. She was an extremely careful buyer, for quantity as well as quality; she made the closest possible estimates of her need for the day, bound that nothing should go to waste. And nothing ever did.

This brings me to mention of the "come-back table," as it was called, which the guests, of course, knew nothing about, and it was just as well they did not. It was a large zinc-covered table, and the come-backs spilled out on it were the remnants of food left in the

dishes. It was Grandma Ridder's duty to save them in case Mrs. Silver's careful buying made it necessary to serve such food again, which often happened.

Grandma Ridder, without any change in costume or personal appearance, might have played the part of one of the witches in *Macbeth*. Her teeth were gone save for a few fangs that failed to meet. Her hair was like a rat's nest; wet wisps of it hung down over her face, she peering through them as, with swift gathering gestures of her long sinewy arms, she swept in the soiled dishes spilled out on the table. Tin bowls to contain salvaged food were ranged alongside her: for peas, string beans, remnants of mashed potato, turnips, pumpkin and squash, for partly consumed pats of butter, and the like. As the dishes were emptied they were sent sliding along to Grandpa Ridder who stood at the end of the table, stacking them on trays to be carried to Black Alice and her assistant in the dishwashing department. At mealtimes, two, three, sometimes four, woeful-looking children, their ages ranging from around seven to fourteen, would enter the kitchen and stand along the wall behind the come-back table. They were the Ridder grandchildren and came there to be fed. In the midst of her labors Grandma Ridder would turn swiftly to stuff a handful of mashed potato into the mouth of the youngest, opened automatically to receive it. More often she would fill plates with leftovers: remnants of T-bone steaks, potatoes, turnips, morsels of pie — odds and ends of all kinds heaped together, and the children would wolf it up for themselves. Their bellies filled, they would quickly vanish. I never saw the parents of this brood.

Grandpa Ridder was an even stranger-looking person than his spouse. His face was of a yellowish tinge, the skin as smooth and unwrinkled as that of a child, and hairless save for his chin where tufts of beard, with arid patches between, grew to surprising length, as far down as his breastbone. These he looped up while at work and tied close under his chin with a piece of string. The top of his head was bald, but around the base of his skull was a fringe of sparse hair in

clumps, falling to his shoulders. He was afflicted with what may have been a form of palsy which kept his head shaking with a slow negative motion, as though it were set on a well-oiled pivot. His eyes were a pale watery blue, completely expressionless, making a strange contrast with the habitual vacant smile upon his face. Despite the palsy — if it was that — which affected only his head, he was quick of movement as Grandma Ridder herself. Plates, cups, saucers, side dishes slid toward him in an endless stream during the busy part of the meal, but he kept abreast of it, stacking the dishes swiftly and carrying them to Black Alice at the dishwashing sink.

Black Alice was, indeed, coal-black and proud of it. She was in her late twenties, strong as a horse, with the heartiest laugh and the whitest teeth that one could wish to hear and see. One would have said that washing dishes was sheer delight, she worked with such gusto, making a prodigious racket the while. She was full of gaiety and sang at her work, but on several widely separated occasions I saw her with her temper aroused; then she was a different person, like one of the Furies. Her armory was at hand, and when the dishes began to fly we were all forced to take cover, for her aim was as poor as the propelling force behind the dishes was great. I still hear the anxious, conciliatory voice of Jack Grant, the chief cook, calling: "Now, Alice . . . Now, Alice . . ." and that was as far as he would get. I don't remember that he was ever the cause of her rage, but his mild protests made him an immediate participant in the effects of it. Heavy "bird bath" side dishes would fly in his direction, crashing against the stove and the walls on either side. These bursts of temper were like midsummer electrical storms: quick to brew, dangerous while they lasted, but soon spending their fury. I remember one occasion when a waitress was knocked cold and several stitches had to be taken in her scalp, but for the most part nothing was damaged save the dishes.

For a student waiter the Bristol House was a college within a college, but not on a Congregational foundation. The regular dining-

room staff consisted of rather elderly girls whose ages ranged from the middle twenties to the early thirties. Throughout the week there were four of them, and from Saturdays to Mondays, two, sometimes three, more were added to the staff. I supposed that the extra Saturday-to-Monday waitresses were employed to take care of the influx of commercial travelers, always a quite noticeable one; in fact, the hotel was usually filled over the week ends. This was, indeed, the explanation of the matter, but not the whole of it. My friend, James Stronks, of the Class of 1909, who had been employed at the Bristol House the previous year, enlightened me as to the reason for the week-end increase of both traveling men and waitresses. This was shortly after I began my duties there.

"We are waiting on table in a bawdy house," he said, with a faint wry smile. His term was the one more commonly used in Iowa for such places, but I use "bawdy" because it seems, somehow, more refined. I was astonished, and with reason, for a more modest-seeming, decent set of elderly girls, insofar as their general behavior and their attitude toward us student waiters were concerned, could scarcely have been found. Their manners and their language would not have been considered objectionable in a Y.W.C.A.

"Do you suppose the College knows about this?" I asked.

Stronks shook his head. "Would they permit students to work here if they did?" he replied. "They have no idea of what goes on at the Bristol House. College professors are mere children in some respects. There's Professor Stoops, head of the Philosophy Department; Dr. Steiner, Professor of Applied Christianity; Professor Smiley, Ryan, Peck — a good half of the faculty often have meals at the Bristol House." He grinned as he added: "Not one of them has the least inkling of the dangers that we students, working here, are exposed to."

Fortunately, the dangers were triumphantly warded off by the exposed youths; or, I had better say, they never presented themselves. When the time came, we student waiters graduated *cum laude* from

the Bristol House, and I do not mean in the Casanovanic sense. The girls, all of whom were from six to a dozen years older than ourselves, might have been older sisters or maiden aunts, so exemplary was their behavior toward us. We were as safe from temptation as we would have been in church. But it does seem strange that the College should have been so ignorant of the dual nature of the Bristol House: a hotel by day, a bawdy house by night, particularly over the week ends.

Mrs. Silver, the proprietress, was a far more striking figure than my former employer, Boss Kay of the Kitchen. She may have been around sixty-five at this time, although I doubt that anyone could have guessed her age within a dozen years. Her face had the color of old parchment and was so crisscrossed with fine wrinkles as to be quite expressionless; but her eyes were as blue and cold as polar ice, and her smile had all the warmth of late afternoon sunlight on Siberian snows in the dead of winter. Her hair was snow-white and beautifully dressed, but later I discovered that this was a wig. On one memorable occasion I caught a glimpse of her without the hair, in her own apartment adjoining the lobby. Her head was bald as an egg and somewhat the shape of one. The picture of her that remains indelibly in mind is the one she presented at mealtime, seated at the cash register in the lobby as the guests came from the dining room. She was always immaculately dressed in gowns of heavy silk. She wore large diamond earrings, and her hands, covered with rings —

> trembled with diamond sparks
> Myriads of topaz lights and jacinth-work
> Of subtlest jewelry

as she turned the crank of the cash register. No music could have been sweeter to Mrs. Silver than the ringing of the register bell and the clink of silver falling into the various compartments of the drawer. As she gathered in the fifty-cent pieces from commercial travelers — townspeople and college folk were charged only thirty-five cents for

the same meals — I often wondered whether she felt any twinges of conscience as she thought of the come-back table.

It seemed to be an unwritten law in the kitchen that food remainders passing through Grandma Ridder's hands and on to Jack Grant to be reheated and served again, should go only to traveling men and other transients. Glad we student waiters were, for we could not have served leftovers to our professors and fellow students who often dined or supped at the Bristol House. Perhaps the girls had established the rule; their nocturnal adventures with traveling men may have been unpleasant ones save for the emoluments involved. However this may be, it was they who waited upon the traveling men, and there is no doubt that they took pleasure in serving them food that had passed through Grandma Ridder's hands. This was, of course, mostly vegetables; the only twice-appearing meat was that in hamburger steaks. We students waited upon townspeople and college folk, the transients only when so many came in at once that the girls could not take care of them all. When this happened, our services were grudgingly and scowlingly accepted by the commercial travelers. I took a kind of guilty glee in serving leftovers to some potbellied member of the fraternity who should have fasted for a week instead of adding to the fat of his huge paunch, the more so when one of them would glare at me in his chagrin at not having been waited on by one of the girls. Jack Grant had a gift for refurbishing come-backs; he could make them look as tasty and appetizing as when first served to an earlier, more fortunate guest. Big Belly, accepting his hard luck at being waited on by a student, would tuck the corner of his napkin beneath his triple chin, his glance roving gluttonously over the food the while. Then, seizing his knife and fork, he would set to as though he had not eaten for days. And I would say, in the silence of thought: "Mister, if you could have seen those vegetables ten minutes ago I'm afraid that your appetite would suffer for it."

One Saturday, toward the end of the luncheon hour, I reluctantly

served such a meal to a man who sat alone at a table by one of the windows. He was a stranger, but had none of the overstuffed appearance of the usual commercial traveler, and when I went to take his order, instead of scowling he greeted me very pleasantly. I regretted the necessity of bringing him secondhand food, but the dining room had been crowded and all of the fresh supplies had run out. Fortunately, he ate abstractedly, reading the while from a book propped open before him. It was a book of verse, which aroused my immediate interest. I wanted to know whose poetry it was, but I couldn't very well stand behind him, peering over his shoulder.

My tour of duty on Saturdays, when I had no classes, came during the latter half of the luncheon hour. The stranger's attention was so deeply engaged in his book that he read on until the other guests had left the dining room and the doors were closed. At last, glancing up, he beckoned to me and ordered his dessert. I cleared away the other dishes and brought him a piece of apple pie, cheese, and coffee, happily quite fresh.

When he had finished he placed a quarter by the side of his plate. "That was a very nice lunch," he remarked. Little he knew the truth of it, but even if he had not been served with Grandma Ridder's remnants I could not have taken the quarter.

"I'm sorry," I replied. "We students don't take tips."

He glanced at me over the top of his nose-glasses.

"I fancied that you were a student," he said. "Isn't that all the more reason why you should take them? But no offense, young man," and he put the quarter back in his pocket. He then questioned me in no perfunctory manner about the College, my studies, what I planned to major in, and the like. When I told him that English literature was to be one of the majors he was particularly interested.

"Good! You are making no mistake," he remarked. He took up the book he had been reading. "Would you consider a volume of poetry a tip?" he then asked.

"No, sir," I replied, promptly.

"Then if one isn't, neither are two," he said. He had a briefcase propped against the table leg. From this he took another small volume and handed me the two of them. "These books cost me nothing, so you need feel no hesitation in accepting them. They are by an English poet. I think you may enjoy them." With that he rose, gave me a friendly nod, and left the dining room.

Oh, red-letter day! Oh, increasing, fructifying double tip! Oh, unavailing regret, that I had earned it by serving my benefactor with food that had come from Grandma Ridder's come-back table!

A quarter of an hour later — this was in the spring of 1907 — with all the afternoon at my disposal, I was breathing the fragrance of May from a bench in the Grinnell park, just across the street from the Bristol House. The books were *Poems* and *New Poems,* by Francis Thompson. I read on and on, poem after poem, with the eyes of the spirit opened for the first time, it seemed. I had a strange awareness of wakening, budding out — perhaps spring had something to do with this — even as I sat there, taking in new ideas and conceptions in a manner for which "exhilaration" would be far too feeble a word. I had just turned twenty and was behind rather than abreast of the usual burgeoning period in youth. Francis Thompson's poems furnished the human plant the kind of nourishment needed to force it — to make it put out leaves and twigs and branches on the instant, so to speak. I shall never forget the immediate impression made upon me by the following lines, in "Contemplation":

> No hill can idler be than I;
> No stone its inter-particled vibration
> Investeth with a stiller lie;
> No heaven with a more urgent rest betrays
> The eyes that on it gaze.

>

> In poets floating like a water-flower
> Upon the bosom of the glassy hour,

In skies that no man sees to move,
Lurk untumultuous vortices of power,
For joy too native, and for agitation
Too instant.

.

From stones and poets you may know,
Nothing so active is, as that which least seems so.

.

When, like a city under ocean,
To human things he grows a desolation,
And is made a habitation
For the fluctuous universe
To lave with unimpeded motion.

.

His heart's a drop-well of tranquillity;
His mind more still is than the limbs of fear,
And yet its unperturbed velocity
The spirit of the simoom mocks.

.

Here for the first time I found explained the brooding nature of the creative spirit before, or between, periods when intense creative energy is again released. I felt that I had always known this, not knowing that I knew.

At supper that evening my unknown benefactor was again at his table, fortunately among the first to enter the dining room. I hastened to serve him with the best and freshest of food. When he asked whether I had read any of Francis Thompson, my fumbling attempt to thank him was, perhaps, more eloquent than any smoothness of speech would have been. He was a discerning man, but even so he could not have guessed the value of his gift to me, at that particular time. His name was Curtis W. Coe, and he was a traveling representative of the Pilgrim Press, a Congregational publishing house in Bos-

ton. Later, I again met him there, and the acquaintanceship, begun when I was "tipped" Francis Thompson's poetry, ripened to a friendship that lasted until his death. But even when I knew him well I never ventured to tell him about "the very good lunch" I was compelled to serve him on that day in the spring of 1907.

vii. The G-Note Road

SUMMER IS ALSO a time for education and that long vacation after my freshman year was, indeed, the high summer of youth for me. Never thereafter did I attain such uplands of pure felicity. My Hill was no ordinary hill during that summer, but Andean, Himalayan, in what I could see, or dream that I saw, from that height. Colfax — "a one-horse flag station on the Rock Island," as I sometimes heard it contemptuously called — had suddenly and gloriously altered. There was nothing common or mean in any part of it, nor in the lives of those who were fortunate enough to call it Home.

No man can legislate for another in the matter of how he shall use his time. In my own case, I often waste it shamefully, as many would say, with a clear conscience. I may spend an hour, or an afternoon, lying at ease, watching ghost terns flying seaward from their nesting places high in the mountains, following their flight until they are lost in the haze of blue distance. Or I sit on my Hill here on the island of Tahiti, engaged in no more profitable employment than that of estimating the moment when the quality of light changes from that of midafternoon, to late afternoon, to evening. But valuable by-products are often gained from this kind of employment. When I feel that hours of such moments have passed forgivingly, I conclude that my use of them has been right, for me.

I should not be surprised if it were Francis Thompson's poem, "Contemplation," that fostered my inborn love of idleness, so-called.

Certain it is that a stanza in "The Cloud's Swan Song" suggested
what I then decided was to be my vocation in life.

> Of my wild lot I thought; from place to place,
> Apollo's song-bowed Scythian, I go on;
> Making in all my home, with pliant ways;
> But, provident of change, putting forth root in none.

Thompson's poems came into my hands before I was able to read
some of them with complete understanding and appreciation, but I
had been preparing from boyhood for that one stanza in "The Cloud's
Swan Song." Those who were born toward the end of the last cen-
tury in lonely little towns on the plains or prairies, will know what
the preparation was, and will understand why I was quick to find
only a splendid literal meaning in the stanza quoted: a symbol, of
what beauty, of the ideal wanderer. It became a promise of my own
high destiny.

For it was to be a high destiny — so with the assurance of youth
I decided — none other than this: to wander over the earth as long
as life should last. I would put aside all other desirable ends that
might interfere; count other ambitions as nothing; be content to
reap no rewards but one which seemed best of all: a growing delight
in the new and strange; an appreciation, ripening as the years passed,
of all the glories of earth seen at first hand. I would rest here and
there for some brief time, then move on to vague and remote destina-
tions. And, after long periods of wandering, returning to old haunts
I would look upon them, too, with unaccustomed eyes, and be there,
as elsewhere, a stranger and a guest.

Having chosen the vocation during that summer of 1907, I began
selecting destinations — some remote enough, others nearer at hand —
suggested by reading, or musing, or both. Two definite ones con-
nected with poets were Burns' farm, near Mauchline, Scotland, and
Nether Stowey, in Somerset, where Coleridge had written *The
Ancient Mariner*. Geographical ones in the U.S.A. were the giant

redwoods, of California — now all but destroyed — and the Grand Canyon of the Colorado. Judging by the emotion that mere photographs of these places had given me, I could imagine what it would mean to stand in the presence of such grandeur. More vague and remote were the Himalayas, the lagoon islands of the mid-Pacific, the Straits of Magellan, and the Northern Lights viewed from vantage points on or beyond the Arctic Circle.

Another destination, more remote and unattainable than any of these, was connected with my dream life. I shall have to return to the days of childhood to explain how the dim sense of a journey to be taken in search of it was first awakened.

There was a road leading south out of Colfax, turning in that direction at the top of Howard Street Hill within fifty yards of our house, that I loved more than any other, from childhood on. Like all Iowa roads of those days it remembered the old prairie; in fact, the strips of grassy land on either side of it comprised the prairie, all that remained of it. In early summer the fragrance of wild roses and geraniums, honeysuckle, sweet william and other prairie flowers hung over it, and in autumn it was a narrow ribbon of scarlet and gold. In childhood I often traveled this road with my father — this was before the days of motorcars — to the neighboring town of Prairie City, six miles distant. About a third of the way to Prairie City the southward-leading road was joined by one running west. Near the junction was a pond scarcely twenty paces wide that lay in a hollow enclosed by low green hills. Morning Sun Pond we called it, and whether it was there or not depended upon the amount of rainfall earlier in the year.

Ponds, to say nothing of lakes, were few indeed in that part of Iowa, and this one became a place of pure enchantment to me. It was fringed with willow and cottonwood trees whose clear reflections in the water gave me a strange emotion: something between joy at what I actually saw and a kind of breathless expectation of something wonderful yet to be revealed. On the slope beyond was a red barn,

like many another dotting the landscape thereabout, but owing to its nearness to the pond it was bathed in a glamorous light that came from the water and spread its magic for a considerable distance around that particular spot.

How is one to make clear, in words, the kind of emotion that floods the heart of a child upon viewing some commonplace sight that his elders pass by with scarcely a glance? It cannot be done. All I can say is that the little meadow with the pond in the center seemed, somehow, sacred, as though it had been set apart from the world of everyday; and the road leading westward away from it was sacred as well. It was, merely, a dirt road, and its fascination lay in the fact that no one ever seemed to use it. I wanted it to remain as it was — lonely, empty, untraveled, until I could explore it for myself; follow it into strange country toward some unknown destination in the direction of the setting sun.

My mother's piano played an important role in connection with this road. A favorite rainy-day amusement of mine in childhood was to stand beside it and strike various notes along the keyboard, with my ear pressed closely against the piano so that I could hear the sounds dying away. Each note had its own haunting quality and seemed to go in a predestined direction. The G-Note, just below the middle octave, followed the road to Prairie City, but at the crossroad by Morning Sun Pond it turned west, traveling on and on in that direction until it became the ghost of sound, as though the faintest of the Horns of Elfland were summoning me from the further side of Silence.

It was around my ninth or tenth year that I first dreamed of the road. My father had given me a bicycle for a birthday present, and in the dream I was walking along a sandy stretch of the road, pushing the bike, in a fret of eagerness to be done with the sand and come to the rise where I would catch the first glimpse of Morning Sun Pond and the junction where I would turn west to explore the untraveled road that had been waiting for me all this time. I could hear the

G-Note already turning there, the sound of it dying away far in the distance.

The dream repeated itself several times in a brief interval, and each time I failed to reach the westward turn; but I awoke with a feeling of great happiness communicated from the dream itself. Then it ceased to delight and tantalize me. Thereafter, though I often passed Morning Sun Pond, it had lost its glamour. I remembered how I had felt about it in childhood, but retained only the memory, nothing of the feeling itself.

One day, during this summer vacation after my first year at Grinnell, I walked to Prairie City without thinking of the Pond, but upon reaching it I might have been the child once more. The Pond, the meadow enclosing it, and the westward-leading road were again "sacred." I tried to hold fast to the sense of something wonderful to be revealed, but it faded as the sound of the G-Note had faded in the dream. Nevertheless, I was entranced at having been able to recover, even for a moment, the identical sense of rapture I had known there as a child. It was one of the highlights of that high summer of Youth.

viii. The Ocean and the City

AT GRINNELL we students had the freedom of the library stack-room which contained, if I remember correctly, around fifty thousand volumes at that time. I was awed by what seemed to me so vast a collection of books; but not bewildered and disheartened as students in the libraries of great universities are likely to be at the sight of endless book-lined corridors so many of which they will never be able to explore even in a cursory manner. At Grinnell there was no danger of being hopelessly lost. One soon had a general knowledge of the library and what it contained, learned how to reach any part of it again and knew what he would find there. The only section that I then cared to explore thoroughly was that devoted to poetry. There was a table by the window giving a good light where I spent some of the happiest hours of my reading life, more than I should have, perhaps, but I have never regretted one of them. There was such a plenitude of choices and directions, and, to me, such a vast amount of unknown territory, that during my freshman year I was like a grass-hopper not caring which way I hopped or flew.

At the beginning of my sophomore year I decided that a more orderly progress was called for; and so, remembering the awesome delight I had gotten as a child from the Doré illustrations and the quotations beneath them in *Paradise Lost,* I decided to read the whole of Milton. But when I realized the extent of the task and computed the amount of time I could allow for it — having board and lodging to earn and other subjects beside poetry to consider — I reluctantly

postponed the plan and read only the shorter poems. But there was one poet I read complete at this time — Matthew Arnold. I "consumed" the whole of the *Collected Poems*, beginning at page one and taking each in the order in which it appeared. I read all of the dramatic and narrative poems, and felt that, as Professor Payne had said, most of these were examples of Arnold fulfilling his destiny as a poet: the kind of poems that he felt he should write. There was one notable exception, "The Scholar-Gypsy," which aroused my deepest interest. Youthlike, I identified myself with that elusive, lonely figure whose way of life so nearly met my own conception of what I would like to choose for myself. There were passages that brought me to a halt while I savored them over and over, some for their meaning, some for their beauty merely as sound, more often for both. One was to weave itself into the very texture of subconscious memory. It appears in "Rugby Chapel":

> . . . the moonlit solitudes mild
> Of the midmost Ocean . . .

Its immediate effect was to reawaken and increase my desire to reach one of the planned destinations, the tropical Pacific. In a composition class under Professor Noble I handed in a sketch under the title, "The Midmost Ocean," an imaginative conception by one who had never yet seen the ocean. When it was returned to me I found written on it in red ink: "Cultivate the gift of literary expression. You have it." Little could I have guessed, then, that I was to spend years wandering through those solitudes, and to make my home on a small island in eastern Polynesia where I would have them all around me.

Then came a sudden revulsion of feeling with respect to Arnold, for the reason, perhaps, that I had read too much of him at once. I already knew most of Bryant, Poe, Whittier, Holmes, Longfellow and Lowell, but had never read any of Sidney Lanier or Walt Whitman. It was a curious experience for a young man not yet oriented to come

of a sudden upon Whitman. I could always find a message directed to me personally by whatever poet, and Walt did not fail to add his. What he told me was deeply encouraging; namely, that the raw material for poetry lies everywhere about; that the earth and all human life upon the earth is a great inexhaustible reservoir of it. Needless to say, leaves of imitative grass burgeoned from scores of pages in my notebook. One of the longest poems was about Colfax — "Prairie Hills" I called it.

> In the town of my birth I stand
> Looking calmly both to the right and left.
> I see the water-tower at the top of the Howard Street hill,
> And the Christian Church below, at the other end of the street.

Nearly everyone in town was present and most of the streets in the town; I left little for a surveyor or census taker to do. Presently I came to smells:

> Do you make a choice of smells?
> Are the delicate ones alone agreeable to you?
> I say that no smell native to Mother Earth is preferable to any other,
> I say that the smell of skunk wafted from the timbered bottom-lands of a river, or creek, or prairie slough is one of the finest of smells, and grateful to the nostrils of a healthy man or woman,
> I say that the smell of dry manure has a fragrance of its own, equal to that of clover hay. It is the perfume, metamorphosed, of the hay itself.
> The fragrance that comes from a groundhog's hole is as good a smell to a man as it is to a dog, but for different reasons.
>
> What autumn or winter smell did you love most in boyhood, after that of bread-baking day, or the other that came from a hot griddle of a morning, as your mother turned the buck-wheat cakes?

Mine was the smell of snow-wet mittens drying on the nickeled top of a hard-coal stove. And better still was the Hallowe'en fragrance of jack-o-lantern pumpkin scorched by candle-flame.

There is no smell with nothing in its favor except the smell of Death, and even that can be endured.

A young man who has never imitated Walt Whitman has missed one of the joys of youth.

This was rather a lonely year. I no longer roomed with Chester Davis at the Chapin house, but was now installed in a house at 713 Main Street, south of the railway tracks, on the far side of town. It was a wrench, leaving Chester and the happy Chapin-house association presided over by Professor Payne; but earning room rent by miscellaneous odd jobs in various parts of town took up a good deal of time, and it seemed advisable to accept an opportunity offered for doing them all in the same place. This was at the home of Lizzie and Edna Davis, spinsters, and both principals of grammar schools.

"The Davis girls," as they were known to all Grinnell, were in later middle age at this time, portly women, lovers of good food and first-class providers of it for their many friends who often dined or supped at their house. Their "cross," born with good-humored resignation, was their weight, which occasional periods of fasting never sufficed to keep down. As a matter of fact, they didn't try very hard, and their friends loved them just as they were. They would not have been the Davis girls without amplitude of body. To me they were like a pair of maiden aunts, with all that such a relationship at its best implies. I could not have loved them more had they been my own flesh and blood.

I did the household chores: washing windows, beating rugs and carpets, mowing the lawn, shoveling snow and keeping the fur-nace going in winter. Their house was an old story-and-a-half dwell-

ing painted white, across the street from the town water tower.

My ten-by-twelve room in the half story above was as snug a re-treat as a woodshed poet could wish for, with a window to the south and another to the west. In one of Frank Moore Colby's essays he speaks of his liking for "a ghosthood in the suburbs, preferably on the wrong side of the railway tracks." I have the same preference; if one likes privacy that is where it can best be found. My west window looked across the railway yards of the C.R.I. & P., and I could hear the whistles of all the trains. And they were steam-locomotive whistles, not the horrible grunt of the diesels of today. The west window framed the glory of the winter sunsets. I recall particular moods and shades of emotion as I sat by the window of a late winter afternoon, watching the slowly fading splendor. The moment when all that remained of winter dusk was the faintly glowing ashes of crimson light, was associated with Schubert's "Serenade," the music dying as the light faded. I would hug to myself, so to speak, the feeling of melancholy stirred by this combination of fading light, and music growing fainter, like the sound of the G-Note on the road leading west from Morning Sun Pond.

A single shelf at 713 Main held the beginnings of my library, the identical volumes that now stand in honored places in my present library, ranged five shelves high around the walls of the room where I write, and most of the other rooms as well, in my home here on the island of Tahiti. Among them are my fifty-cent edition of Burns; Wordsworth Complete; *The Lyrics and Minor Poems of Shelley;* Keats; Goldsmith, and my double tip, *Poems* and *Later Poems,* by Francis Thompson. Wherever I went in later years, these well-thumbed and battered volumes, so soaked through with associations, with many additions, went with me, except for periods when they would have to be stored for a time.

I first read Shelley's *Alastor* at 713 Main Street, and it was then that the Scholar-Gypsy became an even lonelier figure, identified with the poet —

> . . . whose untimely tomb
> No human hands with pious reverence reared,
> But the charmed eddies of autumnal winds
> Built o'er his mouldering bones a pyramid
> Of mouldering leaves in the waste wilderness.

I don't know why I should have had so deep a love for poems of this kind, about solitary spirits seeking ever more solitary retreats from the world of men. I am and always have been a social being, and I enjoy comradeship, if it is really that, fully as much as other men do. Nevertheless, there has always been this strong pull in the other direction, as though some recluse of an ancestor — or, perhaps, a would-be recluse whose circumstances had never permitted his dreams of solitude to be realized — were tugging at the strings, speaking, not in Zarathustra's voice but using his words: "Oh, Lonesomeness! My home, Lonesomeness!" His influence has had a greater effect upon the events of my life than I would have believed possible in the days of youth. Subsequent world events exerted a strong influence as well. World War I and its aftermath must have made the thought of Solitude deeply attractive to a considerable number of naturally gregarious men.

My ignorance of the outside world and of much that had happened there throughout the period of boyhood and youth, was abysmal. As I think of it now, it seems all but incredible that any youth could have been so unaware of life beyond his own horizons. It is an indication of how self-centered and self-contained life was at that time in small country towns of the Middle West. I was no reader of newspapers, and had the further limitation of the introvert who spends so much time looking within himself that much of what is taking place around him passes unnoticed. The gaze turned so steadily inward accounts for the great arc of blankness that meets his eyes when they are turned in the opposite direction. It is not that the introvert has any feeling of self-importance; he thinks much about himself but less than nothing of himself. How could it be otherwise with any honest inward-looker?

But I could not be oblivious to my wretched grades in trigonometry and my flat failure in the final examination was an intellectual defeat. I knew I would not graduate with my class unless I conquered that specter of mathematics. He could not be faced at Grinnell where there was no summer school, but I learned that he might be, at the University of Chicago. And so to Chicago I went. The gloom of that great city met me in the appalling suburbs, made even gloomier and grimmer by my awareness of the specter.

I got a job to pay for board by waiting on table at the University Commons; then, for a day or two until the summer session opened, I looked about me, waving invisible antlike antennae to get the "feel" of this new environment. The Spirit of the Place seemed to be the collective spirit of millions of human ants completely indifferent to one another, unable to speak to one another even had they wanted to because of the thundering, never-ceasing "I will!" of Chicago in the abstract.

That summer was one long period of profound disillusionment, and the University of Chicago seemed to me as inhuman as the city itself. It was far too large, an educational factory rather than a university in the fine sense. Mine was, of course, a superficial view, that of a country youth without human connections there and oppressed by the worst form of loneliness, the solitude of multitude. At all times I was comparing the U. of C. with Grinnell, always to the great advantage of Grinnell. I neglected to take into consideration the fact that this was the summer-school session and compared the relationship between faculty members and students as I knew it at Grinnell with what I saw at Chicago. At the University it struck me as being no relationship at all, a mere casual connection like that of people waiting for trains in the same railway station.

The most valuable part of my education during this summer was the discovery of the slums of Chicago. At the University, Sunday was my one day off, and, although I sometimes visited the parks, art galleries and the like, most of the time was spent in wandering through those grim districts that I had glimpsed upon first arriving

in the city. It seemed necessary to do this, to atone for my ignorance of such places by viewing them week after week so that the romanticist might never forget this side of life in modern Camelot. Perhaps, during one of these day and night rambles I rubbed elbows with Carl Sandburg who saw what I saw but was not dismayed, looking over and beyond these cesspools of humanity to the City with the Big Shoulders.

What I saw was no matter for sneering. I went to extremes, no doubt, in seeing so much of one side of Chicago that, except for the University, I was scarcely conscious of any other. I could not picture the city as a husky, brawling, laughing Youth, proud of his strength, and saying "I will!" with the joy and confidence of a great Builder and Creator. When in the early autumn I started for home and the train emerged from the gloom of that great human ant-heap into the green country, golden in the September sunshine, I looked back with feelings of profound relief. I had come away with a passing grade and trigonometry was never again to trouble my waking hours.

ix. The Bird in the Bush

THE SUMMER of my junior year was far different from the gloom of Chicago. The first of my planned-for destinations was reached: the farm, near Mauchline, where Burns wrote the Epistles to Davie and John Lapraik. That was the summer when I first saw the ocean, the North Atlantic; and it cost me only $33 to cross it, steerage, in the old S.S. *Furnessia*, from New York to Glasgow. Among the steerage passengers I met one of Burns' countrymen, a young fellow of my own age named Alex Gall, returning home for his first visit since coming to America four years earlier. When we parted, at Glasgow, he gave me a warm invitation to visit him at his parents' home, a village called Longside, near Peterhead, in Aberdeenshire. I gladly accepted, but told him about my long-delayed rendezvous with Burns, in Ayrshire. I had to go there first. Alex understood that, of course; our meeting was fixed for later in the summer.

I bought a secondhand bicycle in Glasgow and set out for Ayr, Alloway, and Mauchline. The weather was perfection itself during that first week, and I found Burns in spirit, where I had hoped to meet him — by the banks and braes o' bonnie Doon.

I biked up on the west coast of Scotland to Oban, followed the Caledonian Canal to Inverness; then east to Longside where I met Alex Gall, his parents and sisters. His father was a farmer with a forty-acre leasehold. As I had hoped, but had not dared to expect, I biked straight into the Cotter's Saturday Night and remained until the following Thursday. Mr. Gall was a more prosperous farmer than

Burns' father, and none of his bairns were out at service unless that might have been said of Alex, employed by a wholesale hardware company, in Cleveland, Ohio. Otherwise the conditions were nearly the same. When I said good-by to the family I knew how truthfully Burns had written:

> From scenes like these old Scotia's grandeur springs,
> That makes her loved at home, revered abroad:
> Princes and lords are but the breath of kings,
> "An honest man's the noblest work of God."

I biked an immense distance between Longside, Aberdeenshire, and Braemar, in the northern highlands of Scotland — not in miles but in time. While I was en route to Braemar, on July 25, 1909, Blériot flew across the English Channel, crash-landing his monoplane on a slope just behind the Cliffs of Dover. When I reached London his plane was on exhibit at Selfridge's store. With thousands of others I viewed that frail contraption of wires and ribs and linen fabric with a feeling of uneasiness and disapproval, but little any of us could have realized that overnight — literally, overnight — we had stepped from one age into another. At the moment I was more worried by the rapid dwindling of my little supply of cash. However, my calculations had been well made. I had sailed from New York with $150 in a money belt my mother had made for me. I returned to Colfax, in mid-September with a balance of two cents in my pocket.

Among the various student organizations at Grinnell were a number of societies whose common purpose was partly social, partly literary. Membership in one or another was open to all and they played an important part in the student life of those days. One evening in my senior year I read a paper on "The Four Alfred Tennysons" — the four I was most aware of. The first was the poet laureate and author of *Idylls of the King*. The second was the author of "Locksley Hall," *In Memoriam*, and *Maud*. The third was the robust,

hearty, earthy Tennyson of the "Northern Farmer" poems and "The Northern Cobbler." The fourth, whom I worshipped "a little this side of idolatry," was the author of "Mariana," "Now Sleeps the Crimson Petal," "The Spendour Falls," "Come Down, Fair Maid," "Ulysses," and "The Lotos-Eaters."

I don't remember what impression, if any, I made upon my fellow members, but I was so stirred by the magic of "Mariana" that at the close of the meeting I wandered out to the south campus to cool off.

It was a cloudless starry night and I stretched out on the grass near the outdoor theater, a raised platform of lawn-covered earth surrounded by fine old trees and clumps of shrubbery. Presently I heard voices which I recognized. Two faculty members, Mr. John D. Stoops, Professor of Philosophy, and Professor Peck, Head of the History Department, were having an evening stroll and seated themselves at a corner of the turf-covered stage within a dozen feet of where I lay hidden by shrubbery. They were discussing various students who were or had been in their classes, and presently my name was mentioned.

"He's another example of the exasperating type of student," Professor Stoops said. "They seem to have ability in the abstract; it can't be defined in any other way. You hope it will crystallize so that you can see what it is composed of, but it remains in solution."

"I know," Professor Peck replied. "Their promise is always better than their performance. How do you grade such students at the end of the semester?"

There was a moment of silence; then Professor Stoops said: "My tendency is to give them the benefit of the doubt. I've been teaching long enough to know how difficult it is to judge them by classroom performance. I believe that most of them get more out of their work than the record shows."

I listened with deep attention, but they said nothing more on the subject of students. They switched to a discussion of education in general, comparing that given by colleges such as Grinnell with the

more specialized training of the universities. Professor Peck feared that liberal arts colleges would, eventually, have to abandon their long struggle for survival. Odds were too greatly against them. Professor Stoops was more hopeful. "Unless life changes beyond anything we have reason to expect," he said, "liberal arts colleges will never out-live the need for them, provided that they remain true to their long-range purpose." He was silent for a moment, then added: "And that is to teach young men and women that the bird in the bush is worth two in the hand."

Presently they resumed their walk, and I remained where I was, puzzling over this remark of Professor Stoops. I puzzled over it for several days. I was encouraged rather than disheartened at having been classed with students having ability in the abstract. It was comforting to assume that one might have it. Nevertheless, as Commencement drew near, I spent some anxious hours, thinking of the immediate future. I envied those of my classmates with decided bents and aptitudes; who had known a good two years in advance in what direction they were heading. Some planned to return to the farms, others to go on to scientific, law, or medical schools. But I had Professor Stoops to thank for giving a name to the vocation I hoped to follow: Pursuit of the Bird in the Bush. The only trouble was I couldn't earn a living by it. However, I was soon to graduate *cum laude* from the Bristol Hotel. If worst came to worst I could always get by, waiting on table, until something better turned up.

Meanwhile, the return of Halley's Comet with its great luminous tail announced Commencement for the Class of 1910, and, to the world at large, the belated end of the nineteenth century and the beginning of the twentieth. I doubt whether many college graduates could have received their degrees with more reluctance than I did mine. I would have been content to have had "the classic bell" ring me back to old Grinnell for an indefinite period; but whether I would or no, I was now a bachelor of philosophy.

At the last vesper service of this senior year I committed a mis-

demeanor that would appear to indicate little benefit from the service after four years of steady attendance. I stole one of the chapel hymnbooks — *Hymns of Worship and Service,* published by the Century Company. I still wonder that I could have done this; had I asked for a copy I am certain that one would have been given to me. The nearest I can come to an explanation is that I wanted the transaction to be a private one known only to the Chapel and myself; and so I tucked the copy under my arm beneath my senior gown and walked off with it. The memory of the theft has lain lightly on my conscience these many years. I think of the book as borrowed, merely. I mean to return it on the fiftieth Commencement Anniversary of the Class of 1910, if I survive till that date. I will then compare it with whatever hymnbook may be in use at that time.

Among the alumni who returned to Grinnell during Commencement Week was a graduate of one of the 1890 classes, Mr. C. C. Carstens. He was Director of the Massachusetts Society for the Prevention of Cruelty to Children, in Boston, and was seeking a young college graduate to join the Society's staff of Special Agents. I learned of this through Dr. Steiner, Professor of Applied Christianity, who arranged for me to meet Mr. Carstens. As a result of the interview I was offered a position with the Society at a salary of $60 per month.

The summer in Chicago as well as wanderings in Glasgow and London during the following summer had wakened my social consciousness, and here was an opportunity not only to increase my knowledge of life in a great city, but also to be of some use while doing so.

I was to have three weeks at home and they were woefully brief. There was so much I wanted to do; so many boyhood friends I wanted to see, not for a few moments only but for hours. I had a sad awareness of a door about to close upon the cycle of childhood, boyhood and youth. The hall door at our house between the parlor and the stairway leading to the bedrooms on the upper floor gave warning of this every time I opened it. That door had squeaked

loudly, piercingly, for as far back as any of the Hall family memories went. Only when opened with extreme caution, which was how I had opened it upon returning from night rides on the pilot of Number Six, would the thrill quality of the squeak be reduced to less audible proportions. Not a drop of oil was ever applied to the hinges of the door. Even when my brothers and I were all at the night-prowling stage we would as soon have considered burning the house down as to have silenced the voice of the door, for it belonged to the house as well. We children had all been born there. The old frame house was as full of happy memories as it was of icy drafts in the wintertime under the buffeting of the north wind, with the thermometer at from fifteen to twenty below.

On the evening of the day before I set out for Boston we were all gathered in the sitting room around Mother's piano which her father, our Grandfather Young, had given her when she herself was a student at the Washington Academy, in Washington, Iowa. She played the songs we all loved, and later, when we went out to the front porch, she sang "Last Night the Nightingale Woke Me," which evoked for us so many happy memories of the summer nights of childhood. The illusion that time had rolled back was made all but perfect for me when the headlight of Number Six appeared over the horizon to the west, at the top of the Mitchellville grade, and I heard —

> . . . the whistle far away
> Sounding through the air so still.

I felt the old quickening of the pulses, and it seemed to me that I should have been hiding under the water tank with Buller Sharpe and "Preacher" Stahl, going to Grinnell for the first time instead of just having come away for the last time, as a student, with a bachelor of philosophy degree in one hand and a stolen hymnbook in the other.

Later that night I walked east out the railway track to say good-by

to my Hill. It looked more beautiful, if that is possible, than ever it had. The fireflies were everywhere, and I heard the stilly music of the frogs along the bottom lands and of the whippoorwills on the hill itself. I might have been the woodshed poet of the summer of 1904.

The piercing squeak of the old hall door sounded mournful indeed upon this occasion as I went upstairs to bed, well after midnight. "Here he is, Mother Hall," it seemed to say; "stealing up for the last time. I'm warning you!" Mother heard it as she had so often before, in earlier years, when I hoped that she wouldn't hear. We talked until nearly daylight, and a few hours later I set out for Boston, in quest of the Bird in the Bush.

x. The M.S.P.C.C.

Mr. CARSTENS had suggested that upon arriving in Boston, until I'd had time to find suitable lodgings, I should stay at his home in Brookline. I arrived late on a Sunday afternoon and was given a friendly welcome by Mr. and Mrs. Carstens and their three children. After supper he took me into the library and when we were seated he said with a faint smile, "Now for the Massachusetts Society for the Prevention of Cruelty to Children." With his hand he felt his jaw lightly, as though fearing that it had become slightly dislocated, adding: "More commonly referred to as the M.S.P.C.C." He went on to speak of the many organizations in Boston, both public and private, concerned with social welfare work and so aroused my interest that I went to bed in an eager frame of mind.

Monday morning early we walked together from the Park Street subway station to the State House, and along Mt. Vernon Street, I taking in so many new impressions that I had no time to sort them out. I remember my shock of surprise at seeing a brass plate at the entrance of a building, with THE ATLANTIC MONTHLY engraved upon it. Having so long dreamed of Eldorado, to pass its very portals was still in the nature of a dream experience. On we went and I followed Mr. Carstens up the footworn sandstone steps into the cool interior of the building at 43 Mt. Vernon Street.

It had once been a spacious old family mansion, and the changes made to convert it to the uses of the M.S.P.C.C. had not been so great as to alter its character. A broad stairway led from the hallway

to the upper floors. Fronting Mt. Vernon Street was the office of Mr. Carstens, and adjoining it, one for the Assistant General Agent. Behind them were the telephone operator's booth and switchboard, and the desk of Miss Butler, Mr. Carstens' secretary who also received reports of cruelty to children that were brought by complainants in person. The remainder of the lower floor was occupied by a large room, lighted by tall windows facing Joy Street, where the desks of the Special Agents were placed as well as those for the stenographers and filing clerks.

Having introduced me to the staff, Mr. Carstens left me to my own devices. I was to have no assignments during the first week and to spend my time getting "acclimated" and in learning procedure. Most of the agents were young men, recent graduates of Yale, Harvard, Dartmouth, and other colleges and universities. My desk was next to that of "Judge" Ewers, a graduate of Yale Law School, whose work was largely connected with cases of desertion and non-support of families. He conducted the court cases for the complainant mothers. Cheney G. Jones, another Yale man, was the Society's agent in Brockton, dividing his time between that city and Boston. Ray S. Hubbard, a Dartmouth alumnus, later Supervisor of Branches, was at this time in charge of the work connected with appeals for and the bequests of funds. In those days, before the establishment of Community Chests, the M.S.P.C.C., like other private welfare agencies, was supported by bequests from estates, and individual contributions.

The records of the Society were kept in filing cases in a large vault adjoining the agents' room. There I spent much of my time during the first week familiarizing myself with the work I would soon be doing. Some of the records were bulky, to say the least, with cross reference to others where one found the neglected children of one generation becoming the neglectful parents of the next. The early records of the Society were handwritten and dealt for the most part with physical cruelty, some of it incredibly grim. There were cases of beatings and

maimings, incest, infanticide, poisoning, death by deliberate starvation. For such revelations one needed more preparation than I had had. Indeed I had such arrears of ignorance to make up that I read evenings as well. The doors at 43 Mt. Vernon closed at 5 P.M. but the agents often remained late, talking over the events of the day, studying the blue complaint sheets impaled on their spindles, outlining the facts of new cases to be investigated.

In addition to the men, there were two women agents, Miss O'Rourke and Miss Marsters, whose work dealt with the problem of wayward girls and the family conditions that made them so. They were hard pressed and sometimes snowed under by the number of such cases reported to the Society. Miss O'Rourke informed me that, despite work of the same kind performed by other agencies, waywardness seemed to triumph over their combined efforts to deal with it. Miss O'Rourke had any amount of good common sense and I enjoyed talking with her. I was rather taken aback at first by the frankness with which she spoke of sex problems, but these were what she dealt with week after week and month after month, and a cool detached point of view seemed to have become second nature to her. Although a fairly young woman she had snow-white hair, the result — she informed me, with a faint smile — of her efforts to accomplish the impossible. I asked what that was.

"To change human nature," she replied. "We social workers are supposed to have the training and the ability to correct the errors in human conduct that Adam and Eve were responsible for. There are university professors who really believe they can be corrected — men with imposing lists of degrees after their names."

"You mean you're discouraged about your work?" I asked.

"No," said Miss O'Rourke, "I am merely exasperated with Adam and Eve for having made it so difficult."

She then became serious and spoke of the home and family conditions under which the girls they dealt with had to live. Private social agencies could do little to better them. It was a problem for the City

of Boston to undertake by wiping out the slums. "When you have lived here for a while," she added, "you will see for yourself how little Boston is concerned about it."

One evening that week I was alone in the office when Mr. Critcherson came in. The district he covered was East Boston. His desk was just across the aisle from mine but I had had little chance to talk with him. Now he seemed ready and willing to chat at leisure. Mr. Critcherson was in his late fifties and told me that he had been with the M.S.P.C.C. for many years.

"I'm a hold-over from the old Society," he said. "After it was re-organized and brought up to date I expected to be fired. Don't know why I wasn't."

"Why should you have expected that," I asked, "with long experience behind you?"

"It wasn't the right kind of experience," he replied. "I'm an old-fashioned Cruelty Society agent. All these bright young fellows from Harvard and Yale and so forth are social workers, like yourself," he said. "But I was a policeman to start with, then I got a job here. That was a long time ago."

"You still like the work?" I asked.

"Well, yes, in a way. I like children and hate to see 'em abused. I guess that's the main reason I'm still at it. But there's been a lot of changes in the way the work's done."

"How does it differ now from what it used to be?"

"Well, it's what they call more scientific," Mr. Critcherson replied. "For one thing, they keep better records than we used to. And that's going to be one of your troubles, young man. When you go out to investigate a case of cruelty you've got to get the family history to start with; the names of the children, the dates of their birth, where they were born, and a lot of other information. That ain't always so easy, as you'll find, but you'll be in Mr. Carstens' bad books if you don't manage it somehow. I don't say it's not useful information. Some of it is. Good thing to get if you can. We didn't bother so much about

it in the old days, but times has changed as I said. It's hard for me to get used to new ways of doing things."

He glanced around the empty office, and assured that we were alone he brought out a cigar and lit it. "When we was just Cruelty Society agents instead of social workers we could smoke when we'd a mind to, even in office hours." He pulled at his cigar as though short, indignant, smoke-filled puffs expressed his feeling better than words could do.

"I'm prejudiced against the Associated Charities," he went on, "so don't take what I say about 'em for the whole truth. Maybe the way they do things is better than the way ward politicians do them. When they hear about a case, maybe from a policeman on the beat, the hard-up family gets the help right off; and the ward boss, or his boss, makes sure that he gets the father's vote at the next city election.

"There's another way needy families get help," he went on, "or they used to: from private people with big hearts who don't stop to ask questions or make records of the family history. The A.C. considers them their greatest enemies. 'BI's' they call 'em — Benevolent Individuals. 'Benevolent' is a word they hate; it's poison to 'em. And of course there used to be a lot of misplaced charity. But I think it's better to take a chance on that, now and again, than to have so much misplaced caution."

Mr. Critcherson took from the sharp-pointed spindle on his desk half a dozen blue complaint sheets of new cases to be investigated in his East Boston district. After glancing through them he impaled them on the spindle again as though wishing that they might all be dealt with in that swift and easy fashion. Then he closed his desk.

"Good night," he said. "Don't pay any attention to what I say. I'm a cantankerous old fogy. Ought to have been fired long ago."

It was past six o'clock, a beautiful midsummer evening. Thus far I had seen no more of Boston than the small area between the Park

Street subway station and 43 Mt. Vernon Street. I decided to take a stroll and keep a lookout for a possible lodginghouse.

My good angel led me in exactly the right direction. I followed Mt. Vernon Street down the hill till I came to Louisburg Square. When I saw that charming little place with its tree-shaded grass plot in the center and the dignified old brick houses surrounding it, I thought: "This is the place! If only I could live here!"

There didn't appear to be even a ghost of a chance. The stately old dwellings seemed to draw away at the mere thought of a young upstart from the Middle West entering one of their doorways, but they didn't object to his walking around the Square admiring them. I made the circuit once and was halfway around the second time when I stopped short at the Pinckney Street end of the Square, before the house at #91. There was a small neat card with the word LODGINGS printed on it, in the corner of one of the windows. It didn't seem possible, but there it was. I mounted the steps and rang the bell.

An elderly lady opened the door. In the shadows of the entryway I could not see her clearly, but I liked the sound of her voice as she said, "Yes?"

"I saw the card in your window," I replied. "Have you a room you could rent to a young man?"

"Well . . . yes . . . I might have," she replied, hesitantly. "Are you single?"

"Oh, yes," I said. "I'm an agent of the Society for the Prevention of Cruelty to Children, at 43 Mt. Vernon Street. I've only just come to Boston."

Mention of the Society seemed to impress her favorably. She invited me in and we talked in the hallway for a moment or two. "I'm not very affluent," I said, "so I'd better ask the price of the room before I see it. I don't want to bother you unnecessarily."

"Would four dollars a week be more than you could pay?" she inquired.

My heart leaped. "No; that's just what I expected to pay for a room," I said. "I'll take it."

"Wait till you see it," my landlady replied. "You mustn't buy a pig in a poke, young man."

Then, excusing herself for mounting slowly — "I ain't as spry as I used to be" — she led the way to the fourth floor, under the roof, into a snug little 8-by-10 room lighted by a dormer window that looked down on Louisburg Square. I could hardly refrain from throwing my arms about her and giving her a smack on both cheeks.

"It's quite a climb, but then you're a young man. I guess you won't mind that so much. There's no heat up here, but that little stove will keep you warm as toast in the wintertime, no matter how cold it gets. Coal's included in the rent. That cot bed's real comfortable; my son used to sleep in it. The bathroom's on the floor below; the water never gets good and hot, but it's always warm." It was exactly what I wanted and on the spot I paid my landlady, Mrs. Atherton, a week's rent in advance.

I moved in the next day, Sunday, and after arranging my few belongings I spent a good part of the day looking down on the Square from my window, then going down to look up at my window from the Square. There was no bookshelf in my room, but the chest of drawers did very well in lieu of one; and, as I've said, my library was small at this time. I had made one addition since leaving Grinnell — Thoreau's *Walden*, bought in Chicago as I was passing through on my way to Boston. After four years of college, the bachelor of philosophy had enough mathematics to understand perfectly Thoreau's arithmetic with respect to the cost of his hut on Walden Pond.

Boards	$8.03½, mostly shanty boards
Refuse shingles for roof and sides	4.00
Laths	1.25
Two second-hand windows with glass	2.43

and so on, the total coming to $28.12½. I valued the items of my lodging at 91 Pinckney Street as follows:

Shelter	$00.05½
Furnishings	00.03½
View	1.91
Satisfaction	2.00
	$ 4.00

Actually, the worth of the view and the satisfaction which came from living under such ideal conditions was, like the value of my library, beyond estimation in terms of figures. I had read the first half of *Walden* on the journey between Chicago and Boston. Needless to say, Walden Pond was immediately placed on the itinerary of destinations. And there it was, awaiting me, within an hour's ride of Boston.

xi. My First Case

PINCKNEY STREET took on the character of its immediate environment. As the north side of Louisburg Square it lived up to the quiet dignity of the dwellings on the other three sides and maintained it downward from the Square and across Charles Street to the promenade along the Charles River Basin. Uphill it became rather slipshod and Bohemian, in the Boston sense of that word. At #53 was a combined boarding- and lodginghouse run by a Mr. and Mrs. Le Clair, French Canadians. My landlady directed me there on this same Sunday afternoon. "I don't know the Le Clairs," she said, rather primly, "but I believe their rates are quite reasonable." So I found them; the price for board was only $3.50 per week and Mrs. Le Clair had a vacancy at her table. I was jubilant. Thirty dollars per month for board and room left half my salary for incidental expenses. I had supper there that same evening and very good it was. Mrs. Le Clair, a motherly type of woman with a quite evident mustache which seemed to belie her character, introduced me to her other boarders.

Now the Special Agent was all set to enter upon his duties. The following day, Monday, returning to headquarters from lunch at Mrs. Le Clair's, I found a blue complaint sheet impaled on the spindle on my desk. It was my first case.

Complaint received by telephone from Landlady at —— Springfield Street. Reports that young mother of two-year-old child (probably illegitimate), leaves him alone all day in her room. Landlady has spoken to mother of her neglect but without result. Requests early investigation.

Neither the mother's nor the landlady's name was given, and Miss Butler, the complaint secretary, informed me that the landlady had said that she did not know the name of her lodger and had hung up the receiver without giving her own. "I judged by her voice over the phone that she's a surly sort of person," she said. "That may be something for you to go on at the start."

Miss Butler was a gentlewoman, sensitive and kindhearted. It seemed strange to me that she should be the one to receive complaints with their, often, sordid details, but the work appeared to have no effect upon her delicacy of feeling. She was in striking contrast to Miss O'Rourke who was hard-boiled, with a kind of Rabelaisian sense of humor. For example, to Miss O'Rourke a whore was a whore, but Miss Butler would say "a woman of the streets," with an air of gentle sadness as though that made the oldest of professions, not respectable perhaps, but forgivable. The way she said it made one feel that no woman had ever gone into that profession willingly but had been driven there by force of circumstances. When I asked what she thought of the facts, such as they were, in this particular case, she replied: "She may be a woman of the streets, but you mustn't take that for granted. I shouldn't wonder at all if she were a young unmarried mother out of work and trying hard to get a job; this would account for her seeming neglect of the child. If that is the case we can easily help her by arranging to have the child cared for at one of the day nurseries. But the facts must come first, of course. It is useless speaking of whatever case until the facts are known."

She then informed me that Mr. Carstens wished me to become familiar with all parts of Boston and its environs; therefore, I was to be a kind of agent-at-large for some weeks, with no definite territory assigned to me. "Springfield Street is in the South End," she added. "I suggest that you stroll through that area for an hour or so to get your bearings. You will still have plenty of time to get the facts of this case."

Nothing could have suited me better, and so with my map of

Boston handy in the side pocket of my coat I walked down Joy Street, across a corner of the Common to Tremont, and out Tremont toward my destination. Every step taken was over historic ground. Long-fellow, Lowell, and Oliver Wendell Holmes had trod this pavement not a great while before my own day. Dr. Holmes, in his youth, had seen the Last Leaf, the old gentleman in the three-cornered hat, who had been in his prime at the time of the Revolution.

> But now he walks the streets,
> And he looks at all he meets
> Sad and wan,
> And he shakes his feeble head,
> That it seems as if he said,
> "They are gone."

Gone indeed they were, and the Boston of that era; but as I write these words I wonder whether the era of the Last Leaf could have seemed as remote to Dr. Holmes as the Boston of early July, 1910, seems to me now.

I walked slowly on, thinking of my good fortune in having found an occupation so exactly suited to my tastes. There was I, in leisurely pursuit of the Bird in the Bush. What pleasure was in store for me in the days to come, exploring the labyrinths of Boston: the mazes of crooked streets and courts and alleyways leading off in every direction! At first sight Boston reminded me of London as I had seen it, all too briefly, the previous summer, and more strongly still of Dickens' London as I had imagined it when my mother read *The Old Curiosity Shop* and *Oliver Twist* to us children.

I noticed that the buildings bordering Tremont Street were grow-ing dingier as I walked south. Then I came to Springfield Street and found to my surprise that it bordered one side of a quiet square, at first sight almost as attractive as Louisburg Square. Trees shaded the grass plot in the center and the brick dwellings surrounding it had much the same air of native dignity. But closer examination revealed

that what had once been homes now had a forlorn, decayed, down-at-heel appearance, and the few persons whom I saw entering or leaving them had the same look of "homelessness."

I found the lodginghouse I was seeking, but it was still early, so I followed Miss Butler's suggestion and explored that quarter of Boston as far south as Ruggles Street. It was midafternoon when I returned to the lodginghouse, mounted the steps and pulled the bell. The door was opened by a tall, gaunt, grim-visaged woman who regarded me with a dour, suspicious look.

"What d'you want?" she said.

When I told her who I was her scowl deepened.

"Why didn't you get here sooner?" she asked. "I told 'em for you to come right away. Now it's too late. She's cleared out, the little bitch!"

Nevertheless, she grudgingly admitted me to her own rooms on the first floor at the rear of the house. I questioned the landlady, but without much result.

"Ain't I told you she's cleared out? I don't know her name or her brat's name. I don't know where she's gone or where she came from."

"When did she go?" I asked.

"Last night, and owin' me three weeks' rent. But I'll find her! Wait and see if I don't! She'll be sluttin' around the South End somewhere."

The mother, she said, was around eighteen or nineteen. She would go out at nine or ten in the morning and be gone until evening, leaving her child — "a bastard, that's sure" — in her room with a bottle of milk, but no one to look after it. "Tryin' to make me believe she was lookin' for work! I know the kind of work she looks for, the bitch! Layin' on her back. But that wouldn't be no business of mine if she'd paid her rent."

"Do . . . do women of the streets go out in the daytime?" I asked. "I thought it was only at night."

I am reluctant to give the exact words of her reply. But I am now a social worker and perhaps I'd better. They can't shock the reader any more than they did me.

"Why shouldn't she go out in the daytime? 'Tain't only at night that studs get horny."

That was all the information I got except for one other item. I asked whether she had told the mother of the complaint she had made to the S.P.C.C.

"Yes, like a fool!" she said, sullenly. "I could see she was fond of the brat and I wanted to scare the livin' daylights out of her. And so I did. She had a big suitcase full of their things. I couldn't see her luggin' that away and the kid too without my knowin' it. But she did, in the night. I might have known some buck would help her."

I had other questions to ask but it was useless; she fairly pushed me out of the room. "What more is there to tell? She's gone. Find her for yourself," and she slammed the door in my face. I walked along the dingy hall toward the entrance. What had once been a beautiful staircase led to the upper floors. I halted there, thinking uneasily of returning to 43 Mt. Vernon Street to make the following report:

> Mother: name unknown
> Child: a boy about two years old, name unknown
> Landlady, name unknown, reports that mother and child have
> gone from Springfield Street; she doesn't know where.

What would Mr. Carstens think of that for an investigation of his first case by the new Special Agent? I decided that I'd better consult some of the other lodgers; they might be able to give me some information. I mounted to the top floor, to work down.

I knocked at two doors and got no response. The third was opened by a little old man who seemed out of place in that dreary house. He had a clear ruddy complexion, bright blue eyes, and hair that was snow-white. His clothing was well worn but very neat and clean. He wore a green eye-shade pushed up on his forehead and asked me in as though he really meant it. His room was a combination of bedroom and workshop. There was a small carpenter's bench against one wall with woodworking tools neatly arranged on a rack above

it. In front of a window stood a small lathe operated by a foot-tread.

I briefly explained my errand, but the old man shook his head. "No, I don't know dot voman," he said. "I don't know nobody in de house, none of de lodgers. I got my vork. Dot keep me busy."

Then he showed me what the work was, and I would, willingly, have spent the rest of the afternoon there, watching him. He made toys for children, the smallest and daintiest that I have ever seen. At this time he was working on dining-room furniture. There was a complete set of dishes for four covers, all of wood — dinner plates, soup plates, butter plates, cups and saucers, and so small that they fitted into a beautiful little box with a slide cover, scarcely larger than a box for safety matches. Another, slightly larger, contained kitchen utensils: rolling pin, bread board, mixing bowls, skillet, and other dishes for cooking, also of wood and exquisitely shaped, even with carved decorations on the dinner plates. Then there was a dining-room table with four chairs for the family: "De papa, de mama, and de two little chillerns." They were daintily shaped, with real faces, arms and hands, legs and feet, jointed at the waists and knees so that they could sit in the chairs. The papa and mama were about two inches tall and the children, a boy and a girl, half that size. Unless I had seen them I would not have believed that such tiny figures could have been so beautifully made. He told me that it took him two weeks, working all day long, to make such a set, figures, dishes, furniture and all. He sold them himself, he said, to rich people out in the Back Bay. "I don't have no trouble," he said. "De minute de mamas see 'em, if dey got little chillerns, dey vant 'em." I could readily believe it. They would have been suitable gifts for the children of the King of Lilliput. It was a wrench, leaving that workshop and returning to my own affairs.

On the floor below I again had no response from two doors. I heard voices, male and female, coming from behind a third. My knock was followed by abrupt silence from within. A moment later the door

was opened just wide enough for a woman's head to be thrust out. She was young and rather pretty in a hard, vulgar fashion.

"I beg your pardon," I began; "do you happen to know a young woman with a child about two years old who has been living here?"

"What's her name?" she asked.

"I don't know her name, but . . ." and there I stood, regarding the panels of another slammed door. The paint was peeling from the woodwork but that fact was not pertinent for the record. There was another door on the opposite side of the hallway with a printed card tacked on the panel. It read: MADAME HORTENSE — CARD READER — PALMIST.

The door here was opened about half an inch in response to my knock, but a voice said: "Wait just a minute! I'll be right back." I waited scarcely longer than that. The door was opened wide this time and there was Madame Hortense herself. She was around thirty-five or forty, with yellow hair that looked as though it had been bleached that color. Instead of a grim suspicious scowl she beamed at me. "Well! What a nice surprise! Come in!"

I started my explanation at the door but she interrupted me. "We can't talk here," she said. "I'll catch cold. Come into the studio."

The "studio" was a large room facing Springfield Street and still showed evidence of vanished dignity. It had evidently been the drawing room in former years. There was a fireplace with a marble mantelpiece, with a divan furnished with crumpled sofa pillows on one side and a plush-upholstered chair facing it. On the opposite side of the room was an alcove containing a bed. Newspapers had been spread on the floor there, and resting on them was a tin tub with a soap dish and towel beside it. Madame Hortense drew the curtains across the alcove.

"I wasn't expecting visitors just now," she said, glancing back at me over her shoulder. "Ain't it hot? I've been having a sponge bath. Now I'm all nice and comfy." She motioned me to the chair and seated herself on the divan, making a kind of nest for herself with

the sofa pillows. I wasn't feeling so "comfy" in her near presence. She wore a dressing gown of faded blue silk fastened by a single button over her ample bosom. I had an uneasy awareness that there was nothing underneath. Her bare feet were slipped into bedroom slippers. The windows were open but a strong odor of some cheap perfume or sachet powder filled the air. I was just beginning my explanation when Madame Hortense got up to draw the curtains across the windows; then she turned on the light in two bracket lamps on either side of a portrait that hung above the mantel. "Now we're all cozy," she said as she resumed her seat, looking at me expectantly.

I again began my explanations and a moment later Madame Hortense said, "Oh, yes. I know her very well. Her room was on this floor. Poor Edie! She's gone."

"I know," I replied. "The landlady told me. Do you know where she's gone?"

She looked me over with a smile that made me feel still more uncomfortable; then she nodded. "But I won't tell *you*, you bad boy! Why didn't you come when she needed you?"

I remembered a piece of advice Mr. Critcherson had given me: "Get your facts before you tell them who you are. They'll shut up like clams if they know you come from the M.S.P.C.C."

And so, though feeling rather guilty, I replied: "I only learned this morning that she was in trouble. I would like very much to know where she's gone."

Madame Hortense continued to regard me in the same smiling, speculative manner.

"Wouldn't you, though?" she replied. "And you're still just crazy about her? Listen, honey! She ain't crazy about you, not any more. Oh, I know all about you! Edie told me you'd be coming. And she said: 'When he does, tell him I hate him and I'll never see him again!'"

I didn't know what to say. The S.P.C.C. had no "Beginner's Guide and Manual" and I was not prepared for the situation. She was still

gazing at me so I let my glance wander to the mantelpiece and the oil portrait that hung above it. The bracket lights brought out the figure of a fat nymph reposing in a languorous attitude on a couch. It was, evidently, an idealized portrait of Madame Hortense in her younger days, and even more scantily clad; in fact, her complete costume was a piece of gauze across her middle, the end of it flung over one shoulder.

"Honey, let her go. You'll have to. I ain't going to tell on Edie. But I'll say this: she's left Boston."

"Did . . . did you help her to go?" I asked.

She nodded. "I'm a woman, honey, with a soft heart; not a bitch like the landlady." She laughed as she added: "Wouldn't she scratch my eyes out if she knew!"

"Was she married?"

"You ask me that, you bad boy! Edie's awful fond of the baby. That's what's made her hate you so."

I will not particularize the rest of the conversation, although I remember it almost word for word. It must have continued for another five minutes. I wanted to get some definite information and Madame Hortense kept stringing me on as though she were at the point of relenting and telling me where the mother had gone. I gazed at the floor for the most part in the effort not to see Madame Hortense as she flattered herself she had been, in younger days, or as she was at the moment.

"Honey, I can't tell you any more. I promised Edie. So . . . you see? You'll have to find a new sweetheart."

I couldn't very well speak to the floor. Raising my eyes I was horrified to see that the single button on the dressing gown had come unfastened, although Madame Hortense didn't appear to have noticed this. She was regarding me with what was meant to be a sultry smile.

"Come over here, honey. Let me see your hand. I know just who she's going to be, if you've got two dollars."

I decided that it was time to go and took up my hat.

"Honey! I'll make it one dollar for you. Look!"

Those were her last words; at least, the last I heard. As I went out the door I turned my head for a final glance. She was standing by the divan with the dressing gown held widely apart. She hadn't a stitch on, underneath; nothing but the slippers on her feet.

I quite forgot to consult the lodgers on the ground floor. I had spent more time than I'd realized with the old toymaker and it was nearly six o'clock when I reached 43 Mt. Vernon Street. Miss O'Rourke was coming down the steps as I went up. Fortunately, she merely nodded as we passed and remarked, in her husky voice: "Hope you've had a lovely day." Mr. Critcherson was the only one left in the agents' room, and that was just as I'd hoped it would be. He was on the point of leaving, and I asked if he could wait for another ten minutes.

"Sure. Why not?" he replied. "Won't be the first time I've kept the old lady waitin' supper."

He leaned back in his chair, listening quietly as I told him of the results of my first "investigation," with a full account of the interview with Madame Hortense. When I had finished he still regarded me gravely, but there was a ghostly twinkle in his eyes.

"Was she good-lookin'?" he asked.

"She must weigh at least two hundred pounds," I said.

I was surprised by Mr. Critcherson's quiet chuckle. I couldn't, at the moment, see the humor of the situation, but he was the best of medicine for the romantic idealist.

"I guess you'll be all right," he said, "since it didn't strike you blind and prevent your runnin' away. We see some queer things in this business. Maybe it's just as well you had this kind of start with. . . . Now then, let's think of the Record . . . remember what I told you about that. What have you got for facts?"

"I've told you everything," I replied.

Mr. Critcherson chuckled again. "Madame Hortense — card-reader

— palmist. One button to her dressing gown. Weighs around two hundred pounds. Price, two dollars, but bargain rates for young social workers. They're interestin' facts, no doubt of that, but not the kind Mr. Carstens wants."

I laughed then, or would have, except for the reference to Mr. Carstens. I knew that all agents were required to discuss their cases with him either weekly or semimonthly and I dreaded that prospect. I wanted to make a good showing to begin with.

We went over the results of my investigation and Mr. Critcherson said: "You see, you haven't got much to go on so far. Madame Hortense's information is not what you could call reliable. She probably does know the mother and that Edie was expecting a young man to inquire for her; but the message the mother gave for him may have been nothing like the one Madame Hortense gave you. Maybe what she wanted most was to have the young man know where she's gone. She may have been married to him; anyway, it seems likely that he is the father of her child. But when Madame Hortense sees you, thinkin' it's him, she says: 'Oh, oh! Here he is! And he's my meat if he's got two dollars . . . I mean, one dollar if he has to be coaxed.' "

I smiled rather lugubriously. "You think Edie may be a decent girl down on her luck?"

"Could be. On the other hand, she may be one of the toughest little tarts in the South End. But there's one thing in her favor: she loves her baby. That seems clear because the landlady herself acknowledged it. Plenty of prostitutes have more genuine mother love in 'em than a lot of so-called mothers in respectable homes. I've been in this business long enough to have found that out. Suppose Edie is one of these; then comes the question, in case you find her: where will the child be better off — with the mother or taken away from her?"

"There can't be any doubt about that, surely?" I said. "How could a prostitute be fit to bring up a child?"

Mr. Critcherson didn't reply at once. He smoked in silence, absently regarding the portrait of one of the founders of the M.S.P.C.C. hanging on the wall nearby.

"Young man, I've never been to college as I've said. But if I had college degrees yards long danglin' behind me I couldn't answer that question without knowin' the mother. Most of the high authorities in child welfare would say right off, she never could be fit. But take this from an ex-policeman who only went through high school: sometimes they're dead wrong." He rose and closed his desk.

"What do you think I should do next?" I asked.

"For one thing, I'd see the policeman on the beat. They generally know a lot that goes on in their districts. Then you ought to know something definite about the young man: who he is and whether or not he's married to Edie."

"But how is it to be done?"

Mr. Critcherson's eyes twinkled again as he replied: "I guess you'll have to consult some card-reader, or palmist, to find out about that."

And I had to do it. There was no alternative. But to delay the ordeal, when I returned to Springfield Street the following morning I remembered that I had not consulted the lodgers on the street floor. The outside door was not locked and I stole quietly in, hoping not to meet the landlady. Besides her own there were two apartments on that floor. I knocked at the door of one and got no response. I had just knocked at the second when the landlady, hearing me, came out of her own quarters. She scowled when she saw who it was. "What are you doin' here?" she asked. I explained the purpose of my errand. "Ain't I told you she's gone? They don't know nothin' about her. Now you get out, and don't you come snoopin' around here no more!"

I then looked up the policeman on the beat. He told me what I already surmised, that the place was "a dump," "all but that old Austrian toymaker on the top floor," he added. "He don't seem to know the kind of neighbors he's got." The officer could give me no information about the young woman with the baby. "What's her

name?" he asked. "I don't know her last name," I said, "but she's called Edie. That's what a palmist who lives there told me."

"Hortense? Ain't she something? She's been livin' in that house for years. We run her in now and again, but she carries right on at the old stand."

I spent the rest of the morning getting better acquainted with the South End, persuading myself that I was carrying out Mr. Carstens' wishes, but I knew very well that it was my duty to see Madame Hortense once more and, somehow, get the truth out of her. It wasn't until afternoon that I summoned up the courage to return to the lodginghouse. Luck was with me. I got in and up the stairway without meeting the landlady. I knocked very gently on Madame Hortense's door. When she first saw me there was a gleam of triumph in her eyes. "Come in, honey! I knew you'd be back, you bad boy! Now sit down and let me look at you." I was scared stiff but I took the chair I'd had the previous day. I had rehearsed exactly what I meant to say to her, but instead of that I sat there like a dumb man, staring at her with a kind of horrified fascination.

"You been dreamin' about me, honey, and that's gonna cost you two dollars." Then before I could gasp off came the dressing gown, but this time there was a chemise underneath; it concealed nothing, however. She was a mountain of flesh with breasts as large as captive balloons. My well-laid plan for getting information went for nothing. "Wait!" I said, jumping up. "You've made a mistake," and I blurted out the fact that I was an agent of the Society for the Prevention of Cruelty to Children. I've had many a smile about this in later years, but it was no laughing matter at the time. I learned the truth of the old adage that "Hell hath no fury like a woman scorned," or, rather, cheated out of two dollars. She reviled me in language beyond anything I would have believed possible, screaming at the top of her voice. There was nothing for it but to retreat, which I did, hastily; and, as I ran down the stairway, there was the landlady at the bottom. Her blast, added to that of Madame Hortense, fairly lifted me from

the doorway and dropped me at the corner of Joy and Mt. Vernon Streets.

This ended the investigation of my first case, but I still had to dictate the results of it to Miss Blake, one of the Record stenographers, a jolly wholesome girl and a devout Catholic. I watered down the "facts," paraphrased the landlady's remarks and omitted the details of my two encounters with Madame Hortense. I described her merely as "a woman lodger on the second floor who claims to know mother but refuses to say where she has gone."

When, later, I had my first consultation with Mr. Carstens, I laid the Manila folders containing my first case histories on his desk and waited anxiously while he read the results of my Edie investigation.

"Edie," he remarked. "That is, evidently, an abbreviation for Edith. You were not able to get her family name?"

"No, sir," I replied.

"No facts concerning her history, nor any definite information as to where she may have gone?"

"No, sir."

He glanced through the record again and then remarked, gravely: "It would be well, I think, for you to see once more the woman lodger on the second floor. Evidently, she knows the mother, and the young man who may be the father of the child. She refused to give you his name?"

"She thought I was the young man," I replied. "I didn't tell her, at first, that I was an agent of the S.P.C.C."

"But you did, later?"

"Yes, sir; at the time of my second visit."

"And then she refused to say anything more?"

Mr. Carstens' quiet office vanished from view, momentarily. I heard again the Madame Hortense's enraged screeches mingled with those of the landlady, and saw the heads of other women lodgers — who had not been "at home" when I called — peering over the bannisters of the upper floors. I was tempted to tell Mr. Carstens of Madame

Hortense's manner of saying nothing more, but, somehow, I could not bring myself to discuss facts of this kind with the General Agent. He didn't speak of it, but I could feel his annoyance as he examined the Manila folder, noting that it was marked Edie for filing.

"Well," he said, "let this case be marked 'Closed,' for the present, at least."

But it has never been completely closed in my memory.

xii. "Old Slum"

DURING THOSE EARLY WEEKS in Boston I was, in fact, a little home-sick, and as I sat by the window of an evening I would close my eyes and imagine that I was under the linden tree on my Hill. But my work was so varied and interesting that I soon forgot to be homesick, and when the day ended I looked forward with increasing pleasure to returning to my dormer room on Louisburg Square, where the woodshed poet was at ease.

My next assignment was the case of Mrs. Moriarty, the mother of three young children who lived in what Mr. Critcherson had described as "one of those five-story boxes to pack human beings in, one toilet that don't work to each floor." I had already seen many a street and alley lined with such tenements and had been inside a dozen or more of them. I was conscious of a deepening feeling of indignation toward the City Fathers of Boston who allowed such abominations to exist, and more particularly toward the owners of these rat warrens who drew fat revenues from them. A boyhood spent in a small country town of the Middle West had kept me free from any proletarian feeling; it was not until the Chicago summer that I became aware of the gulf that separates the poor from the well-to-do. There were no classes in Colfax. But in Boston the contrast between the dwellings on Beacon Street, Commonwealth Avenue and other districts in the Back Bay, and the rat warrens of the slums was appalling.

The complaint in this case had been made by another lodger who

accused Mrs. Moriarty of being unfit to raise her three children because of lewd conduct. She "harbored men," the term Miss Butler had used in making out the complaint sheet; in particular, an Italian maker and vendor of plaster-of-Paris images. "Complainant asserts that he visits mother frequently, and that mother is often away from home until the small hours of the morning, leaving children alone. Believes children illegitimate. Other lodgers at Mullin Court can verify her accusations."

These supposed "facts" made me suspicious to start with. I wondered if the complainant were not the kind who attends to everyone's business but her own. But the complaint had to be followed up, so I went first to her tenement for further details.

She was a thin-lipped, middle-aged woman with a wedge-shaped face that seemed to have been fashioned for peering around curtains and through the cracks of doors. She informed me that she did not belong in such a neighborhood, in a tenement filled with riffraff; but she had to put up with it, now that her husband had "passed away" leaving her only fifteen dollars a week insurance money to live on. She was a respectable woman and felt it her duty to report the carryings-on of "that Moriarty woman."

Her replies were vague when I asked for particulars of the "harbored men." Presently she acknowledged that she knew only one by sight: the Italian image-maker. "Far's I know he only comes in the daytime, but he stays with her for as long as an hour. She ain't buyin' plaster dolls fixed up to look like saints all that time. But don't you let on I made the complaint. She's an awful woman, and strong, too. She might murder me."

I asked about the husband.

"She ain't got none; that's my belief. I hear other women around the Court yellin' 'Where's your husband?' at her. There ain't a night, except the last week or two, that she don't go out, and she comes back at all hours. I hear her. Her rooms is right over mine."

"Do you know her at all?" I asked. "Have you spoken with her?"

"I'm a Protestant," she replied; "the only one in this block I shouldn't wonder. I don't mix up with anyone here. But she's got a tongue like poison and fights with other women all around the Court."

I inquired about the neighbors who were to verify her accusations, but she could give me no names. "All you need to do is ask around," she said. "You'll find plenty. But don't you let on I told you," she repeated as I went out the door.

In the hallway where the staircase turned to mount to the next floor was a small window with the lower sash raised and propped up with a stick to admit what little air there was. The heat was intense and the air stagnant; it seemed coeval with the tenement — air that had been breathed over and over again for decades past. I stood at the window looking down into the brick-paved court. There were no proper receptacles for garbage. Boxes, rust-eaten dishpans, pots and kettles no longer fit for other uses, heaped high with rubbish, were placed outside the doorways. Banana skins, melon rinds and old newspapers littered the pavement. At each floor, from window to window across the court were clotheslines rigged on pulleys and filled with washing. Women on both sides of the court were engaged in a hot argument concerning the clotheslines: who had, and who had not, the right to hang out washing on that particular day. They yelled at one another in various languages, but the Irish had the best of it, both in volume of sound and the telling nature of the salvos exchanged. A voice directly above me — I guessed it to be Mrs. Moriarty's — hurled threats, curses, and anathemas so varied and so vividly pictorial that I marveled at her versatility; but she had no mean adversary across the court. The words of the answering blasts seemed to burn the stagnant air. Presently the uproar died down somewhat. I mounted the stairway and knocked at Mrs. Moriarty's door.

She had a careworn face, though without a hint of meekness in it, and her hair was streaked with gray. She looked to be about forty and was, indeed, well built. She was breathing quickly and her attitude was that of a woman whose fighting Irish blood was up, and

who had turned from an enemy at the window to face another at the door.

"Mrs. Moriarty?" I inquired, politely.

"I am," she replied, and then, without giving me a chance to say more she lit into me with a vigor that left me groggy. I was to go straight back to "the cold-blooded divil" that sent me, and if I or any other of his collectors knocked at her door again, she'd murder him with her bare fists.

It required a moment or two to gather that Mrs. Moriarty had mistaken me for a collector of dues for a Burial Society, and as soon as she allowed me to speak I relieved her mind about that. She then quieted down and asked me to take a chair, but her attitude was that of a woman on her guard, who believed that any strange face must be that of an enemy, real or potential.

"It's the truth I was sayin'," she remarked. "I've been lamed at me charin', scrubbin' floors the night long, but I'm ready for wurruck again, or near it. What's your business with me?"

She sat with her sturdy arms folded, the fists closed, as though to be ready for battle on a moment's notice. A child, a boy of about four years, appeared from an adjoining room and went to the mother with that unmistakable assurance of welcome that indicates at once the relationship between mother and child. Mrs. Moriarty silently took him on her lap while waiting for me to speak.

One of the most delicate and difficult tasks of an agent of the Society for the Prevention of Cruelty to Children was that of informing a parent, or parents, that a complaint against them had been made, and the nature of it. Sometimes the evidence in proof of neglect was evident at first glance — as in one case where I found a mother in a drunken stupor, lying upon the body of her two-weeks-old child which she had crushed to death, while another child, a little ghost of famine and neglect, stared at the mother from a chair nearby. But how could I tell Mrs. Moriarty of the complaint against her? Two small plaster-of-Paris images of saints that stood on a little shelf near

the stove seemed to offer proof of innocence rather than of guilt, and the best proof of all was in her honest Irish face.

She listened with an air of ominous quiet while I explained as diplomatically as possible that a complaint had been made, not disclosing the nature of it. "Please understand, Mrs. Moriarty," I said, "that I am merely an agent sent out to inquire into the facts. Every case reported to the Society has to be investigated, and we often find that there is no word of truth in the complaints." I added, like the novice I then was: "Sometimes the complaints are malicious ones made by enemies of the father, or mother."

Mrs. Moriarty still remained calm; she had not yet fully grasped the fact that she was said to be a mother neglectful of her children, but this was coming home to her little by little.

"D'ye see anything amiss with my Timmy?" she asked, grimly. "Does he look like I starved him or abused him?"

"Not at all, Mrs. Moriarty," I replied, heartily. "He's a fine little fellow and very fond of his mother, that's sure."

"And I've two more, studyin' their lessons at St. Joseph's School at the very minute. Don't I walk the floors of the courthouse on my knees, night after night, scrubbin' the marble steps after the dirty feet of them asleep in their beds that pays me ten dollars a week to house and feed three healthy, hungry boys? And don't I do it in spite of 'em, and pay me dues, up to three weeks ago when I was lamed past bearin', for a decent burial when I'm a worn-out old woman at rest in the peace of God? But I'm not that yet, blessed be Mary and Joseph that stands on the shelf above the stove where I've got a fine stew cookin' . . ."

Then she noticed smoke coming from the pot, set Timmy down quickly and ran to the stove. As she raised the lid of the pot the air was filled with the acrid smell of burning meat and vegetables, and I could scarcely see her through the cloud of steam that rose as she poured in water. Had Joseph and Mary been made of wax instead of plaster of Paris they would have been melted by Mrs.

Moriarty's comments as she peered into the pot at the ruins of her children's supper. The heat of the day in that wretched tenement was enough to have tried the patience of a saint, and Mrs. Moriarty had provocation and to spare beyond that. Forced, temporarily, to give up her charing work because of crippled knees, she had been pestered by collectors from the Burial Society, and to top all she was now complained of to the Cruelty Society for neglect of her children. I was more than glad that my apologetic manner in speaking of the complaint had absolved me from blame, but she remembered what I had said of malicious enemies.

"Who was it?" she demanded, peering at me through clouds of steam as she stirred the mess in the pot as though she were boiling the entrails of her enemies. "The lyin' foul-mouthed she-divil! I'll tramp her down! I'll give her a beatin' she'll never forget!"

I wished that I might have replied, "Old Hatchet-Face who lives just below you," but we were not permitted to reveal the names of complainants other than policemen and such other public officers. Strangely enough, Mrs. Moriarty did not suspect the real informant but jumped to the conclusion that it was "Kate Foley," her enemy across the court. I knew nothing of Mrs. Foley's character but it was my duty to relieve her of suspicion here. Mrs. Moriarty would not listen; she was in all truth "beside herself." I was reminded of Black Alice of the Bristol House when the dishes began to fly. She ran to the window and a moment later Mrs. Foley appeared at hers across the court. Mrs. Moriarty used only words for ammunition, but these were murderous enough.

I tried in vain to get Mrs. Moriarty's attention; she paid not the slightest heed to me, and so, after standing helplessly behind her for some little time, I left the tenement and went down into the court. Women were at most of the windows, leaning out on their forearms. Some were mere spectators; some took Mrs. Moriarty's part and others, Mrs. Foley's. Because of the many lines of washing I heard rather than saw most of the contestants, but the court was

bedlam itself. As I stood there, undecided whether to go or stay, the Italian image-vendor emerged from a door at the end of the court. On a platform about two feet square which he carried on his head, stood a congregation of saints, some female with gilded halos over their heads, others male with their hands outstretched in benediction or blessing. The Italian was a fat, jolly-faced man who walked with an easy, jaunty swing keeping the platform perfectly balanced. Neither he nor the saints seemed to be conscious of the stream of sulphurous words passing overhead. A moment later he vanished at the entrance to the court.

"Come down into the yard, ye piss-pot and I'll put ye to the use ye was made for!" Mrs. Moriarty was yelling. "Come down and say to me face what ye've been tellin' behind me back!"

She vanished from the window, and a moment later strode into the court, without a hint of lameness, ready for battle. Then — whether Mrs. Foley had cut the clothesline stretched between their windows, or whether it was rotten and had parted because of the weight of washing festooned along it, I could not tell; but down the washing came. The far end of the line was caught, momentarily, by another beneath; then it fell free, dragging the washing in the muck of the court. Mrs. Moriarty seized the middle of it, though her head and shoulders were enveloped by one of her own petticoats. Derisive hoots and yells came from members of the Foley faction and indignant cries from those who favored Mrs. Moriarty. Still facing her enemy she held the line aloft to keep as much as she could of her washing from the filthy pavement. I wished that she might have been standing on the prostrate body of old Hatchet-Face who had caused all the trouble.

The same afternoon I consulted the officer on the beat. He was indignant when I told him the nature of the complaint made against Mrs. Moriarty.

"Now who could have been tellin' such lies about the good woman?" he said. He confirmed what Mrs. Moriarty herself had told

me of her work, scrubbing floors and stairways at the courthouse. "Sure it is that she comes home at all hours," said the officer, "for she works at night; but she's as decent a woman as you'll find in the block." As for the Italian image-vendor, there was not an ounce of harm in him. He made and sold, not only images of the saints, but figures out of storybooks, elves, dwarfs and the like. "If he stays for an hour in Mrs. Moriarty's tenement, it'll be because the children keep him there, listenin' to the stories he tells 'em while the poor woman sleeps, after workin' the night long."

He then spoke of the father who had deserted his family two years before, since which time Mrs. Moriarty had managed as best she could on her ten dollars per week. I asked whether she had tried to find her husband. "Poor woman, what time has she for that?" said the officer. His face lighted up when I told him that bringing absconding fathers to book was a part of the work of the M.S.P.C.C. "Is it, now!" he said. "Then you couldn't do better than to search for that rogue of a Moriarty."

He went with me to her tenement, and as we mounted the stairway, Hatchet-Face was spying at her door; evidently she thought she had succeeded in getting Mrs. Moriarty into trouble. Later, I gave her a piece of my mind, but there was more important work to be done at the moment.

This was toward evening of the same day, but as I saw no prostrate body lying in the court, I gathered that Mrs. Foley had not accepted Mrs. Moriarty's challenge. The place was quiet now, or comparatively so. The children had had their supper and the unwashed plates were still on the kitchen table. Not a scrap of food was left on them. Burned or not, they had eaten the beef stew.

Mrs. Moriarty received us quite calmly. She had retrieved her washing and the soiled garments were again soaking in a tub. I asked whether the clothesline had been cut. She shook her head. " 'Twas broke," she replied, and her eyes blazed as she spoke of the agent for the tenement who refused them even a bit of new line to hang

their washings on. As for Mrs. Foley, they were friends again. " 'Twas not Kate who's been spreading the lies about me."

"That's what I told you, Mrs. Moriarty," I said.

"I was that stirred up I wouldn't believe ye," she replied, adding, grimly: "I'll thank ye now to tell me who it was."

I was right on the nail. With Officer O'Brien putting in a word here and there I spoke of her husband who had walked out, leaving to her the care and support of the children.

"Was it *him* ye was speakin' of?" she said. "Why didn't ye tell me?"

"You didn't give me the chance," I replied. Then Officer O'Brien and I urged that she owed it to the children to make their father support them, if she knew where he was to be found. "Why did he leave you?" I asked.

It was partly her fault, she said. She had "the divil's own temper" when her blood was up. "But the man's lazy and loves his drink better than his children."

The result was that she consented to a search being made for her husband. The case was then transferred to "Judge" Ewers, the agent at the M.S.P.C.C. who had charge of those concerned with nonsupport. With the little information that Mrs. Moriarty was able to furnish, her husband was traced, found at Worcester, brought into court there and ordered to pay his wife twenty-four dollars per month. This he agreed to do, provided that he should not be compelled to return to her.

While carrying on with my work at the M.S.P.C.C., at Mr. Carstens' suggestion I attended the weekly meetings of the Monday Evening Club, held at 3 Joy Street, where papers were read by eminent authorities on social welfare work, followed by round-table discussions. Why is it, I wonder, that I have so faint a recollection of these meetings when I remember so clearly the impromptu lectures of John Powers, janitor at the M.S.P.C.C., and the "round-table" discussions that followed between John and his audience of one?

John slept in the basement of the building, and in the summer evenings he sat outside the Joy Street entrance, his chair tipped back against the wall, taking his ease as he watched the passers-by. He was a grimy old Diogenes, with a walrus mustache of such proportions that the bowl of his pipe barely reached beyond it. His clothing looked as though he slept in it, and he shaved only now and again. After supper at Mrs. Le Clair's, I often joined him at his observation post. John would bring me out a chair and the lecture would begin, interrupted by frequent pauses to relight his pipe.

His opinions on social reform and the various agencies connected with it, including the M.S.P.C.C., were not orthodox. One of his favorite expressions was: "I'm only tellin' you how it looks to me"; and how things looked to John furnished matter for many discussions between himself and the earnest young social worker from the Corn Belt. He had an innate distrust of all social workers, and others who believed in the possibility, or the desirability, of social betterment. He liked Boston just as it was, particularly the slum areas, and the dingier, the more crowded they were, the better he liked them. I came to think of him as "Old Slum," the name seemed to fit him so well. One evening when I had told him of my visits to Mullin Court, while on the Moriarty case, and of the conditions there, his comment was: "People in them places has plenty of fun."

"Fun!" I said. "You think that human beings enjoy being herded in tenements not fit for pigs; that lack even the most primitive conveniences? They are quarreling and fighting from morning to night."

"That's what I was tellin' you," said John. "They love fightin' and they get more chance when they're all pigged in together. Mr. Hall, if you was to give every one of them families a nice cottage in the country all fixed up clean an' tidy, inside of two weeks they'd want to come back to Mullin Court or any other court." It was useless trying to convince him that all people love decency and privacy and order. "You don't know nothin' about it," he would say. "You was born and raised in the farmin' country where everybody has their

own home, with cows an' chickens walkin' around. You couldn't *give* that kind of home to people who was born an' raised in the tenements. They don't mind noise an' dirt; they wouldn't be comfortable without it. These social workers make me laugh, inside. They think they're goin' to change human nature. You do, yourself."

"No," I said, "but I think the conditions under which tens of thousands of human beings are forced to live will be changed." He gave a sardonic grin. "When they are you come around an' tell me. You don't know Boston. It's full of shanty Irish, but of course the shanties is bigger here than they was in the Old Country. . . . No, I ain't losin' no sleep about what social workers will do in Boston."

One of his contentions disturbed me because I felt that there was truth in it. He believed that it was better for children to be neglected at home than well cared for in whatever institution. "Take the kind of children we have to do with: there ain't one in a hundred that wouldn't ruther be in his own home, no matter how bad it is, than in any Home, no matter how good it is." A considerable number of my later experiences as an agent of the M.S.P.C.C. bore this out. More than once I had a case before Judge Baker, in the Juvenile Court, in which the evidence showed the most gross and palpable neglect, moral and physical, on the part of fathers and mothers who were a disgrace to parenthood. And yet, when the moment came to decide what was to be done with the children, there was no doubt as to their wishes: they wanted to stay with the parents. I realize that this is no valid reason for permitting them to remain. Nevertheless, when the bonds of love between parents and children were unmistakable, it was disturbing, to say the least, to see them broken. I can still hear Judge Baker's voice, and his words, meant to be reassuring, when the decision was made. "Now, children, I'm going to send you to a *good* Home where you will be well cared for. I am sure that you will be very happy there." The children would look at him forlornly as though not understanding, or not believing that such a thing could be; and the parents, well knowing how just the decision was, would

listen in woeful silence. And when the moment of parting came, the scenes that followed were, often, deeply affecting. I would try to remain wooden-faced, but it was no easy matter.

During those early days in Boston, I was happy in forming three friendships that neither time, nor intervening space — five thousand miles of it — have dimmed or tarnished. Their names, carved deeply in the rock upon which real friendship is based, are, Roy M. Cushman, George C. Greener, and Laurence L. Winship. Cushman was then a probation officer in Judge Baker's Juvenile Court. Greener was connected with the North Bennet Street Industrial School and soon after became the head of that institution. When I first met him, Laurence Winship had just graduated from Harvard. He, too, was earning $15 per week. For a year or two he assisted his father, a leading spirit in the National Education Association, in editing the *Journal of Education*. He then became a cub reporter on the Boston *Globe* and is now its editor.

Of all Boston social agencies, I know of none that has been of greater value, directly and indirectly, to the people of Boston than the North Bennet Street Industrial School. Its main purpose was, and still is, to provide youngsters — mostly of Boston's North End, who are compelled to earn their living as soon as they finish grammar school — with spare-time training in the skilled trades: carpentry, cabinetmaking, tin-smithing, jewelry manufacture and the like, that will lift them above the status of errand boys, operators of elevators, casual laborers. And the main purpose draws with it so many subsidiary ones, not the least of them that of making good citizens of boys who might so easily become mere drifters and wasters. One of my great pleasures upon returning to Boston from time to time, during these many later years, has been to walk with Greener down Hanover Street to Salem Street, and along Salem to North Bennet; or through other streets in that section of Boston. His circle of friends and acquaintances seems to include practically everyone living in the

North End. Faces light up when they see him coming. "Hello Mister Greener," "Morning, Mister Greener," "Hi-ya, Mister Greener!" Such a walk is a leisurely one, for he is halted many times by former North Bennet School boys, now fathers of thriving families, and by students in training who have matters to discuss with him. The old four-story brick building at 39 North Bennet Street — which was dingy enough when I first saw it, forty years ago — has always seemed to me a sacred place, a very temple, and one in constant use six days and nights per week. I think of it as an institution that deserves to be named with the Public Library on Copley Square, Faneuil Hall, the Athenaeum, Symphony Hall, and 8 Arlington Street, home of the *Atlantic Monthly* — institutions that have made the name of Boston honored and revered.

The North Bennet Street School was my ace-in-the-hole in discussions with John Powers. When he spoke of some social agency of which he disapproved and went on to make a blanket indictment of all others and the people connected with them, I would speak of the North Bennet Street School. "That ain't no social agency," he would say, and when pressed to explain why it was not he would hem and haw and finally admit that maybe it was, a kind of one. He acknowledged that the work done there was useful, but his approval was, mainly, of the building that housed the school. Its ramshackle, down-at-heel appearance was just as it should be, he thought.

So, I continued my double life, carrying on by day with the work for which I was paid, and, at night, writing verse that I couldn't even give away except for one poem, "October," printed in the Boston *Transcript*. But "Old Slum" and Mrs. Moriarty had taught me lessons that were beginning to sink in and I remember my delight when a sonnet, "Charwomen," was not only accepted and printed, but paid for ($5), by the editor of *The Bellman*, a magazine published in Minneapolis. During my nightly rambles in Boston I discovered that Mrs. Moriarty was only one of a small army of women, of all ages, "walkin' the floors," on their knees, of office buildings,

banks, public buildings, restaurants, and the like, in the small hours
when the daytime occupants had long since gone home. During these
solitary excursions I mused about two aspects of Boston: the city as
seen upon a golden autumn afternoon, and as it appeared in the murk
of a November night when a raw east wind had driven all but the
homeless within doors. In this latter picture I would see Mrs. Moriarty
trudging wearily to Mullin Court, in the cold and wet. I wanted to
pay a tribute of deep sympathy to her and to all charwomen who
toiled so hard, for bare subsistence.

CHARWOMEN

There is a building on a city square
That soars in marble to a golden dome;
A temple reared to Pleasure, and her home.
Thither, at night, her votaries repair
To worship her in wine, and dainty fare.
Laughter and lights and music dance and foam
Upon the liquid hours. But when they come,
The toiling ones, Silence alone is there.

The tired old women, creeping on all fours,
Do Pleasure's drudgework when herself hath fled.
To them her palace nothing is but floors
And staircases, all soilure with her tread.
They move through empty rooms and corridors
Scrubbing, on hands and knees, to earn their bread.

This was the one accepted by *The Bellman*. And the five dollars?
Did I share it, as I should have, with Mrs. Moriarty? I did not. There
must have been a reason why I failed to do so. More than likely I
was behind with my room rent; I was earning only five dollars a week
more than charwomen's wages. But this was no adequate excuse, and
my failure to divide with Mrs. Moriarty has burdened my conscience
these many years.

xiii. A Bench on Boston Common

NOT FAR FROM the broad walk that leads across a corner of Boston Common from the Park Street subway station to the steps mounting to Beacon Street where the Shaw Memorial stands, there is a bench that has for me many happy memories connected with my reading life during the years 1910–1914. It was no different from other benches that bordered the walks crossing the Common, but it became my custom to choose this particular one when reading out-of-doors in fine weather, on Sundays and during other hours of leisure. When I was last in Boston, I again sat on the identical bench — at least it looked the same — thinking of the books I had read, in whole or in part, at that spot: *Don Quixote*, Charles Lamb's *Letters*, an 850-page pocket-size abridgment of Pepys' *Diary*, Edwin Arlington Robinson's *The Children of the Night* and *Captain Craig*; and how many other associations connected with books cluster around that bench! But one stands out above all others. While sitting there one midsummer Sunday I first opened a book which a friend had loaned me: Joseph Conrad's *Lord Jim*.

I read through the whole of that Sunday, missing both lunch and supper at Mrs. Le Clair's, and when the out-of-doors light faded I hurried back to my room on Louisburg Square and read on, until I had finished the tale. At first I was mystified and puzzled as to the continuity, but that did not prevent me from going on with it, as it has some readers with whom I have discussed *Lord Jim*. The first reading was followed within a week by a second, and I will not ven-

ture to say how many times I have reread it since those days. Patusan — the Lord Jim country — is, to me, the most glamorous of all lands that have been imaginatively revealed in the Kingdom of Romance.

As my reading indicates, I continued my double life throughout my four years in Boston: the hope of becoming a writer was the one I held in my heart of hearts. Knowing well by this time my limitations as a poet I did not aspire beyond them. I had what I thought was a splendid idea. I would be a newspaper poet, and so I consulted my friend, Laurence Winship, about the possibility of getting employment in this capacity on the Boston *Globe*. Winship was then only a cub reporter without much influence in the upper hierarchy of editors on the *Globe*. Nevertheless, he made inquiries in my behalf, but was obliged to tell me that the *Globe* did not require a poet. Had the decision been favorable I might have been a precursor of Eddie Guest, but I am sure that I could never have approached his versatility in writing newspaper verse — a poem a day, year in and year out.

I had little encouragement from magazine editors. My collection of printed rejection slips would have covered one wall of my bedroom. Why not try prose? And so, one evening, I wrote at the top of a clean new sheet of paper: "Letters from Louisburg Square."

What a relief! Presently I found myself writing easily, joyously, without any of the mental sweat which the writing of verse had caused me. This may have been due to the fact that I chose the letter-form for my first effort and that I kept a particular audience of one in mind. The letters were addressed to "Dear William" — William A. Ziegler, one of the Grinnell Glee Club. We had been warm friends all through college, and at this time he was a Rhodes Scholar at Oxford. We corresponded regularly, but I told him nothing about the "Letters from Louisburg Square." I wanted to surprise him by dedicating to him the volume of letters which were flowing so readily from my pen. This, my first "Work," I found an easy task; and it was both the first and the last time that I found one so. I wrote of my

daily experiences as an agent of the M.S.P.C.C.; of the books I was reading; of my excursions to Salem, Concord, and elsewhere. Henry Thoreau appeared often in the letters, for I had, of course, long since begun week-end pilgrimages to Concord and Walden Pond. In those days I had the Pond pretty much to myself, with the spirit of Thoreau for my only companion. But "companion" is hardly the word. I had such respect for Thoreau's love of privacy that I felt something of an intruder even then, many years after his death. In the mind's eye I would see his solitary figure slipping across back lots on his way to the woods, or hoeing his beans, or sitting at his table in the hut as he worked over his journals. Having read *Walden* I went on to his other books, including the four volumes from his journals named for the seasons, edited by his friend, H. G. O. Blake. It was Thoreau who made me unhappily aware of the heterogeneous nature of my own character. I felt that I was made up of odds and ends, shreds and patches of ancestors, while he was so completely a whole man, harmonious in every part.

It was my hope to have the letters appear serially in some magazine. Alas! I added eight more rejection slips to my rapidly growing collection.

As I think back to the winter of 1913–1914, the mood of quiet desperation which prevailed during that winter returns to me. I was still tramping through slush and snow along tenement streets in various parts of Boston, with the familiar blue complaint sheets in my pocket. I continued to be deeply interested in my work, and the fact that my wages had been raised from $60 to $100 per month seemed to indicate that Mr. Carstens was, at least, satisfied with it. But I had a growing conviction that the Society's efforts were of a purely palliative nature. I never doubted the usefulness of the work, but as I peered ahead I could not even dimly glimpse a time when the conditions of life that made it so would no longer exist; but I could see myself, twenty or thirty years later, as I saw Mr. Critcherson and Mr. Currier, the two oldest agents on the staff of the M.S.P.C.C., in a rut

growing steadily deeper, and, perhaps, at that time, resigned to remaining within it.

But if I gave up my job, what then? I had no desire to go into any kind of business, and the prospect of making a living by writing seemed hopeless. The net result of four years of such effort in my spare time amounted to: my poem, "October," printed in the Boston *Transcript*; "Charwomen," sold to *The Bellman* Magazine for $5; and one other poem, "Fifth Avenue in Fog," for which *The Century* Magazine paid me $15. In a notebook of those days, which I still have, appears the following entry: "3 poems per week at $15 = $45." The arithmetic is flawless, but the hope expressed in the notation was not to be realized even for one week. I thought that, by keeping from fifteen to twenty poems in continuous circulation from editor to editor, I might be able to average a weekly sale of three, but this was momentary enthusiasm engendered by the *Century's* purchase of one. I might have known that I had no grounds for such optimism; in fact, I did know it, for my entire earnings, by writing, during four years in Boston amounted only to the $20 I have mentioned. If I was to leave the M.S.P.C.C. I needed some gainful occupation that would at least keep body and soul together.

During these years I kept in touch with my old roommate, Chester Davis, who had gone West and was then editor of the Miles City *Daily Star* at Miles City, Montana. In one of his letters he gave me a hint for a possible job that greatly appealed to the solitude-loving part of my nature; that of a sheepherder on the great Western plains. I wrote him for details about it.

Dear Norm: —

About a sheepherding job, I have made inquiries and find that there are opportunities. Miles City is the greatest primary wool market in the world. There are great sheepmen left in the country out here; the Yellowstone valley is filled with them. They are in a bitter struggle against the homesteaders who are taking up the lands and water rights, destroying the free range

which is the foundation of the sheep business. At this moment
a partner in one of the big sheep outfits is lying in the hospital
here, hovering between life and death as the result of a punc-
tured chest from a Luger 38 in a fight with a homesteader
over a water hole. The homesteader is bound to win out in the
end, for he is constructive and intensive, while the sheepman
is extensive and destructive.

In the winter time there is plenty of need for sheepherders,
and as I am personally in touch with some of the big sheep-
men I am sure that I can get you a job. The pay is around $50
per month which you have no opportunity to spend. One of the
travelling freight agents for the Northern Pacific told me today
that there is nothing to keep a man from salting away $600 at
the end of his year's work at sheepherding.

There is no need to warn you about the loneliness of the
life. Unless a man has that in his head which eliminates the
need for companionship and external amusement, he had bet-
ter not herd sheep. But I know that, in your case, solitude is
an attraction rather than a drawback. There is opportunity for
boundless reading; and when, at dusk, you retire to your little
wagon for the night, with the wind howling about your ears,
there is plenty of time for reflection and meditation.

No more alluring prospects could have been presented to me at
that time. I remember the vagueness of my conception of the actual
duties of a sheepherder, but Chester's picture of his solitary delights,
sitting warm and snug by the little stove in his wagon during the long
winter nights, perhaps twenty or thirty miles from his nearest neigh-
bor, reading to his heart's content with the winter winds howling
about his shelter, convinced me that there was the life I wanted, for
a year, at least. And who could say what literary by-product might
not result from the experience? I could see myself, at the end of the
year, with *The Memoirs of a Sheepherder* under my arm and $600
in cash in my pocketbook, ready for the next vague and remote
destination.

The result was that, early in April, on the spur of the moment, I decided to call the Boston chapter of experience closed. I remember my guilty feeling as I came from Mr. Carstens' office after a lame attempt to explain the reason for this sudden decision. I had spent four years under his skilled supervision and training, and now I was pulling out with no adequate explanation for such a course of action. I wanted to tell him of my chosen avocation: pursuit of the Bird in the Bush, but, for some reason, I had never felt on easy terms with Mr. Carstens. He never unbent, even when we were drawn together over some of my case histories, cases that were fresh in my mind when we had our last interview. There was feeble-minded Effie, a lanky girl in her late teens, her limbs twitching convulsively. I remember my railway journey with Effie halfway across the state of Massachusetts to the town of Palmer where the Home for Epileptics was located. She was subject to fits, and throughout that interminable journey she kept assuring me that she was "gonna have one." But she failed to keep her promise and I was able to turn her over to the authorities at Palmer without having had the experience of being male nurse to an epileptic having a fit in the crowded day coach of a Boston and Albany train. There was Mrs. H—— and her brood of hopeless children. My guess is that the case history of the H—— family is far from complete even today, and that the children of those children are now the neglectful parents of a new brood; for the H—— children bred young. The age of consent, with the girls, might be described as "Any time. Any where. Any one." And there was Mrs. O'Brien, the giantess armed with a butcherknife, who when half drunk had chased me round and round her kitchen table; all that saved me was her drunken eagerness to get at me. She tripped and fell which gave me a chance to dodge out the door, and I barely missed being "crowned" by a china chamber pot which she hurled down at me as I came out the entryway below. I sometimes felt that Mr. Carstens did not fully realize the difficulty in getting complete records in cases of this kind.

Many a strange experience we agents had in the course of our work, and sometimes real temptations were thrown in our way — at least, in my way. Not all mothers of neglected children were hideous, middle-aged creatures. Some were extremely attractive, not spiritually or intellectually of course, but physically. Now and then I was assigned to cases that should have gone to Miss O'Rourke or Miss Marsters, and did, later, when the facts were known. Delinquent mothers may be far more dangerous and aggressive than delinquent girls; at least, that was my guess, having confronted a fair number of them. They were never bothered by moral scruples. Their attempts to contribute to the moral delinquency of an agent of the M.S.P.C.C. sent out to investigate them for the same offense were, sometimes, of so bold a nature that the only possible course of action was to flee. At least, that is what I would do. Fortunately, I survived four years' experience as an agent of the M.S.P.C.C. without becoming a "case" to be investigated rather than the investigator of the case; but when I recall the manner in which some of the temptations were offered, I wonder that I had the strength of character to resist them. Perhaps I flatter myself in calling it that. It may have been fear, and a consciousness of the everlasting shame that would be mine, if I were to fall.

The mere fact that I *could* be tempted may have had a good deal to do with my feeling that I would never make a first-class social worker. All of those with whom I came in contact seemed to me, like Mr. Carstens himself, far above even the possibility of temptation. They were a class apart, so devoted to and so deeply absorbed in their work that I could not imagine any of them ever being troubled by my kind of troubles. There is this to be said, however. Many of them were married, and a considerable number of those who were not gave one the impression of having reached middle age and beyond in complete ignorance of, or superior to, the appetites of the flesh.

There was an exception, a lady of about thirty whom I met in

the strangest possible way. A case of cruelty, in the Roxbury district, no details being given, was reported through the customary channels and I found the complaint sheet impaled on the spindle on my desk. It was referred to me automatically, for I was then the agent covering the Roxbury district. Upon calling at the address of the complainant, in the Back Bay, and at the time requested — eight o'clock one Saturday evening — I discovered that she was a lady whom I knew by sight but not by name. I had seen her upon several occasions at meetings of the Monday Evening Club. A table laid for two stood before the fire in her pleasant living room, and to my great surprise I discovered that the second place was for me. I had already had supper at Mrs. Le Clair's, but I had no difficulty in eating a second meal which was light and beautifully prepared. Naturally, I wondered that I had been expected for dinner, but the lady seemed to take it for granted that I must have divined this, as though the invitation had appeared in invisible ink on the complaint sheet. She was like no social worker whom I had ever met, and she had the gift of putting a young man she had never met before, completely at ease. During the meal she said nothing of the case she wished to report. When I discovered that she, too, was a lover of poetry, self-consciousness vanished. This was the first time since coming to Boston that I had found anyone with whom I could talk freely about it. She spoke in general terms of social work and in particular terms, in a smiling, gently derisive manner, of various women social workers of her acquaintance. "I am not a professional social worker," she said; "only a volunteer for certain kinds of work that interest me. I'm afraid I am what an Associated Charities secretary would call a 'Benevolent Individual.' Isn't that terrible? You must not give me away at the Monday Evening Club. But my motives are not always wholly benevolent," she added.

I am not going into the details of that meeting, so important, so memorable for me. I will state the bare facts and nothing more. After dinner, before speaking of the case she wished to report, she asked that I would listen and not speak until she gave me leave. Then she

said that she had depended largely upon her woman's intuition in deciding that it was a case needing investigation and appropriate action. "I am rarely mistaken in such matters although I may be here," she added. "It is a case of self-inflicted cruelty, and it concerns not a child but a young man. What makes it so pitiable is the needlessness of his suffering. Any discerning woman could have told him that and have suggested the best possible remedy; but perhaps there are not so many of that kind. I asked him to call here this evening to assure him that, if help is needed, and wanted, I shall be glad to be of service."

She then rose and went to a door leading off from the living room. She turned there, her hands resting on the knob of the door at her back, regarding me in silence for a moment, the ghost of a smile upon her face. "If my intuition has betrayed me, that other is the door to the street," she added, and left the room.

Very late that night, returning through the Public Garden and across the Common toward Louisburg Square, I sat for a time on a bench, conscious of a peace of mind and body that was like heaven itself. I thought of a tortured young man who had been sitting on another bench on the Common repeating silently to himself the words of a stanza in Whittier's beautiful hymn — "Dear Lord and Father of Mankind":

> Breathe through the pulses of desire
> Thy coolness and Thy balm;
> Let sense be dumb, let flesh retire;
> Speak through the earthquake, wind, and fire,
> O still small voice of calm.

The hymn, sung often at chapel or vespers at Grinnell, had never come home to me then as it did, later, at Boston; nor had I realized that Whittier must have endured periods of intense suffering just like my own.

In writing these reminiscences I had meant to pass over in silence

such intimate, personal matters. But the fact of sex having popped up unexpectedly in the course of this chapter, it occurred to me that complete silence might lead a reader to suspect that I wished to give the impression of having been a Sir Galahad, "a virgin heart in work and will," throughout the entire period of my youth. This, of course, was not true.

What further persuaded me to speak of the experience was the curious nature of it. The originality of the method used in reporting the case through the customary channels at 43 Mt. Vernon Street, the complainant knowing that it would reach the agent concerned, was typical of the lady who chose that method. Nothing that she did was commonplace or to be expected. To think that the complaint sheet had actually passed through Miss Butler's unsuspecting hands!

I did not, of course, dictate the history of the case to Miss Blake, my stenographer; it is not to be found filed under "B" — Benevolent Individual — in the Society's record vault. Perhaps I have been guilty of a breach of good taste in recording the outline of it here. I hope not. My hope is, rather, that some young man of today — if the kind I was forty years ago is still to be found today — may be invited to dinner by a Benevolent Individual as discerning, as gracious, and as lovely as the one I had the good fortune to be noticed by. And if her motives should not be wholly benevolent, so much the better for him.

I traveled homeward in the day coaches of local trains, all the way from Boston to Colfax. Trains could never go too slowly for me. I loved seeing the country, conscious all the while of the vastness of the continent which we Americans have the good fortune to call Home. With me I had small gifts for various members of the family in my suitcase, and a large framed picture, well wrapped in cardboard and heavy brown paper, on the seat beside me. It was a print I had found in an art shop on Bromfield Street, of that superb, well-known mid-ocean seascape: Mother Ocean herself, in all her loneliness and

grandeur, as she had been through countless ages, still is, and, one hopes, always will be. I knew my mother would love that print. She was inland born and bred, and had never seen the ocean; but because of that fact, perhaps, she had an imaginative conception of its vastness, beauty, and grandeur that had been passed on to me.

As the westbound local crossed the Mississippi into Iowa I had an immediate sense of an altered Spirit of Place. Ever since my Chicago summer the influence of that city seemed to spread westward across Illinois until it reached the Mississippi and there the river halts it. "Thus far but no farther," it says. To this day I am a kind of Tam o' Shanter, not feeling safe until the train has crossed the bridge to the Iowa side; then I leaned back in my seat and thoroughly enjoyed the rest of the journey, through West Liberty, Iowa City, Marengo, Brooklyn and other towns on the C.R.I. & P. that bring back so many happy memories of boyhood days.

The train halted for five minutes at Grinnell and I looked eagerly out of the window, hoping to catch sight of a familiar face, but the only one was the southern face of the Bristol House, showing the large sunny windows of the dining room, including the one at which Mr. Curtis Coe was seated on the day of the "very nice lunch," when he had tipped me Francis Thompson's poems; and there in the park was the very bench where, on that same day, I had spent the afternoon reading them. I wondered if Grandma and Grandpa Ridder still presided over the come-back table, and Black Alice at the dishwashing sink. However, I meant soon to return to Grinnell to renew whatever old friendships remained to be renewed at both my colleges. But it was home, first, of course.

I arrived there just in time for the hepaticas; or, rather, a day or two before the first ones appeared. All the family were at home over that week end. My older brother, Fred, was in business with my father who was a bottler and shipper of Colfax Mineral Water. Harvey was in the advertising end of the newspaper business in Des Moines. Dorothy, the older of my sisters, was a junior at Grinnell

College, and Marjorie was a third-grade teacher in the local grammar
school.

I remained at home throughout the month of April and the first
week in May. Many a "stilly night" I spent under the linden tree on
my Hill. The fragrance of hepaticas worked the old magic, but I can
find no words with which to explain the nature of it. The nearest I
can come is to say that breathing in that most delicate of perfumes
gave me a feeling of the sacredness of life akin to the childhood feel-
ing of the sacredness of Morning Sun Pond and the G-Note Road.

Colfax was still the town of my boyhood, but I had a forlorn in-
tuition that I was seeing it so for the last time. Plummer's livery
stable and old Mr. Prouty's harness shop were where they had always
been, and over and around them clung the unforgettable fragrance
of the horse-and-buggy era, but on the street fronting the railway
tracks was a garage whose oily, "gassy" smell sent shivers of apprehen-
sion along my spine. In the rear of the Gould clothing store I actually
heard farmers, including some of my old enemies, talking of "miles
per gallon" and the need for good roads, as though there could be
any better ones than the road to Prairie City or the one leading north
out of town past the farm of E. E. Black, Elmer's father. Elmer was
now a veterinarian, and as he bumped over the dirt roads in his
Model T, in the vicinity of Colfax, he was one of those unpaid
evangelists, whose numbers increased so rapidly that Mr. Ford, a few
years later, was able to announce to the nation at large: SEVEN THOU-
SAND MORE SINCE YESTERDAY — FORD.

There had been one change at home that I thoroughly approved of.
Our old "necessary house" had vanished, and a small upstairs bedroom
at the head of the stairway had been converted into a bathroom.
Mother had written me about this, so I was prepared for the change.
My father, who deplored change, even in the domestic economy,
apologized for having had water brought up from the cellar. "I had
your mother to consider," he explained, feeling that an explanation
was necessary for having gone so thoroughly "modern." It must have

been from my father that I inherited my own dislike of change, but I did not carry it to the lengths he did.

Both the barn and the woodshed remained, the woodshed poet's verses still legible on their walls; and the squeak, or, better, squeal, of the hall door had the same piercing quality that made the neighbors wince whenever they heard it. But the family had long since agreed that its voice was never to be stilled.

As I "looked to the northward" from the window of the bedroom that had been mine from boyhood, it was not to count the lights of occasional motorcars bumping slowly into town from that direction. I thought, rather, of the number of years that had passed since my graduation from high school, and how little ostensible progress I had made toward any definite goal in life. Ten years out of high school and four out of Grinnell, and I might still have been the youth debating Mr. Gould's offer of an end to work toward. My father had said no word in criticism of my sudden decision to leave my Boston job, but I wondered if he were not thinking that, instead of going to college, I might better have remained in the clothing business.

On my way back to visit the College I recalled what Professor Stoops had said of young men having ability in the abstract: "You hope it will crystallize so that you can see what it is composed of, but it remains in solution." When I met the Professor at Grinnell, he peered over the top of his spectacles in the old quizzical manner as though he were trying to peer inside me for some evidence of crystallization.

I was tempted to tell him of the spring evening of 1910 when I had overheard the conversation between himself and Professor Peck, but I knew that Professor Stoops liked to hear of tangible progress made by his former students, and so I made the best report I could of my four years of social work, and let him suppose that I was returning to it, after a brief vacation.

At the Sunday vesper service I had the good fortune to hear once more Gounod's *St. Cecilia Mass,* so loved by the students of my day;

and for a week-day chapel service, without letting me know, Professor Pierce selected two hymns which he remembered were my favorites: the first was "O, Love That Will Not Let Me Go," and the second, "Dear Lord and Father of Mankind." As I listened to the fifth stanza of the latter hymn, despite my efforts to prevent it my thoughts returned to two successive evenings on Boston Common. I felt that I should leave the chapel, but I could not do that, in the midst of the service. Professor Stoops, who had given me the benefit of the doubt in grading me in his "Ethics" course, was seated only two rows in front of me. What would he have thought, had he known!

Professor Payne no longer lived in the Chapin house; he had moved to rooms on the other side of Park Street. Though a professor of history, he was the same lover and discerning judge of poetry. With him I felt free to discuss my attempts to write it, and the result of those attempts. I even read him some of the poems while he listened with grave attention.

When I had finished he was silent for some time; then he said: "Norman, I know what you should do: enter the teaching profession; become an instructor in English literature. With your enthusiasm for poetry, think what you could do for youngsters just entering college, stirring in them the same kind of interest and enthusiasm! I see more and more clearly that the tendency in the U.S.A. is away from beauty and toward interests of a wholly practical nature. What kind of a nation will we become if the interests of young men of the oncoming generations are wholly confined to business, or science, or one of the professions, such as law and medicine, which are growing more and more specialized? Liberal arts colleges still stress the great importance of the teaching profession, but they alone do so, and their influence is small as compared with that of the great universities. All the more reason then why they should do their utmost to make that influence felt.

"Can you, seriously, consider taking the sheepherding job? If I know Chester he is secretly thinking: 'Good Lord! Does Norman

really want to waste a year of his life herding sheep when there are so many youngsters needing shepherds of the right kind?' But he will not say that to you because you are friends; Chester has a high conception of friendship and believes that no man should interfere or try to influence the course of his friend's life. So have I a high conception of friendship, but I don't agree with Chester in this latter respect. I have always known that you are a romanticist; at least, I knew it very soon after our first meeting. I am glad that you have so much of that quality in your nature; nevertheless, a romanticist must guard against the dangers inherent in romanticism. For example, your plans for world-wandering: what will such a career as that amount to? You must know as well as I do that it leads nowhere. I feel bound to speak out, for I would not willingly see any old student of mine choosing to spend his life as an irresponsible hobo."

Professor Payne went on to say that my great defect, as he saw it, was my lack of social consciousness. "You think too much about yourself," he said. I told him that I could not help that, having been born an introvert, adding: "I have spent four years in social work. That should prove that I am not completely lacking in social consciousness." "It should, perhaps, but it doesn't, in your case," Professor Payne replied. "The fact that at the end of the four years you want to become a sheepherder convinces me to the contrary. Granted that you are an introvert, this doesn't mean that you must go off to the plains of Montana and sit in a sheepherder's wagon. Give yourself a chance to become an extroverted introvert. If you will become a teacher of English literature, with special reference to poetry, I can almost guarantee that this will happen. The preoccupation with self will vanish in the interest you will take in your students."

The mere thought of becoming a teacher sent cold shivers running up and down my spine. I could imagine entering a classroom and finding myself confronted by twenty or thirty students. I knew exactly what would happen; my mind would go blank. I would be of no more value as a teacher than a dummy filled with straw.

Professor Payne glanced at his watch. "Have lunch with me at the Bristol," he said, "and we will discuss this further."

My old "college within a college" had not changed in the least, insofar as I could judge by its outward appearance. It chanced to be a Saturday and the lobby was well filled with the week-end influx of commercial travelers. Professor Payne remembered that I had been a waiter there and willingly consented to wait in the lobby while I went to the kitchen to see whether any old friends of my day were still employed there. I had another reason for going before lunch rather than after. I wanted to make sure that the unwritten law about serving come-backs only to commercial travelers still prevailed.

As I entered the kitchen, there was Grandma Ridder, clawing in the dishes a pair of student waiters had just spilled off their trays, and Grandpa Ridder was at his old place at the end of the table.

"Hello, Grandma!" I said.

She looked up, peering at me, holding in her hand a side dish half filled with uneaten mashed potato. With her other hand she clawed this into the mashed-potato container and slid the dish along to Grandpa.

"Why . . . you ain't . . . what's your name?"

I told her, adding: "I used to work here — remember?"

"Why, course I do! Norman, I wouldn't a knowed ye! . . . Paw! Recollect this feller?"

Grandpa Ridder shook his head, but he had been doing that steadily for years and I was in doubt as to whether he meant Yes, or No. But he did appear to remember me vaguely. Jack Grant, the chief cook, was the only other member of the kitchen staff who had been there in my day. Black Alice had gone, Jack did not know where, but he gave me news of two of the girls who had been waitresses in my time. They were sisters, and, as I have already said, like elder sisters to us student waiters. Jack said they had bought a farm in northern Iowa, paying cash for half the purchase price and giving a mortgage for the rest. "They made the cash right here at the Bristol,"

said Jack. "Those girls got good level heads and didn't throw none of their money away in foolishness." Even so, I was surprised. At its cheapest, Iowa land sold for no less than $100 per acre; they had paid at least $2000, cash down, he told me, probably more. I could not help thinking of the hours and hours of overtime they must have put in through countless week ends to have saved that amount.

xiv. Good-by to Summer

O N MAY 27, 1914, I sailed for Liverpool on the steamship *Laconia* and I went steerage for the simple reason that I could not have gone any other way. My sudden decision was prompted by the fear that I might yield to Professor Payne's plea to enter the teaching profession. I knew deep down that I could never hope to succeed as a teacher; nevertheless, Professor Payne's conviction to the contrary had made an impression upon me. Perhaps he understood my character better than I myself did. Perhaps he was right in assuring me that, after a month of teaching, my interest and enthusiasm would be so stirred and quickened that I would wonder how I could have had any doubts as to my fitness for the work.

On the other hand . . . I remembered Mr. F——, a Harvard Ph.D., who had taught at Grinnell in my day. He had a profound knowledge of English poetry, and there was no slightest question about his love for it. And yet, because of unconquerable shyness, he was a complete failure as a teacher. In the classroom I used to suffer with him and for him. My blood was hot with indignation toward some members of his classes who would chat in low voices among themselves during classroom periods, paying not the slightest attention to the instructor. Mr. F—— was deeply hurt by such behavior, but he lacked the resolution to speak up and smack them down in no uncertain terms.

I wanted to place the width of the Atlantic between myself and any possibility of further temptation and my funds were barely

enough to carry me through a summer in England. I had two plans in mind: the first was to reach Nether Stowey, in Somerset, where Coleridge had lived while writing *The Ancient Mariner*. I would visit the country thereabout, and walk the roads that Coleridge and Wordsworth had walked together at that time. Perhaps I would also catch glimpses of the ghost of John Chester, Coleridge's short, bow-legged friend: the one Hazlitt speaks of, who, he said, would break into a kind of trot in order to keep pace with Coleridge so that he might miss none of his conversation. My second intention was to spend the rest of the summer trying to write. I was not compelled to earn my living during the three months in England, but I still wanted to prove to myself that it could be done. Romanticists rarely profit by experience and I had been able to persuade myself that my luck would be better in England. It was a happy, hopeful woodshed poet who, early in June, arrived in London, a suitcase in one hand and a portable typewriter in the other.

I was as fortunate in finding lodgings in London as I had been on Beacon Hill, in Boston. It might have been a sister of my land-lady at 91 Pinckney Street, who showed me into a fourth-floor room of a somewhat decayed but genteel lodginghouse at 47 Bernard Street, W.C. 2. It was larger and more comfortable than my room on Louisburg Square, and the rent was only thirteen shillings and six-pence per week, including breakfast. As my landlady quietly closed the door behind her on the way out, I had the feeling of a man await-ing the crack of a pistol at the beginning of a three-mile race. Mine was to be a three-month race, and if I were to win it I knew that no time should be lost in making a start. I had had only a glimpse of Lon-don during my trip to England in the summer of 1909 and was deeply tempted to do some sight-seeing; but I feared that if I yielded to the temptation it might end in my doing nothing else. And so, grimly but hopefully I unpacked my few belongings and placed my type-writer on the table with a box containing 500 sheets of clean new paper beside it on my right hand. With a kind of panicky feeling

and with only a blurred notion of what I wanted to write, I drew up my chair and said to myself: "Now, then! To work!"

My mother used to save her children's letters, and I brought some of mine with me to Tahiti. Two of them tell the story.

<div style="text-align:right">

47 Bernard Street
London, W.C. 2
June 21st, 1914

</div>

DEAR MOTHER: —

I have been hard at work since two o'clock this morning — that is, two A.M. Colfax time; it was rather later than that by the London clocks. Now my brain is getting foggy and a change of occupation is called for.

I am enjoying London, what little I've seen of it so far, mostly from my fourth-floor window here on Bernard Street. All the sight-seeing I've done is when I go out for meals and an occasional evening walk after supper. Mother, will you please stop worrying about my food? Believe me, I'm not starving. Living here is much cheaper than it was in Boston. For sixpence I get a fine feed of fish and chips as they call it, with bread, butter and tea thrown in. A shilling, or a shilling and sixpence, provides me with a first-class meal in the evening, meat and vegetables that stick to the ribs. I have breakfast here in the lodginghouse; it is included in my rent. Breakfast has always been my best meal of the day, and here I get bacon and eggs, muffins or scones, with butter, marmalade and a fine big pot of tea. I'm beginning to like tea over here. My landladies certainly know how to make it, or it may be their cook.

Although there are no reproaches in your letters, I seem to read between the lines that you are far from happy about my giving up my work in Boston and deciding so hastily to come to London. But I'm glad that I did. As you know, I have long had yearnings for a literary career and it seemed high time to be starting in that direction if I were ever going to do so. Now I have three clear months to show myself what I can do.

Llangollen, Wales
July 26th, 1914

DEAR MOTHER: —

Alas for my hopes of earning something by writing this summer! After nearly six weeks in London, during which time every one of my manuscripts came back, I decided to seek inspiration in the country. I bought a second-hand bicycle and headed south, travelling for two days in that direction. Then I headed north again, avoiding London, and biked as far as Chester where I spent two days, though I wish it might have been as many weeks. But I wanted to see Wales. I plan to stay here for a week or two and then make a leisurely journey south and cross the Bristol Channel into Somerset.

I'm afraid this summer is going to prove a flop insofar as writing is concerned, or I should say, selling what I write. I see now that I shall have to go home at the end of September. And then — what? I don't want to go into business. I have a feeling in my bones that I was not cut out for a business man. I want to go home, of course, to see you all, and while I'm there perhaps dad could give me a job in the bottling works, or I could go back to Gould's clothing store with John and Billy Davis. This may seem to you like backing in my tracks, but I would stay only until spring. Remember, mother, that many a man who wants to write has a hard time getting started. A few months at home would do me a world of good. The birds will be gone of course — all but the crows in the bottomlands along the river. It would be good medicine for me, I think, to sit brooding in the snow on my Hill east of town, listening to the crows calling derisively: "He wanted to be a writer! . . . Caw! Caw! Caw! . . . Haw! Haw! Haw! And here he is back home again, no furrader than when he left high school! . . . Caw! Caw! Caw! . . . Haw! Haw! Haw!" After this summer's disillusioning experience I will need something like this to get my dander up and make a fresh start.

I did not explain in this letter why I had first gone south from London. It was for the purpose of calling upon Joseph Conrad. I have already spoken of my discovery of Conrad's *Lord Jim*, in Boston, and of the effect it had upon me. I then read *The Children of the Sea* — called *The Nigger of the Narcissus* in the English edition — and the *Youth* volume, containing those superb tales, "Youth," "Heart of Darkness" and "The End of the Tether." Never before had anything in the realm of prose fiction stirred me as these stories did. To me Conrad was the greatest artist of our times, and now that I was in England I longed to see the man who had stirred my emotions so deeply, and to whom I owed so many hours of the purest kind of pleasure. I made inquiries at several London bookshops, and the proprietor of one of them told me that Conrad was living at a place called Capel House, near Ashford, in Kent.

At Ashford I was given directions for finding Capel House. I will not enlarge upon this experience. It is enough to say that, as I biked in the direction of Conrad's home, although it was a warm July day my feet grew colder and colder. I realized that the chill was communicated by my old enemy, Diffidence.

"Do you think that Conrad will see you, or have the least desire to see you?" he asked.

"I don't intend to go in," I replied. "I will merely stand on the doorstep and tell him in a few words what I wish to say."

"Why didn't you send a note in advance and wait for a reply?" the voice continued. "You would know then whether or not you would be welcome."

I had not thought of this and was brought up short by the belated suggestion. That, of course, is what I should have done. The result was that I saw only the outside of Conrad's dwelling, looking so peaceful and quiet in the sunshine of late afternoon. I stood with my bicycle, gazing toward it, but saw no one. Then, lest the temptation to proceed up the walk and ring the bell should prove irresistible I

biked away at full speed, and did not slacken my pace until both he and I were well out of danger.

And yet . . . who can say? If I had rung the bell, the maid who answered it might have asked me in, believing me to be a friend of Conrad, which I was indeed. And Conrad, listening to my halting attempt to explain why I had come, might have thought: "I believe this young man has something to tell me, if only he can get it out. I will be patient and give him the chance." And this might have been the prelude to an invitation to tea, prepared by Mrs. Conrad's capable hands, and an hour's visit the memory of which I would have treasured for the rest of my life.

As I traveled north through the beautiful countryside in the direction of Wales, I had not the faintest premonition that I was enjoying with all England the last days of the Indian summer of an age that was all but gone. The peaceful farms and villages seemed rather to belong to people living in a Golden Age that might never come to an end. I caught glimpses of family groups having afternoon tea in their gardens, of others looking on at cricket matches, or fishing from the grassy banks of streams, or strolling through the fields, or floating dreamily along in punts on gently winding rivers. It seemed to me that I was passing through an earthly paradise, as it was, in fact. Here were people who had long since learned the art of living; who kept broad margins of leisure around their lives. Business in England seemed to be an avocation rather than the be-all and end-all of existence. No wonder, I thought, that England has nourished so many poets; the country itself proclaimed that all of these people were poets at heart. I was fortunate on that journey for I saw England at its best, and in perfect midsummer weather.

It was in the village of Beddgelert that I walked, all unsuspecting, into my first news of World War I. I had arrived from Llangollen only the evening before and took lodgings for the night at an ancient

inn called Llewellyn's Cottage, lighted by small leaded windowpanes in walls three feet thick. I well remember the events, such as they were, of that last evening I was ever to spend in a world at peace. Even then peace had gone, but I did not know of this until the following day. I was the only guest at the inn and had a delicious supper: roast spring lamb with greens and vegetables and a mug of home-brewed ale. I had been cycling all day through glorious country. After supper I read for an hour in George Borrow's *Wild Wales: Its People, Language, and Scenery*, a book which added greatly to the interest and pleasure of my journeys. Early the next morning I set out to climb Mt. Snowdon, but before I was halfway up heavy clouds covered the mountains and it started to rain. I realized that I would have no view from the summit and returned to Beddgelert where I saw a dozen or more men in uniform gathered at the post office. I fell into conversation with one of them, first about Snowdon which he had often climbed, and his account of the view from the summit made me more than ever eager to see it. Presently I asked in a by-the-way fashion about his army service and if he was quartered thereabout. He was not in the regular army, he said, but in a Territorial regiment which had just been called up because of the war.

I stared blankly at him. "War? What war?" I asked, and he stared in his turn at me. "Where have you been?" he said. "Don't you know that England, France and Russia are at war with Germany and Austria?"

All through the summer I had read no newspapers and had lived in such solitary fashion that I had spoken with scarcely anyone. I had heard something about the assassination of an Austrian archduke, in Serbia, but had no idea that it was an event of world-shaking importance. The following day I returned to Llangollen, sold my bicycle and proceeded by train to London. This must have been August 8 or 9. The next two weeks I spent walking the streets and squares of London: Piccadilly, Oxford Street, Tottenham Court Road, Leicester Square, Trafalgar Square, the Horse Guards Parade. This last was the

place where I spent most of my time, watching the long lines of young men moving slowly up to and into the recruiting offices. On August 17 the woodshed poet joined one of these lines, and when he left the Horse Guards Parade two hours later he was Private J. N. Hall, 9th Battalion, Royal Fusiliers, with a guaranteed stipend of one shilling per day.

xv. Kitchener's Mob

IN SEEKING A WORD with which to describe the spirit, the general feeling in England during the late summer and early autumn of that year, it seems to me that the one which comes nearest to expressing it is "Joy" — a kind of deep, solemn, sacred Joy. Rupert Brooke spoke for England, and not alone for the youth of England, when he wrote:

> Now God be thanked who matched us with His hour,
> And caught our youth, and wakened us from sleeping,
> With hand made sure, clear eye, and sharpened power,
> To turn, as sleepers into cleanness leaping,
> Glad from a world grown old, and cold, and weary,
> Leave the sick hearts that honour could not move,
> And half-men, with their dirty songs and dreary,
> And all the little emptiness of love.

By the process of slow, but increasingly swift evolutionary change — the only kind of change that has permanent value to mankind at large — the world was moving forward into an era of human betterment which, had it not been checked by war, would have shown magnificent results by this time. It is not conceivable that any young poet of today — granted that a third World War is in the making — could write in Rupert Brooke's vein; yet they did in 1914, which indicates the vastness of the change in men's feeling concerning war that has taken place in the intervening years. The change was all but

complete, of course, before the end of World War I. One has only to compare the work of the soldier poets who followed Brooke — those who wrote during the years 1916, '17, and '18 — to be convinced of this. They knew what sacrilege it was to speak of young men, with the best of life before them and each one eager to make the most of it, as "sleepers into cleanness leaping" — into the horror, shame and degradation of war.

One would think that a romanticist would have been cured forever of the disease by his experience in World War I, and I was cured of whatever illusions I may have had as to war being a noble adventure, but this was not until later. In the autumn of 1914 I shared the romanticism common, as it seemed to me, to the whole of England. This was not to be wondered at, perhaps, when one remembers that, up to that time, war had been something in which mainly professional soldiers were concerned. There were, of course, the ghastly butcheries of the American Civil War, but half a century had passed since these had occurred. In 1914 the great mass of people knew of war only through hearsay, and governments themselves — I cannot believe intentionally — contributed to the illusion that it was a sadly noble fulfillment of life at its highest intensity.

On the day following my enlistment I joined my just-formed battalion at Hounslow Barracks, near London: the headquarters, or depot, of the Royal Fusiliers, an ancient London regiment with a distinguished history. I was in a daze, not yet realizing what had happened to me, and my fellow volunteers appeared to be in the same condition. We were immediately provided with uniforms, Lee-Enfield rifles, and the other equipment essential to the infantryman. The greatest annoyance to me during that first week was the lack of side pockets in our trousers. From boyhood on it had been a problem with me to know what to do with my hands, and I had solved it in the only possible way by putting them in my trousers pockets. This had become as instinctive with me as breathing; the moment I started to walk my hands slid automatically into my pockets. Now, in uni-

form, they slid down the seams of my trousers. I remember how, on my first day at Hounslow, a sergeant paused to regard me critically, observing how my hands made repeated efforts to dive into pockets no longer there. "No place to put 'em — what?" he said. "Just you wait a bit. We'll show you what your hands are for." A good many others were almost as pocket-conscious as myself, but we soon learned the innumerable uses to which soldiers' hands are put and forgot that we'd ever had pockets.

Many of us had joined the army believing that within a few weeks we would be fighting in France, side by side with the First Expeditionary Force. Lord Kitchener had announced that six months of training at the least was essential. This statement we regarded as intentionally misleading. Unlike Germany, England was not prepared for war except insofar as the navy was concerned. She needed soldiers badly, immediately. After a brief period of training we should be proficient in the use of our rifles. All that was needed in addition was the ability to form fours and march in column of route to a railway station where we would entrain for Dover or Southampton, and on from there by ship to France.

Our COs and noncoms soon knocked this foolishness out of our heads. The 9th Royal Fusiliers was one of the earliest battalions recruited for the First Hundred Thousand, and we were fortunate in that our commanding officers and most of our noncoms were men of the regular army who had been on leave from India and other parts of the Empire when war broke out, and were retained in England to whip the volunteers into shape. Naturally, they were disgruntled at this, and our sergeants in particular vented their spleen upon us. I remember the first parade of my platoon of C Company for the purpose of teaching us how to form fours. We were lined up in double rank and the first rank then numbered off — one, two; one, two — quite successfully. Sergeant Breslan, our platoon instructor, a regular-army noncom of twenty years' standing, seemed to regard us as unpromising material.

"Lissen, you men! I never saw such a raw, round-shouldered, pasty-faced batch o' rookies in all my twenty years' service. Gawd 'elp 'Is Majesty if it ever lays with you to save 'Im! 'Owever, we're 'ere to do wot we can with wot we got. . . . Now, then! Upon the command, 'Form fours!' I wanta see the even numbers take a pace to the rear with their left foot and one to the right with the right foot. Like so: One . . . one-two . . . Platoon! Form fours! . . . Oh, my Gawd! As you were! As you were!"

It seemed strange that so simple an order should have caused such confusion in the ranks, but the result was that instead of standing in a column of fours we were at sixes and sevens — all over the place. Some of the men in the second rank behind the number twos in the first rank had not understood that they too were to take a pace to the rear with the left foot and one to the right with the right foot; and some of the odd numbers, instead of standing still, stepped to the rear. Others had forgotten which was their right foot and which the left. After three or four repetitions of the order resulting in the same confusion, the sergeant weeded out the dumb ones and had them stand watching the rest of us. And after we had been dismissed it required an hour's extra drill to teach this awkward squad the simple maneuver of forming fours.

When I first joined up I felt like a hermit crab deprived of his shell, desperately seeking another, and the only one available was our bell tent which I shared with fourteen other men. I tried at first to draw a cloak of silence and anonymity around me, but that was soon torn to shreds; in fact, it was destroyed well before we came to St. Martin's Plain, near Shorncliffe Camp, in Kent, where we were to train for seven months. Although the 9th Royal Fusiliers was a battalion of an old London regiment we had men from all parts of the United Kingdom: a scattering of North Countrymen, a few Welsh, Scotch and Irish, men from the Midlands and from the South of England. Most were Cockneys, born within the sound of Bow Bells. It was clear at once to my comrades that I fitted into none of these

categories. Although in a sense I didn't belong, this was far from being the handicap I had dreaded. I have never met a more friendly lot of men than my comrades of C Company. I was called "Jamie, the Yank," and the mere fact of my presence among them offered proof that "the Stites" were heart and soul with England in her war against Germany.

As a soldier I had no time to regret my lost opportunities for musing and daydreaming. We were busy from dawn until dark every day in the week except Sunday. The friendships I formed with men with whom I thought at first that I had little in common were, and the memories of them still are, beyond price to me.

After seven months of the hardest kind of training we marched to Aldershot, one hundred and twenty-five miles from our camp. We were no longer the "ragtime army" of the previous autumn. The pasty-faced rookies that Sergeant Breslan had blasted with such scorn were now seasoned, well-disciplined men in superb health. The *esprit de corps* was excellent; we all believed that Lord Kitchener's First Hundred Thousand contained no finer battalion than the 9th Royal Fusiliers.

I see us as we were on the morning of the day when we began our march to Aldershot, drawn up by companies, our battalion CO on horseback, facing us.

"Ninth Royal Fusiliers! . . . Atten-SHUN!"

One thousand pairs of heels clicked together as those of one man, and our rifles were drawn smartly up to our sides from the "At Ease" position.

"Move off in column of route, A Company leading!"

Our battalion joined the others of the 36th Infantry Brigade, a seemingly endless four-column ribbon of men stretching away before and behind us. As we passed through Ashford I remember thinking: "Now I'll never see Joseph Conrad." All through the autumn and winter we had been so near Capel House that I could easily have walked there on a Sunday afternoon. More than once I had been

tempted to do so and had even written a note to Mr. Conrad asking if I might call. But, of course, I decided not to post it.

On we marched through the beautiful country of Kent and Surrey, billeted at night in schoolhouses and occasionally in private homes where we received the most friendly welcome and had meals that tasted wonderful after months of army fare. On the last day's march, just before we reached Aldershot we passed in review before King George V and Lord Kitchener, with their staffs, in motorcars by the side of the road. Although we had marched twenty-five miles since morning, fatigue vanished as though by magic. We passed the King "Eyes Right!" in perfect alignment, and even the woodshed poet remembered to keep in step.

Aldershot was our last training area before we were sent to France; our entire 12th Division was being assembled there. At this time we received our machine guns, one per company; nothing to what the Germans had but all that England could, then, furnish her battalions. I was made No. 2 of the gun team of C Company and found here a band of brothers within a band of brothers. We were excused from all the drills of the rifle-carrying infantrymen and worked from dawn to dark perfecting ourselves in the use of this new weapon. It seems strange to me now that I should have given so little thought to the purpose behind this training: to make us killers far beyond the power of the rifleman who at best could fire no more than fifteen rounds per minute. The only way I can explain it is that I could not at that time visualize the horrors of war without actual experience of it. We saw — all of us machine gunners, while serving in turn in the butts at target practice — machine-gun bullets making sieves of the targets, tearing them to ribbons. But we did not — at least I did not because I could not — visualize the targets as living men receiving that hail of death.

On a Sunday morning in May, 1915, the 9th Royal Fusiliers assembled upon the Aldershot parade ground for the last time. Every man was in full marching order. His rifle was the short Lee-Enfield,

provided with the long single-edge bayonet in general use throughout the British Army. In addition to his arms he carried in his bandolier 120 rounds of .303-caliber ammunition; an intrenching tool, water bottle, and haversack containing both the day's and emergency rations. His pack contained his overcoat, a woolen shirt, two or three pairs of socks, a change of underwear, a "housewife" — the soldier's sewing kit — a towel, a cake of soap, and a "hold-all" in which were a knife, fork, spoon, razor, shaving brush and toothbrush. At this our last parade in England, each man was furnished with one other piece of equipment. It consisted of a kind of sponge made of black gauze impregnated with a chemical which smelled anything but pleasantly. The Second Battle of Ypres in which the Germans used gas with such disastrous but inconclusive effect, had just ended, and our division was, I believe, the first to be provided with a hastily improvised gas mask. In case of another gas attack we were to hold the sponge between our teeth, pressing it closely against the nostrils and fastening it by strings tied behind the head.

Battalion after battalion and train after train, we moved out of Aldershot for Plymouth, our port of embarkation, and pulled up at the side of troop transports, great slate-colored liners taken out of the merchant service. Ship by ship we moved down the harbor in the twilight, the men crowding the rails on both sides, taking their farewell look at England. It was the last farewell for most of them, but there was no martial music, no waving of flags, no tearful good-by's. As we steamed away from the landing slip we passed a barge loaded almost to the water's edge with coal. Some one started singing "Keep the Home Fires Burning" to those smutty-faced barge hands, and in a minute everyone joined in heartily.

The following day, after landing at Le Havre, we were crowded into the typical French army troop train (8 *chevaux* — 40 *hommes*) and started on our journey to the front. We traveled all day at from eight to ten miles per hour with many halts en route, passing through the pleasant towns and villages of Normandy, looking so peaceful in

the spring sunshine and seemingly all but deserted, and through the open country fragrant with the scent of apple blossoms. Now and then children waved to us from cottage windows and in the fields women and girls leaned silently on their hoes to watch us pass. When we detrained that evening I remember our repressed excitement upon first hearing the guns, a low muttering like that of faint thunder beyond the horizon.

The number of casualties in World War I — killed, wounded, missing in action and prisoners of war — as given in *The World Almanac*, comes to a total of 37,508,686. The number of killed and died of wounds is given as: Allied Powers, 5,152,115; Central Powers, 3,386,200 — a total of more than eight million, five hundred thousand men. It is not possible for me to grasp the significance of such a number. I recall an occasion when I saw our 12th Division marching in column of route, and how great an extent of country it covered, the column to the rear dwindling to the vanishing point, the line ahead stretching away over the hills, descending into the valleys and reappearing over other hills beyond. I try in vain to imagine a shadowy host of eight million, five hundred thousand men moving in column of fours at a pace of three miles per hour, and how many days, weeks and months it would take them to pass a given point. The mind can at least grope toward a realization of tragedy on a colossal scale by thinking of them, not as dead, but as they were in life: an endless column of young men in the very flower of manhood, laughing and talking as they march past — the best blood of Europe, whose loss, and that of their unborn children, is so woefully felt in the world today. The War of Attrition so stubbornly clung to and believed in by the High Commands of France, England, and Germany, surely accomplished its grim purpose during the years 1914–1918.

We arrived at the front at a fortunate time, for us. The Second Battle of Ypres, when the Germans first used gas in quantity, was just ended. On many a day the newspapers had "nothing to report"

with respect to the Western front, but from the soldiers' point of view this was often an understatement. It was not "nothing" to us when comrades were killed by snipers' bullets, or when three, five, or a dozen men were blown to bits by shell or trench-mortar fire, or were caught in the open and mowed down by machine-gun fire.

On these nights of official calm we machine gunners were kept busy enough. We crept through saps beneath our wire into no man's land to lie in wait for enemy working parties building up trenches destroyed by shellfire or mending their barbed-wire entanglements. And when, by the light of star shells or trench rockets one was discovered, we would give them a heavy burst of fire and crawl quickly through the rank grass to another position before enemy whiz-bangs could begin searching for us with shrapnel. We fired from the trenches as well as in front of them. It was our duty to see that our guns lived up to their purpose as "weapons of opportunity and surprise." With the aid of large-scale maps we located all the roads within range back of the enemy lines: roads which we knew were used by troops moving in or out of the line and by ration parties and horse-drawn transport wagons bringing up supplies; and at irregular intervals we covered them with long bursts of concentrated, searching fire.

The German machine gunners did the same. They, too, profited by their knowledge of night life in the firing line. They knew as we did that the roads immediately back of the trenches were filled at night with troops, transport wagons and fatigue parties, and that men become so weary of living in ditches that they are willing to take risks for the joy of getting out on top of the ground. On many a night when we were moving up for our week in the first line or back for our week in reserve, we would hear the far-off rattle of German Maxims and in an instant the bullets would be zip-zipping all around us. If there was a communication trench at hand we dived into it; if not, we fell face down in ditches by the side of the road, shell holes — in any place that offered some protection from that hail of lead. Our men

were killed or wounded nightly, often because they were too weary to be cautious, and doubtless we did as much execution with our own guns.

The only book I brought with me to France was my 6-by-4-inch edition of Shelley's *Lyrics and Minor Poems* which I could carry in the pocket of my tunic. It was my old copy, so fragrant with Grinnell memories. Others not so fragrant were added as the weeks went by. At the front I found poetry a greater resource than ever. Sometimes at night as I lay hidden with my comrades in the tall grass and weeds of no man's land waiting for targets, I would sort over passages that I particularly loved.

There were times when I would close my eyes and imagine that I was on my Hill at home, listening to the whippoorwills, or I would walk the G-Note Road toward Morning Sun Pond, trying to recapture, in the imagination, the feeling of "sacredness" I had felt when viewing it as a child. I remember "stilly" nights when the line was really quiet; when the stilliness was accentuated by the occasional vicious, mournful whine of ricochets dying away in the distance. Nothing more weird and ghostly could be imagined than the light of trench rockets revealing briefly the desolate landscape with its tortured trees and ruined farm buildings, and, as the light faded, the shadows rushing back like the very wind of darkness.

War has one compensation — a great one — which peace cannot provide to anything like the same extent; namely, the strength of the friendships formed among men sharing equally the misery, boredom, horror and danger of active service. I recall a rainy autumn evening of boredom at its worst. All along the line the trenches had caved in, becoming a series of mudholes filled with water; there was no hope of repairing them until the rain had stopped. Men, chilled to the bone, stood or crouched where and how they could, their ground sheets over their heads to protect them from the coarsest of the wet. Near our gun position was a waist-deep hole. A temporary bridge of

boards had been built around it, but in the darkness it could not be seen.

We heard someone approaching, sliding into hole after hole, cursing to himself as though he believed himself alone in that part of Dante's hell. He fell with a resounding splash into the hole near our gun position. We heard him pick himself up and stand there, in silence. Apparently he could find no words with which to comment upon this last bit of misery heaped upon misery.

Then an exasperating voice nearby said: "Na, then, matey! Bathin' in our private pool without a permit?"

Another voice said: "Grease aht of it, son! That's our tea water you're a-standin' in."

The man, waist-deep in muddy water, must have been half frozen, but for a moment he made no attempt to move on.

"One o' you fetch me a bit of soap," he replied, in a coaxing voice. "Don't talk about tea water to a bloke ain't had a bawth in seven weeks."

Toward the end of September there was increased artillery fire for miles along our sector of front. It came from our batteries and we knew that it must be the prelude to infantry action. Then came sudden orders to move. Within twenty-four hours the roads were filled with the incoming troops of a new division. We made a forced march to a railhead and were soon moving southward to take part in the Battle of Loos. I remember the brief remarks of the CO to us machine gunners.

"Listen carefully, men. We are moving up to take over captured German trenches near Loos. No one knows yet the situation there. The men you are going to relieve have had a tough time. The trenches are full of dead. Those who are left are worn out with the strain and need sleep. They won't want to stop long after we come in and we can't expect much information from them. We will have to find out things for ourselves. Our immediate orders are to hold those captured

trenches and to repulse counterattacks. What we are to do later we will know when the time comes."

We marched along a road that had been churned to a watery paste by thousands of feet and all the heavy wheel traffic incident to the business of war. The rain was still falling and it was pitch dark except for the reflected light on low-hanging clouds of the flashes from the guns of our batteries and those from the bursting shells of the enemy. We halted frequently to make way for long lines of motor ambulances which moved slowly because of the darkness and the awful condition of the roads. In addition to the ambulances there was a steady stream of traffic of other kinds: dispatch riders on motor-cycles feeling their way cautiously along the sides of the road, ammunition-supply and other transport wagons, many of them horse-drawn vehicles, the frightened horses rearing and plunging in the darkness. We halted at a crossroad to make way for some batteries of fieldpieces moving to new positions. They went by on a slippery cobbled road, the horses at the gallop. In the flashes of gunfire they looked like a series of splendid sculptured groups.

We moved on and halted, moved on again, stumbled into ditches to make way for outgoing traffic, and moved on once more. Because of the enforced halts we would lose touch with the troops ahead and have to march at the double in order to catch up. It was weary work, to say the least. During this night march I discovered the truth of a statement I had read while at college in a textbook by William James. He said in effect that men have layers of nervous energy which they are rarely called upon to use, but which are assets of great value in times of heavy strain. I proved the truth of this, not once but at various times later when I thought I had all but reached the end of my resources of strength.

We halted to wait for our trench guides at what remained of the village of Vermelles. Here we were ordered to fall out, which we did, quite literally. We lay down in the mud at the sides of the road which were veritable beds of roses to men as weary as we were. I slept

soundly during this halt despite the incessant gunfire and the fact that rain was still falling. When the time came to move on, some of us had to be hauled to our feet, still sleeping. There was a further march over open country. The ground was a maze of abandoned trenches and pitted with shell holes. We machine gunners were always heavily loaded, for, in addition to the usual infantryman's burden we had our guns and ammunition boxes to carry, so it was hard going for us in the mud. We crossed what had been the first line of British trenches before the attack began, and from there the ground was covered with the bodies of our fallen comrades, proof of the heavy toll the Germans had taken for every yard of ground given. Some were huddled in groups of two or three as though they had crept together for companionship before they died. Some were lying just as they had fallen; others were hanging in tangles of barbed wire which the heaviest of bombardments never completely destroys. We saw them only in the distant light of trench rockets and stumbled on and over them as darkness returned. I can still hear the voices of dead-tired men passing the word back to those who followed them in file: "Mind the hole. . . . Mind the wire. . . . Mind the bloke," as we moved slowly forward. "Bloke" all but lost its significance as referring to a living man.

The men we were to relieve were packed and ready to move out when we arrived. We threw our packs, rifles and other equipment on what remained of the parapets and stood close to the sides of the trench to allow them to pass. They were cased in mud as were we ourselves. Their faces, occasionally revealed by the glow of matches and lighted cigarettes, were haggard and worn. Some of them were hysterically cheerful, voluble from nervous reaction. They had the prospect of getting away for a little time from the sight of maimed and shattered bodies, the deafening noise, the nauseating odor of decaying human flesh. As they moved out, there were the usual bits of conversation which take place between incoming and outgoing troops.

"What sort of a week you had, mate?"

"It ain't been a week, son. It's been a lifetime."

"Is this the last line of Fritzie's trenches?"

"There's no last line, that's my guess."

"Bury our pals, will you, if you get the chance? We've not had time."

During our first night in these captured trenches, the fire of German batteries was directed chiefly on positions to our right and left. The shells of our own batteries were exploding far in advance of our sector of trench, and we judged that they were shelling positions along which the Germans would attempt to dig themselves in again. At daybreak we learned that we were between the village of Hulluch, on the left, and Hill 70 on the right, neither of which had yet been taken. Immediately in front of us was a long stretch of ground rising gradually to the skyline. In the first assault British troops had pushed on past the trenches we were holding and nearly a mile farther. Owing to some failure in staff work no reserves were on hand to follow up this advantage and by the time they arrived the Germans had closed the gap and were ready for them. When, after a fatal delay, they tried to advance, so heavy a fire had been concentrated on them that they were driven back to the line we were holding. They had met with heavy loss both in advancing and retiring, and the ground in front of our sector was strewn with dead.

The trenches and dugouts in these enemy lines were a revelation to us; the deep dugouts were palaces compared with the wretched little surface "funk holes" to which we were accustomed, but the ground here was unusually favorable. Under a clayish surface soil was a stratum of solid chalk. Some of the dugouts were from twelve to fifteen feet below the surface, and still intact for all the hail of high explosive that had been rained upon them, but the stairways leading down to them were choked with earth and debris. There were also surface dugouts capable of holding an entire platoon, but these had not been proof against shellfire. Most of them were in ruins, the tiers of logs that covered them, beneath a surface screen of three or

four feet of earth, had been splintered like matchwood and scattered far and wide. Our C Company gun team took up quarters in one of these surface dugouts which was only half destroyed.

It is a truism to say that death comes swiftly in war and that one's luck is the result of pure chance. The most trivial circumstance may save or destroy. There were always two men on duty at the gun position, the other members of the team in reserve nearby when the gun was not in action. We off-duty men were making tea in our half-ruined dugout when Richard McHard, one of the men at the gun, came in to look for his water bottle. He asked me to take his place at the gun while he searched for it. I had no sooner reached the firing trench when the Germans began a heavy bombardment of our sector of the line. As I reached the gun position a shell made a direct hit on the dugout I had just left. Seven of our comrades were inside.

High explosives were bursting all along the line. Great masses of earth and splintered logs were blown on top of men seeking protection where there was none. The ground heaved and rocked beneath us. Freddy Azlett, my companion at the gun, and I were half buried by the shell that wrecked our dugout but we were otherwise unharmed. We rushed back to help our comrades but there was little we could do. McHard, whose place I had taken at the gun, was lying with his head split apart as though it had been done with an axe. Will Gadd had been killed by a piece of shell casing that made a great hole through his chest. Harrison was so badly hurt that he died while we were trying to bandage him. Bryant was completely buried. Fortunately, he lost consciousness as we were trying to dig him out from beneath the earth and splintered timbers, and he died before he could be taken to the field-dressing station. Charley Powell was lying by the wall staring at his crushed leg as though he could not believe it his own. Of the seven men in the dugout, three were killed outright, three died within the half hour, and one escaped with a crushed leg that had to be amputated at the field hospital.

What had happened to our little group was happening to others

all along our sector of front. The line was a shambles of loose earth and splintered logs; at many places it was difficult to see where the trench had been. Had the Germans launched a counterattack immediately after the bombardment we would have been hard put to hold the position; but no attack came at that time and we set to work building up the trenches as best we could. The worst of it was that we could not get away from the sight of the mangled bodies of our comrades. Arms and legs stuck out of the wreckage, and on every side we saw the distorted faces of men we had known, with whom we had lived and shared hardships and danger for months past. One thinks of the human body as a beautiful, sacred thing. The sight of it dismembered, disemboweled, smeared with blood and filth and trampled in the bottom of a trench, is so revolting as to be hardly endurable. Nevertheless, we had to endure what there was no escaping, and worse, even, than the sight of the dead were the groans of desperately wounded men waiting to be carried back to the field-dressing stations.

Throughout October there were frequent attacks and counterattacks preceded by heavy artillery fire. There were moments of calm when men wounded in the early stages of the battle were able to crawl back to our lines. One plucky Englishman was discovered about fifty yards in front of our trench. He was waving a bit of rag tied to the handle of his entrenching tool. Stretcher-bearers ran out under fire and brought him in. He had been badly wounded in the foot when his company was advancing up the slope fifteen hundred yards away. He had not been seen by his comrades when they were forced to retire and had been left with many other dead and wounded, far from the possibility of help by friends. He had bandaged his foot with his first-aid dressing and had started crawling back, a few yards at a time. He secured food and water from the haversacks and water bottles of dead comrades and after a week of painful creeping, reached our lines. I saw another man who was brought in at daybreak by a working party. He had been shot in the jaw and lay

unattended through five wet October days and nights. He looked scarcely human. Blood poisoning had set in; his eyes were swollen shut and his face was a bluish green. He died in our trench of a wound that would not have been fatal could he have received early attention. We knew that there must be many other wounded still alive hidden in the grass and weeds between the lines. Nightly searches were made for them, but there was a wide area to be covered, and in the darkness men lying unconscious, or too weak from the loss of blood to groan or cry aloud, were discovered only by accident.

For a full month we had no opportunity to remove any of our clothing. We were moved from one position to another through the wreckage of trenches where the tangled mass of telephone wires, seemingly gifted with a kind of malignant humor, caught in the piling-swivels of our rifles or coiled themselves around our feet. Trenches were repaired only to be destroyed while the work was still in progress. Twice we received orders that we were to attack at dawn; then the order was countermanded. There were many such orders and counterorders, alarms and excursions. Through them all my comrades kept their balance and their air of grim unconcern, but many a one wished he might be "struck pink" if he knew "wot we was a doin' of, anyway."

The Battle of Loos was but an incident in the War of Attrition which was to end only with the war itself. I have read that it was the bloodiest battle in English history up to that time, but it was nothing when compared to the losses during the Battles of the Somme and Passchendaele, to come in 1916 and 1917. Around 60,000 men were killed at Loos. The gain, in territory, amounted to one mile on a front of four miles.

In the early nineteen-thirties I read Mr. Winston Churchill's *The World Crisis*. Chapter II, in Part I of volume 1916–1918, is "The Blood Test." I have no doubt that many thousands of survivors of World War I, upon reading that chapter, learned for the first time at

what an appalling and needless cost the War of Attrition, so relent-
lessly pursued by the French and British High Command, was
brought to an end. In that chapter Mr. Churchill writes:

> *During the whole war the Germans never lost in any phase
> of the fighting more than the French whom they fought, and
> frequently inflicted double casualties upon them.* In no one of
> the periods into which the fighting has been divided by the
> French authorities, did the French come off best in killed, pris-
> oners and wounded. Whether they were on the defensive or
> were the attackers the result was the same. Whether in the
> original rush of the invasion, or in the German offensive at
> Verdun, or in the great French assaults on the German line,
> or even in the long periods of wastage on the trench warfare
> front, it always took the blood of 1½ to 2 Frenchmen to inflict
> a corresponding injury upon a German.
>
> The second fact which presents itself from the tables is that
> *in all the British offensives the British casualties were never
> less than 3 to 2, and often nearly double the corresponding
> German losses.* . . .
>
> In the series of great offensive pressures which Joffre de-
> livered during the whole of the spring and autumn of 1915, the
> French suffered nearly 1,300,000 casualties. They inflicted upon
> the Germans in the same period and the same operations
> 506,000 casualties. They gained no territory worth mentioning,
> and no strategic advantages of any kind. This was the worst
> year of the Joffre régime. Gross as were the mistakes of the
> Battle of the Frontiers, glaring as had been the errors of the
> First Shock, they were eclipsed by the insensate obstinacy and
> lack of comprehension which, without any large numerical
> superiority, without adequate artillery or munitions, without
> any novel mechanical method, without any pretence of sur-
> prise or manoeuvre, without any reasonable hope of victory,
> continued to hurl the heroic but limited manhood of France
> at the strongest entrenchments, at uncut wire and innumerable
> machine guns served with cold skill. The responsibilities of this

lamentable phase must be shared in a subordinate degree by Foch, who under Joffre's orders, but as an ardent believer, conducted the prolonged Spring offensive in Artois, the most sterile and prodigal of all. . . .

In the face of the official figures now published and set out in the tables, what becomes of the argument of the "battle of attrition"? If we lose three or four times as many officers and nearly twice as many men in our attack as the enemy in his defence, how are we wearing him down? . . . The aggregate result of all [these offensives] from 1915 to 1917 . . . was a French and British casualty list of 4,123,000 compared to a German total of 2,166,000. Not only is this true of numbers, but also of the quality of the troops. In the attack it is the bravest who fall. The loss is heaviest among the finest and most audacious fighters. . . .

Mr. Churchill, as everyone knows, was firmly opposed throughout World War I to the policy of attrition and to the belief that the war must be won, and could only be won, by killing Germans on the Western front. If he had had the power then that was given him in World War II, how many tens and hundreds of thousands of the eight million, five hundred thousand dead might have been saved!

Sir William Robertson, whose belief in "attrition" was responsible for so many of these dead, in a letter dated September 27, 1917, wrote to Sir Douglas Haig: "My own views are known to you. They have always been 'defensive' in all theatres but the West. . . . I confess I stick to it more because I see nothing better and because my instinct prompts me to stick to it, than because of any good argument by which I can support it." And Sir William Robertson was Chief of the Imperial General Staff at the time this letter was written! The Battle of Passchendaele was then being fought.

In Mr. Liddell Hart's *A History of the World War 1914-1918* he writes as follows concerning the Battle of Passchendaele:

[Sir Douglas Haig] was lured on by a lofty optimism that extended even to the cost. After the disappointing attack of July 31st, he advised the Government that the enemy casualties exceeded the British "not improbably by one hundred per cent"; and in his final despatch he still declared that it was "certain that the enemy's loss considerably exceeded ours." That optimism was nourished by ignorance of the situation, due in part to the failure — a moral failure — of his subordinates to enlighten him.

Perhaps the most damning comment on the plan which plunged the British Army in this bath of mud and blood is contained in an incidental revelation of the remorse of one who was largely responsible for it. This highly placed officer from General Headquarters was on his first visit to the battle front — at the end of the four months' battle. Growing increasingly uneasy as the car approached the swamplike edges of the battle area, he eventually burst into tears, crying, "Good God, did we really send men to fight in that?" To which his companion replied that the ground was far worse ahead. If the exclamation was a credit to his heart it revealed on what a foundation of delusion and inexcusable ignorance his indomitable "offensiveness" had been based.

xvi. Leave

THE BATTLE OF LOOS was ended; winter was at hand, and our division had been sent to the rear for rest, to re-equip and to make up our numbers once more with replacements sent out from England. A feeling of gloom settled upon the troops everywhere, after the fiasco at Loos. Even the most hopeful of soldiers had no further illusions as to the probable length of the war. The stalemate would continue indefinitely, for years, perhaps. But there was one prospect to cheer men facing another winter of trench warfare. Leave was to be given.

One evening our reconstructed C Company machine-gun team was having tea in a barnyard, talking of our prospects, when one of them said: "Jamie, if we get leave together I want you to come home with me."

Another one said: "When he's got a home of his own to go to in the States?"

"What chance would he have to go there?" another remarked.

"He could ask for it, couldn't he? He's an American. Maybe he'd get it."

Until that moment it had not occurred to me to ask for leave home. I hoped, when my turn came, to go to my wartime home at 47 Bernard Street, London, as I had when we were given leave at Christmas, 1914, but for nothing more than this. But a few days later, as the result of repeated urgings of my fellow gunners I decided that it could do no harm to ask for leave home; and so, I made my way to battalion headquarters.

"Yes; what is it?" the adjutant asked.

I was as brief and soldierlike as possible in making my request.

"You are an American? What are you doing in our army?"

"I'm a machine gunner, sir, in C Company," I replied.

"Humm! . . . You know President Wilson?"

"No, sir."

"If you did, and you could persuade him to send a million or two of your countrymen back with you, we might let you go. Otherwise, not." I saluted and left the room.

But once the thought of leave home had come into my head I couldn't get rid of it. During these weeks I had been worrying about my father who was in the first stages of that incurable malady known as Parkinson's disease: this added urgency to my longing. I didn't know President Wilson, but I did know George Greener, of the North Bennet Street Industrial School, in Boston. I also knew that various influential Bostonians were on the board of directors at the School. So I wrote Greener asking whether any of his board might be willing to use his influence — how, I didn't know — to get me permission to make a visit home. I had not the slightest expectation that anything would come of this, but a few weeks later I was sent for by the battalion adjutant.

"Corporal," he said, "not long ago you asked for leave to the U.S.A."

"Yes, sir."

"You told me that you do not know President Wilson."

"No, sir."

"You didn't tell me that?"

"I mean that I don't know President Wilson."

"Nor your American ambassador in London?"

"No, sir."

"Well, evidently someone in authority has been pulling wires for you. You are to report to regimental headquarters at Hounslow. You will go tonight with the other leave men."

On the day of my arrival in London I reported at regimental headquarters at Hounslow and was directed to an officer who greeted me in a very friendly fashion which surprised me.

"I've good news for you, Corporal. Do you know why you've been sent for?"

"Am I to be given leave to go home?" I asked.

"Better than that," he replied. "You're to be discharged from the army."

"Discharged! . . . But I joined up for three years, or the duration. I would like a spell of leave, but do I have to take my discharge?"

"Don't be foolish, young man," he said. "Why shouldn't you take it? America isn't in the war. Evidently, someone with influence has been using it to get you out of the army. The orders are that you are to be given your discharge, but you needn't accept it if you don't want to. Take it or leave it. If you leave it you will return to France immediately. In that case you stay put with your battalion until the war ends, with the chance that you may stay put for good, over there."

The officer smiled faintly. "There's nothing to prevent your re-enlisting if you want to later. . . . Well, which is it to be: Iowa, or the trenches once more?"

"I will take my discharge," I replied.

I don't know what he thought of this decision, but what he said was: "Very well. I will have your papers made out."

I still have my British Army discharge, a booklet bound in red cloth covers. It reads in part:

CERTIFICATE OF DISCHARGE OF No. 690

(RANK) LANCE CORPORAL

NAME: James Norman Hall
REGIMENT: The Royal Fusiliers

WHO WAS ENLISTED AT: London

ON THE: 18th August, 1914

HE IS DISCHARGED IN CONSEQUENCE OF:

"On the ground of being an American citizen" (Authority, War Office letter no. 1226)

AFTER SERVING: 1 year, 99 days with the colours. Served 172 days with the British Expeditionary Force in France.

CHARACTER: Very good

> *Signed*: L. W. THOMAS, MAJOR
> *for Colonel Commanding*
> *Depot: Royal Fusiliers*

I doubt whether in the whole of London there could have been found that day a happier, more miserable man than former Lance Corporal 690, J. N. Hall. It may seem incredible that one could experience these conflicting states of feeling at the same time, but so it was in my case. I was going home, leaving that band of brothers whose friendship was one of the finest things that had ever come to me, and many of whom I would never see again. If ever there was a split personality I was one at that time, and for days and weeks thereafter. I was like a man suffering from amnesia, vainly trying to discover his proper identity. I remember nothing that happened during the eight-day voyage from Liverpool to Boston; nor the names of any of the passengers on the ship — not even that of the man who shared a cabin with me. My mind is a complete void with respect to that brief chapter of experience. It was not until I reached Boston and found my friends, Cushman, Greener, and Winship on the dock to greet me, that I began to grope toward my old identity: that of the former "Special Agent" of the M.S.P.C.C.

I could scarcely believe in the reality of the life I saw around me in Boston, so peaceful, so bustling with cheerful civilian activity; I felt, somehow, lost and alone, out of touch with my fellow creatures

who were living as though there were no World War on the other side of the Atlantic.

I went to see my old friends and fellow agents at the Society for the Prevention of Cruelty to Children, at 43 Mt. Vernon Street. There had been few changes in personnel since I had left the Society. Mr. Carstens was still General Agent. Miss Butler, receiver of complaints, was at her desk just behind Mr. Carstens' office and Christina Boyd was at the telephone switchboard saying "Haymarket, two-six-one-seven." As I entered the hallway, Dr. Lovell, the Society's woman physician, was coming down the stairway with two children from the Society's temporary home on the top floor. I didn't ask where she was taking them, but guessed it might be to the Massachusetts General Hospital to have their tonsils or their adenoids removed. And my old friend and mentor, John Powers, was in his basement lair stoking the furnace. His walrus mustache was as bushy as ever, and what particularly pleased me was to see that he was still smoking the long-stemmed pipe I had given him. When I spoke of this he said: "It's a good pipe. No reason to change it." I imagined from the smell of the smoke that he saw no reason to clean it, either.

My memory is hazy about my first meeting with Ellery Sedgwick who was then editor of the *Atlantic Monthly*, but it must have occurred only a few days after my arrival in Boston. At that time the *Atlantic* was associated with Houghton Mifflin Company, the publishing firm, and the office was still on Park Street where it had been during my years in Boston. My friend, Laurence Winship, had put something in the Boston *Globe* about the arrival of a former social worker with the M.S.P.C.C. who had just returned from the battlefields in France, and this must have been how Mr. Sedgwick first heard of me. I seem to remember receiving a note from him asking me to call. At any rate, I do distinctly remember rounding the corner by the Park Street Church on my way to the *Atlantic* office. The corner of Park and Tremont Streets is supposed to be the windiest in Boston,

and it certainly was windy on that December day. There is an old story that a shorn lamb was tethered there many years ago in the hope of tempering the wind, but without having had the least effect upon it.

It seemed incredible that I was actually going to call upon the editor of the *Atlantic Monthly*, and at his invitation. This was another dream experience, surely: so different from my many earlier communications from the *Atlantic*. The first meeting with Mr. Sedgwick was the beginning of a friendship which has endured, warm and unbroken, until this present moment. I would not attempt to estimate how precious it has been to me — and I am not speaking in terms of money, although checks received from the *Atlantic* in later years were, to say the least, more than welcome. Many a time when my nose was barely above water, and sometimes even below it, Mr. Sedgwick has saved me from going under. The chances are that I would not have persisted in trying to write without his never-failing encouragement. I would not venture to say how many times he has yanked Old Man Diffidence from off my shoulders.

Mr. Sedgwick asked if I had ever done any writing, and I said, "Yes, a little. At least, I've always wanted to write," without informing him how often I had tried to "make" the *Atlantic*. He then spoke of a book just published by Houghton Mifflin Company: *The First Hundred Thousand*, by Major John Hay Beith, a British officer who had written, under the pen name "Ian Hay," of his experiences as a member of Lord Kitchener's volunteer army. "It is an excellent story," Mr. Sedgwick went on, "and is certain to have a great success in America where we know so little thus far of the actual battle experience of British soldiers in France. . . . Well, I want you to write some articles for the *Atlantic* about the experiences of a private in the British Army. The fact that you are an American will make them all the more interesting to readers over here. And you will be doing a real service to the Allied cause; I can assure you of that. Except for a few towns and cities on the Atlantic seaboard America is not awake

to the significance of this war. Most people still believe that it is merely another of Europe's perpetual squabbles to be settled by Europe alone. They think it is none of our business and are strongly back of President Wilson who believes we should keep out of it."

"Would you want me to stress the fact that we should be in it?" I asked.

"No. . . . No preaching, or exhorting, or reproving the American people for their neutrality." He smiled faintly as he added: "After all, who are you? A young American known to no one except your friends, who joined the British Army and has now returned direct from the battlefields of France. I want you to write a simple, straightforward narrative of your experiences: your day-to-day life in the trenches; the kind of men you served with; the hardships and dangers you shared together. Don't try to be 'literary.' Write as you would if you were telling of your experiences in letters to a friend. And don't leave out any touches of humor. Life in the trenches cannot be all sheer tragedy, and readers will want to know the lighter side of it as well."

"How many articles would you want?" I asked.

"One to start with. I can speak more definitely about others when I've seen what you can do."

Instead of walking on air as I left the *Atlantic* office, I was in a more than sober frame of mind. How could I accept Mr. Sedgwick's generous offer even though, as he had said, it might mark the beginning of a literary career for me? I knew my failings too well to believe that I could sit down and rattle off at high speed a story of my experiences. Besides I was going home and wanted to spend all the time I had with my family, particularly with my father.

Mr. Sedgwick had given me a copy of Ian Hay's *The First Hundred Thousand* which I read immediately, at one sitting. It was a splendid account of war experience from an officer's point of view, far better, I knew, than anything I could attempt from the private soldier's point of view; but I had already thought of a title for my story,

Kitchener's Mob, and decided that I should at least make a beginning. I was under no obligation to write more than one article, and if I set to work with grim determination I could do that, surely, in a month's time or even less. And so I left for Iowa, trying to put out of mind all thought of the future save the happy prospect immediately before me of spending Christmas at home.

Many a time, in both England and France, I had dreamed of my return home, if I survived the war, and these dreams had brought moments of anticipated happiness almost too keen to be endured even in the imagination; but none of them had been concerned with my return in the midst of war. The train was filled with holiday travelers: young married couples with small children going to spend Christmas with Grandpa and Grandma; students homeward bound for the holidays from Eastern schools and colleges. At one moment I would regard these gay-hearted people with a kind of bitterness in my heart, thinking, "How can they be so happy when the young men of Europe are dying in their tens of thousands?" And the next moment I would think, "Thank God that one great peaceful nation has refused to be drawn into all that bloodshed and horror!" I was torn between my conviction that we must and should enter the war on the side of England and France, and my other conviction, almost equally strong, that we must and should stay out of it. But if we did stay out of it and Germany should win, what would the world have to look forward to? The enlightened, live-and-let-live Pax Britannica would be destroyed, and I could well imagine the Pax Germanica that would take its place: one of complete domination which no great nation however deep its love of peace could long endure and maintain its self-respect.

When the festivities of Christmas Eve and Christmas Day were over, I shut myself in my room with the feeling that I had no time to lose. My parents and the other members of the family knew nothing of my plans. They believed that I was out of the army for good, and I lacked the courage to tell them the truth. But I had, of course,

told them of my commission from the *Atlantic Monthly* and they were pleased as only one's family can be. Even my brother Harvey was impressed; at last the woodshed poet seemed to be making some progress.

Then came the old trouble of making a start. I am appalled when I think of the time wasted during the course of my life in writing first paragraphs, and *Kitchener's Mob* was no exception. Even now as I copy the first two paragraphs I "itch" to revise them all over again:

"Kitchener's Mob" they were called in the early days of August, 1914, when London hoardings were clamorous with the first calls for volunteers. The seasoned regulars of the First British Expeditionary Force said it patronizingly, the British public hopefully, the world at large doubtfully. Kitchener's Mob when there was a scant sixty thousand under arms with millions yet to come. Kitchener's Mob it remains today, fighting in hundreds of thousands in France, Belgium, Egypt, Africa. And when the war is won, who will come marching home again, old campaigners, war-worn remnants of once mighty armies? Kitchener's Mob.

It is not a pleasing name for the greatest volunteer army in the history of the world; and yet Kitchener's own "Tommies" are responsible for it: the rank and file, with their inherent love of ridicule even at their own expense, and their intense dislike of "swank." They fastened the name upon themselves lest the world should think they valued themselves too highly. There it hangs. There it will hang for all time.

The writing went more easily after that and I had the article finished well before the month was ended. I sent it at once to Mr. Sedgwick and received a wire from him a few days later: "First article excellent. Send more."

At last I really was launched on the long-wished-for literary career. Nevertheless, I knew what my immediate reply to Mr. Sedgwick should have been: "Very sorry, but must return to service in France.

May be able to send further articles from there." But the message was not sent. Instead I went to Grinnell to see my friends there, particularly Professor Payne and to ask his advice as to what I should do.

I opened my heart to him completely: told him of the resolve I had made before leaving London, of meeting Mr. Sedgwick in Boston and the result of that meeting. Professor Payne heard me through without comment, and when I had explained everything he was silent for some time. Then he said: "Norman, this is a decision you must make for yourself. No one can help you with it."

"I feel that, too," I replied. "I merely wish to know what you would do in my place. You can help me to that extent."

"I don't think you should ask me to," he replied, with his autumnal smile. "Do you realize that you might be placing your life quite literally in my hands? Supposing I should advise you to return to England at once, to re-enlist, and supposing you were to accept my advice. You might be killed before the winter is ended. How do you think I would feel in that case?"

"I'm sorry, Professor," I said. "I had not seen the matter in that light. I will say no more."

We then talked of other things: happenings at Grinnell, faculty changes and the like. It was inevitable that we should talk about poetry and Professor Payne was interested in my account of poetry under the fire test, and of various passages that I had proved could stand up to it superbly, under the severest conditions. I had brought with me a copy of my *Atlantic* article hoping he would ask me to read it, which he did. It was a late hour when I rose to go.

"Wait a bit, Norman," he said. "Let's come back to your problem. I've been considering it in the back of my mind while we've been talking here. I see that you are still an incurable romanticist, which prevents you from taking a common-sense view of things. You believe that because you resolved to return to service after a month of leave, you are bound to do so. . . . How long do you think the war will last?"

"Two or three years more, at least," I replied.

"That is my own opinion. Furthermore, I belive that it cannot be won without the help of the U.S.A. and that we are bound to come in. Well, then, the articles the *Atlantic Monthly* wishes you to write may be of real service in making America more conscious of what English soldiers are enduring in a cause that is ours as well. I think you should stay here and finish them. What will it matter if you miss two or three months of service with your battalion, particularly in the wintertime when fighting has again come to a standstill?"

"That is your honest opinion?" I asked.

"Yes. You will have plenty of time to be killed before the war ends. Being a romanticist, I suppose you think of that as the most fitting end to a soldier's career in the greatest war in history?"

"I am not a romanticist to that extent," I replied.

And so I returned home, resolved to go on with *Kitchener's Mob* and to have it finished well before spring.

Never have I spent so miserable a winter as the one of early 1916. Despite Professor Payne's advice to take "a common-sense view of things," my conscience gave me no peace. I knew that I should not be sitting at home writing about the war, but that my duty was to return to France to my comrades in the 9th R.F. I kept in constant touch with them by letter and so knew what was taking place at the front. Nothing, from the War Office point of view, was happening; it was a continued story of boredom and misery with the trench lines just where they had been in the autumn, with endless processions of working parties strengthening them at night, adding successive lines of support trenches. "And the Jerries are doing the same," one of my comrades wrote. "It looks to me as though both sides will be stuck in the mud here for years to come." Steel helmets were being issued to the troops to protect their heads from shrapnel, and waterproof trench coats lined with sheeps' wool were replacing the old greatcoats which were little better than sponges for soaking up rain.

Scarcely a letter received but contained news of comrades killed, and I wondered whether, by the time I returned, there would be any of them left.

Meanwhile, I was asked to give a talk at the Methodist church about my experiences in France. The church was packed on the evening when I did so. It was my first public appearance at home since the night when I graduated from high school and clung so grimly to the opening lines of my oration: "One hundred years ago the morning broke. . . ." The faces looking up at me appeared to be the same, except that my brother Harvey was not in the second row as he had been on that memorable night. I had no memorized speech to deliver on this occasion. I merely talked, simply and informally, with no attempt to preach the duty of the U.S.A. with respect to the war. I had the feeling that my audience considered me as something of a curiosity — a Colfax boy who had joined the British Army. Whatever for? In those days which now seem so remote, Iowans, like the folk of the Middle West generally, took little interest in European affairs. The war was no concern of ours. If Europe could not take an example from the great peaceful U.S.A., let them stew in their own juice.

That talk was a complete failure except as entertainment. I had hoped to arouse these old friends and neighbors; to give them a clear idea of what war meant and of the courage of the men who were fighting it, but I did not succeed. It was all too far away, too remote from their own experience. I related the incident of the rainy autumn evening when the trenches were reduced to a series of mudholes and the man fell into the hole of waist-deep water near our gun position.

"Na, then, matey! Bathin' in our private pool without a permit?"

"Grease aht of it, son! That's our tea water you're a-standin' in."

There was a general ripple of laughter at this, as there might have been had I told a funny story about "Pat and Mike." They failed to see its significance as an illustration of the kind of spirit which kept

English soldiers going and enabled them to accept whatever situation with a kind of wry humor which is beyond praise.

I can count on the fingers of one hand the times in my life when I have given way to deep anguish of spirit, and this night was one of them. The reason for it is still somewhat obscure to me, but I believe the underlying cause was the outburst of amused laughter which greeted the story just mentioned. I kept control of my feelings until I ended my talk and for fifteen or twenty minutes afterward, while answering questions. Then I managed to slip away down the alley leading to the C.R.I. & P. depot. There was not a soul in the station. I sat by the potbellied soft-coal stove in the Gents' waiting room, and what happened then I will pass over. The reason must have been that I felt such a renegade, sitting behind a "Wilson machine gun" at home when I knew I should be with my comrades in France. Then, as I got control of myself I heard the whistle of Number Six far away to the west, and went out to the station platform to see the brilliant headlight I remembered so well lighting the track down the Mitchellville grade. "Preacher" Stahl and Buller Sharpe should have been there with me, but on that night I couldn't even imagine that I was a boy again, about to hop the pilot on a night ride to Grinnell.

I walked forlornly home and up to my room where the sheets of my *Kitchener's Mob* manuscript were scattered on the table and on the floor beside it. I sat at the table, chin in hands, staring at vacancy. On a shelf nearby lay the little packet of letters I had received from my C Company comrades, the pages soiled with the mud of the trenches. I had read and reread them until I knew them almost by heart. "Little Willy Gunn was killed last week. You'll know how we miss him" . . . "Joe Hammond got his, a piece of shell-casing through the head. Good old Joe! The best mouth-organ player in the Company" . . . "Bobby Windle had a wonderful piece of luck. He got a Blighty one, a dose of shrapnel in the back. He's out of this mudhole for the rest of the winter, anyway."

It was on this same night that I wrote —

RETURN TO FLANDERS

Hearing the voice, as in a dream
He rose and followed. Nothing stirred
Save that the air was ringing still
With the call he'd heard.

Before him stretched a level land
Where it was neither night nor day;
How forlorn, how desolate
No words could say.

Along a road, what had been trees,
Though dead, seemed begging still to die.
That evil place seemed very heaven.
He knew not why.

Musing, he stood, as still as stone;
Then, in a flash, his body knew
And cried in anguish: "What is this
You make me do?"

Little could his body guess
Why spirit found that stricken plain
So beautiful, or why it said,
"Home! Home again!"

This was a chapter in my Kitchener's Mob experience that I would
have liked to send to Mr. Sedgwick: it told more of the meaning of
true comradeship than I could have said in a book of prose. But he
had not asked for verse, and it was not until many years later, in 1932,
that I submitted and he published the poem. At the time few readers
would have understood what I was trying to explain.

xvii. The Escadrille Lafayette

WHEN MY MANUSCRIPT was finished I paid a last visit to my Hill just as the hepaticas were pushing up through the dead leaves in that beloved bit of forest land, and their delicate fragrance worked its old magic. On that April morning I said to myself: "I'm not going to re-enlist as a machine gunner. I will join the Royal Army Medical Corps as a stretcher-bearer." This gave me an immediate lightness of heart and I wondered that I had not thought, long since, of this possibility. I would not be with my old C Company comrades, but so many of them were already gone that it would be a saddening experience to rejoin the few who were left. And I would be sure to find a band of brothers among men who had chosen, for war service, the work of salvaging human bodies instead of destroying them.

Kitchener's Mob, a small book of only eleven chapters, was finished and the manuscript was in the hands of Ferris Greenslet, editor in chief of Houghton Mifflin Company, who had written me that it would be published in May. My friendship with Ferris Greenslet, formed at this time, is another one of the enduring kind that need not be kept in repair by means of letters. I would not attempt to estimate my debt of gratitude to him, but among items on the list is this: that he first told me of Willa Cather and gave me a copy of *My Antonia,* and from this, of course, I went on to her other novels.

At long last, five months after my discharge from the British Army, I was ready to return to England. While making preparations for

leaving, Mr. Sedgwick asked me to dinner at his home on Beacon Hill. Many a time during the years spent in Boston, while walking through Walnut Street I had paused to look at the beautiful old house at #14. There is a garden behind it which, owing to the steepness of the slope, lies high above the level of the street, so that a passer-by sees only the tops of the trees in the garden itself. I often wondered who lived there, not knowing that it was the home of the editor of the *Atlantic Monthly*. On this particular evening I saw both the home and the garden as Mr. Sedgwick's guest, and they were as beautiful as I had imagined them to be.

While sitting in the garden after dinner, Mr. Sedgwick said that he had another writing project in mind for me if I cared to accept it. He wanted two or three articles for the *Atlantic* concerning the Escadrille Lafayette, a squadron of American volunteer airmen serving with the French, which had recently been placed on active duty at the front.

"It would not take you long to write these articles," he said, "and they will be valuable in further arousing American interest in the Allied cause. If you accept the commission I will furnish you with letters of introduction which will smooth the way for you when you arrive in France."

This was the first I had heard of the Escadrille Lafayette. The plan for forming such a squadron had originated with Norman Prince, of Boston, as early as November, 1914, when he was learning to fly hydroplanes at the Burgess School at Marblehead. But owing to various causes, chiefly official red tape, the squadron did not become a reality until the spring of 1916.

I accepted Mr. Sedgwick's generous offer with alacrity. I had been deeply interested in flying since the summer of 1909 when I had seen the monoplane in which Blériot had crossed the Channel, on exhibition at Selfridge's store, in London. And in 1911 or 1912 — I've forgotten which year it was — I attended what was, I believe, the first aviation meet ever held in the U.S.A., at Squantum, Massachusetts.

Graham White was one of the participants and Tom Sopwith another. A flight was made around Boston Light, about ten miles from the harbor, considered a splendid achievement at that time.

I sailed with my friend, George Greener, who had business connected with the North Bennet Street School to transact in England.

When Greener and I left Boston we were given some letters of introduction, including one to Mr. and Mrs. Wilfred Meynell. Greener was not then familiar with Francis Thompson's poetry but I urged him to go with me to the Meynells who, as everyone knows, had found Francis Thompson starving in the streets of London and had taken him to their hearts and into their lives; otherwise his poetry would never have been written. We sent our letter to Mr. Meynell and a few days later received a gracious note asking us to spend a week end with him and his family at Greatham, Pulborough, in Sussex. We were received as though we had been old friends of the family. Greener was perfectly at home in any company, but not the woodshed poet who was, commonly, shy in the presence of strangers. But in less than five minutes Mrs. Meynell completely conquered my feeling of embarrassment. Seeing my interest in Francis Thompson her talk was all of him. Mr. Meynell had in his library all of Thompson's manuscripts and I spent an hour or two reading them, noting the changes made as he composed. Never shall I forget that week end. It has been a treasured memory ever since.

Immediately after this I said good-by to Greener and went to Paris. At the time of my arrival there the Lafayette Squadron was being transferred from an airfield near Bar-le-Duc in the Verdun sector to one near Luxeuil, in the Vosges, and I had the good fortune to meet some of the pilots who had a day or two of leave while the transfer was being made. Paul Rockwell, of Asheville, North Carolina, who, with his brother, Kiffin, had crossed to France in August, 1914, to enlist as volunteer infantrymen in the Foreign Legion, had been

wounded in the desperate fighting in the early months of the war and was invalided out of the service. When I arrived in France he was in charge of the Paris bureau of the Chicago *Daily News*. With Paul Rockwell I formed an immediate friendship, and it was thanks to him that I had an opportunity to meet some of the pilots of the Escadrille Lafayette at this time: his brother, Kiffin, who was killed in combat only a few days later, William Thaw, Raoul Lufbery, James McConnell, and others.

Then Paul suggested that I see Dr. Edmund L. Gros, an American who had lived long in Paris and was one of the heads of the American Ambulance Service. Dr. Gros was the warm friend of all the American volunteers serving with the French, whether as infantrymen, ambulance drivers or airmen. It was thanks chiefly to him that the Escadrille Lafayette was enlarged to the Lafayette Flying Corps. By the time the war ended 180 of these American volunteers had fought in 66 pursuit and 27 observation and bombardment squadrons of the French Air Service. After America's entry into the war, 93 of these experienced pilots were transferred to the U.S. Air Service, and 26 to U.S. Naval Aviation, while 33 remained in the French Service.

But on the day when I walked into Dr. Gros' office at 23 Avenue du Bois de Boulogne, enlistment in the Lafayette Flying Corps was just getting under way. I explained briefly to Dr. Gros about my service in the British Army and my commission from the *Atlantic Monthly*. He listened quietly while I was telling him this; then he said: "Do you feel obliged to re-enlist as an infantryman in the British Army? Why not join up as an airman with your compatriots over here?"

I stared blankly at him. I heard his words, but their significance did not come home to me for a moment or two.

"As an airman! You mean, it would be possible to do this?"

"Why not?" Dr. Gros replied. He opened a drawer in his desk and brought out a paper which he passed to me. It read:

Monsieur le Ministre: —

J'ai l'honneur de vous demander de vouloir bien m'autoriser à contracter un engagement, pour la durée de la guerre, dans l'aviation militaire française.

Nom et prénoms
Âge
Nationalité
Lieu de naissance
Poids
Langues parlées
Université ou École
Références

Veuillez agréer, Monsieur le Ministre, l'expression de mes sentiments respectueux.

(Signature)

I read this slowly, incredulously, and when I had finished Dr. Gros said: "Would you like to fill it out? My name is the only reference you will need."

"Dr. Gros," I replied, "I know nothing whatever about flying."

"Neither did the other men who are now *pilotes de chasse* with the Escadrille Lafayette."

"And I know nothing about internal-combustion engines."

"That isn't necessary," Dr. Gros replied. "Both in the aviation schools and at the front there are expert mechanicians to take care of the planes and engines. Your only duty would be to learn to fly and to fight in the air."

Three days later, with two other Americans, Douglas MacMonagle, of San Francisco, and Leland L. Rounds of New York, I left the recruiting bureau at the Gare des Invalides, with the same feeling of bewilderment I had been so conscious of at the Horse Guards Parade in London, two years earlier. The ex-private 690 Royal Fusiliers had

become EV (Engagé Volontaire) 11921 in the Aviation Section of the French Foreign Legion. In my confused state of mind there was only one thing I was certain of: *"pour la durée de la guerre"* would mean just that. No more "home leave."

When it is remembered that through all the millenniums that man has lived upon the earth, it was not until the beginning of this century that he learned to fly, the feeling of young prospective airmen thirty-five years ago, when the conquest of the air was only twelve years old, can be understood. To have been of the right age at the right time was fortune so great as scarcely to be believed. Often when I awoke of a morning, in the brief period that comes before one is fully conscious, I would think, drowsily: "What has happened? What is it that gives me this feeling of happiness?" Then I would remember. "Oh, yes. I am learning to fly."

In 1916 recruits in the Lafayette Flying Corps were sent for their early training to the École Blériot at Buc, a village near Versailles. Monsieur Blériot's home was close by, and the planes in which we learned to fly were Blériot monoplanes equipped with Anzani engines, the same type of plane exactly as the one in which Blériot had crossed the Channel in the summer of 1909.

At that time double controls were not used in training pursuit pilots, or *pilotes de chasse* as the French call them. Apparently the French authorities believed a man should learn to fly without help if he was to make a good pursuit pilot. Although it was rather an alarming experience at first for the novice, he gained confidence as he proceeded and was proud of the fact that he learned to fly on his own with no more assistance save what his instructors gave him before he left the ground.

Our first sorties were made in what were called "Penguins," Blériots with clipped wings which could not rise from the ground, and equipped with 25-horsepower engines. In these we learned to make straight-line runs across the field, and as soon as this simple maneuver was mastered we were promoted to the next class using

full-winged Blériots with 35-horsepower engines in which we rose to a height of fifty feet or more, flying across the field and coming down on even keel, so to speak, by "coupé-contact," at the far side of the field. Then came the pique class in which we flew at an altitude of one or two hundred feet, and cutting off the motor, dived for a landing, straightening out when only a few feet from the ground. Following this came the *tour-de-piste* class in which the young birdman made the five-mile circumference of the field at an altitude of three or four hundred feet; and when he had done this for the first time without cracking up on landing, he was at the peak of felicity. Life, he thought, had no other experience to offer which could, possibly, equal that one.

Then came an hour's endurance flight at a height of two thousand meters, and two cross-country flights of sixty kilometers or thereabout. The crowning glory before he received his wings as a brevetted pilot was a three-point cross-country flight, landing at air fields about one hundred kilometers apart to fill his gas tank, and a return to his home field.

It requires an effort of the imagination to realize that such vast progress in aviation has been made in little more than a generation. When I see a pursuit plane of 1950, its huge instrument panel covered with scores of gadgets, and think of our little Blériots, Caudrons, Nieuports, Morane Parasols and Spads, I realize how fortunate a man was who learned to fly thirty-five years ago. The conquest of the air was then so recent, and the glory, the wonder of it was still fresh in everyone's mind. Our instruments were few indeed: a compass, an altimeter, a revolution-counter, an oil-pressure gauge, and sometimes a wind gauge. Our engines could not be depended on, and in a pursuit plane we could carry only enough gas for a two-hour flight; but every pilot felt a personal affection for his little ship which I doubt is felt by the pursuit pilots of today. Furthermore, we were not in enclosed cockpits, but in the open air where we could enjoy our flights at from eighty to one hundred and twenty-

five miles per hour and really see the country over which we flew.

Douglas MacMonagle and I were sent to the front on the same day as pilots of the Escadrille Lafayette — Nieuport 124, to give it its official designation. At that time the Nieuport, type 127 — with a wingspread of 18 to 23 meters — was still the plane in common use in French pursuit squadrons, but this was being superseded by the Spad, equipped at first with an Hispano-Suiza engine of 140 horsepower. Ours was the only squadron in the French Service all of whose pilots were Americans; our CO and second-in-command were French. At the time we joined, our officers were: Captain Georges Thénault, Lieutenant Verdier-Fauvety, Lieutenant William Thaw, of Pittsburgh, and Sous-Lieutenant Raoul Lufbery, of Wallingford, Connecticut. The other pilots, most of them with the rank of sergeant, were: Stephen Bigelow, of Boston; Ray C. Bridgeman, of Lake Forest, Illinois; Courtney Campbell, Jr., of Chicago; Charles Dolan, Jr., of Boston; William E. Dugan, Jr., of Rochester; Willis B. Haviland, of St. Paul; Dudley L. Hill, of Peekskill, New York; Chouteau Johnson, of St. Louis; Henry S. Jones, of Harford, Pennsylvania; Walter Lovell, of Concord, Massachusetts; Kenneth Marr, of San Francisco; David Peterson, of Honesdale, Pennsylvania; Robert Rockwell, of Cincinnati; Robert Soubiran, of New York City; and Harold B. Willis, of Boston.

One of my earliest experiences with the squadron was, certainly, the most embarrassing. While in training I had written a letter home describing some of the pleasures of learning to fly, and — by a slip of the pen, surely — I added to my account: "I know, now, why birds sing." A part of this letter got into the local paper and was copied into some city paper — anything that had to do with flying was copy in those days. Well, some friend in America of one of the pilots saw this, cut out the item and sent it to him, and the latter — I believe it was Kenneth Marr — read it aloud at the squadron mess. I never did live it down. In 1950 I was spending a few days in New York City, and a dozen old Lafayette Corps men living in or near New

York got together for a reunion. We had not met in more than thirty years and spent a delightful evening living over the old days in France. Henry Jones, who looks scarcely older than he did when we were flying together, except that he is now completely bald, lifted his glass to me and said: "Tweet, tweet, Jimmy! I know why birds sing."

I will speak of one of my earliest adventures in the air which happened only a few days after I joined the squadron. Our airfield was at Chaudun, a village not far from Soissons, on the Aisne. The front in that sector was quiet at the time and routine patrols were in order: one high patrol daily at an altitude of from 3000 to 5000 meters, and one low patrol at 3500 meters and below. I went out on high patrol with four other planes led, as I remember it, by Harold Willis. As we passed over the lines I was so intent upon looking down over the vast extent of country with its complicated systems of trenches stretching away as far as the eye could reach, that I lost my companions. Looking up presently I found myself alone. It was my business, of course, to keep my eye upon the flight leader, not his to look out for possible stragglers. I felt more than remiss and searched the sky for sight of the others, but our little ships flying at from 100 to 125 miles per hour could quickly vanish. We were flying at 4000 meters above scattered masses of cumulus clouds. While seeking my flight I saw the sky blossoming with blobs of blue smoke from explosions of French antiaircraft shells not more than two or three miles distant and a little below my altitude. Flying in that direction I saw a German two-seater with its black crosses not more than a thousand feet below me. My pulse speeded up a bit. By chance I was in perfect position for attack with the sun directly behind me. "Lord!" I thought, "Can it be that I am going to have a fight and a possible victory so soon after arriving at the front?" Quickly I looked behind and above and all around me for the presence of other planes but saw none. And there was the Boche all unsuspecting, flying quietly on. It was a photographic plane. I could see the man in the rear cockpit, his

machine gun pointing idly at the sky while he was busy with his camera. I throttled down, descending toward him in a shallow glide. I got him directly in my sights and slipped my forefinger through the trigger guard on my control stick. I couldn't have missed. The plane looked huge as I approached and I could plainly see the pilot and the photographer all unconscious of their danger. And then . . . I didn't shoot. I nearly collided with the German and pulled up on my stick just in time to zoom over him at a distance of not more than twenty-five meters. As I veered I saw the photographer spring for his gun and then the plane vanished as though it had melted into the air. When I turned again it was gone, probably into one of the masses of white cloud below us.

Why did I fail to take this superb chance for a victory during my first week at the front as an airman? I don't know. Perhaps without my realizing it my mind was functioning apart from my body, saying, "And yet . . . on the other hand . . ." until the chance was missed. When I returned to the airport without having found my patrol I was given a well-deserved dressing-down for having lost contact with the others. But this was mild compared to what it would have been had Captain Thénault known the truth. I did report having seen a German photographic plane but said that I had lost it in the clouds. It was a poor beginning for a so-called pursuit pilot. Not a week later I learned to my cost that Germans have no scruples about shooting a sitting duck even with the odds seven to one in their favor.

And this brings me to another woodshed poem, written in pencil, the manuscript of which, only a few days later, was to be stained with my heart's blood. It brought in far greater returns from the monetary point of view than anything written before or since, and although Uncle Sam, not the woodshed poet, was the beneficiary, I was well content that this should be so.

Upon arriving at the front as an airman I seem to have had a return to the mood of pleasant sadness I have spoken of as being common in England at the outbreak of the war, and this, I think, was due

to the fact that I was then reading Alan Seeger's *Poems*. It is not to be wondered at, perhaps, that a romanticist would be tempted to write some verses in a similar vein to his "I Have a Rendezvous with Death," and this I did under the title —

THE AIRMAN'S RENDEZVOUS

And I, in the wide fields of air
Must keep with him my rendezvous.
It may be I shall meet him there
When clouds, like sheep, drift slowly through
The pathless meadows of the sky
And their cool shadows move beneath . . .
I have a rendezvous with Death
Some summer noon of white and blue.

Oh, he must seek me far and wide
And track me at his fleetest pace,
For there are lonely depths in space —
Solitudes where I may hide,
Laughing at him when he has gone
On a false scent, with laboring breath . . .
But I've a rendezvous with Death
Over Verdun, as night comes on.

Perhaps some autumn afternoon
Of cloudless skies, far in the blue
Beneath a ghostly waning moon,
I shall be flying without care
Or thought of war, or thought of death;
Unwarned that he is coming, too,
Swiftly through the upper air
Straight to his well-planned rendezvous,
Until I hear, with darkening brain:
"Well met! We shall not meet again."

I had just finished these verses when a group of American Air Service officers — the U.S.A. had entered the war less than two months earlier — came to our flying-field on a tour of inspection of the Western front. The Escadrille Lafayette was one of four squadrons comprising Groupe de Combat 13, commanded by Commandant Philippe Féquant, and occupying the same field. The officers had called upon Commandant Féquant, who, with typical French courtesy, wished to show his visitors a group of pilots going into action, and he delegated this honor to pilots of our own American squadron.

Patrols for the day were over and the sun was near to setting when eight Lafayette men went out to the hangars to "show off" before the visitors. I was one of them and felt keenly the honor of having been chosen for this exhibition patrol. We were to go out to the lines, patrol our sector for half an hour, and return to the field in time to land before dark, and every pilot hoped there might be some action to report when we came back. Being a new pilot I was then flying one of the old planes handed on to me by one of the older pilots who had a new machine. It was a 140-horsepower Spad with a rebuilt engine. My mechanics had trouble in getting the engine to functioning properly. In those days a pilot was considered lucky who got one hundred hours of flight from an engine without an overhaul.

The others were already in their planes ready for the take-off, their motors idling as they waited for me. Then they left without me, and having assembled over the field, headed for the lines. I was in a fret of impatience as I stood by my Spad while the mechanics were working on the engine. The American officers watched the flight until it had vanished to the north; then, escorted by Captain Thénault, they strolled back toward the squadron mess to wait for the return. Cartier, my chief mechanic, climbed out of the cockpit of my Spad with a baffled, apologetic look on his face, shrugged his shoulders and threw out his hands in that eloquent Gallic gesture which is so wonderfully expressive. Knowing nothing whatever about motors I could offer no suggestions as to the possible source of the trouble;

nor would any suggestions have been welcomed, for those French *mecanos* knew their business. Of a sudden Cartier struck his forehead with the heel of his palm and made a dive beneath the hood of the engine. A moment later I heard the heartening roar of an engine functioning, not perfectly, perhaps, but well enough. *"Voilà! Ça gaz!"* Cartier said, his face beaming. Quickly I climbed into the cockpit, fastened my seat belt, adjusted my goggles and waved to the mechanics to take the chocks out from under my wheels. I gazed anxiously toward Captain Thénault, but he was then a good quarter of a mile distant. I knew that he would have forbidden me to go had he been present, but there was no one in authority at the hangars to stop me, so off I went.

Our airport was about fifteen kilometers back of the lines. I crossed them just as the sun was setting; in fact, it had already set from the point of view of men in the trenches, but I was at four thousand meters which was as high as I could persuade my rebuilt Hispano-Suiza engine to take me. A few antiaircraft shells burst harmlessly around me at distances of three or four hundred yards, for antiaircraft fire in those days was nothing to what it was to become in World War II. I searched the sky in every direction but saw no other bursts, nor the sight of any planes. I flew along the lines for a quarter of an hour, perhaps, trying without success to get more altitude; then I spied my patrol — at least I thought it was mine — about five kilometers inside the German lines. I counted seven machines, five of them well grouped, a sixth — that would be Raoul Lufbery — several hundred meters above the others, and a seventh several hundred below. I turned in their direction at once. It was getting dusk and as I approached I lost sight of the plane lowest down; he was approaching at exactly my altitude and it is difficult to see a plane in that position, particularly in fading light. Suddenly he loomed up directly in front of me, and he was firing as he came. His tracer bullets were going by on the left side but he corrected his aim and my motor seemed to be eating them up. As I banked to the right I felt a

smashing blow in my left shoulder accompanied by a peculiar sensation as though it had been thrust through by a white-hot iron. My left arm seemed to be off, but it was still there although there was no more feeling in it. Blood was trickling into my eyes so that I could scarcely see and my flying-goggles were hanging down over my ears in two parts; they had been cut through at the nosepiece. I have never been certain of this, but I don't believe I fired a single shot; after the bullet that creased my forehead I couldn't see anything to shoot at. There followed a vacant period that I can't fill in, but when it passed I realized that I was falling in a kind of half-*vrille* — spinning nose dive — with my motor going full speed. The Boches were following me closely, judging by the sound of their machine guns. I fully expected to feel another bullet boring its way into me, and one did graze a very important part of my anatomy but I didn't know of this until later. Perhaps it was as well that I did fall out of control for a considerable distance, for the firing soon stopped; evidently the Germans thought, with good reason, that they had bagged me.

I pulled out of the spin, got my stick between my knees, reached over with my right hand and throttled down the engine. The propeller stopped dead, and when that happened in the air with a Spad, there was no way of getting it turning again. I didn't much care at the moment, except for wondering in a kind of drowsy way whether I were on the French or the German side of the lines. I came out in *ligne de vol* at about a hundred and fifty meters from the ground. It was a wicked-looking place for landing: trenches and shell holes everywhere, dimly seen in the gathering dusk. I was still wondering in a vague way whether they were French or German when I fell into a most restful sleep.

I have no slightest recollection of the crash; I might have fallen as gently as an autumn leaf. When I came to, it was at once, completely. I was on a stretcher and remembered immediately what had happened. My heart was going pit-a-pat, pit-a-pat, but I felt no sensa-

tion of pain. This made me think I must have been badly crushed. I tried moving first one leg, then the other; then my arms, my head, my body. No trouble at all except with my left arm.

I accepted this miracle without trying to explain it, for I had something more important to wonder about: who had the handles of my stretcher? I opened my eyes but saw nothing at first but a red blur. I wiped them dry with my right sleeve and looked again. The broad back in front of me was covered with caked mud. It was impossible to discover the color of the tunic, but the shrapnel helmet on the man's head was French. I thought in the hospital, later, that if I lived long enough to gather a few possessions and have a home of my own, I would have a bust-length rear-view portrait of a French *brancardier*, mud-covered back and battered tin hat, as a souvenir of the war. Unfortunately, I never did this.

I was being carried along a trench and the stretcher-bearers had to lift me shoulder-high at some of the turns. It was weary work for them. The Germans were shelling the lines in desultory fashion. Several fell fairly close and they took me down a flight of steps into a dugout to wait until the shelling ceased. While waiting they told me that I had fallen just inside the first-line trenches at a spot where a rise in the ground hid me from sight of the enemy. My Spad was a complete wreck. It fell squarely into a trench, the wings breaking the force of the fall. Before reaching the ground I turned, they said, and was headed back for the German lines. Fifty meters higher and I would have come down in no man's land.

For a considerable time we listened to the subdued *crr-ump*, *crr-ump* of the shells. Showers of earth pattered down the stairway and we could hear the high-pitched, droning *v-z-z-z-z* of pieces of shell casing as they whizzed across the opening. One of the men would say, "Not far away, that one," or, "He's looking for someone, that fellow." I was reminded of days and nights when my C Company comrades would make similar comments: "Gor Blimey! That was *close!*" "There's another one hasn't got our number."

The first-aid dressing station was in a dugout lighted by candles. At a table in the center of it two medical officers were working over a man with a badly crushed leg. When they had finished with him I was laid on the table and orderlies cut away my flying combination which was soaked with blood along the left side, as was my tunic beneath it. I didn't know how badly I was wounded and watched the doctors' faces as they worked over me for some hint of the nature of my wound, but no hint was to be read there. It was all in the day's work to them, but when they stripped off my trousers to regard my nether parts, one of them said to an orderly: "Lift him up a bit." When he had done so the doctor looked at me with a smile. "*Regardez, Sergent. Vous avez de la chance.*" He held a nickeled mirror between my legs, and I could see a livid crease along my scrotum. A bullet had cut the skin but that was all. Oh, the difference to me! The bullet that had caused all the bloodshed had entered my left shoulder from behind, just missing the shoulder blade, making a sizable hole where it came out under the arm.

I spent several days in an evacuation hospital near the lines, and then, thanks to Dr. Gros, I was sent to the American Ambulance Hospital at Neuilly, a suburb of Paris. Although I tried to conceal the fact, I felt melancholy indeed to have been shot down so soon after my arrival at the front, and my conscience hurt me because I had failed to take advantage of the wonderful chance I'd had to bag the German photographic plane. It was said that the average annual cost of keeping one pursuit plane in service at the front was 300,000 francs, and I felt more than ever guilty, remembering that I had not paid even one franc on the debt I owed to France for my training in aviation.

Only a week or so after I had been sent to the American Ambulance Hospital, I received a letter from my friend, Curtis W. Coe, who had "tipped me" with the two volumes of Francis Thompson's poetry on the spring day in 1907. He said that since the U.S.A. had entered the war the feeling in the country had entirely changed:

there was now great enthusiasm for the war effort and many people were putting their savings into Liberty Bonds. Curtis Coe was active in the Liberty Bond campaign, and he asked if I could send him something from the front — a souvenir of some sort from the Escadrille Lafayette — that would be of use to him in selling bonds. At this time the contents from the pockets of the uniform I was wearing when wounded had been returned to me, and among them was the paper, stained with blood, on which I had penciled "The Airman's Rendezvous." I sent this to Mr. Coe, and later he wrote me that he had sold tens of thousands of dollars worth of bonds merely by displaying this "exhibit" from the front. This eased my mind greatly.

xviii. New Year's Day

AN AMERICAN NEWS CORRESPONDENT in Paris cabled his paper an account of my "heroic battle" against seven Germans and reported that I was "lying at the point of death, shot through the lungs," in a hospital not far behind the lines. War enthusiasm was mounting rapidly in the U.S.A. With little yet to report of actual fighting by Americans the newspapers seized upon any incident concerning the volunteers in the French service which proved that blood had actually been spilled by one of them. It was thus — owing to the cable from Paris — that I became a forty-eight hour "hero."

And there was I, ignorant of my fame, propped comfortably up with pillows at the American Ambulance Hospital, reading the *Oxford Book of English Verse* which one of the nurses had loaned me. My only difficulty was in turning the pages with the fingers that held the book but I managed this after a fashion. My companions in the ward were for the most part desperately wounded men concerning whom not a word appeared in any of the Paris newspapers, which was not strange considering the fact that France had been fighting for nearly three years. A mere roster of the names of French soldiers killed and wounded in a week would have filled any Paris newspaper several time over.

Some of the most eminent face and brain surgeons of France and the U.S.A. were on the staff at the American Ambulance Hospital, for here were sent soldiers who had received terrible head wounds, some with their jaws shot away or parts of their skulls — men one

would think had no chance of survival. Some had been in the hospital for many months and it was a revelation to me to see how the surgeons were building up new faces for them, not as good as the old, of course, but serviceable nevertheless. If I could have had any illusions left as to war being a noble adventure — which I had not after my experience in the British Army — the last vestige of them would have vanished at the American Ambulance Hospital. I can still hear the animal cries of terror and pain ringing through the wards as the doctors made their rounds of a morning to change the dressings of terribly wounded men. Some were not able to suppress the cries; others stuffed their pillows into their mouths and endured in silence. In the bed next to mine was a French padre whose left hip had been frightfully shattered by machine-gun bullets. Against my will I was sometimes forced to look as the doctor removed his dressings. Sweat poured down the padre's face but his only outcry was, *Ô, là là! Ô, là là!*" The mildest of French expressions became for me the voice of a man suffering incredible torture with more than human fortitude.

On the other side of me was a French airman, a Voisin pilot, who had been badly hurt in a crash returning from a night bombardment. He had been flying since the early days of the war and told me a story of the origin of air combat, his eyes twinkling as he did so, as much as to say: "Believe it or not, this was the way it happened." A friend of his, he said, attached to a certain Army Group during August and September, 1914, and flying a Blériot monoplane, often met a German airman flying a Taube, during his reconnaissance patrols. In those days fighting in the air was a development for the future, and the two airmen exchanged greetings, not cordially, perhaps, but courteously; a wave of the hand which meant: "We are enemies, but we need not forget the civilities"; then both continued with their work of spotting batteries, watching the movement of troops, and the like. One morning the German failed to return the customary salutation. The Frenchman thought little of this and greeted his enemy in the usual manner at the next meeting. To his surprise, the Boche shook

his fist at him in a blustering, caddish way: there was no mistaking the insult; the Blériot pilot distinctly saw the clenched fist. On his next reconnaissance he ignored the German, but the latter approached very closely and threw a missile at him: the Frenchman thought it was a small monkey wrench but could not be sure as the object went wide of its mark. The Frenchman was so incensed that he made a *virage* and approaching closely, drew a small flask from his pocket and hurled it at his boorish antagonist. The flask contained some excellent port, he said, but he was repaid for the loss by seeing it crash on the exhaust pipe of the enemy machine. This marked the end of courtesy in the air and the beginning of hostilities. Soon airmen were shooting at each other with pistols, rifles, and later with machine guns.

"*C'est dommage, n'est-ce pas?*" said my fellow *blessé*, with a grin. "*Mais, que voulez-vous? Ce sont les boches, les sales bêtes! qui ont commencé la guerre aérienne. Ce sont toujours les boches qui font les bêtises.*"

Little could either of us know, then, what the Boches would do in a little more than a generation from that day. Among other "*bêtises*" they murdered six million Jews in cold blood, two thirds of the total number of men killed in World War I.

In early September my wound was healed and I was ready for the front again. By a mistake in orders I was sent, not back to the Escadrille Lafayette, but to a French squadron, Spad 112, in which my friend, Leland Rounds, was the only American pilot. A few days after my arrival at the squadron we went out on a special mission to an aerodrome near Belfort, almost on the Swiss border. There we learned that our mission was to furnish air protection to the King of Italy and members of his staff who were visiting the French lines in that sector. That was an experience never to be forgotten by a man born and brought up in the prairie country. There was so little activity on that part of the front that our patrols were more like sight-seeing tours, with the snow-covered Alps gleaming in the September sunshine. As I remember it, we saw no more than a dozen enemy planes

during the week we spent there, and they were so far within their lines that the King of Italy was never in the slightest danger.

Upon returning from Belfort to the Verdun sector I had one of those adventures so common to airmen thirty-five years ago when motors could never be counted on to carry one safely to the end of a flight. I was over the Vosges mountains when my motor began to miss: the pump which carried the gas from the tank at the bottom of the fuselage to the engine had ceased to function. There was an auxiliary hand pump by the side of the pilot's seat to be used in case of emergency, and I worked this until it, too, ceased to function. I had one other resource: a small gravity tank attached to the struts of the Spad and containing enough gas for a flight of from ten to fifteen minutes. I turned the spigot on this tank and by the time the gas was exhausted I was over the mountains and among the foothills of the Vosges. I planed as flatly as possible, looking for an airfield, but there were none of course in that hilly country, mostly covered with forest. Then I spied a miniature sugarloaf mountain whose summit was pasture land. It was that or landing in the treetops so I chose the pasture. I got the direction of the wind from the smoke blowing from the chimneys of a nearby village and turned into it. The hill, which looked possible for a landing from the height of two thousand meters, loomed more and more steeply as I approached; I had to pull up at a climbing angle to keep from nosing into the side of it. Then I saw cows, half a dozen or more, grazing on the hill: their natural camouflage of browns and reds and whites had prevented my seeing them before. By making spectacular *virages* I missed collisions by inches. At the summit of the hill my wheels touched the ground for the first time. I bounded on, going through a three-strand wire fence without any appreciable decrease in speed. Passing between two large apple trees I lost both of my wings. But my fuselage and landing chassis were intact and my Spad went on down the reverse slope and after crashing through a thicket of brush and small trees I came to rest against a stone wall. Unscathed, except for a broken nose, I looked

back upon my wreckage-strewn path like a man who had been riding a whirlwind in a wicker chair; and there was, indeed, little left of my Spad except the seat.

Rarely did pilots in those days make a forced landing without the mayor of the nearest village appearing on the scene shortly afterward. We believed that the mayors of all French towns sat on the roofs of their houses, field glasses in hand, on the lookout for wayward airmen. On this occasion I went to meet the mayor as nearly as I could. Indeed, had there been one more cow browsing under the apple trees I would have made one last feeble turn to the left and piled up against a summer pavilion in the mayor's garden. Like all French mayors of my experience he was a courteous, warmhearted gentleman.

After getting his breath — he was a fleshy man and had run all the way from his house — and being assurred that I was far from dead, he said: "Now, my boy, what can I do for you?"

First he placed a guard around the wreckage of my Spad; then we had tea in the summer pavilion where I explained the necessity for this sudden visit. Having frightened his cows, destroyed his fences, and broken limbs from his apple trees, I had now to borrow money from him, for I was a long way from Verdun with less than five francs in my pocket. It seemed like adding insult to injury, but he granted it gladly, and insisted upon giving me double the amount asked for.

I felt pretty glum after this adventure. As a *pilote de chasse* I was not doing so well although this second accident was no fault of mine. But I had completely wrecked two Spads for the French Government and all I had given in return was blood from a punctured shoulder and more from a battered nose.

We were fighting in the prehistoric dawn of the Air Service. As I have said, our primitive little pursuit planes flew at a maximum speed of 125 miles per hour and could carry only gas enough for a two-hour flight. Antiaircraft guns were nothing compared with the terrible precision instruments of World War II. On a two-hour patrol over the lines one hundred or more shells were often fired at us, but

almost never did one make a direct hit, and usually they burst at a distance of from three to four hundred yards so that we had little to fear from them. We were at a disadvantage in two respects compared with war pilots of these days: we could not depend upon our engines, and we had no parachutes. The only parachutes used in World War I were those provided for the men in observation balloons — huge clumsy things that could not be carried in a plane. The lives of hundreds of airmen would have been saved if the small compact parachutes now in use were then available.

The great air formations of World War II, when hundreds, even thousands, of planes were in the sky at one time, were, of course, unknown in our day. (By the time World War I ended, the total number of American airmen who had fought at the front was only 650, and 110 of these were Lafayette Corps men who had served with the French.) Rarely, until the last spring and summer of the war, did a squadron have all its planes in the air at one time, and then only when the War of Attrition flared up at various parts of the line. Ordinarily, we went out in flights of five or six planes, and lone pursuit was not uncommon in those days. Raoul Lufbery, of our squadron — who, before his death in combat in May, 1918, had shot down and received official confirmation for 17 enemy planes — was a great lover of flying alone. When I think of Lufbery I think of those lines in Tennyson's "The Eagle":

> The wrinkled sea beneath him crawls;
> He watches from his mountain walls,
> And like a thunderbolt he falls.

There was no wrinkled sea in our landscape, save on the Channel coast, but great masses of heaped-up clouds served as mountain walls for Lufbery, particularly when there were wide pools of clear sky between them. Or, if the sky was cloudless, he would nurse his Spad up to 5000 meters and above and lurk in a favorable position, with the sun at his back, for the sight of enemy planes.

This brings me to the day when, being myself on lone pursuit, I gained my first victory, so called. Shortly after the return of Spad 112 from the Vosges sector the mistake in my assignment papers was rectified and I was transferred back to the Escadrille Lafayette. I had enjoyed my brief experience with the pilots of Spad 112; they were a fine lot of men, but naturally I was happy at the prospect of returning to my comrades of Spad 124.

I landed at the airport near Senard, at the foot of the Argonne Forest where Groupe de Combat 13 was then stationed, just as a flight from our squadron was returning from the lines, and the first news I heard as the planes taxied up to the hangars was that Douglas MacMonagle had just been killed. The flight had met and "tangled" with one from Baron Richthofen's Flying Circus, and although the results were even — one plane shot down from each flight — the fact that Douglas MacMonagle was the victim on our side was bitter news to me. I felt more than ever that it was up to me to prove my worth as a pursuit pilot, and I particularly wanted to avenge MacMonagle's death.

But the autumn and early winter passed and I was still just a common or garden pilot without the distinction of a single victory to my credit. I returned from the lines on a number of occasions with my plane well punctured with machine-gun bullets, and this had been the net result of my air battles. Cartier, my chief mechanic, was proud of evidence that "his pilot" had met with Germans, but his satisfaction was not what it should have been or what I wanted it to be.

Then came New Year's Day, and Bill Thaw said: "Jimmy, let's go out to the lines and have a look around." It was bitterly cold and our mechanics had a hard time getting our engines warmed up, but at last they were turning over at a good 1900 revolutions, so we took off.

One of my difficulties in flying was to keep in formation. Even when there were no more than five or six planes together I sometimes lost the others because I would forget, momentarily, that I was a pursuit pilot engaged in the grim business of war. But one thing

I never lost was the keen sense of the glory of flying, and the wonder of it, which was not strange in those days of the early conquests of the air. In the exhilaration of flying I could even forget how cold I was, sitting in an open cockpit at a height of four or five thousand meters on a midwinter day.

Presently I realized that I had lost Bill Thaw who had been scarcely one hundred meters in front of me only a moment before. Then I spied him — at least I thought it was he — his plane a tiny speck silhouetted against a mass of cloud about half a mile distant. I put on full motor and started to climb, thinking to get well above and behind him without his seeing me, and to tell him later what an easy mark he would have been had I been a German. But when I found him again I discovered that the easy mark had no tricolored *cocardes* on his wings, but black crosses. It was an enemy single-seater, and I knew by the way he was flying that he believed he had all the sky to himself. He was doing loops and barrel-turns, lazing along over the summits of clouds and raveling out peaks of vapor as he passed over them. The thought passed through my mind: "There is a man who loves flying as much as I do, and who has forgotten, as I sometimes do, what he's up here for." But I didn't hesitate on this occasion. I was a good five hundred meters above him and about the same distance behind. As he was passing over another mass of cloud I dove, full motor, and started shooting at about one hundred yards. I could see my tracer bullets bouncing off his engine. He turned up on a wing and started falling out of control. He vanished in the cloud but when I had followed him through I picked him up again, still falling. I looked at my watch and took my bearings from the ground so that I could report where and when I had met the German and then flew back to our aerodrome at La Cheppe, on the Champagne sector.

Lieutenant Verdier was at squadron headquarters when I went in to report. He gave me a kind of wry disapproving look as I entered.

"Where have you been?" he asked.

"Out to the lines with Lieutenant Thaw," I replied.

"I know; but where have you been since you lost him? Thaw returned twenty minutes ago."

"I met a German pursuit plane," I replied; then, going to the wall map of the sector I showed Lieutenant Verdier the place above which the one-sided battle had taken place, and I gave him the time of it. He called up Group headquarters, reported the action and listened while some one spoke from the other end.

"*Bon! Merci*," he said. He hung up the receiver and turned to me.

"You got him," he said.

"I thought I had," I replied, soberly.

"Group headquarters have just received word from the Infantry. There's no doubt about confirmation. One of his wings came off in the air and fell in our lines. The rest of the plane crashed in no man's land." He put out his hand. "Congratulations on your first victory. That's the way to begin the New Year."

I suppose it was, for a pursuit pilot. But I felt no elation whatever; only a kind of grim satisfaction that, at long last, I had avenged Douglas MacMonagle's death.*

To me there were few flights comparable to those of early morning when we climbed to meet the dawn. I remember, with quietest pleasure, for they were usually the least eventful, the high patrols of midwinter mornings. And first, one was wakened out of dreamless sleep to find Tiffin, our old French orderly, standing beside one's cot, candle in hand, the light shimmering through the cloud of his frosty breath.

"*C'est l'heure, Sergent*," he would say.

Then what resolution was needed to throw back the warm coverlets and to take the plunge, pajama-clad, into the biting air! The

* In all, Hall was accredited with five German planes, and for his service in the air he was decorated with the *Croix de Guerre*, with five Palms, the *Médaille Militaire*, the *Légion d'Honneur*, and the Distinguished Service Cross. — The Editor.

square of starry sky framed in the open window offered no welcome invitation, and the thought of possible combats in half an hour's time was, to say the least, unpleasant.

Among the memories of this zero hour comes that of the messroom phonograph, sure to be set going by some pilot whose animal spirits were amazingly resilient. No matter what the airfield or what the sector of front, phonographs were always to be heard before the early morning patrols, and this sprightly music, filtered through the cold light of dawn, increased one's sense of the unreality of wartime adventure. There are certain music-hall ballads, the favorites of airmen all along the Western front, which will have forever the significance of songs before battle: "The Broken Doll," "For Me and My Gal," "Poor Butterfly," Al Jolson's "Down Where the Suwanee River Flows" — to hum one of these is to recall vividly long-forgotten experience, and the precise shades of emotion which passed through consciousness at patrol time.

A cup of hot chocolate by the messroom fire while we were getting into flying clothes, and the blood began to flow more vigorously. Then a brisk walk to the hangars, a quarter of a mile distant, and one was fully awake. From northwest to southeast along a cold horizon, the last trench rockets gleamed palely in the half-dawn; and the subdued mutter of guns — what a forbidding sound it was, and how alluring too!

Our machines, groomed for flight, stood in front of the hangars, the motors purring softly, propellers "idling over" at 350 revolutions. Machines, motors — one uses the words reluctantly. Machines they never were, those little Spads. Call them *zincs* or *coucous*, the French pilot's terms of endearment.

The mechanics look over their charges with practiced eyes. They are a hardy race, those French *mecanos*, always flimsily clad, and often without gloves even on mornings of bitter midwinter weather. Cartier, who had the well-being of my Spad in his keeping, had no more flesh on his bones than a sparrow, and his jacket and trousers

gave little protection from the intense cold; but he seemed never to mind. His love for the complicated mechanism of an airplane engine seemed to transcend all thought of comfort or discomfort. It had the abstractness of ideal passion, and yet it was a practical love, too, for which I had to thank him on more than one occasion. It had him from his bed long before dawn, and filled his thoughts and governed his actions on stormy days when flying was at a standstill, and pilots were pleasuring in Nancy, or Chalons, or Bar-le-Duc. He regarded his calling as vastly higher than mine, save only in the literal sense.

"*Ah, mon vieux! Il chante ce matin, tu sais!*"

This was often his morning greeting as he sat in my Spad testing out the motor.

"*Il chante comme une alouette! Dans dix minutes tu seras à quatre mille.*"

As he said this he would look upward with a curious watching gaze as though he already saw the plane at that height, a rapidly vanishing speck far to the eastward. Then, blowing on his numbed fingers, he opens the throttle. With a tremendous roar the motor leaps to its full power. A gasoline tin and a heap of oily rags are swept into the icy current from the propeller and carried far down the field. I cling to the side of the cockpit and watch the revolution-counter: nineteen hundred, twenty-two hundred, twenty-three hundred. I nod vigorously and clap him on the back to indicate that I am satisfied and ready to mount, but he gives no heed. What can I know of motors? It is for him to pass judgment. He reduces, opens, reduces, opens, his eyes closed, an expression of rapt virtuosity upon his face as he listens to the bellow of the engine. Content at last, he throttles down, and before he dismounts, loads the machine gun and arranges the seat straps. Then he helps me on with my fur boots. He always insisted upon performing this service, regarding it, I think, merely as the last of his duties, making ready the human mechanism which should take his *coucou* into the air and exhibit before his eyes as a hostler puts a horse through his paces in the presence of his master.

At five minutes to the hour, Lieutenant Verdier, watch in hand, walks briskly over from squadron headquarters.

Once settled in my seat, feet on the rudder bar, arms drawn down into the tiny cockpit, Cartier mounts the step, pulls the fur collar of my combination well up around my neck and winds a knitted muffler around it. Then he hands me my gloves, first the silk ones, then the paper, then the fur-lined leather ones.

"*Alors! ça y est?*"

I nod as I adjust my goggles and try out the controls. The chocks are jerked from under the wheels, and Cartier, clinging to a strut, runs beside me with giant strides as I taxi out for the take-off. The first plane of the flight is already in the air, nosing up in a steep climbing turn half a mile distant. Another, gathering flying speed, skims along the ground half hidden in a dust of powdery snow. My turn comes. Cartier signals all clear, and a moment later, coming back over the field at two hundred meters, I see him waving good-by with both hands. Then he joins the little group of mechanics at the doorway of a hangar.

They are soon lost to view. The snow-covered hangars are merged in the winter landscape, and the wide belt of pine forest which borders two sides of the field dwindles to the size of a carpenter's square. The flight assembles at two thousand meters over the field, and as we turn northeast toward the lines, holding a steady course, we seem to be hanging in space without effort, without movement. A few stars are hanging there, too, glittering so brightly in the frosty air that five minutes of climbing flight would seem ample to bring them within reach. Wisps of cloud touched with a ghostly light, fall away on either side. Watching them while climbing gives the illusion that they are drifting slowly downward, as though they had been blown about the sky by winds long since dead.

So we mounted swiftly, watching the horizons recede as a ripple moves outward over water disturbed by the cast of a pebble, conscious of having left behind old limitations of thought, the age-old con-

ceptions of time and space. This sense of the wonder of flight, ever present with us, will soon be lost. We looked down on a world as lonely seeming and as lifeless as the moon. Entire sectors of the front lay within view, the scenes of battles greater in extent, more terrible in the scope of their horror than entire centuries of old wars. These we examined with a kind of Olympian curiosity for it was hard to realize that we had any concern with what might be taking place there. We were lost in the blue sky, invisible from earth save at intervals when the sunlight flashed for a moment from the silvered undersurface of wings or fuselage. Now and then a few shells burst harmlessly, far away, the explosions scarcely to be heard above the roar of the motor. More often we had only the evidence of our eyes to convince us that we were being shelled. Looking backward we saw the fields of sky sparkling with points of intense light, and clouds of black smoke billowing outward with the force of mighty concussions. We were at the summit of the azure lists, ready for battle with our kind, and far above the effective range of the groundlings.

xix. Behind the German Lines

SHORTLY AFTER the U.S.A. entered the war we began to hear rumors that all of us were to be transferred to our own service. These rumors both pleased and alarmed us. We were pleased because all men like to fight under the flag of their own country. We were alarmed because, knowing that the U.S.A. had no Air Service at that time, we feared that we would be taken from the front and sent, perhaps back home, to serve as instructors in flying schools. At last the rumors crystallized into the definite report that the U.S. Government had requested our release from French Aviation. This was a request, not a demand, and we were told that the individual pilot could decide for himself whether he wished to remain in the French Service, or accept his release for the purpose of entering American Aviation.

The Lafayette Squadron, after many heart-searchings on the part of its pilots, decided to make the transfer as a unit, and, fortunately, we were not removed from the front. We became the 103rd Pursuit Squadron, U.S.A.S., the first American squadron on active duty, still attached to Groupe de Combat 13. The only difference was that we were now commissioned officers and in American uniform.

I was lifted from the modest rank of a sergeant in the French Service to that of a captain in the American Service; and when I got into my new uniform with the two silver bars on the shoulder-pads I was again a split personality. It was not until I was sent as a flight commander to the 94th Pursuit Squadron, in March, 1918, that I became somewhat accustomed to the change.

The 94th and 95th Pursuit had been ordered to an airport near Toul on the St. Mihiel sector, to start the ball rolling for American Aviation, and a brilliant start it was. On April 14, 1918, the morning of the 94th's first day of service at the front, the first flight of the squadron was on *alerte* duty at the hangars. There was a strong northeast wind blowing, with heavy clouds covering the sky at from 300 to 500 meters, and it seemed unlikely that there would be anything to do. Then the telephone rang: "Enemy planes heard in the vicinity of Toul." The town of Toul was near our aerodrome. Alan Winslow, a former Lafayette Corps man who had been a pilot in the French squadron, Spad 152, and Douglas Campbell, immediately went up in search of the enemy and had just left the ground when the German planes — which, as we afterward learned, had lost their way in the thick weather — emerged from the clouds. They were an Albatross and a Pfalz, single-seaters. The fight was of less than five minutes' duration. Winslow forced his German to the ground where the machine turned over, partly wrecking it. Almost at the same moment Douglas Campbell shot his down in flames. Luckily, the pilot of the burning machine had only 300 meters to fall and was thrown out when the plane crashed. Neither of the Germans was seriously hurt. The battle was witnessed by many soldiers and civilians in the vicinity of Toul. One of the spectators was slightly wounded in the ear by a bullet from Winslow's machine gun. He was rejoiced at the honor, as he called it, of receiving a *si bon souvenir* of the first combat of one of the first American squadrons to reach the front, and he thanked Winslow most heartily for it. Both the 94th and 95th squadrons made distinguished records at the front before the Armistice came, seven months later. I have always felt highly honored to have been a flight commander in the 94th — Eddie Rickenbacker's squadron — even though I was with it for so brief a time.*

* It is an amusing paradox that Hall, who never learned to drive an automobile, proved to be one of the most spectacular American airmen. He was on patrol with Eddie Rickenbacker when the latter brought down his first German

The 94th and 95th Pursuit were equipped with a new untried plane of French manufacture, the Nieuport, type 28. It was thought to be an advance on the Spad, and it was, indeed, a splendid little ship equipped with a rotary motor, and so fast in its pickup of power that it could be pulled off the ground almost as soon as its wheels were rolling. It was superb for "acrobacy" and had wonderful maneuverability: in Air Service parlance, it could be turned around on a dime. But it was soon discovered to have a fatal defect: when diving vertically or at a steep angle the fabric along the upper surface of the top wings would sometimes burst along the leading edge and rip back in great strips. Jimmy Meissner of the 94th was, I believe, the first pilot to have this happen to his plane. I remember his returning to the field with the fabric of his upper wing in tatters, and it seemed a miracle that he had been able to reach the field safely. Fortunately, only the fabric on the upper surface of his top wings was affected; it held on the under surface which gave him enough stability to keep in the air. It was believed at first that this was a defect of a particular plane; but later it was discovered that it was an irremediable fault in the construction of the Nieuport, type 28, which was then relegated

plane. Rickenbacker gives a graphic account of the combat in his book *Fighting the Flying Circus* (Frederick A. Stokes, 1919), and after the "kill" he goes on to say: "I had brought down my first enemy aeroplane and had not been subjected to a single shot! Hall was immediately beside me. He was evidently as pleased as I was over our success, for he danced his machine about in incredible maneuvers. And then I realized that old friend Archy was back on the job. We were not two miles away from the German anti-aircraft batteries and they put a furious bombardment of shrapnel all about us. I was quite ready to call it a day and go home, but Captain Hall deliberately returned to the barrage and entered it with me at his heels. Machine-guns and rifle fire from the trenches greeted us and I do not mind admitting that I got out quickly the way I came in without any unnecessary delay, but Hall continued to do stunts over their heads for ten minutes, surpassing all the acrobatics that the enraged Boches had ever seen even over their own peaceful aerodromes. Jimmy exhausted his spirits at about the time the Huns had exhausted all their available ammunition and we started blithely for home. Swooping down to our field side by side, we made a quick landing and taxied our victorious machines up to the hangars. Then jumping out we ran to each other, extending glad hands for our first exchange of congratulations." — The Editor.

to the scrap heap of experimental planes. It was my hard luck that the fundamental weakness of the plane was not discovered until after I bade a reluctant farewell to the 94th Pursuit.

On the morning of May 7, 1918, Eddie Rickenbacker, Eddie Green and I were on *alerte* duty at the hangars when a phone call was received from the lines that a flight of five single-seater enemy planes was in the air not far from Pont-à-Mousson. We took off in search and found them in the region of Armaville, a village south of Metz, on the Moselle. We had the advantage of altitude, and when we had maneuvered into position, dived to the attack. I had my hoped-for victim well in my sights and went down standing on the rudder bar. Then I heard a strange cracking or ripping sound just above my head. Glancing up quickly I saw that the fabric was ripping back along my upper right wing. I was forced to pull up at once, in line-of-flight, and turn homeward for our lines, which I could see far in the distance.

I remembered, of course, Jimmy Meissner's mishap of the same kind, which gave me hope that I could reach home if I nursed my plane along gently. The Nieuport, type 28, had a rotary motor capable of three speeds by manipulating a small throttle which cut out some of the cylinders. I throttled down to the lowest speed, and, by keeping my control stick to one side I was able to keep my little ship fairly level. But I was losing altitude all the while and was forced to fly as nearly as possible in a straight line. German antiaircraft batteries were firing steadily at me, and, as I could not change direction they were putting their bursts closer and closer. Of a sudden my plane gave a violent lurch and I started falling out of control. I had about a thousand meters altitude at the time, and it doesn't take a falling plane long to cover that distance, though it seemed long to me. I saw the ground coming swiftly up to meet me at various angles, and just before it did I pulled back hard on my stick, with the happy result that my Nieuport hit at not too steep an angle. The landing gear was sheered off and the fuselage skidded along the ground right side up.

By sheer luck I fell in an open field surrounded by woodland. German troops had their dugouts in the wood and came rushing from all sides toward my plane. When they had lifted me out I asked one of them who spoke English to set me on my feet; but the moment I touched the ground I knew that one or both of my ankles were broken and grabbed for their shoulders for the pain was severe. They carried me into a dugout near the border of the wood, and a few minutes later a Medical Corps orderly came. He examined my feet and told me that my right ankle was badly broken but he was not certain about the left one. Both hurt badly so I told him to leave off further examination until I was taken to a hospital. He bound up my ankles and put a dressing on my nose which was broken again. Then I was given a drink of water and a German cigarette, and I thought: "This is not as bad as it might have been."

Presently an Infantry officer appeared and asked for my papers. Luckily, I had nothing in my wallet but 800 francs in money — it was near the first of the month — and my pilot's identification card. At least, I thought I had nothing else, but later I found a typewritten carbon sheet of squadron orders in my trousers pocket. In a moment of unguarded leisure I wadded this into a little ball, slipped it into my mouth, chewed and swallowed it, my stomach receiving the morsel not gladly, but in a co-operative spirit. The officer kept my identification card, returning my wallet and money, taking my word for it that I had nothing else.

About an hour later several other officers — airmen — arrived. They were pilots of the squadron we had attacked that morning, and I met the man I had been diving on when the fabric burst on my upper right wing. He spoke no English, but I conversed with him through another officer who spoke it well. It gave me a strange feeling to be talking with this man who should have been dead, and, I believe, would have been dead except for the accident to my Nieuport. I did not try to analyze this feeling at the time, but later, in the hospital, as I lay gazing at a fly-specked ceiling, I regretted, as a pursuit pilot,

that I had not shot him down, and was deeply grateful, as a human being, that the event fell out as it did. They told me that, as a result of our combat, one of their pilots had been shot down in flames. (This plane, as I learned afterward, was brought down by Eddie Rickenbacker. It was his second victory.) The "living dead man" then suggested that I have lunch with them at their squadron before being taken to the hospital. I was not feeling in a company mood just then, but, of course, accepted the invitation. Then they went out to look at my plane.

I had a homesick quarter of an hour while sitting in their car, waiting for them. I was thinking of the uncertain future, aware that for me even an attempt at escape was out of the question for months to come. Far in the distance I heard the drone of rotary motors and knew that it could come only from the planes of the 94th or 95th. Presently I saw three of them making jaunty earth-scrutinizing changes of direction which told me that they were, perhaps, looking for me. When I saw them again, a few minutes later, they had turned in the direction of Toul. They were not fifteen minutes distant from our airfield and would be landing there before the smoke of the antiaircraft shells fired at them had been raveled out by the wind. My own distance from that green, secluded, sunlit field I made no attempt to compute.

When the German airmen returned they brought with them an officer of an antiaircraft battery in the vicinity who was very happy because, he said, his battery would get the credit for bringing me down. "How is that?" I said. "You saw what happened to my plane." "Yes," he said, "but that isn't what brought you down." Then he told me that in their battery they had a 37-millimeter gun which had been firing at me, and that one of the shells had stuck fast in my engine without exploding. I remembered, then, the sudden lurch my plane had given just before I started falling. Nevertheless, I couldn't believe what he had told me until I was shown the engine with the shell stuck fast in it. It seemed incredible. I have said earlier, that anti-

aircraft batteries in World War I almost never made a direct hit upon a plane. And that is true. I know of only one other plane which suffered a direct hit, a Caudron, G—4. The engine was completely wrecked but the pilot and his observer had managed to bring the plane down inside their own lines. This was considered such an extraordinary happening that the plane had been taken to Paris and placed on exhibition at the Gare des Invalides, where I had seen it. So my own missed rendezvous with death was even more remarkable than I had supposed it to be.

It was a drive of about fifteen kilometers to the aerodrome of the German squadron at Mars-le-Tour. They were quartered in a comfortable old house in the town, much better accommodation than any we had ever had on our side of the lines. But, of course, we were not living in invaded territory. We could not commandeer any dwelling that pleased our fancy and order out the rightful owners. I was placed on a sofa. While we were waiting for lunch one of the pilots sat down at the piano and played some French songs that were popular on our side of the lines. I thought: "This is, doubtless, a part of the game. First the mellowing influence of music, then that of wine, and then — they hope — the indiscreet disclosures." It is better for a prisoner of war to be too cautious than not cautious enough. Furthermore, American aviators were rarities on the German side of the lines at that time, and my captors knew not only that I belonged to an American squadron with a hat-in-the-ring insignia — for that was marked on my plane — but also that I had been a pilot in the Escadrille Lafayette, for I was wearing my old flying helmet marked with that name. I knew that the Germans were more than curious to learn the plans and the organization of our Air Force: how many squadrons were already at the front and the numbers soon to come. They were greatly interested in my Nieuport, type 28, and I did not hesitate to say that it was a superb pursuit ship, far better than their Pfalzes and Albatrosses.

First we had a roast, then a salad, dessert, and coffee to finish with.

I was relieved, of course, and amused as well. They were quieting my fears with a vengeance. I would not have objected to one glass of wine and a liqueur with the coffee. Everything was open and above board insofar as I could judge. I was even informed in advance that an Intelligence officer was coming to question me. He was a major, not at all alarming in either appearance or manner. He questioned me for some time in an easy, affable way. He professed to know a great deal about the movements of our troops and the organization of our Air Force. Some of his information was quite accurate, but of course I made no comment one way or the other. When he showed me some superb aerial photographs of our flying fields, among them one of our field at Toul, I successfully registered only polite interest. This cost some effort. I had seen that view of our field many times when going out on and returning from patrol, and the thought that I might never see it so again was a gloomy one.

After lunch I was taken to the war hospital at Jarny-Conflans and placed in a ward for wounded German soldiers, but I was not kept there more than fifteen minutes. The officer who accompanied me to the hospital made an immediate protest against placing a "*Hauptmann*" in a ward with common soldiers. The fact that I was an enemy "*Hauptmann*" didn't matter; he insisted that I be sent to a room reserved for officers. And so, to my disappointment, I was sent to a ward containing only two beds. One was occupied by a German Infantry lieutenant, a man about thirty-five, who spoke English. I didn't like the look of him, and I loathed him before we had been an hour together. He was one of those arrogant Germans of the worst kind, without an ounce of courtesy or tact. He had been wounded when his battalion had made a night raid on units of the American 26th Division which had just gone into the line at Seicheprey on the Toul sector. This was on April 20, and this Deutschland-über-alles Boche told me what a walk-over it had been. He said that his battalion had closed in from two sides on the Americans who were like so many sheep, scared stiff and made practically no resistance. They had simply

mopped them up and returned to the German lines driving their prisoners before them. They had taken several hundred, he said. He also told me how eager he was to get back to the front and that he hoped his battalion would always have Americans to fight, they were such easy marks.

We had some hot arguments, but I managed to keep my temper, for I would have been ashamed to have lost it in the company of such a man. If he survived World War I, I am sure that he was a fanatical Nazi when Hitler came to power. He was a man of the Hermann Göring type. Göring, in World War I, was one of the pilots of Richthofen's Flying Circus, and I've often wondered if he may not have been the man who killed my friend, Douglas MacMonagle. I am not naturally vindictive, but I was greatly disappointed when I learned, at the end of the Nuremberg trials, that Göring had escaped hanging by taking poison. I had hoped that he would be strung up with Kaltenbrunner, Ribbentrop, and the other barbarians.

The German airmen I met at Mars-le-Tour were of a different stamp altogether. A courtesy often extended between opposing Air Forces in World War I was that, when a pilot was shot down behind enemy lines but not killed, a message would be dropped by his captors on his own side of the lines so that his friends would not be mourning him as dead. I gratefully accepted the offer to have this done for me, and when the Intelligence officer said, "Where shall we drop it?" I told him it didn't matter; they could drop it anywhere between the Channel coast and the Swiss border and it would get to my squadron eventually. They smiled at the vagueness of the directions but I was not pressed for more definite ones. I learned afterward, from some captured American pilots, that the message had been received, and that the German pilot who dropped it was himself shot down in our lines and made prisoner. When I returned to France after the Armistice I tried to find this German, but as I did not know his name the search was fruitless.

I must not forget to mention another courtesy extended to me by

the pilots of this German squadron. While I was in the hospital at Jarny-Conflans they brought me a snapshot of my Nieuport just as it fell, showing the tattered fabric hanging down from my upper right wing and the engine spilled out in front. I still have this photograph, which was taken by the pilot I had failed to kill. Although he did not say so, he may have thought that he owed me this memento of the day when, by the fortunes of war, we both missed death.

xx. Escape de Luxe

FOR SIX WEEKS I lay in a whitewashed room, gazing dully at the flyspecked ceiling; and when I was again able to walk, I went where I was told in a kind of waking dream, more than half believing that I should presently return to full consciousness, to find Tiffin, our squadron orderly, shaking me by the shoulder to rouse me for an early morning patrol.

By degrees this sense of unreality wore off, giving place at length to an almost painful awareness of present circumstances. Not that the circumstances in themselves were particularly unpleasant. On the contrary, we were well housed, decently fed, and, on the whole, treated more generously than we had reason to expect as prisoners of war. Being officers, we were not compelled to work and had nothing to do from day's end to day's end except to answer to an occasional roll call. But the monotony of the existence was hard to endure with any patience, accustomed as we had been to daily adventures of the most stirring kind. There were seven peals of bells (or was it eight?) in the ancient Bavarian town of Landshut, and every quarter of an hour they rang from as many church towers, reminding us with ruthless persistency that once winged hours were now leaden-footed and pedestrian. The last of the bells to sound was that in Saint Martin's Kirche, and, after its final, deliberate, sonorous clang, the sound lingered in the air indefinitely, as though it were audible time reluctant to be gone. Those days were longer than the longest days of childhood.

Sometimes we could hear faintly the clatter of a cart in the cobbled streets of the town, or the musical call of a fruit or vegetable huckster on his morning rounds; but these and the pealing of the bells were the only sounds that came to us from the outside world; and we saw nothing of that world save the fleecy summer clouds floating across our patch of sky, and the branches of trees that rose above our high-walled prison yard. Our own little world seemed to be lapped round by an ocean of silence and slow time.

Nevertheless, days passed, and we occupied our abundant leisure as best we could. We talked of old combats which seemed to have taken place centuries ago, in the course of a previous existence. Or we lay in our grassgrown recreation ground, looking up into the blue sky, finding it hard to believe that we had ever wandered through those pathless meadows, to say nothing of having fought battles there; or we nibbled at the Tauchnitz editions of British and American authors, published at Leipzig, which had been provided for us by the inspector of the prison camps, and of which I was the librarian.

Ours was a typical crowd of wartime airmen: day bombers, night bombers, reconnaissance and artillery *réglage* pilots and observers, combat pilots — we represented all branches of the Air Service of various Allied nations, and we bore on our persons and uniforms evidence of the mischances that had brought us tumbling out of the air and had swept us to that quiet old town in Lower Bavaria, far beyond the tumult and clamor of war. Some men were on crutches, some hobbled slowly about with canes, some had been horribly burned about the hands and face, others bore the livid creases of just-healed bullet wounds. We had youth in common, memorable adventures in common; whatever our nationality, we spoke a common language, the vivid picturesque slang of the Air Service which contained so many newly coined words and phrases; and we had met a common fate, or, more accurately, perhaps, an uncommon one, for we were still living. Above all, we joined in being heartily bored with the tediousness of existence within a walled, carefully guarded enclosure.

As time went on, the roll calls became more frequent, and they were even held at unexpected hours during the night, for various attempts at escape had been made, and in some of them small parties of prisoners had succeeded in gaining their freedom, temporarily at least. At last, those of us who remained — although we had not lost hope — were so rigorously watched that any further break for the Swiss border, two hundred miles distant, seemed foredoomed to failure. Whereupon ennui became boredom, or boredom ennui, whichever term is the more expressive for this disease in its aggravated form.

Glancing out of the window of our prison-camp barracks one morning in November I saw the guard being relieved with a lack of discipline that surprised me. I turned to one of my companions in misery, Charles Codman, of Boston.

"Come here a minute, will you, Codman?" I said. "See how they are changing the guard this morning."

As he came to the window we saw one soldier, a burly middle-aged man, throw his round infantryman's cap on the ground and stamp on it. We could not have been more astonished had we seen the prison gate standing open with no one to guard it.

Codman, who is nothing if not self-possessed under whatever circumstances, turned to me with a faint smile, blinking his eyes rapidly.

"I've just had a curious hallucination," he said. "I thought I saw that man throw his cap on the ground and stamp on it."

Then another guard tore off his regimental insignia and threw it away. By this time Oberleutnant Rheinstrom, the second in command at Landshut prison camp, had appeared, and stood with his back to us, talking to the men. They listened with an air of reluctant, sullen attention. The lieutenant's back was eloquent of persuasion, not command, a fact in itself sufficiently startling. We could not hear what was being said, but we saw him turn and look in our direction. He again addressed the guard, speaking very earnestly, and a moment

later they went, without evident unwillingness, to their positions on the walls.

What had happened, as we were to learn, was the revolution in Bavaria. The old regime in Germany was "tottering to its fall," as a journalist would say, and the air was charged with the electricity of the breaking storm. We felt it even in our confined and isolated position. Lieutenant Rheinstrom was grave and preoccupied, and Herr Capp, our usually genial *Feldwebel,* looked as though he had seen a ghost in broad day. He had, in fact, seen a considerable number of dead men, for he had just returned from Munich, forty miles distant, where machine-gun fighting was taking place in the streets.

There were only four of us, members of our prisoners' Red Cross Committee, in the camp at this time, for Landshut was only a way-station for airmen prisoners-of-war, brought here to be examined and then sent on to permanent camps. We were too restless to sit still, and walked round and round the path we had worn through the turf of our recreation ground, wondering, conjecturing, keenly watching for new portents which would give us an inkling of events we felt were impending.

Then we were again visited by Herr Pastor, the Bavarian prison-camp inspector. He was not in the least excited and greeted us in his customary urbane, slightly bantering manner.

"Well, gentlemen, I hope you are enjoying your solitude these cool autumn days?"

"Herr Pastor, what has happened?" Henry Lewis, of Philadelphia, asked.

"What makes you think that anything has happened?" was the reply. "Do you mean, here in the camp?"

"No, no! Outside. What is taking place at the front?"

The inspector took his pipe from his pocket and stuffed it in leisurely fashion with ersatz tobacco. He lit it and let the smoke curl slowly from his nostrils. At last he said: "Yes, you are right. Something has happened. I'm sure that you'll all be sorry to learn of it, but

the fact is the war is over. An armistice was signed at eleven o'clock this morning."

For a moment we merely stared at him. Codman was the first to break silence. He spoke in an odd deprecatory voice and manner.

"And so you've come to bid us farewell," he said. "We'll often think of you, Herr Pastor. You've been very decent to us, and in some ways we have enjoyed our stay here. . . . Well, good-by. Shall we go out at the main gate or at the little one on the other side?"

"Herr Pastor, you're not joking, are you?" I asked.

"If there's any joke about it, it's on us, not you," he replied. "No, the war is finished."

"Then let's get ready at once!" Lewis exclaimed. "Oh, sweet Land of Liberty! Think of it! In an hour's time we shall be on our way to Paris!"

The inspector smiled faintly. "Now don't be in too great a hurry. I said that an armistice had been signed, not that there is to be an immediate release of prisoners. It may be some weeks, even months, before you see Paris again."

Then, in truth, we did all speak at once. We argued, pleaded, begged, cajoled. What was the sense of keeping longer four inoffensive airmen, thus tying up the services of so many guards? Granted that no arrangements had been made for the release of prisoners, it could do no harm to let us go. All we asked was that a gate be left inadvertently open: we would vanish through that gate and make our way to the Swiss or the French border. We would be his everlasting debtors if, etc., etc.

The inspector walked up and down the yard, his pipe going furiously as though he meant to lay a smoke screen at once that we might slip out undetected. But he pulled up short in front of us. "No," he said, "it's quite impossible. I'm sorry, but you must stay here until you can be released in the proper way." We refused to take this as final and at last wormed out of him a promise that he would at least "think it over."

That night we lay sleepless in our bunks staring into the darkness,

trying vainly to realize that the war was ended. After a long silence Codman said, "What rotten luck!"

"If we can't persuade Pastor?" I said.

"That of course," said Codman, "but I was thinking of those poor devils who have just died of the flu."

The week before we had been sent, under guard, to attend the funeral of some French infantrymen who occupied another prison camp in the vicinity of Landshut. They had been captured in the early autumn of 1914 and still wore the old red trousers common to the infantrymen of that remote period. The influenza epidemic was then ravaging Germany as it was other countries, and it had taken a heavy toll in this camp where the men were weakened by poor food and long confinement. To be snuffed out just before the armistice was, indeed, wretched luck.

"Lord!" said Lewis. "I hope none of us come down with the flu at this last moment!"

"Now, Henry," said Codman; "no forebodings! Remember: tomorrow we shall be on our way to Paris."

And so we were. Herr Pastor appeared toward noon the following morning. "You may go," he said. "I think it will be best for you to make for the Swiss border, by way of Munich, Lindau and Lake Constance. I have wired to a friend, an artillery officer, at Lindau. He will meet you at the station there, so be on the lookout for a well-set-up man of thirty-five, with ruddy cheeks, blue eyes, and a small blond mustache. He wears a captain's uniform."

"And we may go now?" I asked, hesitatingly.

"And do you mean that we are to go by train?" Lewis added.

"You don't want to walk to Switzerland, do you?" said the inspector. "There is a train for Munich at twelve-thirty. You will have to stop there for the night and leave for Lindau the following morning. If you succeed in getting through you will be at Romanshorn, in Switzerland, before dark tomorrow evening. Remember, this is an escape. . . ."

"Theoretically," I said.

"No, actually. I have no right to let you go and am doing so on my own authority. The commandant is strongly opposed to the idea, and I have promised to take the blame in the event that you are re-captured. Don't let that happen. You might make it very awkward for me. But with the revolution on in Bavaria, if you have your wits about you, you should be able to get through."

We rushed off to get ready at once. We had little baggage, of course, and were in full marching order within three minutes. We bade fare-well hastily to Feldwebel Capp. He was amazed at what Herr Pastor was doing, and it was plain from his manner that he thought the world had gone mad; at least, the once orderly German world. The inspector was waiting for us outside. He had already bought our rail-way tickets to save us any possible trouble at the station. We paid for them, of course, in prison-camp currency.

The moment we were outside the castle walls the air felt purer and much more invigorating. We wanted to skip, goatlike, from rock to rock, down the steep hill, and restrained ourselves with difficulty. Fortunately, the streets of Landshut were comparatively empty, it then being the noon hour. Although the time seemed endless we had only ten minutes to wait for our train. We climbed into a second-class compartment that had but two occupants: a nun in an enormous starched headdress, and an elderly man with a snow-white beard who would have made an excellent model for one of the Old Testament prophets. We took our places very quietly opposite them. Lewis bowed his head as though in prayer. Browning's beard quivered with excitement. I gazed at the ceiling. Codman glanced through a time-table Herr Pastor had given us, as though he had just seated himself in a train at South Station, in Boston, for a tedious daylight journey to New York. We clattered through the suburbs and were soon in the open country.

We were, of course, in our American Army uniforms — rather worn and faded, but clean — with the pilots' insignia of the Air Service on our tunics. The old man opposite us leaned on the handle of his

walking stick and scrutinized us, item by item, with a severe air. I caught his eye several times and immediately looked at the ceiling again to admire the decorations. Once he cleared his throat as if about to speak, but if so he thought better of it and thereafter gazed resolutely out of the window. I wondered what he was thinking. He was a man of eighty, I should say. What changes he had witnessed! And now, in the late evening of his life he was witnessing a last stupendous change in the life of his country, of the world at large, whose outcome he could not hope to see. The nun read her breviary, her lips moving silently.

The station at Munich was thronged with people, both civilians and soldiers. Along one wall a company of infantrymen were standing by their stacked arms. A military policeman passed within two feet of us, but he was evidently going somewhere on important business and didn't notice us. We had no papers of any kind and had we been questioned we would have been hard put to explain our presence there. Several people glanced curiously at us, but, as Herr Pastor had said, everything was topsy-turvy in Bavaria, and we pressed on, unnoticed for the most part, in the crowd making for one of the station exits.

Our plan was to get out of sight as quickly as possible. If we loitered about the streets the chances were that we should be taken up, for men in the uniform of any of the Allied nations were not then to be seen in Germany except in prison camps. Therefore, eager though we were to see what was taking place in Munich, we decided to be discreet. Not far from the station we saw a hotel, and, as it was necessary to take a chance somewhere, we agreed to take one there. It was, I think, to Codman's knowledge of German that we were trusting. He asked for a room large enough to accommodate the four of us. The man at the desk looked at us in a bewildered manner and said, *"Bitte schön?"* Codman repeated the request and added that we should like lunch served in our room. He did this with admirable casualness, as though it were a customary thing for American army

officers to be touring Germany. This went off all right, and presently we tucked into a hearty meal, with excellent Munich beer to wash it down.

We spent an uneasy afternoon and evening, expecting at any moment to hear a knock at the door and to find ourselves in the presence of the military police. But we might have spared ourselves the anxiety, nor did we have the slightest trouble, the following morning, in boarding the train for Lindau. Great events were taking place in Germany, and in the midst of them small events and small fry could pass unregarded so long as they did not attract attention to themselves.

We reached Lindau late in the afternoon and waited on the platform while the crowd was dispersing. There were several officers. One of them approached rapidly, made a stiff little bow and said, in English: "You wish to go to Switzerland, gentlemen? In that case perhaps I can be of service to you. Will you follow me, please?"

All this seemed very odd. After our long imprisonment and plots for escape, it was hard to realize that we were to be actually escorted out of Germany by an officer in the uniform of our erstwhile enemies. "If this is a dream, let me sleep on," Lewis muttered to me, under his breath. "Look! Lake Constance! Oh, noble sight!" We could see open water glimmering at the end of the street, and far away, glowing softly in the light of the westering sun, the snowclad summits of the Alps. The artillery captain halted at some distance from the quay and waited for us to come up with him.

"There is your boat, gentlemen," he said, "but I can't promise that you will be allowed to cross in her. However, walk aboard, and, if you are merely turned back, there is one other possibility. Of course, if you are arrested here — in that case there is nothing more to be done. You will understand that I can hardly be your advocate."

We thanked him warmly and hastily, went on to the landing and up the gangplank past two customs officers who eyed us suspiciously. But we were not halted, and the moment we reached the deck we

made ourselves scarce, retiring into the most unobtrusive corner of the little saloon. A few moments later, with an exultant toot — at least it seemed exultant to us — the little steamer backed from the quay and turned toward Switzerland. Looking through the portholes we saw two stone lions of heroic size, seated on piers at either side of the harbor entrance, and that is the last I have seen of Germany to this day.

I remember clearly the voyage across the lake to Romanshorn. Now that freedom was assured, my mind once more became active, registering everything and storing it up in memory. A rather stout woman in furs — she looked like an opera singer — walked the deck, humming softly, in a contralto voice. A father and mother with two rosy-cheeked children — German Swiss, I imagined — ate bread and cheese ravenously as though they had not broken their fast for days. But our attention was attracted and held most of the way by the second officer of the steamer, a stocky little man in a brass-buttoned coat. He wore an enormous mustache with the ends twisted up at right angles, like that of the German Kaiser; and a small, closely trimmed pointed beard, a French imperial, that seemed to have been stuck on his chin. He spoke three languages, German, French and English, and he assured us that he loved equally the people of all three nations. With one hand twirling the ends of his German mustache and the other stroking his neat imperial, he would say: *"Moustache — Allemand. Barbe — Française."* He wished us to understand that he was the perfect neutral.

Upon arriving at Romanshorn we were put under arrest by the Swiss authorities. We asked the reason for this and were told by an officer that we had arrived from Germany in a very irregular manner. The Swiss authorities had received no word, either from the Central or the Allied Powers, with respect to the release of prisoners; therefore he felt it his duty to take us into custody.

"But we've escaped," Codman said. "We made an escape de luxe. We traveled by train instead of walking to the border, and crossed

the lake by steamer instead of swimming. Surely, you don't object to that, do you?"

But the officer was not satisfied. It was irregular, and apparently there was nothing in the manuals to cover such a case. However, he was willing to send a wire to the American authorities at Berne. Within half an hour a reply was received asking that we be sent there; so off we went with our Swiss lieutenant as escort, and upon arriving at Berne he was given a receipt for four American aviators, to wit: etc., etc.

That evening we had dinner at the Hotel Bellevue — a sumptuous banquet. I had not supposed that there was such food left in a war-ravished world. We fell into conversation with an Englishman at an adjoining table who seemed well acquainted with the *habitués* of the place. In a guarded voice he pointed out to us various agents of the Central and Allied Powers who had made headquarters in Switzerland since the outbreak of the war.

"See how they glare at one another," he said. "They've been doing that since the autumn of '14, and the habit is now so fixed that none of them will ever be able to smile again." And, indeed, the atmosphere of the restaurant seemed to be surcharged with international hatred. One could all but see dotted lines of venom darting from one pair of eyes to another, crisscrossing in the air like the penciled lines of smoke from machine-gun tracer bullets. It seemed a pity that such excellent food should have been eaten, by many of the diners, in a spirit so inimical to good digestion. Now that the war was over, one would have thought that they would be able to lay aside their enmities. It was at this time that I felt the first glimmer of anxiety with respect to the peace to come, but it was only a glimmer and quickly vanished. I was too sanguine by nature even to conceive of the possibility of another World War.

Two days later we were in Paris. I must confess that my recollection of the events of the succeeding twenty-four hours is rather hazy. Somehow, Browning, Codman and Lewis had disappeared, and, while

searching for them at Henry's, the Chatham, Maurice's, and other favorite meeting places for airmen in Paris, I met two old flying companions who I thought were dead, and they could hardly be convinced that I was not a ghost. Meetings of this sort were then taking place daily in Paris, and when old friends rise from the grave, so to speak — well, perhaps they may be pardoned for celebrating such rare and happy occasions.

I remember, vaguely, sitting in a crowded, well-lighted restaurant with my two friends and a British flying officer with three rows of decorations on his tunic, who had appeared from nowhere. I also remember, much later that night, sitting with this same Englishman on a bench somewhere along the Seine, possibly in the vicinity of the Pont Alexandre III. My friends had vanished and the Englishman and I were having a delightful conversation about Chaucer. He, too, loved the Canterbury Tales, and was reciting from "The Miller's Tale," strongly accenting the rhythmical flow of the lines:

> This dronken Millere spak ful some ageyn,
> And seyd-e, "Lev-e brother Os-e-wold,
> Who hath no wyf, he is no cok-e-wold,
> But I seye nat therfore that thow are oon. . . ."

The shade of Chaucer himself, had it been present at that moment, would, I believe, have looked on indulgently. And, indeed, those who speak so disparagingly of "the demon, Alcohol" must be those who have unwisely spent most of their lives in his service, or men who have never had the slightest acquaintance with him; who have not learned, through experience, what a delightful demon he can be when treated as he would like to be treated: not as a bosom friend, but only as an occasional companion. The next morning I waved him and the British flying officer a casual good-by; and although I have, at times, met the former since that day, my fellow Chaucerian vanished forever. I don't even remember his name.

xxi. Last Flight

THOSE WHO were in France shortly after the Armistice of 1918 will never forget the universal feeling of blessedness — there is no other word for it — prevailing then. Bitterness, sorrow, even mourning for the millions dead, seemed to have been put aside, for the moment, at least. I doubt whether, in all European history, there had ever before been a time when the hearts of men were so filled with serene hope for the future; and I believe this was true not only in Paris but also throughout the entire Western World. The war that was to end war had run its appalling length. Now time was standing still as though to give mankind a dateless period for remembrance, reflection, and preparation for the new world to come. And everyone — all common folk at least — believed that the opportunity could not and would not be lost; that they would see the new world beginning to emerge from the ruins of the old: one in which oncoming generations were to be freed forever from the threat, or even the thought, of war.

That was a happy time, if ever there has been one in human history. I sauntered through the streets of Paris, flooded with the mellow sunshine of late November, watching the crowds and looking at the German cannon ranged along the Champs Élysées and around the Place de la Concorde. Those monsters, fantastically camouflaged, were silent and harmless now. Children slid down the long barrels or perched on the muzzles, peering into their cavernous throats, and their elders looked on with a happy, wondering expression upon

their faces. One would have said that word had been received and spread abroad that the three-headed dragon of greed, hatred, revenge, which had preyed upon nations since the dawn of history, was to be at last driven into outer darkness forever.

Meanwhile, I was wondering how I could bring my own career as a soldier and airman to a fitting and memorable close. I had learned that my squadron, the 94th Pursuit, had been moved into Germany with the Army of Occupation. I didn't want to rejoin it, if this could be avoided. There would be too many new faces among the pilots, and I had had more than enough of Germany for the present. Furthermore, it would be anticlimactic, to say the least, to resume flying now that the war was ended. Then, unaccountably, came a splendid idea. I am at a loss to account for the wisdom I displayed; perhaps my good angel plucked me by the sleeve and whispered that here was an opportunity not to be lost, for it would never come again. However that may be, the idea was to have a last flight over the old front from the Channel coast to the Swiss border, and then to say good-by forever to the Air Service.

As luck would have it, when I reported at U.S. Aviation Headquarters on the Avenue Montaigne, I was assigned to temporary duty there. This suited me precisely, and one day shortly afterward, having mustered up all the persuasive arguments I could think of, with the connivance of a staff captain I was ushered into the presence of General Patrick, Chief of the Air Service, at a moment when he was alone.

"Yes? What is it?" he asked, brusquely but not unpleasantly.

"General Patrick," I began, "I have a somewhat unusual request to make" — and I went on, eagerly and hastily, to tell him who I was, what my present duty was, and to formulate my request.

He heard me through, tapping his desk with the rubber end of a pencil, and when I had finished he was silent for a moment. Then he said, "Why do you wish to make this flight?"

"Solely for my own pleasure, if it may be called pleasure," I replied.

"It will satisfy a need I can scarcely define if I may fly over the old front once more, and for the last time."

"How long would you expect to be gone?"

"Four or five days. A week at the most unless I should be held up by bad weather."

I had little expectation that my request would be granted, but General Patrick hesitated not more than half a moment. He reached for a pad, wrote something on it, signed and stamped it, and pushed it toward me across the table.

"Good luck," he said. "Don't get yourself killed now that the war is over."

The paper was an order to the Operations Officer at the American Aviation Depot at Orly, not far from Paris, to provide me with a plane for a "special mission."

No doubt General Patrick forgot this incident the moment I left his office, but I shall always remember with deep gratitude that I owe to his kindness one of the most memorable experiences of my life.

Two weeks passed and I was still waiting for favorable weather, for I wanted to make this flight under the best possible conditions. At last I decided to go no matter what the weather. Troops were leaving France in thousands, and I was in daily fear of receiving my own travel orders to return to the United States. So, one cold winter morning, with a high cloud ceiling through which the sun shone wanly, I took the train for Orly. I had gone there several times before, only to be turned back each time because of rain or snow.

"Same old luck," said the Operations Officer. "It will be snowing before evening."

"It doesn't matter," I replied. "I'm going to chance it. I'll land somewhere on the way if it gets too thick."

I went with a lieutenant, a test pilot, to the Spad hangars. There were hundreds of planes fresh from the factories ranged wing to wing inside them.

"Take your pick," he said. "We've got 'em to burn, now." I doubt whether he knew how prophetically he spoke, for the "million-dollar fire," as it was called, did take place later that winter when hundreds of these new planes were burned to get rid of them. A million dollars was, certainly, a modest estimate of the cost of that bonfire. I asked the lieutenant to select one for me, for he had tried out many of them and knew their qualities. He chose a 180-horsepower Spad never flown before except by himself, and a few moments later the Orly airport was far away below and behind me.

What a glorious sensation it was, after six months in a prison camp, to be traveling by route of the air again! I am grateful for the fact that I never became used to flying in the sense of being wearied by it. Every time I left the earth I felt exhilarated, lifted up in spirit as well as in body. It was, rather, as though I had left my body behind, and all the slowness and heaviness of corporeal existence.

I followed the Marne past Meaux, Château-Thierry, Epernay, and at Chalons turned northward until I came within view of the inconceivable desolation of the old front. During the autumn and winter of 1917, the Escadrille Lafayette had been stationed at various airports along the Champagne front, and our sector for patrol had been from Rheims to the Argonne Forest. As I passed over the ruins of the village of Souain — how often I had seen it from the air! — I was conscious of a quickening of the pulses, and instinctively I began to look in all directions, overhead, behind, beneath, for the presence of enemies. It was all but impossible to realize that one could now fly anywhere, in perfect safety.

I knew in advance that this would be a lonely experience. I had wanted it to be so, but I had not imagined finding such complete solitude so soon after the fighting had ceased. Armies were already being sent home for demobilization, and those remaining in service had been moved on into Germany, or away from the devastated areas to places where decent billets were to be found beyond reach of the stench of death and desolation of the old front-line positions. As for

the air, it was as though men had never before traveled there. I neither passed nor saw other planes. Insofar as I could tell, not a sound broke the stillness of that gray winter world save that of my own motor.

I thought of all those who had flown over this same country since the beginning of the war — all of them young men, high-spirited, loving life, of reckless courage whatever their nationality; the best of them dead: Guynemer, Richthofen, Lufbery, McCudden, Ball, Dorme, Victor Chapman, Kiffin Rockwell, James McConnell — hundreds more. And, thinking of old friends, it was cold comfort to recall the passage in Chaucer's "The Knight's Tale," where that good soldier thus offers consolation to those who have lost comrades in battle:

> And certeinly a man hath most honour
> To dyen in his excellence and flour,
> When he is siker of his gode name;
> Thanne hath he doon his freend ne him no shame.
> And gladder oghte his freend ben of his deeth,
> When with honour up-yolden is his breeth,
> Than whan his name apalled is for age.

When one is young with the best of life before him it is difficult even to imagine that the time will come when he and his contemporaries will be "apalled for age." But how quickly it does come! And then, at moments at least, he thinks with envy of old comrades, killed so long ago, who died in their "excellence and flour," missing all the disillusionment and despair that was to come in the years so nearly at hand.

At Dontrier, midway along the sector, I crossed the precise spot — if one may speak of a spot in space — where I had seen a three-seater French reconnaissance plane burst into flame. After it had fallen a thousand feet, turning this way and that, the wings had crumpled and it plunged vertically to earth. I saw the men, their flying-suits afire, throw themselves off into space. It seemed strange that the air above those desolate battlefields should not be scarred as

they were, giving evidence of the events that had taken place there.

Hour after hour I winged my way in great serpentines but in a general southeasterly direction, beneath the high cloud ceiling, through occasional flurries of snow. Upon landing at various airfields to replenish my gas I found them deserted save for a few elderly *poilus* left there as guardians over war supplies that filled the hangars where the planes had been. As I climbed out of my little ship before one such group sitting around a charcoal brazier at the entrance to a hangar, a grizzled old veteran remarked to his comrades: *"Voilà! le dernier pilote de guerre!"* adding, with a smile of deep content: *"Il n'y en aura plus,"* as though he truly believed there would never be another one.

I recall vividly the various reflections and shades of emotion that passed through consciousness during that solitary flight. Some were inevitably, as I have indicated, of a somber cast, but not all by any means, for at that time the serenity of the hope I have spoken of had not yet begun to blur even a little. Presently I climbed through the cloudbank into the pure sunlight above it. The gray earth vanished, and then, as had happened so often before, I knew loneliness at its best. And there was nothing, now, to mar the fullest enjoyment of that upper world: no danger of ambush; no need to scrutinize the sunlit peaks of curling shifting vapor for the presence of enemies. My only companions seemed to be bands of seraphim and cherubim hidden somewhere in the depths of blue sky. Even above the roar of my motor I caught fragments of the music they were wafting earthward: themes from Dvořák's *New World Symphony*, first heard at Grinnell, and which I had been hearing, soundlessly, so to speak, in Paris, throughout the weeks of late autumn and early winter.

This was what I had wanted above everything else, after six months in a prison camp — a *bain de solitude*. But I felt that I needed one of indefinite length, now that the war was ended, and I could not fly on forever over a sea of cloud. But what of that other sea, the vast Pacific, dreamed of so often but never visited?

> . . . the moonlit solitudes mild
> Of the midmost Ocean . . .

I would soon be at liberty once more to order my life as I chose. Why
not go there to seek out the remotest of islands in that greatest of
solitudes and settle down for a while to resume my interrupted call-
ing as a woodshed poet? In the South Seas where life is so simple
and food so plentiful I should be able to live at very little cost in
money. A feeling of deep content came over me as I began to con-
sider this possibility. I forgot the present moment until my engine
began to sputter and misfire; then I remembered that I had been
flying for a long time and that my supply of gasoline must be nearly
exhausted. Turning the valve of the small auxiliary gravity tank I
descended below the clouds at once to seek some landing place and
lodging for the night.

My assignment to Headquarters in Paris, after my return from
Germany, had been arranged for by Dr. Gros. He wished records
to be collected for a history of the Escadrille Lafayette and the Lafa-
yette Flying Corps, and rightly decided that the time for assembling
the material was immediately, while the members of the Corps were
still in France. When the U.S. declared war upon Germany Dr. Gros
was commissioned major in our Air Service and shortly afterward was
promoted to lieutenant colonel. He was still one of the heads of the
American Ambulance Hospital at Neuilly, but his chief duties after
receiving his U.S. commission were in connection with the pilots of
the Lafayette Flying Corps, arranging for their transfer to our service,
and in acting as a kind of liaison officer between French and U.S.
Aviation.

"I have arranged for another man to work with you on this L.F.C.
History," Dr. Gros said. "Charles Nordhoff, of California. Do you
know him?"

I confessed that I did not.

"He was a little after your time in the aviation schools," Dr. Gros

continued. "When he was brevetted he was sent to the French Pursuit Squadron, Spad 99 — the Flying-Horse Squadron. After you were all transferred to U.S. Aviation, Nordhoff, to his great disgust, was taken from the front and attached to the Historical Section of the Air Service. At my request he has been transferred to work on the L.F.C. History. You two will be the editors of the History and Edgar Hamilton will be your Associate Editor."

I knew Hamilton — or "Ham" as we called him — well. After receiving his wings in French Aviation, he was first made a flying instructor at the French Aviation School at Avord, then technical instructor at the American training school at Tours and later at Châteauroux. He remained in the French Service until the end of the war, and then, strangely enough as it seemed to me, he decided to make a career of soldiering. He was first a lieutenant and then a captain in the French Foreign Legion, and when I last heard from him, years ago, he was lying wounded in a French hospital after an outpost battle against the Riffs in Morocco. What became of him afterward I have never been able to learn.

A day or two later, Dr. Gros took me to the room assigned for our work at Air Service Headquarters on the Avenue Montaigne and there introduced me to Nordhoff, a tall, blond-haired, blue-eyed man who stood so straight that he gave the impression of leaning slightly over backward. Naturally, the memory of his experience after his transfer from French to American Aviation when he had been taken from the front and assigned to a desk job, still rankled with him, and this may be why my first impression of him was unfavorable. He shook hands with me in a coldly punctilious manner, and I was thinking: "Lord! How am I to work with this man?"

We made little progress toward friendship in our first conversations. The fact that I was from Iowa was anything but in my favor with Nordhoff, although his only comment when he learned this was that his state, California, was "lousy with Iowans." Later, we had some rather heated arguments about this. Iowans were rootless people

in his estimation: they didn't belong anywhere, least of all in California. Naturally, I stuck up for my own people.

"It's the fault of you so-called 'native sons,'" I told him. "Your Chambers of Commerce spend all of their time trying to persuade Middle Westerners to settle in California. You send out special trains filled with exhibits of your products: oranges, lemons, figs, English walnuts, and the like. You boast about your perfect climate; you beg, wheedle and cajole our people to move to California, and when they do you resent their coming. If you don't want them, why don't you stop advertising your wonderful Golden State?"

"All Iowans are 'from,'" he would say. "You are, yourself. All you have to boast about is being 'from' Iowa."

This was a rather odd beginning of a friendship which was to remain firm and unbroken for a period of twenty-eight years — from that winter of 1919, in Paris, until Nordhoff's death in Santa Barbara, in the spring of 1947. After a day or two we agreed to lay aside the Iowa-versus-California dispute and get on with our work. Neither of us knew anything about writing a history. I supposed that Nordhoff did, having been attached to the Historical Section of the U.S.A.S., but he told me that all he had done there was to remove split infinitives from government reports.

I was fascinated by Nordhoff's accounts of his boyhood, most of which was passed on a ranch owned by his father, in Lower California, a wild, lonely place that stretched for miles along the coast below Ensenada. Nordhoff came from adventurous blood on his father's side. His grandfather, for whom he was named, had been a contemporary of Herman Melville, and during his boyhood and youth, lived a life that paralleled Melville's. In 1845, at the age of fifteen, he joined the U.S. Navy as a cabin boy on a 74-gun ship bound for China and the East Indies; and for the next nine years he was continually at sea, in men-of-war, whalers and merchant vessels, most of the time in the Pacific. Like Melville, Charles Nordhoff the Elder wrote of his experiences in later years. Some of his books were:

Man-of-War Life; Whaling and Fishing; Stories of the Island World; Cape Cod Stories; California for Health, Pleasure and Residence. The title of this last, I told Nordhoff, proved that his grandfather must have been one of the early California boosters and he had, probably, started the first Iowans on their trek to the Golden State. Although he was not a teller of tales in the Melville sense, some of Nordhoff's grandfather's books are still in print, and they deserve to be.

Nordhoff knew Paris well and was something of a gourmet in the matter of food. There were certain small restaurants where, he informed me, one could enjoy superb food at a third of the cost of meals on the boulevards. I went with him to some of these places and discovered that his idea of good food and mine were vastly different. He liked grilled kidneys, escaloped brains, tripe, sweetbreads, and the like. I have always loathed the "innards" of animals with the single exception of calves' liver. Nordhoff even relished steamed snails and frogs' legs. There was one restaurant we both liked: the Brasserie Universelle, where, often, we made a full meal on hors d'oeuvres, the best I have ever tasted anywhere.

Nordhoff was a delightful companion. Once I got to know him my liking for him increased daily. I had never before met a man who had a wider store of information upon so many unrelated subjects. I discovered, later, that some of it was misinformation, but he spoke upon whatever subject with such an air of authority that one was ready to believe whatever he said. He loved to exaggerate, to astonish people by making extravagant statements with the gravest air, but it was all a kind of game with him. He was often surprised — shocked, rather — that he got away with so many of them. But in the field of natural history he was deeply learned, particularly about game birds, their habits, haunts, migrations, and the like. He loved wild birds far better than people. He told me that his father had given him the best possible education as a youngster — that is, no education at all except what he had been able to pick up for himself

on the lonely ranch in Lower California. He had not learned to read and write until he was twelve. At least, so he insisted, but this may have been one of his exaggerations that he held fast to until he believed it himself.

One thing that brought us together quickly was the dream we held in common: to visit the South Seas; many an evening we spent discussing this possibility.

"Why shouldn't we go as soon as we are demobilized?" Nordhoff said. "We'll both be at loose ends. We are not married and have no jobs to return to."

And so that was agreed upon. Neither of us would make any new commitments. As soon as we had finished the Lafayette Corps History that dream was to become a reality. Nordhoff's desire to visit the islands of the tropical Pacific had, I think, been aroused by his grandfather's voyages. I didn't tell him that mine had been stirred by Matthew Arnold. Instead, I told him — which was true — of the unforgettable impression Melville's *Typee* had made upon me when I first read it, in boyhood.

Meanwhile, we spent our days at U.S. Aviation Headquarters, gathering the materials for the L.F.C. History. Dr. Gros turned over to us all of the records that he had assembled from the beginning, and the French Aviation authorities were more than co-operative, giving us access to all of their files and records. During the three months immediately following the Armistice, nearly all of the men who had served in the Corps came to see us as they passed through Paris. Some had been in German prison camps, some in hospitals recovering from wounds; others were still with their squadrons awaiting orders for return home. Many had had truly remarkable experiences, or they would have been so at any other time, but in war, of course, they were commonplace, a part of the day's work, similar to those of scores, hundreds, of other pilots.

Kenneth P. Littauer, flight commander in the French 88th Observation Squadron, had remained to the end of the war in the French

Service. He came to see us, bringing with him the windshield of one of his planes — a Caudron, G–4. By some miracle, Littauer had survived the war, flying Caudrons throughout. The G–4 was a biplane, equipped with two rotary motors, with a top flying speed of 80 miles per hour. Littauer's squadron had been chiefly engaged in artillery réglage at low altitudes, flying necessarily below all enemy pursuit ships. Pursuit pilots felt sorry for the observation and artillery-réglage pilots and observers, for theirs was dangerous work indeed: they were always being pounced upon from above. Littauer's windshield had been punctured almost exactly in the middle, the bullet missing his head by the thickness of a cigarette paper.

"I'm taking this home as a souvenir for my children when they come along," he said. "When they ask me: 'Daddy, what did you do in the Great War?' I'll show them my windshield and reply: 'Children, you would not be here to ask me that question if I had not turned my head at just the right second to look at a Boche who was on my tail.'"

Alan Winslow who, with Douglas Campbell, had started the ball rolling so brilliantly for the 94th Pursuit Squadron by shooting down two enemy single-seaters near Toul, came to see us with his left coat-sleeve empty. He himself had been shot down in enemy territory on July 31, 1918, and had spent five months in various hospitals and prison camps.

Nordhoff, Hamilton and I worked hard, collecting our historical material, and by the end of February we had most of it in hand. The History was not to be written for the general public but for the families and friends of the men who had served in the Corps. Owing to the many photographs and other illustrative material the book was to contain and the limited number of copies to be printed, the price of the work would have been prohibitive had it not been for the fact that Mr. William K. Vanderbilt, Jr., Honorary President of the L.F.C., underwrote the cost of publication. Owing to Mr. Vanderbilt's generosity the two volumes, when published, sold at only $12 for

the set. I have since been told that it now sells for $70 when a set
appears on the market, which is rarely.

At the end of February, 1919, Nordhoff and I received our travel
orders to return home. We were among about one hundred casuals
who embarked on the SS *Mauretania* which was filled with troops of
the New York 27th Division.

I recall vividly the windy March morning when we came within
view of New York City. New York gave her returning soldiers a
warm and demonstrative welcome. As we approached the harbor the
Mauretania was met by dozens of tugs filled with newspapermen,
reception committees and brass bands. The whistles of all the tugs
were going full tilt, drowning out the music of the bands. One of the
tugs accosted the ship and the newsmen swarmed aboard. They
spread out in extended order on every deck and combed the ship, so
crowded with troops that it was a wonder they were able to push
their way through. My field of vision was limited to a portion of
the boat deck and what was taking place alongside. Just below my
vantage point was a tug displaying a huge banner: WELCOME TO
THE HEROES OF THE TWENTY-SEVENTH! The whistle drowned out the
music of the band; we could see the players blowing away but only
their movements showed that they were actually playing. The tug
was crowded with both men and women around whose feet were
boxes heaped up with miscellaneous gifts: packages of chocolate and
chewing gum, oranges and apples, and newspapers and magazines
rolled up and fastened with rubber bands. These they tossed up in
desperate haste toward the lines of heads far above them. One would
have thought that these reception committees considered it a matter
of vital importance for the returning heroes of the 27th to read the
newspapers and magazines before the ship docked. Nearly all the
parcels fell short of the outstretched hands of the soldiers who scarcely
knew what to make of this demonstration. One could see a continuous
line of flotsam sweeping back along the side of the vessel to meet one
from the opposite side, and bobbing up and down in the wake of the

slowly moving ship as far as the eye could reach down the harbor. I watched two women emptying such a box, parcel by parcel. They seemed to be in an hypnotic state, unconscious of us and their own bizarre behavior. Their flushed faces wore fixed smiles of ghastly archness, like those of wax figures in a department-store window. They would bend over the box of gifts, take one up and throw it in a woman's awkward overhand fashion against the side of the ship, and then stoop for another. It was sheer waste, a 100 per cent loss.

But the most touching sight was that of the parents and friends crowded on the wharf as the ship docked, eagerly scanning the lines of faces high above them for a sight of "their boy." We casuals were the first to disembark, and when I reached the quay I joined the crowd waiting there. Just in front of me was a little woman waving a small American flag. The noise and confusion were great, but I was so close that I could hear her saying, in a voice that could not have been heard three feet away: "Here I am, Henry! Here's your mother!" as though she were, indeed, the collective mother of the entire 27th Division.

xxii. To the South Seas

HAVING BEEN BORN in the horse-and-buggy era, with my roots deep down in the soil of the conservative Middle West, I seem to have taken it for granted that life as I knew it in boyhood and youth would continue indefinitely. But upon my return home in early March, 1919, I became increasingly aware of the vast changes in the spirit of American life that had taken place during the brief time that I had been away from it. "Things were in the saddle" in a sense that Emerson could not have dreamed of. Boosters and so-called forward-lookers were on the scene in such numbers that one was scarcely aware of any other kinds of people. They were preaching, exhorting and prophesying with such confidence in their vision of the world of Tomorrow that I felt troubled and uneasy, for my attitude toward these forward-lookers was one of complete disapproval.

I was a born yea-sayer toward life, and, as though nay-sayer toward the trend of it in the U.S.A., I felt that we had taken a wrong turning somewhere, not realizing that it was an inevitable turning. In my ignorance I vented my bitterness against the whole of our Industrial Civilization, and my particular spleen upon machines with internal-combustion engines, inconsistently excepting those with wings. I deplored the vast changes that motorcars were making in the tempo of life. The good roads they demanded, slashed through the green hills and graded up over the valleys, were not my kind of good roads. I loathed them. In the twenties, of course, they were ghastly livid wounds in the fair green country which Nature would, eventu-

ally, heal and make beautiful, after a fashion, but I saw them only as they were then. I am not defending my reactionary point of view toward motorcars and other material elements in our rapidly changing life; it doesn't make sense from any rational point of view. I am merely stating how it was with me. Most people, I believe, love change, and can move with the times at whatever tremendous acceleration of speed. It was, and still is, impossible for me to do so. I love change only in its aspect of slow and cautious advancement and slow and imperceptible decay. And I dislike change in manners, customs and habits of thought as much as I do in material aspects. This, I believe, is the principal reason why I have made my home on the island of Tahiti, a mere crumb of land in the middle of the Pacific, during the past thirty years. Change there has been here of course, particularly since the end of World War II; but it is nothing compared with what has taken place elsewhere in the world, and, such as it is, one is given a certain amount of time to get accustomed to it.

Nordhoff and I were demobilized at Garden City, Long Island. I remember standing before a major, or colonel, in one of the bureaus there, thinking: "Oh, happy day! In a few moments I will be free, my own man once more!"

The officer said: "Do you want your discharge?"

"Why, yes; of course," I replied.

"Have you thought of staying in the Air Service?" he then asked. "Making a career of it?"

I admitted that I had not.

"It is a matter well worth considering," he went on. "I believe you would be able to keep your captain's commission. The Air Service is just in its infancy and you would be in on the ground floor. There will be enormous developments from now on."

But when I asked about the immediate future he had no alluring prospects to offer. I would, probably, be sent to some Air Force train-

ing school to teach young cadets how to fly, and this did not appeal to me in the least. Little did I guess that, eight years thence, Lindbergh would fly the Atlantic and give the real start to the enormous developments the officer I was talking with foresaw. After scarcely a moment's consideration I told the officer that I would take my discharge.

"Very well," he said, "but I think you will live to regret it."

Nordhoff and I found the best possible place to live while working on the L.F.C. History: on the island of Martha's Vineyard, near the Gay Head end of it. Mr. Gardner Hammond, of Boston, owned a great tract of wild land in that region, called Squibnocket, where he lived with his wife and two stepdaughters. Squibnocket Pond, frequented by thousands of wild ducks during their migrations, was in the middle of it. This was a paradise for Nordhoff. It was thanks to Mr. John Phillips, of Wenham, Massachusetts, the great American authority on ducks, that this place was found for us. On a cliff overlooking the sea in the direction of the island of No-Man's-Land, was a weather-beaten little cottage which Mr. Hammond turned over to us, and there we spent a happy summer while completing the L.F.C. History.

Early in the summer I received a letter from Mr. J. B. Pond, of the Pond Lyceum Bureau in New York, asking if I would undertake a series of lectures under his auspices, about wartime aviation. The mere thought of doing so made me shiver. My only experience in public speaking had been on the June evening of 1904 when I graduated from high school, and the second appearance in 1916 at the same Methodist Church, in Colfax. I was without money at this time, having left the Air Service with only the $60 bonus given every soldier at the time of his discharge. Nordhoff and I were receiving $200 per month each while working on the L.F.C. History, but this would stop as soon as the History was completed. Therefore, having talked matters over with Nordhoff, I decided that as soon as our work was done I would go "lecturing" for two and a half months. Nordhoff was to go to his home in California and wait for me there.

We knocked off work on the History in the middle of the afternoons when Nordhoff would go to watch the ducks on Squibnocket Pond, and I would walk the great lonely beach facing No-Man's-Land, memorizing my lecture. I knew that I did not dare to attempt speaking extemporaneously, and so, with gulls and other sea fowl for an audience, I would begin:

> Far above the squalor and the mud, so high in the firmament as to be invisible from earth, they fight out the eternal issues of right and wrong. Their daily and nightly struggles are like Miltonic conflicts between winged hosts. They fight high and low. They skim like armed swallows along the Front, attacking in their flights men armed with rifle and machine gun. They scatter infantry on the march; they destroy convoys; they wreck trains. Every flight is a romance, every record an epic. They are the knighthood of this war, without fear and without reproach; and they recall the legendary days of chivalry, not merely by the daring of their exploits, but by the nobility of their spirit.

This was pretty flowery, but it suited well the romantic approach to his subject of the woodshed poet whose lecture was to be called "The Azure Lists." As a matter of fact, this first paragraph was not my own. It was an extract from a speech concerning British airmen that David Lloyd George had delivered in the House of Commons. I like far better Winston Churchill's tribute to the young English airmen of World War II, who saved Britain during the winter, spring and early summer of 1940–1941: "Never before have so many owed so much to so few."

Our History was finished in the early autumn of 1919. The manuscript with all the illustrative material filled two suitcases. We carried these to Ferris Greenslet at the offices of Houghton Mifflin Company, and then went to see Mr. Sedgwick of the *Atlantic* about our proposed South Seas venture. Nordhoff had a little money, but not much, and what I was to earn lecturing was already spent before I received it. Therefore, we hoped to get a commission from some

magazine to write a series of articles about the islands of the South Pacific which would at least pay our expenses while there.

The *Atlantic* no longer used travel articles, but Mr. Sedgwick gave us a letter to his friend, Mr. Thomas Wells, who had recently become editor of *Harper's* Magazine, and we had clear sailing from that moment. Mr. Wells said that he would be glad to have some travel articles about the South Seas. Some would be printed in the magazine and the series as a whole collected for publication in a book.

"How are you fixed for money?" he asked. "I suppose you will need an advance, for expenses?"

We admitted that this was the case. Then Mr. Wells had a contract made out that amazed us by its generous terms. We were to be given in advance $7000 of which $1500 was to pay for the articles serialized in *Harper's*, and $5500 was an advance on royalties of the book. We could scarcely believe in such confidence and generosity displayed toward a pair of unknowns. I had written *Kitchener's Mob*, and Nordhoff had written nothing, but Houghton Mifflin Company was soon to publish a small book of his called *The Fledgling* which was made up of letters he had written home during the war concerning his experiences in the Lafayette Flying Corps. "All I ask," Mr. Wells said, "is that one of you insure his life for $7000, Harper and Brothers to be the beneficiary on the policy. This is merely a precaution in case you should both be drowned at sea or killed by the 'savages' in the South Pacific."

I took out the policy with the New York Mutual Life Insurance Company and I still pay the premiums, even to this day, although Harper and Brothers are no longer the beneficiaries. I have also kept up my World War I Government War-Risk Insurance policy, the most generous, surely, ever issued by a government to its soldiers in wartime. Had more Legionnaires of World War I kept up their government insurance, there would have been no excuse for the Legion to make its repeated and shameful bonus raids upon the American taxpayers during the past thirty years.

Then Nordhoff and I parted, having agreed to meet in California as soon as my lecturing misery should end. I went with him to his train at the Grand Central Station, and came away from there grimly repeating the words: "Far above the squalor and the mud, so high in the firmament as to be invisible from earth, they fight out the eternal issues of right and wrong."

Lecturing was not as bad as I had anticipated. I had so thoroughly memorized "The Azure Lists" that I forgot only once in delivering it and this was at my first lecture delivered before seven hundred teen-age girls at the Monticello Seminary, at Godfrey, Illinois. My memory failed me for a good thirty seconds in the midst of the Lloyd George quotation; then I recalled the wording and went on successfully to the end.

While lecturing I covered the country from Berlin, New Hampshire, to Winchester, Virginia, and westward as far as Iowa. It was at this time that I felt resentment at the trend of life in America beginning to assail me. I resented my resentment but I couldn't seem to get rid of it, although it gave some relief to give expression to it in verse. I believe the feeling of bitterness at being forced to become a nay-sayer was common to many young men, particularly during the period of the twenties.

In the poem that follows I gave full vent to the bitterness I then felt. As I looked out over the country from train windows I was thinking how rapidly we Americans had developed a great continent, and how much of the country had been ruined in the process of such development.

BROTHER JONATHAN

(A Composite Portrait — 1620–1919)

Behold this sharp and predatory face
Made softer by unmerited reward.
How little joy is written there, or grace!
The fingers, talon-like, are clutching hard

A ruined land: the forests, prairies, gone;
Slums measureless, the rivers foul with slime.
Three hundred years ago he chanced upon
A very heaven, and this so brief a time
Sufficed him, and he wrought the change we see,
Driven by greed to conquer and destroy
The heritage of millions yet to be.

Our brother? Our? This old, half-witted boy?
Then let us guard him well in years to come
Or he will make a continent a slum.

Iowa at the time of my lecture tour was in the midst of a land
boom; farms were being sold and resold at incredible advances in
price. At one Iowa town where I was to speak, my host was an attor-
ney. He met me at the railway station and I could see that he was in
a happy mood. As we were driving to his home he told me the reason
for it.

"I've made ten thousand dollars today," he said. "I bought two
farms near here and sold them again."

During the boom Iowa farms were selling for as high as $500 and
$600 per acre. I was no farmer and no businessman, but I knew
enough about land values in Iowa to realize that no one could buy
farms at five or six hundred dollars per acre and break even on the
investment — to say nothing of making a profit — except in the most
unusual circumstances. Yet this lawyer believed they could. "People
are just beginning to realize the true value of Iowa land," he said.
"This is no boom. It is a normal development that has come as one
good result of the war."

The "normalcy" of that development didn't last long. When the
boom collapsed, tens of thousands of Iowa farmers and businessmen
were ruined, and banks failed by the hundreds as the result of it.
Iowa has been long in recovering from that orgy.

I was "far above the squalor and the mud" at another speaking

engagement: a Middle Western city with a population of around one hundred thousand. My host here was a dentist who called me "Jimmy" the moment we met. I am not a man to stand on my dignity, but I have never liked this first-name business between strangers: that comes, or should come, in my opinion, only with friendship. But I was to get a dose of it in this city. My host took me to dinner at a commercial club he belonged to. The place was well filled when we arrived; there must have been around two hundred members there. We halted at a table in the vestibule where a young man sat with a heap of tags beside him.

"What name?" he asked.

My host said, "Jimmy Hall," and then gave his own first name and family name. The secretary wrote these on a pair of tags which were then attached to the lapels of our coats. We circulated through the crowd where everyone called everyone else by his first name. This could easily be done because every man was ticketed. I didn't enjoy the dinner much. I could not help contrasting this spurious kind of comradeship with that I had known during the war. Inwardly, I felt indignant toward my host for taking me to such a place, but of course said nothing about it. I could see that he thought he was doing me a favor by introducing me to "the boys" as he called them.

I have heard that President Theodore Roosevelt had a marvelous memory for names and could say, "Hello, Jack!" "Hello, Tom!" to men he had met only once, and perhaps years before. This, of course, is a matter of political capital, but why any man should feel "set up" to be called by his first name, even by the President of the United States, when the President doesn't know him at all, is more than I can understand.

My friend Nordhoff went to the other extreme in this matter. I know of only three or four of his old boyhood friends whom he called by their first names. Although I was his friend during twenty-eight years he never called me by either of my first names. I was always "Hall" to him.

At last my speaking engagements came to an end, and I made tracks immediately for California. I was prepared to dislike the Golden State, having so often heard it cracked up to the skies, by both "native sons" and former Iowans who made their homes there. Another "bitter" sonnet was written when I was en route by train from San Francisco to Los Angeles where Nordhoff's parents lived at that time. Along the beautiful coast between the two cities I saw oil wells in the sea — even in the sea! — and reacted to the profanation in a sonnet ending with the following lines:

> They must be vermin, surely, who defile
> Their very Homeland coasts, mile after mile.

Nordhoff hated change fully as much as I did, but when I showed him some of my verses he reacted in a very cold manner to this sonnet.

"So you think Californians are vermin?" he said. "I wonder that you are willing to associate with one of them."

I told him that I was only getting a little of my own back for what he had said in Paris: that California was "lousy" with Iowans.

"If you owned some of that coastal land with great reservoirs of oil beneath it, you would be one of the vermin, yourself," he replied.

I neither denied nor admitted the truth of this, but I was glad that circumstances had never thrown the possibility in my way.

We sailed for Tahiti late in January, 1920, and little I realized then that I was to make my home in the South Seas.

Nordhoff and I came within view of Tahiti and its neighboring island, Moorea, on a clear, windless, February morning in 1920. I well remember our happiness on that occasion. World War I was behind us, and the thoughts of it sunk far down in the depths of memory — as deep as they would go. We still had the better part of our lives before us and were now as free as birds; or, if not quite that, as free as most young men can ever expect to be. And here,

before and around us, were all of these lonely islands to explore: the Society Islands, the Australs, the Low Archipelago, the Cooks, the Gambiers, the Marquesas.

Stevenson said that one's first tropical island landfall touches a virginity of sense. So it does, and, fortunately, the tenth or the fifteenth. The purity of perception is not lost by repetition of the experience. There is a magic about these islands that is time-defying; that loses nothing of its power however long continued one's association with them may be. Landfalls or departures, by day or by night, each one seems to be the first and most memorable.

I remember in this connection Axel Heyst, in Conrad's *Victory* — the tale he was writing when I came so near to barging in upon him in the summer of 1914 — and Heyst's occasional quiet remark: "I am enchanted with these islands." And his were the islands of the western Pacific, small continents, some of them, steaming in moist heat, under a cruel sun, their lowlands clothed with all but impenetrable jungle, their lofty mountains concealed by clouds, and the air loud with the humming wings of countless insects hostile to man. What would have been the strength of the enchantment had he known the islands of eastern Polynesia: Tahiti, Moorea, Bora Bora, or the lagoon islands of the Tuamotu Group? "The Dangerous Archipelago" these latter are often called, and so they are, high and low islands alike: dangerous indeed to the man who enters the invisible circle of their enchantment, hoping to escape again.

Ever since boyhood the mere name, "island," has had a peculiar fascination for me. An inland birth was, doubtless, partly responsible for that; islands were far to seek on the prairies of Iowa, and yet they could be found, of a sort. A mudbank in the sluggish midstream of a prairie slough was enough; and if at the season of the spring rains I found one larger, with a tree or two, the roots undermined by the current, leaning across it, I asked nothing better than to halt there and moor my flat-bottomed skiff to the roots of one of the trees. Try as I would, though, I could not imagine the sea — any sea. The

fact that the earth is three-quarters water was not a fact to me. Neither the evidence furnished by maps in school geographies nor the assurance of my elders convinced me; or, if I believed, it was only with the surface of my mind. Within was a solid core of doubt.

Until one wintry afternoon — it must have been around my tenth or eleventh year: a memorable day that stands out with the entrancing roundness and clearness of objects seen through the stereoscopic glasses our parents used to keep with the knickknacks on the parlor table. I remember the very weather of it: the fine dry snow filling the wagon tracks in the frozen mud, sifting lightly along the board sidewalks, piling in drifts along the fronts of the store buildings, adding little by little to the grayness of a gray world. I was on my way to Mrs. Sigafoos' shop.

She kept a small "stationery and notions" store not far from the C.R.I. & P. railway station, and there she would sit by the window, a shawl pinned around her thin shoulders, keeping her rocker going when there was nothing to be seen out of doors, stopping it abruptly and peering out when someone passed.

"Ain't that Dr. Holland goin' by? . . . Yes, I believe 'tis. Likely he's goin' to see Mrs. Hopkins. I know she's expectin'."

Mrs. Sigafoos had the habit of talking to herself even when I was present. On winter afternoons she had few of these pleasant distractions from out of doors. The street was often empty for half hours at a time.

There was a small back room, concealed from the shop by a curtain, where she kept her surplus stock of "notions," and delightful notions they were: boxes of marbles, valentines, firecrackers left over from last Fourth of July, Croconole boards, games such as Authors and Lotto; chocolate creams, cone-shaped, with a flavor that has since been lost by makers of confectionery — at least I have never been able to find it again; colored pencils and crayons, tracing-slates with pictures to go with them. The place was heaven to a ten-year-old, and I had the freedom of it, being Mrs. Sigafoos' newspaper-delivery boy,

on the understanding that I would put everything back just as I found it. And back everything went except an occasional misplaced chocolate cream.

I must not forget the music box. It played three tunes; I can hear them at this moment, and the very taste and smell and the dyed-in-the-wool color of boyhood thoughts and feelings come back with them. I have always regretted that music boxes ever went out of fashion, but of course, they could not hold their own against the phonograph.

Mrs. Sigafoos also had a shelf of books: boy's books such as *Cudjo's Cave, Lost River,* and editions of the Henty and Alger books, all of which I read, taking great care not to soil them. There were also padded-leather editions of the poets: Bryant, Whittier, Longfellow and Lowell, for birthday and school-graduation gifts, and several copies of Will Carleton's *Farm Ballads* and *Farm Legends,* illustrated. I am afraid that his ballads could not be ranked very high as poetry, but they met with my deep approval, in boyhood. They had in them the same distinctive flavor that one tastes in Edward Eggleston's *Roxy* and *The Hoosier Schoolmaster.* I could taste it then, without knowing that it was a flavor peculiar to certain inland sections of the U.S.A., and only for a period of two or three decades. Mark Twain preserved it best for us, of course, in *Tom Sawyer* and *Huck Finn,* but his humbler assistants, such as Edward Eggleston and Will Carleton, should not be forgotten. They helped, and it is well they did; otherwise the knowledge of that special quality of American life would be as lost to the world as the flavor of Mrs. Sigafoos' chocolate creams.

There was another book on the shelf. I had noticed it before, but, somehow, it had failed to arouse my interest: *Typee,* by Herman Melville. It may have been the strange title that threw me off. On this afternoon I was tempted to take it down and open it.

Six months at sea! Yes, reader, as I live, six months out of sight of land; cruising after the sperm-whale beneath the scorch-

ing sun of the Line, and tossed on the billows of the wide-rolling Pacific — the sky above, the sea around, and nothing else!

Who does not remember some day in boyhood, such as this one of mine, preserved, fragrant and memorable, between the covers of a book? *Typee* has my day safely hidden among its pages. There was a quality approaching the ideal in my experience; indeed, I cannot imagine anything lacking that might have made it more so. It was my first authentic entrance, in literature, to the world of islands; and what more fitting vantage-point or vantage-time could I have had for the experience than the back room of Mrs. Sigafoos' shop, in a little farming town on the prairies on the afternoon of a snowy winter day? For the first time I believed in the sea — emotionally, I mean. That opening paragraph spread it out before me as something not to be questioned, like the sea of land rolling away to the horizons that bounded my home town. But, as I followed Melville across it, in the imagination, to Nuku Hiva in the Marquesas Islands, I little realized that the first gossamerlike thread of Chance was being spun which was to take me to the South Pacific, with my friend, Nordhoff, so many years later.

Tahiti thirty years ago — to say nothing of other remote islands, both east and west in the Pacific — was a far different place from what it is today. Only the tips of the octopuslike tentacles of Western civilization, as we know it now, had reached this far into the Pacific, and the effect of them was scarcely felt. The character of the life was very much what it had been in the seventies and the eighties of the last century. There were, to be sure, a few motorcars, but not so many but what I could pretend not to see them.

Nordhoff and I could not, of course, begin writing our book for Harper's immediately. We had to know something about the islands and the life of their people before setting pens to paper; and so fol-

lowed a period of loafing and observing that was entirely to my taste. Nordhoff loved fishing and made trips out to sea with the native boys who fished for the Papeete market. I made excursions into the valleys and up the mountains, where no one lives, and at times prowled the streets of Papeete by day and by night. Having been inland born, with dreams of islands running through my head since boyhood days, I found that Tahiti surpassed my most hopeful expectations. Even with my feet on solid earth I could scarcely believe in the reality of the place. I liked being abroad at the time of the midday siesta when I had the streets almost to myself, and my first writing was a sketch in which I tried to put into words my feeling about that particular time of day.

I love the hour between twelve and one when this island world falls under the enchantment of silence and sleep; but having been born in the higher latitudes, I can't accustom myself to the siesta. Sleep fails to come, and so, often, I set out for a stroll through the deserted streets.

But my own wakefulness is only seeming. I too am under the midday enchantment which plays curious pranks with the senses, giving each of them the qualities of the others; and when a mynah bird, hidden in the deep shade of a mango tree, drops a single drowsy chirp into the pool of silence beneath and around him, I see, with my ears, so to speak, the silver splash it makes and the circles moving smoothly out over the placid surface. And, with my eyes, I hear the unfamiliar music of color that comes from gardens on either hand: the chiming of innumerable hibiscus bells; the clamorous trumpet-tones of the Bougainvillea; flamboyant trees yearning like saxophones; and modest blossoms, deeply embowered in greenish gloom, giving forth arpeggios of cool notes like the tinkling of mandolins or the plucked strings of violins.

For all this weird music I am aware of the deepening noon-day stillness. The bell in the cathedral clock tower, striking the quarter-past, tries vainly to fathom it, and wider and deeper yet

is the sea silence. I realize now that the faint thunder of surf on the reef is really a part of this silence, thus perpetually self-conscious, aware of its own immensity.

The sunlight too has a peculiar noonday quality. It is heavy, amenable to the law of gravity. It drips from the fronds of the palms, spills in rivulets from broad-leaved banana plants, and runs in bright drops down the stems of grasses. It falls like golden rain in the open spaces and lies on the streets in shining pools, to be splashed through by midday sleepwalkers. As for the shadows, they are more palpable still. I expect to be en-meshed in the lacy shadow-patterns of an acacia tree thrown across the roadway, and come with a perceptible shock against the clear-cut edges of house shadows. "If I were fully awake," I think, "I could lean against one of these and rest awhile."

In this trancelike mood I move through numerous back streets and come to the water front. The silence here is broken only by the creaking of the gangplanks of schooners moored along the sea wall. A few Chinese fruit vendors sit in the shade of their booths, their eyes closed, their chins resting upon their updrawn knees. But as I pass, each one opens an eye to a barely percep-tible width, and the keen appraisement in these brief glances convinces me that sleep, to a Chinaman, is only another form of wakefulness. Not so do the Polynesians enjoy their siestas. They lie sprawled out on the decks of schooners, under the trees, along the porches of closed shops — wherever shade is to be found — and they are as nearly dead as sleeping men can be.

Nordhoff had a practical, matter-of-fact mind, while I had — and still have to this day — that of a woodshed poet. When I read him the above sketch he said: "Is this a proposed contribution to our travel book?"

"I hoped it might be," I replied.

"Hibiscus bells ringing, sunlight spilling like water from the palm fronds, shadows so solid that you get your feet tangled in them and

skin your nose against the sharp-edged ones. What are you leading up to? How do you go on from there?"

"I don't go on," I said. "That's enough for an impression."

I knew of course that his criticism was just. Who would want to read this kind of stuff? And yet, it was what I wanted to write at that time. I was in a world wholly unlike anything I had known in the past, and new impressions came flooding in upon me so fast that I scarcely had time to make note of them. I tried to concentrate upon the travel book, but it was useless. At last I told Nordhoff that I would have to get this sketch-writing frenzy out of my system somehow. I proposed making a bicycle trip around the island for the purpose. Nordhoff didn't want to come with me. He liked Papeete and his offshore fishing excursions. Furthermore, the Bougainville Club was the rendezvous for schooner captains, pearl buyers, traders and the like, and their company was well worth cultivating. So it was decided that, while he remained in town, I would take my bicycle trip around the island, hobnobbing with the country people. I had seen enough of the islanders to be certain that a more friendly, hospitable people could not be found anywhere, and that I would have no difficulty in finding places to put up for the night.

At that time Tahiti's one round-the-island road was little more than a grass-grown cart-track for the greater part of it, and on the far side of the island none of the rivers were bridged. But the streams were not deep and could easily be waded with my bicycle carried on my shoulder.

I set out in a westerly direction and before I had gone far I found that my feet were making revolutions in time to the following words:

> This small island is, for me,
> Everything a home should be . . .

Another poem on the way! I halted to make a note of the lines but I didn't finish it then. It was years later, in fact not until May, 1941, that I published this poem in full in the *Atlantic*.

TOUR DE L'ÎLE

(TAHITI, FRENCH OCEANIA)

This small island is, for me,
Everything a home should be:
As far from any continent
As they are far from discontent
Who, from whatever vantage ground,
Behold the sea that rings them round
Lonelier than the morning sky
Where the waning moon is high.

Here no great plantations are
Owned by men who live afar,
But little lands, where those who toil
Own the food and own the soil
With trees to bear them fruit, and shade
Where their fathers' bones are laid.
The sons have no great store of wealth
Save peace and tranquil minds and health.

I often think how more than wise
In planting islands of this size
Was Mother Earth, and how remiss
To plant so few the size of this.
A world of lesser worlds could be
Scattered on this empty sea,
Though sea enough should still remain
For isolation, fish, and rain.

Five-score miles or, better, four,
Should island circuits be — no more;
So that, when he wished it, one
Could bike around from sun to sun;

Or, circumscribing more at ease,
Loiter 'neath the breadfruit trees
Of his friends, engaged in talk
Of matters pondered on the walk;

For he will walk as much as ride
To look at things on either side;
Then moving on, with matter new
To ponder for an hour or two
Until another halt is made,
This time in a mango's shade,
Cool beneath the midday sun,
There to rest from twelve to one;
Or, if Inclination said,
"Why the haste?" to nod his head
And, "Why indeed?" to make response.
He has a dwelling for the nonce:
Let him make a longer stay
Of half an hour or half a day,
Reading his book till evening comes
And the brisk mosquito hums.

Bordering the still lagoons,
Orion's mirror and the moon's,
Now fares he on, in deep content,
With a silence round him bent
Wider than the dome of Night
There for his express delight.
Let him now drop all but peace;
Tell his arrogance to cease
Concerning with other-where, or how,
Accepting only here, and now.
Thus his mind is healed and whole
And large as the inverted bowl
Of heaven, it seems, for influence
That comes — he knows not how, or whence.

Truth the passive spirit gains
That mind may not, for all its pains.
Unaware, the seeker tries
Varied paths to where it lies
Or doesn't lie, for even wells
May not be receptacles,
And biking round an island road
May lead to some half-truth's abode.
If not, at least he's bound to come
Back to the place he started from.

Now is heaven bare and wide;
Now through checkered gloom he'll ride.
Here, along the sandy shore
Where the feathering breakers roar,
From the corner of his eye
Mermen's children he will spy
In the surf, and from their tails
Moonlight falling off in scales.
Farther on his way he views
Children with no tails to use
Leaping from a palm-tree bole
Into some deep water-hole
Where the foam and broken light
Lacquer bodies creamy white
Over brown. . . . Felicity,
The world is far too small for thee,
And all the wide world knows it not,
Or if it knew, has since forgot,
Save children in such lands as these
Lost in the farthest, loneliest seas.

I spent ten days making my first tour of the island, the main part
of which is eighty-five miles around. But I was not pressed for time
and loitered on the way, halting for a day or night whenever inclina-
tion prompted me. This was a happy experience, and I returned to

Papeete with a whole sheaf of sketches and impressions which I read to Nordhoff who listened to them with no great amount of enthusiasm. I will quote one here for the pleasure it gives me to recall the time and the place where it was written. Furthermore, it was the only contribution I ever made to the science of philology.

VOICES

Grass and fern underfoot, growing, blossoming things on all sides, wide-spreading branches of breadfruit, mango and frangipani trees to catch and scatter the sunlight: so carpeted, walled-round and canopied is the green solitude where stands this little house.

Throughout the afternoon there is deep silence here, but toward evening the village wakens and all the neighbors are up and about their affairs. As dusk deepens to night they pass unseen along the road or through the darkness of the groves, their bare feet making no slightest sound, and I imagine that I am listening to the voices of ghosts floating along on vagrant currents of air.

Their speech has great charm for a stranger from the northern latitudes. Only children of nature, isolated for centuries on such islands as these, could have fashioned words so warm and fragrant with the breath of the land, so cool and refreshing with the breath of the sea. They have words for morning moods as airy as bubbles or foam on the slope of a subsiding wave, and they seem, somehow, as evanescent, as though created for the mood and the moment only. They have drowsy noonday words, soaked with sunlight and languorous meaning. Some of them seem to come from the deep moist gloom of immemorial derivations. Others demand attention by the beauty of their sound alone as they glide smoothly along the current of speech, like the hibiscus blossoms that float across the pools in their mountain streams.

The texture of their voices is like that of smoke — the starlight-filtered smoke of their supper fires; but often when chil-

dren are speaking I hear cadences that remind me, by their tissue of resilient sound, of wind-blown spiderwebs sparkling with a mist of dew. Even in phrases of commonplace meaning one is aware of the influences that have fashioned the language: the loneliness of mid-ocean solitudes, the warmth and generosity of wind-tempered sunlight, the humid fragrance of tropical vegetation.

For the most part it is the light-hearted speech of a laughter-loving people. After the advent of Europeans it was set down in written characters quite inadequate for the purpose. So it remains, and students of the language must study it in this form, represented by these alien symbols.

But one need not, of course, study it. For my own part I find it pleasure enough and profit enough to sit of an evening in the darkness, listening, while strange and harmonious sound-patterns are thrown, now here, now there, upon a curtain of starry silence.

Upon returning to Papeete, Nordhoff and I began discussing ways and means of working on our Harper's book which was to be called *Faery Lands of the South Seas*. We finally decided upon the following plan: we would separate, Nordhoff going to the Cook Islands, and I was to voyage among the lagoon islands of the Low Archipelago. I was to begin the story of our wanderings and to carry the thread of it throughout. Nordhoff's contributions were to be in the form of letters to me. A more clumsy device could scarcely have been hit upon, but it was the only one we could think of at that time, having had so little practice in collaboration. I will say no more of "Faery Lands" except that the book, when published, stayed in print, greatly to our surprise, for a good ten years; we more than canceled our debt to Harper's. Having completed that task, it did not occur to us, strangely enough, to continue writing together nor did we collaborate again until 1927 when we joined forces in writing our book for boys, *Falcons of France*. Nordhoff wanted to write a novel, so I continued

voyaging throughout the years 1920 and '21, on copra schooners, Low Island cutters and other small craft. I wandered widely throughout eastern Polynesia, halting at various islands for a few days or weeks —

> Making in all my home, with pliant ways;
> But, provident of change, putting forth root in none.

On one island I had a home of my own for a brief time, on a little gem of a place where no one lived. It was an islet on the reef of a lagoon island forty miles long by twenty broad, and the house of palm-frond thatch was built for me by the chief and his people who lived on the village island four miles distant. There I had an experience which I shall tell about in the following chapter.

xxiii. An Adventure in Solitude

I AWOKE sometime during the latter part of the night with the be-
mused presentiment that a longed-for event was approaching or
in the process of happening. Hands had passed lightly over my face
— either that or I had dreamed it — and I heard a faint shout coming
from the borderland between sleeping and waking. Puarei's guest bed,
with its billowy mattress of kapok, seemed strangely hard, which led
to the discovery that I was not lying on a bed but on a mat laid over
coral sand in the corner of an empty room. Bright moonlight flood-
ing through the open doorway made a faint radiance in the gloom
and the roof of green thatch was alight with the reflections of moving
water. I was trying to puzzle out where I was when I heard the shout
again, clearly this time, in a pause of silence between what seemed
to be reverberating claps of thunder. From nearer at hand came the
sound of subdued laughter. Something elfish, lighthearted, in the
quality of it stirred a dim memory and there flashed into mind the
lines of an old poem:

> Come, dear children, come out and play!
> The moon is shining as bright as day.
> Up the ladder and over the wall . . .

Raising my head quickly, I saw through the open doorway their
perfect illustration. The wall was the smooth wall of the sea, with
the waning moon rising just clear of it, sending a path of light to
the smooth white beach in front of the house. The coconut palms

bordering the shore swarmed with children who were throwing down nuts. One ancient tree, its stem a fantastic curve, held its fronds far out over the lagoon. Both boys and girls were shinnying up the trunk, one after the other, leaping from the plumed top, dropping feet foremost, their hands clasped around their knees, into the shimmering water. A second group had gathered in the moonlit area in front of my doorway. Several youngsters were peering in my direction. Others were playing a sort of hand-clapping game to the accompaniment of an odd little singsong. A small girl with a baby riding astride her hip walked past, and I saw another, of ten or twelve, standing at the edge of the track of silvery light, holding a drinking coconut to her lips with both hands. Her head was bent far back and her hair hung free from her shoulders as she drained the cool liquid to the last drop.

Imagine coming out of the depth of sleep to the consciousness of such a scene! I was hardly more sure of its reality than I had been of the shout, the touch of hands. It was like a picture out of a book of fairy tales, but one quick with life, the figures coming and going against the background of the great lagoon. I remembered where I was, of course: in my own house which stood on the lagoon side of a *motu*, or islet, known in the Tuamotu legend as "the islet where the souls were eaten." The house had been built for me only the day before by the order of Puarei, the chief, and the *motu* was one of scores of uninhabited islands which were scattered along the reef enclosing the lagoon.

It was ordered — by the chance that took me there, perhaps — that I was never to see the place in the clear light of customary experience, but, rather, through a glamour like that of remembered dreams — a succession of dreams in which, night after night, events shape themselves according to the heart's desire, or even more fantastically, with an airy disregard for any semblance to reality. So it was, waking from sleep on the first night spent under my own roof. I was almost ready to believe that my presence there was not the result of Chance.

Waywardness of fancy is one of the attributes of that divinity, but the display of it is as likely as not to be unfriendly. Here there seemed to be reasoned kindly action. "Providence," I said to myself. "Providence, without a doubt; a little repentant, perhaps, because of questionable gifts in the past." A whimsical Providence, too, which delighted in shocking my sense of probability. What could these children be doing on Soul Eaters' Island in the middle of the night? I myself had left the village island, four miles distant, only the afternoon before. Perhaps, I thought, these are not earthly children. Maybe they are the ghosts of those whose souls were eaten here so many centuries ago.

I dressed quietly and went to the door, taking care to keep in shadow that I might look on for a moment without being seen. My doubts, if I had any, vanished at once. Not only the children had come out to play: their fathers and mothers as well. Tamitanga was there, and Rikitia and Nahea and Pohu and Tauhere and Hunga; Nui-Tane and his wife, Nui-Vahine; Temataha, Manono, Havaiki; and I saw old Rangituki, who was at least seventy and a grandmother many times over, clapping her hands with others of her generation and swaying from side to side in time to the music of Kaupia's concertina. All of the older people were grouped around Puarei who was seated in an old deck chair, a sort of throne which was carried about for him wherever he went. Poura, his wife, lay on a mat beside him, her chin propped on her hands. Both greeted me cordially, but offered no explanation of the reason for the midnight visit. I was glad they did not. I liked the casualness of it which was quite in keeping with the customs of Low Island life. But I could not help smiling, inwardly, remembering my reflections earlier in the evening. I believed then that I was crossing the threshold of what was to be an adventure in solitude. I was to delve, for the first time, into my own resources against loneliness. I had known the solitude of cities, but there one has the sense of nearness to others; the resource of books, pictures, music — all the distractions which prevent any search-

ing examination of one's capacity for a life of complete solitude. At Soul Eaters' Island I would have neither books nor pictures, and for music I was limited to what I could make for myself with my ocarina, my sweet-potato whistle, which had a range of one octave. Thus scantly provided with diversions, I was to learn how far my own thoughts would serve to make solitude not only endurable but pleasant. This was to be merely a trial experiment. If I liked it, I planned to go to a completely uninhabited island where my only companions would be the fish and sharks in the lagoon and the sea, the sea fowl overhead, and the hermit crabs and tiny iridescent lizards on the land. There I would remain for six months, with instructions that I was not to be called for until the end of that period.

So I had dreamed of this first trial experiment as I paddled down the lagoon with my island taking form against the sky to the eastward. It was one of those places which set one to dreaming, which seemed fashioned by nature for the enjoyment of a definite kind of experience. Seeing it, whether by day or by night, the most gregarious of men, I believe, would have become suddenly enamored of his own companionship, and the most prosaic would have discovered a second meditative self which pleaded for indulgence with gentle obstinacy. But my unsocial nature gained but a barren victory at first, being deprived of seclusion by the seventy convivial inhabitants of Rutiaro. Here was half the village at my door, and Puarei informed me that the rest of it, as many as were provided with canoes, was following. Evidently, he had suggested the invasion. My new house needed warming — or the Tuamotu equivalent of that festival — so they had come to warm it.

Preparations were being made on an elaborate scale. The children were gathering green coconuts for drinking and ripe ones for the preparation of food, and fronds for the cloth at the feast. Women and girls were grating the meat of ripe nuts, pressing out the milk for the *miti haari*, cleaning fish, preparing shells for dishes. Some of the men and older boys were making the earth ovens for the roasting of

pigs and the baking of the fish. All of this work was being carried out under Puarei's direction to the accompaniment of Kaupia's concertina. I wish that I might in some way make real to others the unreal loveliness of the scene. The moonlight must be remembered, and how it lay in splinters of silver on the fronds of the palms as though it were of the very texture of their polished surfaces. And you must hear the thunder of the surf along the outer reefs, and, near at hand, the music of Kaupia's concertina, and the shouts of the children as they dove into the pool of moon-silvered foam. The older ones wore wisps of *pareu* cloth around their middles, but the little ones were as naked as when they were born. Tereki was standing among the five- and six-year-olds, too small to climb to the diving place, tossing them into the pool amongst the others, where they were as much at home as so many minnows. Watching them, I thought with regret of my own lost opportunities as a child, and of other children of civilization who rarely know the pleasure of playing at midnight, and by moonlight, too.

I was sorry that the supercargo of the copra schooner which had brought me to the island could not have been present to see how blithely the work went forward. He had called the people a lazy lot, and he was right: they *were* lazy according to our joyless northern standards; but when they worked toward an end which pleased them their industry was astonishing. The supercargo's belief was that man was made to labor, whether joyfully or not, in order that he might increase his wealth, whether he needed it or not, and that of the world at large. This was somewhat the point of view of the early missionaries to the islands; it seems to have irked them, if one may judge by the memoirs that some left behind, at finding people whose lives were completely at variance with the sense of that doleful hymn, "Work, For the Night Is Coming." They, too, believed that the needs of the Polynesians should be increased, but for ethical reasons, in order that they should be compelled to cultivate regular habits of industry. It seems to me that they might have argued as reasonably for a

general distribution of Joblike boils, in order that the virtues of patience and fortitude might have wider dissemination.

The people of Rutiaro worked, as they had always done, only under the pressure of necessity. Their simple needs being satisfied, their inertia was a thing to marvel at. I have often seen them sitting for hours at a time, moving only with the shadows that sheltered them. There was something awe-inspiring in their immobility, in their attitudes of profound reverie. I felt at times that I was living in a land under a perpetual enchantment of silence and sleep. These periods of calm — or, as some would say, sheer laziness — were usually brought to an end by Puarei. It was fascinating to watch him throwing off the enchantment, so gradual was the process, and so strange the contrast when he was thoroughly awake and had roused the village from its long sleep. Then would follow a period of activity: fishing, copra making, canoe building — whatever there was to do would be accomplished, not speedily, perhaps, but smoothly, with no waste effort. My house was built during such a period. I was wondering whether I was ever to have the promised dwelling. Then, one afternoon when I was absent on a shell-collecting expedition, the village set out en masse for Soul Eaters' Island, cut the timbers, plaited the palm fronds, erected, swept and garnished my dwelling and were at the village island again before I myself had returned. That task finished, here they were back again for the house-warming festival, and the energy spent in preparing for it would have more than loaded a ninety-ton trading schooner with copra. I couldn't flatter myself that all of this was done solely to give me pleasure, and, furthermore, I knew that an unusually long interval of fasting called for compensation in the way of feasting.

Puarei was in a gay mood. He was an elder in his church, but once he had sloughed off his air of Latter Day Saintliness he made a splendid master of ceremonies. He threw it aside the moment the drums began to beat, and led a dozen of the younger men in a dance I had not seen before. Three kinds of drums were used: one, an

empty gasoline tin which kept up a steady roll while the dance was in progress. The rhythm for the movements was indicated by three others, two of the men beating hollowed cylinders of wood, while a third was provided with an old French army drum of the Napoleonic period. The syncopation was extraordinary. Measures were divided in an amazing variety of ways, and often when the opportunity seemed lost the fragments were joined perfectly just as the next measure was at hand. The music was a kaleidoscope in sound, made up of unique and startling variations in tempo, as the dance moved from one figure to the next.

At the close of it Kaupia took up her concertina again and dancing by some of the women followed. At length, Rangituki, grandmother though she was, could resist the music no longer. The others gave way to her, and in a moment she was dancing alone, proudly, as though she were remembering her youth, throwing a last defiance in the teeth of Time. Then came a weird *himine* of many verses, a song about the soul-eater which was said to inhabit the island: an evil earth spirit in the form of a beautiful sea bird, and the chorus was:

> *Au-e, au-e,*
> *Te nehenehe e*
>
> (Alas! Alas!
> How beautiful it is!)

a lament that a spirit so vindictive, so pitiless, should be so fair to outward seeming.

Another song puzzled me at first. The refrain was five words long and often repeated:

> *Tu fra, to potta mi,*
> *Tu fra, to potta mi.*

Both the words and the air had a familiar sound. They called to mind a shadowy picture of three tall thin women in spangled skirts, beating

tambourines in unison and dancing in front of a painted screen. I couldn't account for that strange vision at first. It glimmered faintly, far in the depths of subconscious memory, like a colored newspaper supplement lying in murky water at the end of a pier. Suddenly it rose into focus, drawn to the surface by the buoyant splendor of a name — the Cherry Sisters. I remembered then a vaudeville troupe which visited even small towns of the Middle West. I saw them again, on the island where the souls were eaten, as clearly as ever I had as a youngster, knocking their tambourines on bony elbows, shaking their curls and singing —

Shoo, fly! Don't bother me

in shrill cracked voices. The Tuamotu version was merely a phonetic translation of the words; they had no meaning, and, old woman that she was, Rangituki's dance, which accompanied the music, played in faster and faster time, was in striking contrast to the angular movements of the Cherry Sisters, tripping it in the background, across the dim footlights of the eighteen-nineties.

Other canoes were arriving during this time, one of them loaded with pigs and chickens, the most important part of the feast to come. Some of the chickens, having been insecurely tethered, escaped. Like the dogs of the islands, the chickens are of a wild, strangely mixed breed, and they took to the air with sturdy wings. The chase began at once but it was hopeless. Soul Eaters' Island is five hundred yards long by three hundred broad, and there is another, on the opposite side of the pass leading to the open sea, which is more than a mile long. We made frantic efforts to prevent them from reaching it. It was to no purpose; several hours of captivity had made them wary. The last we saw of them they were in flight over the wide pass separating the two islands.

Knowing the wholesomeness of the Tuamotuan appetite I could understand why the loss of the fowls was regarded seriously. A dozen remained, and there were the pigs; nevertheless there was a gloomy

shaking of heads as we returned from our fruitless chase. In this emergency I contributed some one-pound tins of beef and salmon, most of my stock of substantial provisions for the adventure in solitude, but I could see that Puarei as well as the others regarded this as a mere relish, an acceptable but light course of hors d'oeuvres. Fortunately, there was at hand an inexhaustible reservoir of food — the sea, and we prepared to go there for further supplies. I never lost an opportunity to witness those fish-spearing expeditions. The native spears are true sportsman's weapons, provided with a single unbarbed dart, bound with sinnet to a slender shaft from eight to ten feet long. Their water goggles, like their spears, they make for themselves. They are somewhat like an airman's goggles, discs of clear glass fitted in brass rims, with an inner cushion of rubber which cups closely around the eyes, preventing the entrance of water. Thus equipped, with their *pareus* girded into loin-cloths, half a dozen of the younger men dived into the lagoon passage and swam out to sea.

I followed with two other men in a canoe. Dawn was at hand, and, looking back, I saw the island, my dwelling, and the crowd on the beach in the suffused unreal light of sun and fading moon. In front of us the swimmers were already approaching the tumbled waters at the entrance of the pass. Upon reaching it they vanished and reappeared on the far side, swimming parallel to the reef and about thirty yards beyond the breaking point of the seas. They lay face down on the surface of the water, turning their heads now and then for a breath of air. They swam with an easy breast stroke and a scarcely perceptible movement of the legs, holding their spears with their toes, near the end of the long shaft. Riding the long smooth swells it was hard to keep them in view; they were diving repeatedly, coming to the surface again at unexpected places.

Through the clear water I could see every crevice and canyon in the shelving walls of coral; the mouths of gloomy caverns which undermined the reef, and swarms of fish, as strangely colored as the coral itself, passing through them, flashing across sunlit spaces, or

hovering in the shadows of overhanging ledges. It was a strange world to look down upon and stranger still to see men moving about in it as though it were their natural home. Sometimes they grasped their spears as a poniard would be held for a downward blow; sometimes with the thumb forward, thrusting with an underhand movement. They were marvelously quick and accurate at striking, and often impaled two fish in rapid succession. I had a nicer appreciation of their skill after several attempts of my own to spear fish in this fashion. A novice is helpless; he might chase, with as good result, the dancing reflections of a mirror, turned this way and that in the sunlight.

As they searched the depths to the seaward side the bodies of the fishers grew shadowy, vanished altogether, reappeared as they passed over a lighter background of blue or green which marked an invisible shoal. At last they would come clearly into view, the spear held erect, rising like embodied spirits through an element of matchless purity which seemed neither air nor water. The strange whistling noises they made as they regained the surface gave a further touch of unreality to the scene, as though they were in all truth mermen whose home was the sea. Heard against the thunder of the surf, the sounds, hoarse or shrill, according to the wont of the diver, seemed anything but human.

We returned with the canoe filled with fish: square-nosed *tingatingas*, silvery *tamures*, brown-spotted *kitos*, *gnareas* — we had more than made good the loss of the chickens. The fish were quickly cleaned, wrapped in green leaves, and placed in the earth ovens with the other food. The table was already set, or, rather, the cloth of green fronds was laid on the sand near the beach. Down the center of it were scattered my tins of corned beef and salmon, and at each place was the half of a coconut shell filled with raw fish in a sauce of *miti haari* — salted coconut milk — and a green coconut for drinking. When at last the feast was ready I heard Puarei calling, "*Haere mai ta maa*," and went out to join the others. Great piles of baked fish,

pork, and chicken, steaming from the ovens, were heaped up along the center of the table, so called, and the mounds of bread were stacked like cannon balls. These were prepared in the native fashion — lumps of boiled dough the size of large grapefruit. One might think that the hardiest stomach would ache at the prospect of receiving it, but the Low Island stomach is of ostrichlike hardihood, and, after fasting, it demands quantity rather than quality in food. After Puarei had said grace for the Church of Latter Day Saints, and Huirai a second one for the Reformed Church of Latter Day Saints, and Nui-Tane a third one as the Catholic representative, we all fell to heartily.

The enjoyment of food is, assuredly, one of the great blessings of life, although it is not a cause for perpetual smiling as the writers of advertisements would have one believe. In the lagoon islands it is not a cause for smiling at all, but for serious and absorbed attention. I liked their custom of eating in silence, with everyone giving undivided attention to the business in hand. It gave one the privilege of doing likewise, a relief to a man weary of the unnatural dining habits of more advanced people. You are not obliged to turn to the lady on your right hand and, having given her just the proper amount of attention, to turn to the lady on your left hand. In fact, there were no ladies to turn to. They were engaged in bringing in more food and would eat with the children after the men had finished. It may be a bit gross to think of your food while eating it, but it is natural and, if the doctors are to be believed, an excellent aid to digestion. Now and then Puarei would turn to me and say, "E mea maitai, tera" (A thing good, that), tapping a haunch of pork with his forefinger. And I would reply, "E. E mea maitai roa, tera." (Yes. A thing very good, that.) Then we would fall to eating again. On my right, Hunga went from fish to pork, and from pork to tinned beef or salmon, whipping the miti haari sauce to his lips with his fingers without the loss of a drop. Only once he paused for a moment and let his eyes wander along the length of the table. Shaking his head with a sigh of satis-

faction, he said: "*Katinga ahuru katinga*" — Food and yet more food. There is no phrase sweeter to Low Island ears than that one.

A further account of the feast at my house-warming would be nothing more than a detailed statement of the amount of food consumed, and it would not be credited as truthful. It is enough to say that it was a latter-day miracle, comparable to the feeding of the five thousand, with this reversal of the circumstances — that food for approximately that number was eaten by twenty-two men. At last Puarei sat back with a groan of content and said: "*Au-e! Paia 'huru paia to tatou.*" The meaning of this is, "We are all of us full up to the neck." And it was true: we were. That is, all of the men. The women and children were waiting, and as soon as we gave them room they set-to on the remnants. Fortunately, there was, as Hunga had said, food and yet more food, so that no one went hungry. At the close of the feast I saw old Rangituki take a fragment of coconut frond and weave it into a basket. Then she gathered into it all of the fish bones and hung it from one of the rafters of my house. At the beginning of the meal thanks had been given to the God of Christians for the bounty of the sea; but fisherman's luck was a matter of the first importance, and while the old gods might be overthrown, there seemed to be a general belief that it would not do to trifle with immemorial custom.

It was getting on toward midday when the last of the broken meats had been removed and the beach made tidy. The breeze died away, and the shadows of the palms moved only with the imperceptible advance of the sun. It was a time for rest, for quiet meditation, or, perhaps, on the part of some of my hosts, and guests, for merely waiting upon the orderly processes of digestion. All of the older people were gathered in the shade, gazing out over a sea as tranquil as their minds, as lonely as their lives had always been and would always be. I knew that they would remain thus throughout the rest of the day, talking a little after the refreshment of sleep, but for the most part sitting without speech or movement, their consciousness crossed by vague thoughts that would stir it scarcely more than the cat's-paws ruffled

the surface of the lagoon. No sudden half-anguished realization of the swift passage of time would disturb the peace of their reveries; no sense of old loss to be retrieved would goad them into swift and feverish action.

A landcrab moved across a strip of sunlight and sidled into his hole, pulling his grotesque little shadow in after him. The children, restless little spirits, splashed and shouted in the shallows of the lagoon, maneuvering a fleet of empty beef and salmon tins, reminders of the strange beginning of my adventure in solitude.

xxiv. Iceland

I CONTINUED my sea wanderings through 1920, 1921 and to the spring of '22: Conrad's "enchanted Heyst" could have been no more enamored with islands and island life than was the woodshed poet. Then, strangely enough, I became conscious of a longing for the North. Memories of my boyhood dreams of the Arctic Circle came back to me. I was in the Marquesas Islands at that time, traveling on a copra schooner which made the full circuit of the principal islands, putting in at bays and coves to pick up whatever cargo the people had ready for them. This was my first voyage to the Marquesas, and I was, indeed, enchanted with their beauty. Their present-day life is a mere shadow of what it was a century and a half ago; there are no more than 3000 people in the entire archipelago. So I tried not to see it and let my imagination take me back to the time when their inhabitants had had none but the slightest contact with the outside world.

Alvaro Mendaña discovered the Marquesas in 1595, and Captain Cook rediscovered them nearly two centuries later, in 1744. After him came an American, Captain Ingraham, in 1791, and the Russian explorer, Krusenstern, in 1804. Following him came Commodore Porter of the *Essex*, who, during the War of 1812, was sent to the Pacific to prey upon British shipping, chiefly whalers in those days. He went to the island of Nuku Hiva to refit, and while there, in a foolish war with the inhabitants of Taipi Valley, he laid waste their homes. Then, in 1842, came Rear Admiral Dupetit-Thouars,

who stole the islands for France, and that marked the end of their old life for what is said to have been the finest branch of the Polynesian race in all the Pacific.

It will be remembered that Taipi — or "Typee" as Melville spelled the name — was the valley where he and his friend, Toby, lived after deserting from their whale ship, in 1842. Naturally, it had a particular interest for me. I explored the full length of the valley, a forlorn place in these days, with only a handful of people living near the entrance of it. The interior is a complete solitude, filled with jungle concealing the old stone *paepaes,* the platforms, on which their dwellings once stood. I made my way to the farthest extremity of the valley, following the stream all of the way. I wanted to find the little lake Melville speaks of, where he had gone sailing with Fayaway. But there is no remaining evidence of such a lake, and I doubt that it ever existed. This was, probably, a bit of romancing on Melville's part.

The loneliness, the emptiness of most Marquesan valleys, in such contrast to what they had been before white men destroyed the life of their people, made a deep and melancholy impression upon me. This may have been, in part, responsible for my sudden yearning to leave the islands, for a time, at least. But I might not have considered Iceland as a destination had I not had, among the few books I carried with me on the schooner, Trevelyan's *Life and Letters of Lord Macaulay.* I had been reading this at intervals for several weeks, and it just happened that, while in the Marquesas, I came upon the following passage:

Valuable, indeed, is the privilege of following Macaulay through his favorite volumes, where every leaf is plentifully besprinkled with the annotations of the most lively of scholiasts; but it would be an injustice toward his reputation to separate the commentary from the text, and present it to the public in a fragmentary condition. Such a process could give but a feeble idea of the animation and humor of that species of running conversation which he frequently kept up with his author for whole

chapters together. Of all the memorials of himself which he has left behind him, these dialogues with the dead are the most characteristic. The energy of his remonstrances, the heartiness of his approbation, the contemptuous vehemence of his censure, the eagerness with which he urges and reiterates his own opinions, are such as to make it at times difficult to realize that his remarks are addressed to people who died centuries, or perhaps tens of centuries, ago. But the writer of a book which had lived was always alive for Macaulay. . . . When he opened for the tenth or fifteenth time some history, or memoir, or romance — every incident and almost every sentence of which he had by heart — his feeling was precisely that which we experience on meeting an old comrade, whom we like all the better because we know the exact lines on which his talk will run. There was no society in London so agreeable that Macaulay would have preferred it at breakfast or at dinner to the company of Sterne, or Fielding, or Horace Walpole, or Boswell; and there were many less distinguished authors with whose productions he was very well content to cheer his repasts. "I read," he says, "Henderson's *Iceland* at breakfast — a favorite breakfast book with me. Why? How oddly we are made! Some books which I never should dream of opening at dinner please me at breakfast, and *vice versâ*."

There was an end of my own reading for that day. I fell to thinking of Macaulay, and, in particular, of his later years passed so pleasantly in the companionship of his books. I could almost see him at dinner — in what company? With Jane Austen, perhaps, or Thucydides, or Samuel Johnson; and, at breakfast, with Henderson's *Iceland* propped against the coffee urn behind his plate. What, I wondered, was the peculiar quality of that book that made it more acceptable at breakfast than at any other time? I had never heard of it. But how rarely, I thought, does one hear even the name of Iceland in these days! Yet it had been a nation for more than a thousand years. From there had come the actual discoverers of America five centuries

before Columbus had crossed the Atlantic. There, too, poetry had flourished, and a splendid prose literature when most of Europe was without either, and America still a wilderness inhabited by Indians. What could it be like today, and what of the descendants of those ancient poets, sagamen, warriors, explorers? I got out my pocket atlas, which I always carried, to learn what was said there of that ancient land.

Iceland (population 85,133). Capital, Reykjavik. Exports: fish, mutton, wool and dairy products.

I winced at this scant utilitarian description of a country so glorious in the history of civilization. Nevertheless, it seemed to give a shadowy picture of the place. I saw, or thought I saw, the gleam of a sail on a gray sea, bleak snow-covered headlands in the wan sunlight of a winter afternoon, and a farmhouse looking smaller than human under the huge wall of a mountain. If a clearer picture was wanted, there was an excellent way of securing it. And why not? I thought. The Northern Lights, dreamed of since childhood, would be superb in Iceland. If I choose I can be walking the streets of Reykjavik three months hence, or less. Even from these remote islands the journey can be made, very likely, in less time than was needed in the old days to cross from Norway.

But I proceeded no farther, that afternoon, than to a high promontory overlooking Taipi Valley — Melville might have had his first view of the valley from that spot. From that vantage point I had a view of a wide area of lowland and of the sea for thirty miles around. The upper air was all in motion, washing the senses clean of languor and passing over the reeds and grasses that clothed the mountainsides in ripples of green shadow. It was a delightful place in which to dream of a journey — to plan for one; and again I set myself adrift on the Stream of Travel which flows through such varied landscapes, sweeps such lonely shores. But it could not carry me in fancy so far to the north as Iceland. I could not visualize a street scene in

Reykjavik, or bring to focus the dim picture of the farm among the mountains. All the more reason, perhaps, for going there.

But would I not regret leaving these islands where Nature is so friendly to human kind? Here — no doubt of it — I had found real happiness. Day followed day, their passage scarcely noted; time even in human affairs seemed the abstraction it really is. This was a good not lightly to be relinquished; and yet, to hold it at the expense of freedom was to make the most abject of sacrifices. Nor was happiness to be held for long if it were to be dependent upon a miserly husbanding of it in one part of the world. Much better to believe, with Conrad, that it is "quaffed out of a golden cup in every latitude." To be sure, it is, I thought. The result was that I decided, then and there, to go to Iceland. I would travel through the country as opportunity offered, getting as well acquainted as I might with the people in whose veins flowed the blood of the noblest of the old Norsemen. And I would enjoy to the full the splendor of the Northern Lights. Then, perhaps, I would return to the South Seas, and think no more, forever, of that youthful dream of endless wandering.

Upon returning to Tahiti I found Nordhoff hard at work on a novel. Furthermore, he was married, to a lovely island girl, half Danish, half Tahitian. I told him of my plan for a trip to Iceland. He thought I was crazy but made no attempt to dissuade me from it. Shortly afterward I set out for my destination via San Francisco, New York, Copenhagen and the Faroe Islands.

I hoped to write a complete book about Iceland, and Mr. Wells, of Harper's, gave me every encouragement to do so. But I reckoned without my mortal enemy. Throughout the late summer, autumn, winter and early spring spent in that country, he was always at my elbow whispering words of anything but praise, no matter what I wrote. Despite his cursed presence I did get something done. I will introduce here two chapters of this unbegotten book because they belong to these memoirs and relate some experiences which I still think of with the deepest pleasure. I loved Iceland from the moment

I set foot in the country, and had it been possible I would have been commuting between Iceland and the South Seas these past thirty years.

It is late September. More than a month has passed since my arrival in Iceland, and I am now at Akureyri, the little capital of the North Country.

I have taken temporary lodgings at the hotel, a two-story frame building which stands on a strip of land extending far into the fjord. The windows of my room look to the southward over the upper reaches of the fjord and the valley land to the mountains whose peaks are already white with the first snows of autumn. Here I have spent many hours watching the cloud reflections upon the water, the changing lights on the vast wall of mountain to the eastward, and the shadows which gather in ravines and hollows, depth beyond depth of blue, each day a little earlier as the season advances. No doubt I should be more profitably employed. I have letters of introduction to people in the town which should have been presented before this, and instead of seeking out a language teacher I have been struggling alone and hopelessly with the intricacies of Icelandic grammar. But it is hard to forego this seclusion — the enjoyment of the exquisite sense of loneliness which is among the first and best rewards of traveling in a strange country. Thus far I have but three acquaintances in the whole of Iceland: my landlady, the postmaster, and the woman who keeps the tobacco shop at the end of the street.

From without, the hotel has the deserted appearance of a seaside inn at the close of the season. The blinds are drawn in all windows but mine, for there are no other guests, nor will there be others, my landlady says, before next summer. Travelers do not come to Iceland so late in the year, and since the war there have been very few even during the summer months. It is evident that I shall have the country to myself for purposes of winter exploration.

My landlady is a grave, silent woman. Although she has an ex-

cellent knowledge of English she rarely speaks except in reply to a question. At meal time when she has placed the food before me, she sits with her sewing by the window, so quietly that I can hear the click of the needle against her thimble, and am ashamed of the clatter I seem to be making with the dishes at my solitary meal. When I have finished, she dismisses me with a slight nod, and I pass through the empty *dagstofa* and up the stairway to my room as noiselessly as possible lest I should disturb — I scarcely know whom, or what.

The silence is not of the room only, or of the house, but of the street, the town, the land itself. I have been conscious of it from the day of my arrival in Iceland. It is like a presence — something one half expects to see as well as to feel and hear, if one may so speak. Sometimes when reading in my room, I stop in the midst of a paragraph to listen; or, during a solitary ramble I am aroused of a sudden by the croaking of a raven far out on the heath beyond the town, or the bleating of sheep on the mountainside across the fjord. I have heard these sounds elsewhere without remarking them particularly. Here they seem, somehow, to demand attention, and one measures the silence by them as one measures the immensity of a plain by the minute figure of a horseman crossing it.

What a trifling impression man has made on this great lonely land despite more than a thousand years of occupation! The reason for this is largely, of course, the nature of the land itself. Much of the interior is as barren of life, either brute or human, as it has always been. There, among the fastnesses of the glaciers, great rivers rise, flowing out of the very heart of solitude and emptying into lonely seas. Rivers "unknown to song," and some of them almost without history in the sense of man's relationship with them. The population even in the fertile valley lands has increased but slowly. Early in the tenth century, but sixty years after the first settlement of the country, there were fifty thousand inhabitants scattered around the coast and along the valleys leading away from it. Today there are but eighty-five thousand, and a fifth part of this number live in Reykjavik, the

capital. During past centuries famine and recurring pestilence have wrought great havoc, and in recent years many Icelanders have gone abroad in search of larger opportunities. There is no immigration; it may be said to have stopped at the close of the Viking period. Iceland has never had attraction, as a place to live, for men from more favored parts of the earth. So it remains, a land of silence and of vast empty spaces — such solitudes as were found by the handful of Celts who, it is believed, were the first to view them. Perhaps a thousand years hence it will still be so, and men who love the wild, rugged, more melancholy aspects of Nature will always find them here.

For it seems likely that if Iceland were destined to be developed, exploited in the manner of other countries — which I hope will not happen — the process would now be well under way, and this is not the case to any extent. Except for the introduction of more modern methods of fishing and the increased import of commodities from the outside world, life goes on very much as it did a century, two centuries ago. The land is still remote from the thought and the interest of the rest of the world, and altered scarcely at all by the industrial revolution of the past hundred years. Iceland spar is the only mineral resource of commercial interest, and the supply of this is said to be nearly exhausted. There is neither coal, iron ore nor timber. There are only a few small factories, no railroads — all overland travel is on horseback — and motorcars are happily conspicuous by their absence. I doubt that I have seen a dozen so far. There are no cities unless Reykjavik may be called one. Akureyri, the second largest town, has twenty-four hundred inhabitants. Away from the coasts there are no villages of any sort; only isolated farming communities separated from one another by great mountain walls, high tablelands, and vast stretches of desert country. One may travel from north to south or from east to west, when not following the customary trails, and cross the whole of Iceland without once passing a human habitation. Little did I dream when I first came here that I would find a country that meets so completely my idea of what a country should be: a land

having room and to spare for its small population, made up of
people of high intelligence, sturdy, freedom-loving, home-loving, the
very salt of the earth. I could live here with deep contentment for
the rest of my life. Perhaps some of my remote ancestors came from
Iceland, for I have found that the name Hall — pronounced *Hatll* —
is a fairly common one here.

On my journey northward from Reykjavik, with an Icelander for
my guide and companion, we followed the highway connecting the
south and the west country with the north. Although it is one of the
most frequently traveled routes in Iceland, it would be hard to find
anywhere a road which is less a highway in the modern sense. A few
miles beyond Reykjavik it becomes the roughest of cart-tracks; then,
for the most part, merely a pony trail leading over moorland and
mountain, across innumerable rivers and small streams, and along
valleys where, in many places, the trails have been worn through the
turf to the depths of the horses' flanks. Sometimes, after hours of
riding lonely ways, we came unexpectedly upon a valley, secluded,
silent, filled with mellow sunshine, with a river winding in various
channels through the meadowlands. The whistling call of the golden
plover seemed the green-gold of the valley made articulate, and the
faint honking of wild geese — the perfect voice of a lonely land —
told better than the eye how blue the mountains were, and how
solitary.

Dismounting from my pony to stretch my legs, I would sit for a
time with the whole of the valley outspread below. The turf-roofed
houses were scarcely to be seen against the meadowlands, and the
brighter green of the *tuns* — the home fields around them — were
like patches of velvet, at that distance scarcely broader than one's
thumbnail. I would try to fix the scene in mind, being sure that I
should not find another valley so beautiful as this; but there was
always another, and yet another, and for one that beckoned forward
there was one that called back. And at the threshold of each of them
the wind over the mountain-pass blew cold and keen, reminding one

how brief a time remained for the enjoyment of this late summer loveliness.

There is an element in the landscape here which satisfies more than the demand of the senses for beauty — a spiritual element, for lack of a better word. Perhaps I imagine this. It may be merely the clear cold outlines, the economy of Nature in her effects, the lack of trees and dense vegetation in such contrast to the overwhelming luxuriance of the vegetation on the high islands of the South Seas which I have left so recently. It may be that I was weary, without having realized it, of tropical color, and light and shade, and of man's never-ending struggle with tropical Nature. Here, too, there is struggle, but against frugality, not prodigality — the sort of contest that will always appeal most to men of Northern blood. And, in Iceland, the blood of the people is still the old Norse blood, unmixed with other strains since the Celtic fusion made during the ninth and tenth centuries; and their speech is nearly that of a thousand years ago.

What a sense of continuity in the national life the modern Icelander must have! What a sense of nearness to the men and women of the heroic period in his country's history! That they do have it even the most superficial observation makes plain. The farms are still called by the names given them a thousand years ago — pleasant homely names, and rich with the accumulated associations of centuries: Hjardarholt, Herdholt, Hlidarendi, Reykholt, Oddi, Miklibaer, Olafsvellir — there is music in them even to a stranger's ears. One can understand their appeal to Icelanders to whom they are so much more than mere names.

The ancient literature of the country is still universally loved and read. At every farmhouse where we stopped for afternoon coffee or to spend the night, I was sure to find in the *badstofa* two or three shelves of well-thumbed books, for the most part, the older sagas: *Njala, The Laxdaela, Egil Skallagrim's Saga, The Grettir, The Erebiggja Saga,* and many others I did not know even by name. And so little has the old speech altered that children read these tales

today, almost as they were written down in the twelfth and thirteenth centuries; as they were told, by word of mouth, in the great halls on winter nights at a yet earlier period. There is no need for the lexicons and explanatory texts which make the reading of ancient lore so tedious a task for the children of other lands.

It is hard to realize that more than forty generations of men have lived and died since these farms were first occupied, for there has been little change. The old halls have gone, of course, but if its earliest inhabitants could return to Iceland now, they would find the meadows which they mowed still meadowland, and the streams where they fished and bathed on summer evenings still running clear sweet water. They would recognize superficial details of the landscape which in most countries are obliterated or completely altered in a decade. How pleased the men and women of Viking days would be could they look down, as I have during this journey, over the places where they spent their lives! It would sadden them, doubtless, to find that the land itself, for all its changelessness, has no memory of them, no more than of the birds which flew across the moorlands a thousand years ago. But no, this is not quite true. Some faint memory remains: a fragment of wall here and there, the barely discernible outline of a temple site, or a depression in the ground marking the spot where a booth once stood, and trading was done when the ships had returned from Norway or the coasts of Britain. But the snows of centuries have fallen on these places, and winds and rains have filled and leveled, so that a stranger, unless they were pointed out, would hardly have suspected the faint outlines or the few scattered boulders to be evidence of the work of human hands.

Mine was not wholly, or even for the most part, a fair-weather journey. The valleys were not always filled with mellow sunshine. Often they were overhung with clouds which seemed only less solid than the mountain walls themselves. Sometimes a cold mist descended, followed by a long-continued downpour of rain. Then, in

all truth, we seemed to be passing through an empty land, or one inhabited only by ghosts uttering forlorn, foreboding cries with the voice of the raven. When the rain lifted and the gloom lightened a little, solitary figures could be seen here and there, bent toward the earth, walking slowly, swinging their arms across their bodies in curious fashion. I could only imagine them to be what they were: Iceland farmers mowing the last of the precious hay crop. The eye pictured them quite differently. Dwarfed by distance, grotesqued by the mist, they seemed misshapen earth-spirits going about some business which had no concern with humankind. Upon passing one close to the trail, it was always something of a shock to see him straighten up, to observe the friendly welcome in his smile as he exchanged greetings with my guide and traveling companion. For I had read much of Icelandic melancholy, and on those dark days I expected to see evidences of it in the people we met. But if I may judge, after so brief an acquaintanceship with them, Icelanders are quite as cheerful as people in other lands. Certainly they seem far less dependent upon sunshine for healthiness of spirits. Those who have written so much of Icelandic melancholy have, I believe, allowed the character of climate and country and their own sober thoughts while traveling these solitary ways, to color their conception of the people.

But it would be easy to convince one's self that melancholy must be a predominant characteristic of the Icelanders. They are of Norse-Celtic blood. They are thinly scattered over a lonely Northern land surrounded by a gray Northern sea. Both land and sea give them ample evidence of the mindless indifference of Nature to human concerns. As for the farmers, whether living inland or along the coast, their lives are very lonely, and they have few distractions save those they are able to devise for themselves. Their summers are brief and cold; the winters long and dark, and for all their labor they gain what most men would consider a meager livelihood. In the face of all this, how can they be otherwise than sober, silent, morose in character? So I wondered, often, while sitting in the *badstofa* of some

isolated farmhouse, listening to the wind sweeping across the moor-lands, and the rain beating against the small windowpanes.

Silent many of them are, in fact, and their hospitality is of the least obtrusive kind. Indeed, I sometimes thought it too unobtrusive. I came almost to dread the polite *"Gerid svo vel"* (If you please) with which, at the end of a day's journey, I was ushered into the guest room; but it came as inevitably as night and the door was shut as discreetly behind me. Then I would hear the muffled sound of retreating footsteps in the long dark passageway leading to the family quarters; then, faintly, the sound of another closed door; then silence, a solid block of it, enclosed by the walls of the empty room — empty save for my presence, silent save for the loud ticking of the clock.

Before reaching the end of my journey I realized that my privacy was really evidence of the most thoughtful courtesy. I am a stranger in a land where, except in a few of the seacoast towns and villages, there are neither inns nor hotels. When traveling it is necessary to stop at farmhouses, where entertainment is always willingly provided. But since I am both a stranger and a guest, my host for the night quite naturally assumes that I would like the same seclusion at his house that I should want at an inn. Furthermore, thus far I know little or nothing of the language, and what could be more embarrassing than for two men, in the relationship of host and guest, to sit in silence, face to face, throughout a long evening?

There is yet another reason why my hosts and their families were rarely to be seen. The summer was far advanced, and nearly every man, woman, and child who could be spared for the work — and nearly all could be spared — were in the fields from early dawn until the last light had left the sky. In summer when the weather is at all favorable, it is not unusual for farmers to work at their haymaking from twelve to fourteen hours a day. I was often in bed before my host for the night had returned from the fields. Some writers have called the Icelanders lazy. Sabine Baring-Gould, writing of them in

1863, says: "In character the Icelander is phlegmatic, conservative to a fault, and desperately indolent." If the Icelanders I have seen are as desperately indolent as those of 1863, then it would have been a pleasure indeed to have seen some of Baring-Gould's industrious Englishmen.

I had ample leisure during rainy evenings in the guest room for a careful examination of its furnishings, beginning with the library, passing then to the colored lithographs on the walls, the old painted chests for bed and table linen, and the family photographs on the chest of drawers. These, each one in a wooden frame, were arranged in rows. I enjoyed their silent companionship and talked with them in the universal, soundless language which all portraits understand. There were grave faces and gay; fair-haired, blue-eyed girls of the finest type of Northern loveliness; young men with strong faces, deep-set eyes, and well-knit bodies which their homely ill-cut clothing could not conceal; fathers and mothers in the midst of healthy broods of children; grandmothers with broad brows and ample bosoms, their white hair braided and looped up under their tasseled black-velvet caps; grandfathers, hale old men; uncles, aunts, cousins — and all of this silent company with the heritage of good blood and the history of their simple, wholesome way of living written plain on their faces. I examined many such groups of family portraits, and I do not remember seeing one crafty-looking face, or one I should not like to meet in the flesh.

Then I would walk up and down the guest room, thinking of these people whom I hoped, eventually, to know more intimately, wondering how they had managed to live so homogeneously during all these centuries, and to escape, in these latter days, so many of the doubtful blessings of modern civilization. Climate, the character of the country and its geographical position were, doubtless, largely responsible, but there seemed to be more to the matter than this. Baring-Gould was right, apparently, in speaking of their conservatism. They are skeptical of change and live as their fathers and grandfathers

had lived before them. With the exception of the cream separator, I saw, during the whole of my journey across the country, none of the innumerable mechanisms and conveniences of the modern household considered indispensible with us: no radio outfits, no Sunday newspapers, no good roads, filled, bumper to bumper, with motorcars, not even motion-picture theaters except in a few of the larger towns. I can't say that I missed any of these things, but I did miss artificial heat. It struck me that simplicity in this respect might have been carried a little too far.

There was never a fire in the guest room, and, usually, no stove where there might have been one. "What!" someone may ask; "would you have a fire in the summertime?" Gentlest of readers, the solitudes of interstellar space would scarcely seem colder, I think, than the *badstofa* of an Iceland farmhouse on a rainy August evening. It would not have occurred to my hosts that I was cold. They have no fires during the summer except in the kitchen at mealtime, and they would think it strange that I should feel the need of one. Men still fairly young can remember the time when there was scarcely a farmhouse in Iceland provided with stoves for heating purposes, and even today many are without them. In the country, peat or dried sheep's dung is burned when anything is burned, and then, often, solely for preparing food. Icelanders are a hardy folk, almost as hardy as their ponies, many of which live out of doors all winter without shelters of any sort.

I was a little ashamed of my desire, of my need, for artificial heat during evenings which are here considered warm and comfortable; and I thought of the thousands of Americans who would have felt the cold as keenly, many of them more keenly. I believe it is steam heat, central heating of all kinds, that has brought us to this pass. The Icelander's immunity to cold has made me realize how much of old-fashioned hardihood we body-pampering Americans have lost in the past few generations.

But the hour grows late. The empty hotel creaks and complains

under the buffeting of the wind. Never, before coming to Iceland, have I known what the north wind, fully aroused, can be. It seems fluid ice, and sweeps over the ramparts of this coast with scarcely an eddy, like water flowing over a pebble. From high overhead comes a tumult of lonely voices. All the spirits of the North have returned from the Underworld, and, crying and calling to one another, hurry along the upper surface of this mighty torrent of air as over a solid viewless pavement.

The sudden shifts and contrasts in the climate of Iceland are astonishing. This morning, although autumn is now well advanced, was like a day of Indian summer at home, without a breath of air stirring. My landlady was sitting by the window as I passed through the *bagstofa* on my way to the street. She replied to my greeting in Icelandic and the most important word I did not understand.

"You will have to translate, as usual," I replied, a little ruefully. "I'm afraid I haven't made much progress in my Icelandic studies this week, but I am on my way now to see Mr. Thorsteinson."

"I am glad," she replied, gravely. "You really should make a serious effort to learn what you can of our speech since you are to be here all winter. What I said was: It is very calm this morning."

" '*Dunalogn*' — does that mean 'calm'?"

"Something more than calm. How shall I say it? — so calm that the plucked down of the eider duck would not stir in the air."

I shall always be grateful for that chance remark. There was magic in it, and I saw with the senses of the spirit how still it was, and how beautiful the little town could be on such a day. The street was empty and the shops closed, as always on Monday morning until nearly midday. Shops and houses looked very small, like those in a toy-shop window waiting for some child to set the inhabitants about their picturesque affairs. Far down the fjord a fisherman leaned over the side of his dory in an attitude of dreamy content, and the dory hung in the air, or so it seemed, for not a ripple disturbed the surface of the water and a luminous haze concealed the mountains, giving the im-

pression that one was looking over an immeasurable sea of golden light. Two ravens, looking blacker than their wont, were flying westward like long lost remnants of the night which the sun had shattered and dispersed. I watched until they, too, melted into pure sunlight, and *dunalogn* sounded in the air like the music of a bell which has just ceased to ring.

I walked on, thinking of the beauty of this and other Icelandic words, and when I next thought of their grammatical constructions and conjugations I was well beyond the town. It seemed foolish to return, then, for my language lesson with Mr. Thorsteinson — all but criminal to waste such weather indoors, so I went on until I came to a sheltered hollow high among the hills overlooking the valley and the entire length of Eyjafjordur. There I spent the rest of this brief day rereading *The Story of Burnt Njal* — or the *Njala,* as the Icelanders call it — in the Dasent translation. Never, surely, has the art of storytelling, in subsequent centuries, reached the perfection attained by the Icelanders before the invention of printing. Leaving aside the long genealogical lists, so important to the early Icelanders, but rather tedious to a modern reader, I have never found anything to compare with them. And what finer example of this art without art than *The Story of Burnt Njal?* I read it for the first time in the midst of the scenes where the events took place. All of the ancient Icelandic sagas, and this one in particular, spoil one for the reading of contemporary tales. The people "come alive" of themselves by what they say and do; one is completely unconscious of any narrator. And, in the *Njal* Saga, when the reader comes to chapters 127 and 128, which tell of the burning of Njal, his wife and his sons, at Bergthorsknoll, by Flosi and his band of one hundred twenty men, he will recognize, I think, that perfection in the art of storytelling was reached a millennium ago, centuries before there was any talk, in the Western world, at least, of its being an art. I believe the best possible training for a young man who wishes to learn how to write would be for him to read the Icelandic sagas, preferably in Iceland where the events of

them took place. He will learn more from them of the art of story-telling than from all the manuals and textbooks that have ever been written on the subject. But there is danger in it, too, for, as he reads, he looks upward at "the hopeless snows" of perfection which he knows he will never be able even to approach, to say nothing of attaining them.

As I returned to Akureyri that evening the sky gathered to itself fold after fold of filmy cloud that seemed to come from nowhere. The first stars shone dimly through, but before I was halfway back to town snow began to fall — the first snowfall of the autumn on the lowlands: small damp flakes, and still not a breath of air to blow them slantwise. They came faster and faster, whitening the ground, covering it to the depth of an inch or two; then the last diaphanous veil of snowy dew floated gently down, all tattered at the edges. It was a glorious sight to see the peaks of the mountains emerge through the rents of it, still faintly flushed by the afterglow and clearly outlined against the sky.

I descended the moorlands to the road leading to Akureyri from the north. Dusk deepened into night before I reached the crest of the hill above the town. From there I looked down upon a surprising transformation. Every house in the village was ablaze with light; not a window-square but patterned itself upon the snow. I remembered, then, that this was the evening for the opening of the hydroelectric station. There had been talk of it for days. My landlady, the barber, the bookseller, the postmaster — everyone, in the course of every conversation, was sure to say: "But when we have the new lights . . ." and I had not realized what this would mean to dwellers so close to the Arctic Circle. Heretofore the town had been very dark at night, for kerosene which must be transported so far is expensive and oil lamps frugally used. Now, it was plain, everyone could share in a universal alms of light, the gracious gift of a stream of water flowing down the mountains. I called at the tobacco shop which was flooded

with light. The old woman who runs it was almost garrulous in her excitement.

"To think," she said, "that we have lived so darkly all these years of winter nights! You see? one has only to turn this button," and she showed me how it worked.

All the children in town were gathered before the hardware store where lighted chandeliers of many varieties were displayed for sale. Fathers and mothers walked back and forth in front of their houses seeming to doubt them their own. The dim oil damp that had hung in the bookshop window had been replaced by one that made the titles of the volumes displayed there clearly legible. Beside those in Icelandic — history, biography, poetry — there was a copy of *Saxo Grammaticus*, a German *Social and Industrial History*, an *Esperanto Grammar*, Dickens' *Bleak House*, in Danish, several of Robert Louis Stevenson's novels, likewise in Danish; and, in English, a *History of the Reformation*, an edition of Swinburne's *Poems*, and Francis Bacon's *Essays, Civill and Morall*. A very catholic display, it seemed to me, for a little town on the north coast of Iceland, and these were only the books in the window. The volume of Bacon's *Essays* was just right for the pocket, so I bought it, never having before read all of his essays. As I glanced through it I came upon the following passage in the essay, "Of Travel":

> If you will have a young man to put his travel into a little room, and in a short time to gather much, this you must do: . . . let him not stay long in one city or town, more or less as the place deserveth, but not long; nay, when he stayeth in one city or town, let him change his lodging from one end and part of the town to another, which is a great adamant of acquaintance; let him sequester himself from the company of his countrymen, and diet in such places where there is good company of the nation where he travelleth. Let him, upon his removes from one place to another, procure recommendation to some person of quality residing in the place whither he removeth, that he

may use his favour in those things he desireth to see or know. Thus he may abridge his travel with much profit.

The essay is full of sound advice, as pertinent to the traveler of to-day, in Iceland, as it was to the youth of the sixteenth century whom Bacon had in mind. It seemed to be urging me to proceed with my own travels, and, in fancy, I am already embarked, watching, across a space of gray wild water, the desolate headlands of this rugged coast moving slowly past.

xxv. Departure for Spain

THE MEMORY of the journey is already sorted with those pieces of life, zestfully lived, which one lays aside, so to speak with such assurance of their value as memories. Thirty years from now I believe I shall be able to recall the whole of it down to the last detail. If, at the end of this lapse of time, I were to be asked: "What happened on the evening of the tenth of December in the year 1922?" I believe that I would be able to forget my gout or rheumatism, or whatever ailment I shall then be afflicted with, and find myself once more at Akureyri on the north coast of Iceland. I remember that I was late for supper that evening, having had a long session with Mr. Thorsteinson, my language teacher, and upon my return to the hotel I found my landlady setting the table for her one guest. There was yellow cream for the *skyr* — a dish made of the smoothly-beaten curds of milk. I was reminded of the mush-and-milk suppers of boyhood.

"I was hoping there would be *skyr*," I said, as she placed a large bowl of it by the side of my plate; adding — which was the barest truth — "I don't believe a more delicious dish could be found anywhere in the world."

"I am glad you like it," she replied. Then, taking up her sewing, she sat at the opposite end of the table to wait until I should finish. We had no further speech for some time, but at length when the dishes had been cleared away and I had my map of Iceland spread out on the table, she said: "Would you mind going elsewhere to

live as soon as it can be arranged? You see, it doesn't pay me to cater for one, and I should like to close the hotel for the winter. But no doubt you will be glad to go? You must find it very lonely here with no one about?"

"Not in the least," I replied. Solitary meditation — is not this one of man's chief pleasures? And what time or place more suited to its indulgence than early winter, in a deserted hotel on the north coast of Iceland? But one may be solitary enough wherever one goes in this sparsely-populated land and I felt that I had already remained long enough in Akureyri. Therefore, I said that I would move at once, of course, or as soon as an opportunity offered for going elsewhere.

Not half an hour later, while I was still studying my Iceland map, I heard a whistle, the whistle of a steamer.

Were I the patron saint of wanderers, events would always happen in this opportune fashion. There would always be, for those who wished it, a door to open at night upon a great fjord, or bay, and a whistle to be heard when the mood was ripest for remaining "not . . . long in one city or town, more or less as the place deserveth, but not long," as Bacon says in his essay, "Of Travel." It would be a far distant whistle when first heard, translating into sound one's desire for new faces, other scenes; one's joy at the prospect of departure. And there would be sheer headlands and smooth mountain walls rising from the fjord, like those at Akureyri, to multiply the echoes, and deep valleys to lead them away and away until they became fainter than imagined sound. What, I wonder, did travelers do in the old days without steam whistles?

Judging by the remoteness of this one, the steamer would not be at the wharf for some time, so I made leisurely preparations, wondering what vessel it could be. But whether bound eastward or westward she would of necessity go around the north coast, and I would leave her at some village huddled under the Arctic Circle, remaining there until the desire to move on again met with the opportunity.

My landlady was still at her sewing when I came downstairs half an hour later.

"Do you really mean to go?" she asked. "I hope what I said this evening has not . . ."

"Oh, no," I replied. "I'm not rushing off on that account. I've been waiting for an opportunity to travel around the coast."

Then it occurred to me that I was counting rather confidently on this being an opportunity. Having said good-by, I hurried to the wharf.

The steamer was already there; she was a cargo ship of about two thousand tons. No gangplank had been lowered; only a rope ladder over the side, evidence that she was not going to remain long. I went aboard in search of the captain and found him at supper in his cabin. Although I had but recently enjoyed my own supper, the sight of fried eggs and strips of crisp browned bacon made me hungry again. These delicacies are rare in Iceland. There are no pigs, or very few, and chickens lead a sort of discouraged, indoors existence uncongenial to egg-laying. The captain was a thickset man of forty-five or thereabout, plainly an Englishman, and quite as plainly, I thought, not the type of captain accustomed to granting favors to strangers. He regarded me with an air of rather cold appraisement over the rim of his teacup.

"Yes?" he said.

"I was wondering whether you would be willing to take me as passenger?" I began, and without waiting for a reply, became eloquent of the modesty of my requirements in that capacity. I was willing to be stowed away anywhere: on an old sofa, a mattress on the floor, a bunk forward. I was used to these makeshift accommodations, and knew of course that cargo ships were not . . .

He interrupted me. "All right, all right. I'll take you. The steward can make up a berth in the saloon — unless you prefer sleeping forward?" he added, with a faint smile. I assured him that I did not insist upon that.

"Right," he added brusquely. "I don't wonder that you want to leave Iceland. Br-r-r! I've been three weeks taking in cargo around this coast. Hope the Spaniards enjoy their salt cod. There's been trouble enough loading some of it."

"Spaniards! You're not going to Spain, are you?"

"Yes. Where did you think? Don't you want to go to Spain?"

I was silent for a moment. It was a disillusioning question; for, in Iceland, I was beginning to regain our forefathers' sense of the vastness of the world. Traveling on foot, on horseback through this lonely, still inviolate land, measuring it by day journeys over the most primitive of trails, I was coming to think of space as the ancients thought of it. I had forgotten, temporarily at least, that it has now dwindled to the easy measure of man's little ambulatory mechanical contrivances. Oh, the old days, when to cross a province was the event of a lifetime! When the seas were walls months high, years high, repelling all but the adventurous, the persevering! Now that they have been leveled, where is the pleasure any more in making a far journey? Desert solitude has been pricked in a thousand places by the chattering of tourists. There is a honking of motors in the streets of ancient cities, and a clicking of camera shutters in the tombs of ancient kings. What delight can there be in travel now that modern magic has exorcised blue distance?

I did not, of course, give voice to these reflections. They merely passed through my mind, aroused by the captain's "Don't you want to go to Spain?" as though it were only around the corner.

My reply was: "I had not thought of going so far just now but there is no reason why I shouldn't. I would like to see Spain."

"After all," I thought, "a mechanical age has compensations for its children, who may go where they will, to the ends of the earth, at a moment's notice. They may dine on *skyr* in Iceland of a Monday, and toss the pits of Spanish olives into the Mediterranean by Tuesday-week. And what an opportunity to make at least a superficial comparison of these ancient civilizations! Despite modern facilities for

travel I might never have such another. The best of it was that the steamer was to return to Iceland, with salt, in three months' time, and when I asked the captain whether I might return with her he said, "I see nothing to prevent it if you are as easily satisfied with accommodations as you say." And so my decision was made.

The weather changed before we were halfway up the fjord. Wind, the implacable foe of man and beast in Iceland and rarely long at rest, was gathering its forces again. It increased to half a gale by the time we had reached the open sea, driving before it a fine dry snow that stung the face like steel filings. The course was laid, north-northeast, and we pushed our way slowly out into a night as black, as full of the menace of blackness, as any that I remember. I was on the bridge with the captain.

"Go far out — night like this," he half shouted in my ear. "Only few small lights — this coast. Not worth much."

There was not enough heat in them, he said, to melt the snow off the glass casings. We picked up the light on the point beyond Siglufjördur. It seemed to be feebly warning us off that desolate headland. Soon it vanished as though it had never been. Every sea drenched the bridge with icy spray, and the propeller raced and pounded as we wallowed over the crests of them. But when I came on deck the following morning the wind had subsided. We were steaming southward again under a cloudless sky, and far in the distance were the snow-covered mountains, a glorious sight in the red winter dawn.

Later, at breakfast, the captain said: "Well, I've some bad news, a wireless message. One more stop to make in Iceland before laying a course for Spain."

It was not bad news for me. I was conscious of a feeling of great relief, having regretted my hasty decision to leave Iceland almost from the moment of the departure. Winter is the time to see this country, and I could not imagine anything that Spain might have to offer to compensate for the loss of the lonely rugged beauty of the North.

As I stood by the rail watching the coastline open out, a mighty influence made itself felt: the very spirit of the land compounded of all its desolation, all its majesty.

Early in the afternoon we entered a fjord with mountains of gable-end formation on either side, symmetrical, gigantic, like fortresses of the old Norse gods. Having passed between and back of them beyond view of the sea, we came to water so calm that the shoulders of the mountains were reflected in it as in a mirror of steel. Here they were snow-covered from base to summit, and not a tree, not a shrub anywhere to blur the purity of outline. The peaks of those still in sunlight glowed like live embers, and the shadows in the hollows of the lower slopes, blue deepening to purple, seemed as solid, as palpable as ice. Presently we came to a place where the mountain walls, bare of snow, fell almost sheer to the level of the fjord. I was standing in the bow with the first officer.

"Give a hail," he said, "and see what happens."

I shouted, "Hello!" and the response came from either side, again and again. An invisible host seemed to be giving us welcome, but hurrying off at our approach to the farthermost recesses of the land, until the shouting died away in an etherealized cry of half-mournful ecstasy. A thrill of delight went through me. For a moment I was a boy again, at that period of boyhood when one is pure earth-spirit, a frequenter of secret places where greetings of this kind are exchanged with one's unseen kindred among the hills.

"I've been here before," said the first officer. "It's one of the prettiest fjords in Iceland in the summertime. All those rocks are alive with birds, and the lower slopes of the mountains are as green as the hills of Ireland. You should see it then."

But I was quite content with its winter beauty, and a flock of ducks flying close to their slaty reflections in the water gave to the scene the one touch of life needed to make it perfect.

The village, like many another coastal settlement in Iceland, followed the curve of the fjord, with a second street extending a little

way up a steep valley toward the tableland beyond. As we approached, I became aware of those crosscurrents of emotion which come to the traveler from every side the moment land is reached and the land itself hidden, in a sense, by houses and the pigmy figures of one's kind. We are confined within the limits of our humanity, and although at moments, gazing from afar at a continent, we seem to become as large as Nature, we are not long able to maintain that point of view. Seen close at hand, against the snowy background, the village had a forlorn appearance. Some of the houses were of corrugated iron, others of rough concrete, crude boxlike dwellings, shelters from the elements and nothing more. Yet they did not seem to be out of keeping with the landscape. One might think, viewing the scattered towns and villages of Iceland, that it had been peopled no longer than fifty years ago. There is reason for the rough pioneer aspect of many of the settlements. Iceland is rich in spiritual values alone. Century after century its people have toiled for a bare livelihood against climatic and geographical conditions that would have discouraged a less hardy, less vigorous race. So, wherever one goes, one finds little outward evidence of the antiquity of their civilization.

The wharf had been cleared of snow and a great pile of salt codfish was stacked there, ready to be loaded. The first officer measured it with his eye.

"About seventy-five tons," he said. "We'll have that under hatches in no time, and we couldn't take a kilo more, not even to please the King of Spain himself."

He was jubilant at the prospect of an early departure; so too were the second officer, the cook, the captain's steward, the men at the donkey engines. Everyone seemed to feel the call of Spain from afar, and I was conscious of a twinge of regret, thinking of the opportunity about to be forgone. Life is short, and the Stream of Travel, with its numerous tributaries, is, indeed, full of delightful possibilities for exploration. I stood at the rail, lost in reverie. The work of loading went forward so rapidly that it was nearly finished by the time I re-

turned to consciousness of the present moment. Shouldering my knapsack, I prepared to leave the ship. The captain was pacing the bridge.

"Good-by, good-by," he said, brusquely. "You mean to say that you are as footloose as all this — go to Spain, stay in Iceland, do as you please, offhand, this way?"

It was one of the advantages, I said, of being an itinerant journalist.

"Hmmmm! Well, you'd better be getting ashore. We'll be off in a few minutes. Hope you enjoy yourself."

It was then half past two. Dusk was gathering in the valley, but a clear cold light was still reflected from the tops of the mountains. I walked slowly along the village street, stopping now and then to read the signs over the doorways of the shops: *Logmannshlid* — the lawyer's house; *Skosmidur* — shoemaker; *Bakarabud* — the baker's booth. I felt a slight thrill of pride at my virtuosity in translation, but this subsided as I passed the *Husflidsarabeida* and the *Heimlislidnadarutsala*. There was no hotel but I found a kind of boardinghouse. Having left my knapsack there, I turned into the street leading up the valley and was soon beyond the town. The road became a footpath mounting in zigzag fashion. After a hard climb I reached a shelf of land I had observed from below. From that height one might have had, by day, a magnificent view of the fjord, but by now it was quite dark and I could only guess at the prospect beneath me. The descent was more difficult and I made slow work of it. I was passing the cemetery, about a half mile beyond the town, when I saw a weird flash of light on the snow, and looking upward I understood the cause. That spot is forever memorable to me, for it was there, not a quarter of an hour later, that I saw for the first time the full splendor of the Northern Lights.

There had been promise of this splendor on former nights throughout the autumn and early winter, but nothing before to compare with the visible music that I now saw. This was not light as we dwellers of the lower latitudes think of it. It was light translated, spiritualized, the blown dust of stars swept from the floor of the Milky Way by

the wind between the worlds and carried along the cloudless sky in shafts and streamers of glory. Again as I watched it was easy to imagine that the profound blackness of space was itself an unfathomable sea of light, invisible till whipped by this wind into waves crested with color: old rose, amethyst, pale yellow, apple green, subsiding slowly only to gather greater height, or to be dashed high and far in silvery spume against some dead world drifting viewless there.

I don't know how long I might have remained thus, staring into the sky, forgetting time and place. It chanced that I was brought back to earth by the sound of a whistle, very faint, from far down the fjord. I turned my eyes in that direction but could see nothing. My steamer for Spain had vanished, as irrevocably as the castles one builds for one's self in that fabulous land.

xxvi. The Aina Paré

I RETURNED from Iceland in the early summer of 1923, stopping in Boston to see my old friends there. When Mr. Sedgwick inquired about the book for Harper's I was obliged to tell him that I had not finished it. He was concerned about this, but he could not even have guessed how ashamed I was at having to make such a confession. "You should have stayed in Iceland until the book was completed," he said. "Didn't you like the country?" I told him that that was my trouble: I loved Iceland so deeply that nothing I had written about it seemed worthy of it. "Why not sit down here in Boston and finish it?" he then asked. But I had already planned to return to Tahiti and had my ticket bought from San Francisco. Mr. Sedgwick sat back in his chair, regarding me in a manner that made me feel even more forlorn. "I'm afraid," he said, "that when I helped you and Nordhoff to go to the South Seas by putting you in touch with Harper's I did you a bad turn instead of the good one I hoped it would be. If you fellows settle down in Tahiti to a life of *dolce far niente* I will never forgive myself."

"Oh, you needn't worry about that," I replied. "We both love the island but we don't expect to become a pair of beachcombers."

"Will you finish the Iceland book?"

"I can't absolutely promise it," I said, "but I will do my very best."

And so I did. I never agonized more over any piece of writing, but the book was not finished. I deeply regretted this failure. In my opinion, a writer should never leave a piece of work unfinished unless

convinced that it is worthless. I didn't feel so about the Iceland articles; it was only that they came so far below my hopes for them. There was too much J.N.H. in them, as in nearly everything I write. It was as though my personal feelings about Iceland were more important than the country itself.

Upon arriving at Papeete I again took lodgings at the Aina Paré, the little hotel on the waterfront where Nordhoff and I had lived upon first coming to the island; I made it my headquarters until 1925 when I married Sarah Winchester, and, at last, had a home of my own.

The "Aina Paré" means "Paré's Retreat," and the Paré who retreated there, owner and proprietor of the hotel, was the only son of Lovaina Gooding, who, until her death in the great influenza epidemic of 1918, which destroyed 20 per cent of Tahiti's population, had been proprietress of the Hotel Tiare. Lovaina was famous throughout the Pacific, from San Francisco to Shanghai, to Tokyo, to Singapore, to Sydney, to Auckland and Wellington, New Zealand; and her son, Paré, was fully as much a character as his mother. Although he was always short of money he never seemed to care whether he had guests or not; and even when he might have had them he sometimes turned them away because he didn't like their looks, at first glance. I heard him say, on more than one occasion, to a prospective guest: "I'm sorry, but I have no rooms vacant," even though he might have half a dozen ready and waiting for guests.

He was in his late twenties when I first knew him. His brown hair was fast thinning out, and his belly adding contour to contour so that rolls of fat overlapped his waist-cloth which was his usual wear at home. He had a high feminine voice, and his laugh was a kind of giggle rising in pitch until almost beyond the range of hearing. His mother tongue was Tahitian, but he spoke French well and English after a fashion.

The Aina Paré was not what would be called a first-class hotel, but Nordhoff and I thought it was just what it should be for Tahiti.

The old brass beds were lumpy and the mosquito nets around them were masses of puckers where the holes in them had been mended. The other bedroom furniture consisted of washstands equipped with china bowls and pitchers dating back to the seventies and eighties of the last century, with tin buckets, for slops, beside them. There were a few well-worn chairs and sofas upholstered in faded red and green plush belonging to the same era. He had inherited them from his mother together with some paintings in tarnished gilt frames in the romantic style of the last century: "The Stag at Eve," "The Vicar's Garden Party," "The Tryst at Twilight," and the like. The hotel was a two-story building with verandas on both floors, and so riddled with termites that little more than the paint was holding it together. Many a time when going gingerly up or down the stairway I expected the hotel to collapse gently, and to find myself half buried in a heap of wood dust on the ground floor.

The great attraction of the hotel was the view from the upstairs veranda, overlooking the lagoon and the open sea beyond, with the island of Moorea in the background at a distance of twelve miles. I would not venture to say how many hours, and days, and weeks I have spent, all told, merely looking at that glorious panorama of lagoon and sea and sky, with the mountains of Moorea in the distance, so beautiful at any time of day, and particularly so early in the morning, or at evening when the sun had just vanished behind the mountains. Moorea is all that a South Sea island should be, and it surpasses my most splendid dreams of one, as a boy.

I remember the day when Nordhoff and I first took lodgings at the Aina Paré. We had two rooms opening on the upstairs veranda, and were no sooner in them, not yet unpacked, when there came a discreet knock at the door. One of Paré's maids was standing outside. With a giggle something like that of her boss, she handed me a note written in pencil on the back of an old bill. Paré was just downstairs and might easily have communicated with us in person, but he would never do this when he had a small favor to ask. Many a note

of the kind he sent us in the course of the following years. I still have a number of them. This first one, written in a scrawly, schoolboy hand, without punctuation, read:

> Mr. Nordhoff and Mr. Hall gentlemen would it trouble you to let me have your first weeks lodging in advance as I am a little short of cash just now I have some unexpected bills to pay on Monday I have only two other guests at present and I like your faces better than theirs which I hope you will see I am paying you a complement and you will greatly oblige
>
> PARÉ GOODING *Prop.*

Nordhoff and I were flattered that Paré liked our faces better than those of his two other guests, and so, of course, we were happy to accommodate him. Let me give one other letter — we received dozens of them during our various sojourns at the Aina Paré. It was received on the very day, in 1929, when we started writing *Mutiny on the Bounty*. Although we were married and had homes of our own at this time, we had decided to work at the hotel for convenience sake, as it was, roughly, midway between them.

> Dear Hall and Nordhoff sorry to trouble you and forgive this hasty note as I happen to be going to a wedding party tomorrow at Papenoo and you know what they are all gone dry before the party is over so I would like to have two or three bottles of rum to take with me and as I am short of cash just now and longing to have something today I implore you to be good enough to let me have 300 francs if you can spare it you know rum has gone up in price lately and I will pay you back as soon as I can do kindly give bearer the money and if you can't let me have 300 francs 100 will do I would be so much obliged to you to render me this humble request and thank you a thousand times.
>
> PARÉ

But it would be unfair to speak of our small favors to Paré without mentioning the returns he made for them. He had a small back

kitchen separate from the hotel proper and connected with the back veranda by a ruinous bridge of boards. It was about the size of the old Hall-family woodshed where I began my literary career, but much more dilapidated. The floor was half planking, half earth, the latter part containing his *himaa*, the earth oven where all native foods were prepared. No one, seeing this kitchen, could guess the delicious nature of the food prepared there under Paré's expert supervision. No meals, with the exception of morning coffee, were served at the hotel, but when Paré invited a few of his friends to a *déjeuner* in the kitchen, it was an event to be looked forward to, thoroughly enjoyed, and long remembered. How he managed to prepare such superb meals in that tumbledown shack, which looked like an abandoned chickenhouse, except that fowls still roosted there, I could never understand. He had only a few battered pots and pans, and his tableware consisted of old cracked plates, vegetable dishes and the like. But the food! It was, in all truth, something to remember. Paré would start his preparations the night before; the meal itself would begin at ten thirty in the morning and end at about three in the afternoon. To say *"Paia maitai"* — I have eaten well — at the close of such a feast was to say nothing at all. These meals were always at his own expense; never did he borrow so much as a one-franc piece when he was host.

I remember how, on the night of my return from Iceland, I went to the kitchen in the darkness for a glass — there was none in my room — and nearly broke my leg because of a broken board in the bridge mentioned above. I spoke to Paré about this the following morning, and he replied: "Why, don't you remember that hole?" with an air of both surprise and reproach. I realized, then, that the fault was not his for not having the place repaired, but mine for not having remembered, during nearly a year's absence, that the hole was there.

One of the most interesting pieces of furniture at the Aina Paré was the hotel register which had formerly been his mother's at the Hotel Tiare. It dated back to the eighties, but Paré wouldn't have

any other as long as there were still blank pages at the back. It was, indeed, a fascinating roster of the names of people, some of them very famous, who had passed through Tahiti in the course of forty years. Paul Gauguin's name had once been in it, but some autograph collector had cut that out, as well as the signature of Rupert Brooke who had visited Tahiti early in 1914, only six years before Nordhoff and I arrived. At this time I was reading an edition of Brooke's *Collected Poems,* and was deeply interested to learn that "The Great Lover" had been written on Tahiti, in the country district of Mataiea, where he had spent most of his time while here. Not long after my first reading of it, when I myself was in a homesick mood, I decided to follow Brooke's example by setting down, in verse, a list of things, sights, sounds, smells, and the like, that I had cherished since boyhood. As these would be purely derivative verses, I decided that I might derive some inspiration from Brooke by looking at his handwriting in the hotel register; for, although his signature was gone, the date, in his own hand, of his arrival at Tahiti, was still there. So I asked Paré to send the register up to me.

The following day while I was at work Paré came up to my room with a paper in his hand and in a state of great excitement. He had received from Honolulu a check for $500, a legacy, I believe, from some relative of his mother. Paré was so astonished and taken aback by the unexpected windfall that it was impossible for him to believe in the amount of it and he wanted confirmation. I assured him that the sum was, indubitably, $500 and not $50 as he had feared. I congratulated him heartily and immediately returned to my work, for I was in the "white heat" of composition — at least, a woodshed poet's kind of white heat.

A few days later Paré came up again in a baffled, hesitant, apologetic manner.

"Hall," he said, "you remember my showing you my check?"

"Of course I do," I replied. "You're a lucky man, Paré. Have you cashed it yet?"

He shook his head, dolefully. "I've lost it."

"You've lost your check for five hundred dollars?" I said, incredulously. "But that's impossible!"

But I knew, in my heart, that it was by no means impossible in Paré's case. He was just like his mother in his carelessness with money. I remembered stories I had heard of Lovaina, who would put a fistful of hundred-franc notes away anywhere: under a pile of plates, in an old shoe — whatever was handiest at the moment, and immediately forget what she had done with them. Paré, too, was like that, except that he rarely had any money to hide.

"It's gone," he said. "I can't understand how I *could* have lost it. You remember seeing the check in my hand, don't you?"

"Yes, and you gave it to me to look at; then I gave it back to you. Don't worry, Paré. It can't be lost. Have you searched the kitchen?"

"Yes. Everywhere I can think of; my room, too. Well . . ." And then he went out, still glumly shaking his head.

The next day came a knock at the door and there was my landlord again.

"Have you found your money?" I asked at once.

He shook his head. He was in a curious frame of mind; I didn't know what to make of it. He hemmed and hawed, shifting from one foot to the other, giggling now and then, and looking anywhere but at me.

"I went to see Madame Renaire," he said.

Madame Renaire was an old Frenchwoman who owned hundreds of acres of land in the Marquesas, but she lived as though she had not a fifty-centime piece in the world. Every morning she made the rounds of the Papeete market with a dilapidated baby carriage furnished with only three wheels. She picked up outside lettuce and cabbage leaves thrown away by the Chinese market gardeners; spoiled tomatoes, mangos, bananas — anything that was still partly edible. She lived entirely on this kind of food and her monthly expenses were nothing at all. She also collected old clothing, hats, umbrellas, which

people gave her when they were no longer usable. I had seen her passing through the streets of Papeete every day with the ancient baby carriage heaped high with rubbish that the most needy Tahitian — had there been any, which there were not — would have thrown away. Madame Renaire also told fortunes by playing cards, and was considered an oracle by the natives; they believed implicitly everything she told them.

"Well," I said, "did she give you any clues?"

Paré nodded, giggling anxiously, and never once looking at me.

"She said that a thin dark-haired man living in my hotel knows where the money is."

Of a sudden it dawned on me that I was the man.

"Paré, are you trying to tell me that you think I stole your check?"

"Oh, no, Hall! Of course I don't, but . . ."

"Don't you remember my handing the check back to you?"

"Yes, I think so. Anyway, it seems to me you did. But what could I have done with it?"

I had finished my verses and was busy correcting them and didn't want to be bothered just then, but I got up from the table at once and took Paré by the arm.

"We're going to search for that check right now," I said. "Get your girls. We'll ransack the house."

We started with the kitchen, chasing out the fowls which were having dust baths in the earth oven. The eggs of small lizards which infested the place rained down like hailstones from the shelves, and the maxon wasps buzzed around angrily at being disturbed at their work of sticking mud gobs in the corners and crannies along the walls. We searched every article in the place: the pots and pans and skillets and the miscellaneous cracked crockery. There wasn't much of it, so this didn't take us long. No luck. Then Paré's bedroom was gone over. We took the mattress and the pillows off the bed; we emptied the drawers where he kept his shirts and handkerchiefs; we searched every pocket of his scant wardrobe. Still no luck.

As we were standing on the back veranda, Paré said, "Well, I don't know where else to look. I wouldn't have left it anywhere except in the kitchen or my bedroom."

He gave me an apologetic glance that made me feel guilty in spite of myself. I knew just what he was thinking: "Hall couldn't have stolen my money, but then . . . what about Madame Renaire? She said a thin, dark-haired white man living in my hotel knows where it is, and that fits him. He's the only one here now that it does fit."

"Now we'll search my room," I said, leading the way up the staircase.

"Oh, Hall, we needn't do that," Paré said, apologetically.

"Yes, we must," I replied. "You may have left the check among the papers on my table."

I am, customarily, a man of orderly habits and I like to keep my work table in order, but sometimes, in the midst of composition, papers get scattered everywhere. As I have said, at this time I had been writing and correcting my verses suggested by Rupert Brooke's poem, "The Great Lover," and there must have been thirty or forty sheets of paper covered with jottings in longhand lying around, some on the table and some on the floor. I was in the midst of collecting them in an orderly pile when I remembered that the hotel register had been on the table on the morning when Paré came in to show me his check.

"Didn't you take the register out with you that morning?" I asked.

"Why . . . yes . . . maybe I did," Paré replied.

"Where is it now?" I asked. "I'll bet you put the check in it."

"Oh, no," said Paré, "I wouldn't have done that." Nevertheless, at my insistence, he sent one of the girls to look for the register. She returned presently after a fruitless search. The register had vanished, too. But when we descended to the downstairs veranda once more I noticed a pile of old newspapers stacked up against the inner wall of the veranda: copies of the *Sydney Bulletin*, the *Auckland Weekly News*, the *Pacific Islands Monthly*, which guests had left in their

rooms over a period of many months. So, although Paré was sure it was needless, I insisted that we search through that. And there, surely enough, we found the hotel register, and in the register, the missing check. Paré was amazed and very indignant with the girls who had been so careless with the hotel register. But, more than this, he was awe-struck at Madame Renaire's knowledge of how the money would be found.

"Hall, I've never known her to make a mistake. Never!" he added, wonderingly.

Some gay parties followed in the outdoor kitchen. I attended a few of them, and I could well understand why, a surprisingly short time afterward, I received a note from Paré, which began: "Dear Hall sorry to bother you but could you let me have . . ." etc., etc.

In the winter of 1916, when I was an *élève-pilote*, learning to fly at the Blériot School, near Versailles, we fledglings were sometimes permitted to have Saturday-afternoon leave in Paris, if the weather was unfavorable for flying. One afternoon I was strolling along the boulevards with no particular destination in mind. The pavements were wet, shimmering softly in the gray light, and the voice of the streets was the mingled, intermittent toot of taxi horns — those chugging little taxis that had helped to win the First Battle of the Marne. Presently the light drizzle became something much wetter. I was just outside Brentano's Paris bookstore — and a bookshop offers the best possible shelter for a man waiting for a heavy downpour to pass. I was reminded to ask one of the clerks if he could tell me of any volumes of verse by an Irishman named Francis Ledwidge. A few days earlier I had read, in an English newspaper, a poem by this, to me, unknown writer, which began:

> Had I a golden pound to spend
> My love should mend and sew no more;
> But I would buy her a little quern
> Easy to turn on the kitchen floor;

And, for her windows, curtains white
With birds in flight and flowers in bloom,
Gaily to front the road to town
And mellow down the sunlit room.

This had convinced me that I wanted to read more of Francis Ledwidge's verse if it was obtainable, but the attendant could tell me nothing about him, and they had no volumes of poetry under his name. It was not until several years later that I learned of Francis Ledwidge's death; he was killed in action. I mourned for him, and still do, as I mourned the death of Rupert Brooke, Wilfred Owen, Charles Hamilton Sorley, and many other young poets of whatever nation, known and unknown, killed in the war. By the golden promise, so evident in the few poems some of them left behind, one may estimate the loss to the world of these young men killed in the very flower of youth.

I loafed about in the bookshop, picking up volumes at random. Presently I found myself in front of a shelf of small, cloth-covered volumes — the World's Classics series, published by the Oxford Press. *The Mutiny of the Bounty*, one of the titles read. I had a shadowy recollection of that episode in British maritime history. I recalled Captain Bligh's name and that of Fletcher Christian, and I knew that Pitcairn Island was connected with the story; but this was the extent of my knowledge, and I had forgotten how I came by it.

The volume I took from the shelf was Sir John Barrow's narrative, first published in 1831: a clear, factual account of Captain Bligh's voyage to Tahiti for the purpose of taking a cargo of young breadfruit trees to the West Indies; of the mutiny that followed on the return voyage, and the chapters of consequences. My interest was immediately engaged and held, to such an extent that I bought the volume to carry back with me to the aviation school at Buc. And little I realized then the importance of the effect this purchase was to have on the fortunes of Messrs. Nordhoff & Hall. (Indeed, I did not know

Nordhoff at this time. Two years were to pass before our first meeting, in the autumn of 1918.)

After our first joint venture in Tahiti we had gone our separate ways and by the year 1929 Nordhoff and I knew that we were not making much progress toward our hoped-for literary careers. We had collaborated in writing *Faery Lands of the South Seas,* which was published successfully by Harper's in 1921. Then Nordhoff wrote a novel, *Picaro,* also for Harper's, which was stillborn, like two volumes of essays and sketches that Houghton Mifflin Company had published for me. I have Ferris Greenslet to thank for the fact that they, at least, saw the light of print, but I doubt whether either of them paid the cost of publication. Then, at Ellery Sedgwick's suggestion, Nordhoff wrote two boys' books, *The Pearl Lagoon* and *The Derelict* — published by the Atlantic Monthly Press — which sold well and are still in print. In the meantime, the Atlantic Monthly Press had amalgamated with Little, Brown and Company.

Nordhoff and I had done no collaborating since the *Faery Lands* volume. But, after the publication of his two boys' books, he wanted to carry his young hero, Charles Selden, of those tales, through another series of adventures during World War I. He wanted to make him a pilot in the Lafayette Flying Corps, and he asked if I would collaborate with him on this tale. I was glad to do it, and so we wrote *Falcons of France,* published by the Atlantic–Little, Brown Press.

It may be wondered why I am giving these tiresome details. My purpose in doing so is to explain how writers, by pure chance, are sometimes shunted from one set of publishers to another. Nordhoff and I had, naturally, a deep sense of loyalty to Harper and Brothers, and I, personally, had the same feeling toward Houghton Mifflin Company. Then Nordhoff — because of Mr. Sedgwick's suggestion that he write the boys' books — became connected with the Atlantic–Little, Brown Press; and because *Falcons of France* was a continuation of the adventures of the same boy concerned in the two earlier books, it was, of course, published by that Press, as well as the later books we

were to write together. But I remained as loyal as possible to Houghton Mifflin Company, who continued to publish the books that I wrote alone. Any writer would prefer having all his dealings with one publishing house, particularly with any one of such friendly, scrupulously honest concerns as Harper and Brothers, Houghton Mifflin Company, or the Atlantic–Little, Brown Press. But, sometimes, circumstances prevent him from doing so.

To proceed: after we had written *Falcons of France,* Nordhoff said: "Why don't we go on writing together? Two heads are better than one, and neither of us seems to be making much progress writing alone." I was more than willing, so we began searching around for a story that both of us would be interested in. Nordhoff suggested that we might continue his boy, Charles Selden: bring him back to the South Seas, after the war, and put him through another series of adventures, concerning a hurricane, perhaps. But I was not greatly interested in boys' books, although publishers had told us that a good boys' book was like an investment in government bonds, bringing in small but steady returns, sometimes over a period of many years.

One day I said to Nordhoff: "Have you ever heard of the *Bounty* mutiny?"

"Of course," he replied. "Who hasn't, who knows anything about the South Seas?"

"Well, what about that for a story?"

Nordhoff shook his head. "Someone must have written it long since."

"I doubt it," I replied. "The only book I have seen is Sir John Barrow's factual account of the mutiny. Barrow was Secretary of the British Admiralty at that time. His book was published in 1831."

I saw in my friend's eyes a Nordhoffian glow and sparkle which meant that his interest was being aroused. "By the Lord, Hall!" he said. "Maybe we've got something there! I wish we could get hold of a copy of Barrow's book."

"I have it," I replied. "I bought it in Paris during the war."

The result was that Nordhoff took the book home to read and the next day he was back, and he was in what I can only call a "dither" of excitement. "Hall, what a story! What a story!" he said, as he walked up and down my veranda.

"It's three stories," I replied. "First, the tale of the mutiny; then Bligh's open-boat voyage, and the third, the adventures of Fletcher Christian and the mutineers who went with him to Pitcairn Island, together with the Tahitian men and women who accompanied them. It's a natural for historical fiction. Who could, possibly, invent a better story? And it has the merit of being true."

"You're right, it *is* a natural," said Nordhoff, "but . . ." he shook his head, glumly. "It must have been written long since. It's incredible that such a tale should have been waiting a century and a half for someone to see its possibilities."

Nevertheless, after having made the widest inquiries and the most painstaking researches, the only book we discovered concerned with the *Bounty* mutiny — outside of Bligh's own narrative, Sir John Barrow's account, and others written by British seamen such as Captain Staines and Pipon who had written of Pitcairn after the discovery of Christian's refuge by Captain Folger, in 1808 — was a tale called *Aleck, the Last of the Mutineers, or, The History of Pitcairn Island*, published anonymously by J. S. & C. Adams, at Amherst, Massachusetts, in 1845. This book was designed for young readers, and was made up of a compilation, culled from other books, of the facts then known about the *Bounty* mutiny.

I will not go into a detailed account of our collection of source material, although it was a matter that interested us tremendously, and that interest was fully shared by Ellery Sedgwick, of the *Atlantic*. Mr. Sedgwick again proved himself the staunch friend he has always been to the pair of us. He found for us in London a retired British naval officer, Captain Truefell, whose help was beyond price. Captain Truefell had an exact model made of the *Bounty*, and he sent to us, via Mr. Sedgwick, blueprints of her deckplans, her sail-and-rigging

plans, so that we became thoroughly familiar with the ship. Not only this: we received photostat copies of all the old Admiralty records concerning the *Bounty* and her voyage, and of the court-martial proceedings which, at that time, had never been printed, although they were, later. We had boxes and bales of the old records, and the interest and pleasure with which we sorted and read them can easily be imagined.

Although we saw, from the beginning, what a superb trilogy the *Bounty* story would make, we could not assume that the general public would take the interest in it that we did; so our plan was, first, to write a tale concerned with Bligh's voyage to Tahiti, the collection there of the breadfruit trees, and the mutiny that followed on the homeward voyage, with just enough about Bligh's open-boat voyage and the later experiences of Christian and his men on Pitcairn to make an intelligible story of the whole *Bounty* affair, in case only one book was called for. But we hoped, of course, that there would be enough public interest in the story to warrant our going on with the two additional books we had planned: *Men Against the Sea* and *Pitcairn's Island*.

I well remember the day when, after months of preparation — reading and rereading our source material, endless discussions, the laying out of chapters, and the like — we were ready to begin the actual writing at the Aina Paré.

The *Mutiny* met with a surprising response and we went on to complete the trilogy. One day, not many years after, who should mount the steps to my veranda but Mr. Lloyd Osborne, Stevenson's stepson! He was then, I believe, about seventy, but life had so vastly changed since Stevenson's death, in 1894, that I could scarcely believe in Mr. Osborne's reality; yet he was still very much alive and in full possession of his faculties. I knew that Mr. Osborne must have spent his life being Stevenson's stepson; therefore I refrained from even a mention of his illustrious stepfather until Mr. Osborne himself spoke of him. Then I asked one question that I had been

longing to ask since the day of Mr. Osborne's arrival. How was it possible, I asked, that Stevenson had missed writing the story of the *Bounty* mutiny, which would have been a natural for him. "Now that you and Nordhoff have revived interest in it," Mr. Osborne replied, "I, too, have wondered how he could have missed it. The only explanation I can think of is that, when we came to Tahiti in the *Casco*, Stevenson became deeply interested in some of the old native legends told him by his friends, Ori a Ori, of Tautira, and Chief Tati, of the Teva Clan. As you know, he made poems of two of these which he called, 'The Song of Rahero,' and 'The Feast of Famine.'" He added, with a smile: "But you and Nordhoff should not regret that he did miss it." "I know," I replied, "but think what *he* could have done with it, or the two of you together." Then Mr. Osborne said a courteous and a heartening thing: "I think that Nordhoff and yourself have done very well with that story, and I'm sure that Stevenson would agree."

xxvii. Conversation at Arué

ONE OF Nordhoff's antipathies, incomprehensible to me, was for traveling: he loathed it. He seems to have inherited none of his Grandfather Nordhoff's delight in wandering. He did go on several occasions to California to see his parents, but in the South Seas he made only two voyages during all the years that we lived and worked together. The first was in 1920 when we were writing *Faery Lands of the South Seas:* he spent two months in the Cook Islands at that time. This ended his voyaging until 1938, when he went to Sydney to collect material for *Botany Bay,* the story we were planning to write of the settlement of Australia by the convicts carried there in the First Fleet, by Admiral (then Commodore) Phillip, in 1788. Previously, I had done all the voyaging for the pair of us, so Nordhoff consented to go to Australia for our *Botany Bay* material. When he discovered that the city of Sydney now covers nearly the entire area of our proposed tale, he lost interest. He returned from Sydney with a splendid lot of source material: all of the New South Wales Historical Records, and many other books, maps, and sketches concerned with the early settlement of Australia. All of this he turned over to me, saying that our story had ceased to interest him. I spent the better part of a year reading this material, trying vainly meanwhile to arouse his interest once more. I tried to persuade him that the fact of Sydney now covering so much of the area of our story did not matter in the least; with the help of old maps and sketches of the landscape we could see Australia pretty much as it was at the time of the arrival of the First

Fleet. But he was not to be persuaded, so I started writing the story on my own. Then the Paramount Studios bought the motion-picture rights in advance and he consented to collaborate. The picture was never made by Paramount, which I believe was an error in judgment on their part. Even though we wrote the tale, I am certain that it would have made a motion picture of interest to the entire English-speaking world. I felt, and still feel, the same about *Pitcairn's Island*, bought by Metro-Goldwyn-Mayer and never produced: it would make a better picture than *Mutiny on the Bounty*. If MGM had had the foresight to make a trilogy of the *Bounty* story as we did in writing it, following the *Mutiny* part with *Men Against the Sea* and *Pitcairn's Island*, I believe they would have had a picture that would remain long in circulation. It will be observed that my mortal enemy, Old Man Diffidence, is not astride my shoulders as I make this statement. There are moments when I succeed in dismounting him and can speak with the assurance that I feel in my bones and blood.

To return to Nordhoff's dislike of voyaging — how often I tried to pry him loose from Tahiti, but it could not be done. Even when an opportunity, rare in those days, came to make a voyage from Tahiti to Pitcairn — at the time when we were writing the *Bounty* story — I could not persuade him to come with me. He already knew about the island from his reading, he said. So he did, after a fashion, but I could not understand his lack of eagerness to see, with his own eyes, an island so famous in British maritime history, and so particularly interesting to the pair of us at that time. He didn't know all about it by any means, as I discovered when I went there. My visit to Pitcairn was one of the most interesting and rewarding experiences of my life; but I have already written about it in another place, and of our shipwreck on the return voyage, so I will say no more of it here.*

Nordhoff was the best of friends and companions, and, on a crumb of land in the backwaters of the Pacific, companionship of the right kind is more than ever precious. Although we were in almost daily

* *Tale of a Shipwreck,* serialized under the title "From Med to Mum."

contact over a period of twenty years we never seemed to get talked
out. Any kind of conversational matter would do to start with; from
there we would go on as chance or inclination directed, and the hours
would pass like minutes. Although it is somewhat out of chronologi-
cal order, I should like to reproduce here the record of one of our
talks, as nearly as I remembered it, that I made back in the late twen-
ties when we were both married and had children and homes of our
own. It gives a better picture of Nordhoff — one of the various Nord-
hoffs — than I could hope to do now with a brain rapidly becoming
atrophied. Of course, the actual conversation was more colloquial
than the words I have written but the substance is the same.

H. This is a happy surprise. When did you come?
N. Two hours ago.
H. And you've been waiting all this time?
N. It doesn't matter. I've had a pleasant afternoon on your veranda.
H. What have you been reading?
N. Robert Frost's poems. This small volume seemed to bow itself
 into my hand as though it expected to be taken from the shelf.
H.

> My sorrow, when she's here with me
> Thinks these dark days of autumn rain
> Are beautiful as days can be;
> She loves the bare, the withered tree;
> She walks the sodden pasture lane . . .

Did you read that? And "Going for Water," and "Storm Fear"?
N. I like "Mowing" better than the ones you name.
H. Read it aloud, will you?
N.

> There was never a sound beside the wood but one,
> And that was my long scythe whispering to the ground.
> What was it it whispered? I knew not well myself;
> Perhaps it was something about the heat of the sun,

Something, perhaps, about the lack of sound —
And that was why it whispered and did not speak.
It was no dream of the gift of idle hours,
Or easy gold at the hand of fay or elf;
Anything more than the truth would have seemed too weak
To the earnest love that laid the swale in rows,
Not without feeble-pointed spikes of flowers
(Pale orchises), and scared a bright green snake.
The fact is the sweetest dream that labor knows.
My long scythe whispered and left the hay to make.

H. Only Frost could have writen that. How well it satisfies his own definition of a poem: where an emotion has found its thought and the thought has found its words.

N. "The fact is the sweetest dream that labor knows" — that is what all scythes whisper to the ground, and all men to themselves, in thought and action, as long as they have breath in their bodies.

H. You believe it, then?

N. Don't you?

H. The perfect saying of it in this case seems to make it valid, but the facts that labor knows are not the only ones, nor do they necessarily give rise to the sweetest dreams.

N. Now what do you mean by that?

H. Precisely what the words import. But men will never see alike in this matter, fortunately so, for us idle ones. Let those who must, mow, and take pleasure at evening in the fact of their labor and its accomplishment. Let the others who wish to — there are not many of them — sit idly by, watching their own fields of uncut grass ruffled to a deeper, richer green by the summer breeze, and dappled by the shadows of clouds. They will have their own pleasure and profit, as great, in degree, perhaps, as that of the mowers, in the indisputable fact of their idleness.

N. This kind of nonsense is what comes of rambling in the hills so often. I suppose that's what you have been doing all day?

H. Yes. I went far up the Haapape plateau to the highest point you can just make out from the road. From there you can see Mount Orofena from base to peak. It is the most beautiful spot on all Tahiti, and except for myself and a few natives who pass that way to gather *fei,* no one goes there from one year's end to another.

N. How wide a view do you have from that point?

H. You should visit the place for yourself, sometime. Now and then I can make out your boat, and although you are miles offshore, you seem to be creeping along just beyond the barrier reef. I see the rotundity of the earth. In the imagination I visit hundreds of islands scattered over the downward slopes of the Pacific.

N. How do you occupy your time on these all-day excursions? What do you think about?

H. For a part of the time, of nothing at all. I have acquired the habit of reverie. I can sit for a half hour, even longer, lost in what I can only call a dreamless dream — a waking trance that seems as deep as the sky itself. What passes over the surface of consciousness disturbs it no more than cloud reflections stir the depths of the lagoons. It is sensibility lying somewhere between that of animals and vegetables.

N. Has it ever occurred to you that the habit of reverie might be a dangerous one to cultivate? Even on an island in the mid-Pacific you must keep some contact with a workaday world. You have your living to earn. The worst possible preparation for that, it seems to me, is to sit on the slope of a mountain dreaming dreamless dreams.

H. Dangerous? On the contrary. Should a man keep his mental faculties at the stretch through all of his waking hours? I don't believe it. The Polynesians have taught me better. That people in the so-called civilized countries do so is one reason, I think, why our insane asylums and those for other kinds of mental disorders are always filled to overflowing. The time is coming, I

believe, when men will turn back to a simpler, ampler, more wholesome way of living. They will not fear to do some vegetating. They will seek wisdom from Henry Thoreau rather than from Henry Ford, and will refuse to be cheated longer of leisure, the most precious of all gifts.

N. Leisure? How many people want it? Thousands who might have it refuse to accept it on any terms. They travel frantically from one place to another, from one distraction to another, from one war to another, in order to escape this boon. Some have more than is good for them, and so they cultivate the habit of reverie.

H. I am not alone in thinking it worth cultivating. Let me read you a passage from an article written by a hardheaded professor of economics. How, he asks, is a man to bring peace and order into his own life, however chaotic the spiritual and social conditions around him may be? This is one of the suggestions, and as it is the concluding one it was evidently considered of importance:

> And one thing more let him learn: to be still — to sit or walk alone, say, an occasional half-hour, not thinking, not reading, with mind and body as quiet as he can make them. Let him practice this stillness, persevering (for this is difficult) night and morning, until he have its secret. And all for the sake of the adventure, to see what would come of it, with no guarantee that anything would come of it except boredom.

N. And boredom is all that would come of it, in ninety cases out of a hundred.

H. Men need to discover themselves, to learn as nearly as may be who and what they really are; not what others think of them. Nothing could be better as a preparation than to learn to sit quietly, with the mind fallow and the habitual nervous tension relaxed.

N. How many men want to discover themselves? We already know too much to wish to make further explorations.

H. The trouble is that we know too little: that is why we think so meanly of ourselves.

N. You truly believe that?

H. I believe that most men are fundamentally decent, honorable, lovers of good and haters of evil, but they don't give themselves a chance to discover this. They accept, as though it were inexorable law, the old doctrine of Original Sin, as though God Himself had planted it in our hearts. If we go deeply enough . . .

N. Into mysticism, I suppose?

H. Well, even the physicists and the astronomers are beginning to acknowledge the necessity for mysticism. It surprises me that they have been so long in making the discovery. It is a pity that there are no secular establishments where the harassed and distracted Protestant man of our day may go into retreat, as the Catholics do. He might learn there how best to meet the soul-killing conditions under which most men have to live. If I had a fortune I would found such houses, and they would be free to all who cared to use them.

N. You would have plenty of applicants for free board and lodging, but none for spiritual refreshment. . . . But to come back to Tahiti — is that why you stay on here, year after year? Because you love solitude so much?

H. One doesn't have to come as far as this to find solitude. I love a circumscribed world, small enough to be comprehended in a glance, so to speak, and yet large enough to offer a certain amount of variety. And I like isolation made tangible by thousands of miles of ocean stretching away on every side. Here I have become more and more aware of the "uncovenanted society" that Mr. Santayana speaks of in one of his essays. Wait — let me find the passage.

N. I was glancing through your library this afternoon. What a picture of yourself these books offer! A stranger, examining them, would be able to conjure you up: the portrait of a man deduced from his library.

H. It would not be a good likeness. Many volumes that I highly prize are not to be found here.

N. Supposing you had to select ten books to suffice you for the rest of your life: what ones would you choose? I mean, from those now on your shelves?

H. Could you make an offhand choice in such a matter?

N. Well, put it this way: if you had to make a choice tonight, which ten would you most regret leaving behind?

H. We'll talk of that another time. This is the passage from Santayana; it concludes an essay called "Cross Lights."

> There is an uncovenanted society of spirits like that of the morning stars singing together, or of all the larks at once in the sky; it is a happy accident of freedom and a conspiracy of solitudes. When people talk together, they are at once entangled in a mesh of instrumentalities, irrelevance, misunderstanding, vanity and propaganda; and all to no purpose, for why should creatures become alike who are different? But when minds, being naturally akin and each alone in its heaven, soliloquize in harmony, saying compatible things only because their hearts are similar, then society is friendship in the spirit; and the unison of many thoughts twinkles happily in the night across the void of separation.

N. You are always quoting Santayana, and I am conscious of a feeling of irritation whenever you do. He lacks robustness. Don't you feel that, yourself? I wish he would break out, once in a while, in a bit of good, wholesome, earthy vulgarity.

H. If that is wanted, there are writers and to spare where it may be found. But what do you think of the idea expressed here?

N. That sort of companionship is too ethereal for my taste. I prefer actual companionship, the presence in the flesh of other men I can see and hear and touch with my physical senses; men who emit their forces of attraction and repulsion as I do mine. The communion of spirit with spirit across a void of separation — you

can have it. Give me two or three companions around a table with a bottle of Scotch before them, or several bottles of good wine. What if we do become somewhat entangled in a mesh of vanity and propaganda? That is because we are human. Conversation will only crackle and sparkle the more. Don't you agree?

H. Of course. I thoroughly enjoy such conversations, but they are on a different plane from those Mr. Santayana has in mind here. Both kinds are desirable.

N. Give me my kind for a steady diet.

H. And yet, how many times I have heard you say that you like your friends better at a distance, and that you enjoy their companionship most when you see them least. Have your actual friends ever brought you the pleasure you find through books, or music? I doubt it. They disappoint you and you them. You don't have only the best parts of them when they are with you. That is why friendship in the spirit is so often to be preferred to such friendship in the flesh as chance puts in one's way. Chance distributes its favors with such a lack of discrimination. In the matter of friendships, more than likely the ones you receive are not at all the ones you should have had, or would have chosen for yourself. Therefore, one falls back gladly, of necessity, upon this uncovenanted society.

N. But you needn't have come all the way to Tahiti to enjoy its privileges. You might have done that just as well in the U.S.A.

H. Perhaps . . . but what of yourself? If you so greatly enjoy friends within reaching distance, why do you live in a place where there is so little choice?

N. The matter of friendship has nothing to do with it. A man will, usually, find a few congenial souls wherever he goes. I live here because I like a tropical climate, fishing in tropical waters, and going to seed slowly and pleasantly.

H. You think one does go to seed here?

N. I know it. Consider our own cases as examples: we are neither of us anything like as alert, mentally, as we were only a few years back. We used to have quite interesting conversations — do you remember? We discussed everything under the sun and agreed upon nothing. Now, when we have a difference of opinion it is usually only a temporary one. We dislike the mental effort necessary to sustain a disagreement; so one or the other of us is sure to say, "Perhaps . . . Yes, I suppose you are right," and that ends it. More often than not we gossip like a pair of old native women, rather than talk. We discuss island personalities and the small change of island happenings. Or, too lazy to get together, I sit on my veranda in Punauiia, and you on yours, in Arué, each of us in a pleasant stupor, streaked through with sluggish musings. Days pass, each one like the day preceding. We are under the illusion that time is standing still for us, but if you pause to reflect . . .

H. And what more agreeable illusion could one be under? How many men would envy us the possession of it?

N. Allow me to finish. If you pause to reflect you will realize that this is the result of the monotony of our lives. Where there is no variety of happenings from one month to the next a year slips by before you are aware that it has well begun. You flatter yourself that you have acquired, through effort, the habit of reverie. No effort was needed. You are merely going through the same process of decay experienced by all white men in such a tropical backwater. It is an inevitable process. The island has put its stamp on both of us. I'm surprised that you haven't the wit to see it.

H. Why don't you fly, then? Why don't you try to save yourself before the disintegrating process has been carried too far?

N. I have just said that I enjoy going to seed. I am clear-sighted enough to realize what is happening, but I don't care. I don't in the least object. I am now in my forty-third year. Thus far I

have had as wide an experience of life as a man could wish. I
have learned many things and unlearned many. I have arrived,
by hard thinking, at various conclusions with respect to the mean-
ing of life and of man's place in the universe; more particularly,
my own place. By hard thinking I have discarded, in turn, these
conclusions. I shall form no new ones. I no longer care whether
or not there is meaning in life, or whether or not I am entitled to
a place in the cosmical scheme. I have now had the place for a
considerable number of years, and in view of that fact I can
afford to be content. Fly from Tahiti? For what reason? And
where to?

H. You might go home.

N. What chance would I have to go to seed there? I would not be
permitted to. I would be bribed, or forced out of my quite natural
inclination to go downhill. I would be driven uphill to the very
end, and so cheated out of my birthright to an agreeable old age.
And think of the freedom of a special kind that one has here:
freedom from the influence of the mass mind, with its intolerance,
its disregard of minority rights and opinions, its profound belief
in material progress, and that science will, ultimately, solve all
the riddles of the universe. It is impossible for the individual,
living within the scope of this mighty influence, not to be affected
by it.

H. You don't believe in modern science, then?

N. Of course I do. But I don't believe in many of its pretentions and
assumptions, and the arrogance of some of those who worship at
that shrine.

H. But have you no desire ever to live at home again?

N. Why do you say "at home"? Isn't Tahiti home to you, after all
these years?

H. No; and that is, to me, the chief disadvantage of living here. All
of my roots are still in America, in the prairie country of the
Middle West. I realize now that it is useless trying to grub them

up to transplant on this little island. They won't come up. The other night I wrote some verses on my unfortunate situation. Would you care to hear them?

N. Why are would-be poets always wanting to quote their verses to their friends?

H. Because they need an audience of at least one person. This poem isn't long; only four stanzas.

N. Go ahead, then.

H. I have called it, "Thoughts in Exile":

> Inclination, chance, and need
> Demanded that the tree should go.
> The stubborn roots would not be freed.
> "No!" they said, and always, "No!"
>
> The tree, to end an argument
> That would not, could not be resolved,
> Said goodbye to roots, and went,
> Careless of the risk involved.
>
> Sap there was in every cell;
> Leaves and branches seemed content.
> Said trunk, "I'm doing very well
> Without my roots," and on it went.
>
> But roots had greater hardihood;
> Dreams were wafted through the air
> To find and nourish, as they could,
> A tree with all its branches bare.

N. I'm surprised that you feel that way about it. I came to Tahiti taproots and all, and they are now comfortably embedded here. Nevertheless, I realize that I am an exotic plant and must suffer the consequences of the change of habitat. My growth here has been sickly, but my decay will, I believe, be luxuriant and slow.

H. You talk as though you were already on the threshold of old age.

N. So I am. I mean to depart from the practice of most men of our years. They cling to the fiction that they are still vigorous youngsters until, at the age of forty-five or thereabout, the fact that they have long been middle-aged is forced upon them. Then they persist in being middle-aged until they are ready to topple into their graves, crowding their old age into a scant year or two.

H. Yes, so we do, most of us.

N. But consider my happy prospect. I may have thirty, even forty years to spend in this pleasant old-man's garden. I shall have time to enjoy to the full an old man's pleasures. I shall read old books and care nothing about the new ones. I needn't try to keep abreast of the world's doings, and who would care to, in these times? My fishing will keep me healthy in body, and the humdrum existence we live here will keep me tranquil in mind. . . . But I'd better be going. It's quite dark, already.

H. Yes, old men should keep early hours.

N. I never go to bed later than nine-thirty. . . . What a glorious night! Look at those coconut palms against the sky!

H. Wait till I light the lamp. I'll show you down to the road. Mind the second step! There's a board loose.

N. Oh, the decay, the decay, in houses and men, in this humid tropical climate! . . . Good night, my son.

H. Good night. Sleep well, father.

xxviii. The Far Lands

ON OUR GRADUATION the members of my class at Grinnell decided to keep in touch with each other in a chain letter. It started on its rounds that same year, 1910, and is still going. It makes the circuit on the average of once per year, and each man, upon receiving it, takes out his letter of the year before and adds a new one.

I doubt whether any member of the class has enjoyed receiving it more than myself. I have lived so far from home all these years and have had so little contact with the friends of my youth that I must depend upon the letter to renew the old ties that become increasingly precious as one grows older. The men in my class are in many different walks of life. There are lawyers, doctors, scientists, college professors, farmers, businessmen and a minister or two. They live in different parts of the U.S.A. and several of them, like myself, live abroad. Whenever the letter comes my way I set aside an evening, and sometimes two, to read and reread the contributions of these old friends. They are more rewarding and more revealing with respect to what the average American is thinking and feeling than any printed publication that I receive. I not only feel *au courant* with my homeland, and with the best kind of people who live there, but uplifted in spirit; for I know that America has hundreds of thousands of men such as these classmates of mine, and as long as that great leaven remains in the body of the population, we are not justified in despairing of the future.

Iowa, for all the years I have been away from it, has always been,

and still is, home to me. Sometimes, in thinking of home, I suffer severe attacks of nostalgia, although they are not so frequent in these latter days as they used to be, due to the fact that life in the U.S.A. is so vastly different now from what it was during my boyhood and youth. I remember thinking when I was in the midst of one of these attacks of homesickness in the middle twenties; "What am I doing in this part of the world? I don't belong here. I'm as native to Iowa as a pignut tree and will never be really happy anywhere else." This homesickness would sweep over me when I least expected it, and in one Christmas season I tried to express my feeling in these verses:

DECEMBER IN THE TROPICS

The palm trees slope against the sky
As still as they were painted so . . .
Very strange it is that I
Stand under them, knee-deep in snow.

In other lands as green as this
Are other men, perhaps, like me,
Listening to the seething hiss
Of snowflakes falling endlessly.

Oh, kindly hills of home! that keep
For us who left them years ago
A wintry silence, muffled deep
In newly fallen, immortal snow.

At that time I was just barely making a living. Tahiti, in those halcyon days, was an excellent place for a man who was trying to support himself by writing: my expenses were less than a third of what they would have been in the U.S.A. And yet, cheap as it was, I often had a difficult time in keeping my nose above water. I owe my friend, Ellery Sedgwick, who was then editing the *Atlantic Monthly,* a great debt of gratitude for preventing me from foundering

on various occasions. He bought enough of my essays and sketches to enable me to struggle on, and now and then I sold things elsewhere: usually short articles with a South Sea slant for newspapers. When lucky I would receive from $15 to $20 each for them, and these checks were windfalls indeed.

But there was a vein of stubbornness in me then as now. I thought: "No, I will hang on here. Luck is bound to change some day," and so it did.

To return to the Class Letter, as the year 1950 approached, each of the contributors urged upon the others that we should resolve to meet in Grinnell in June, our 40th Commencement Anniversary. I was bound to be on hand if I had to swim the 3500 miles between Tahiti and San Francisco, and that possibility seemed by no means unlikely, for since the end of World War II our island communications with the outside world have been sketchy ones, to say the least.

Luckily, for a brief period, a monthly plane service was established between Noumea, the Cook Islands, Tahiti and Fiji, to connect at this latter point with the British and American trans-Pacific air services. Knowing, after thirty years of living on Tahiti, how the French authorities here manage island affairs, I was certain that our plane service would be short-lived and so it was; but it continued long enough for me to reach Fiji, in the autumn of 1949. This was being beforehand with respect to the Grinnell reunion seven months later, but I had another very important object in mind in going thus early: to visit my daughter, Nancy, and her husband and their two small sons who lived in Hawaii. I had seen neither of my grandsons at this time, and the keen pleasure with which I looked forward to this visit will be understood by all grandpas and grandmas.

Let me say, in parenthesis, that in the autumn of 1949 I was working upon a story to be called *The Far Lands*, concerned with the period, a thousand years earlier, when the Polynesians were making their great voyages eastward across the Pacific, in the search for new lands. I had long thought of this story, and, during a period of at

least fifteen years, prior to Nordhoff's death in 1947, I had urged him to join me in writing it. But he was not to be persuaded. I can still hear him saying: "Hall, forget it. It's an impossible task. Nothing is known of the Polynesians of a thousand years ago. There is scarcely a scrap of source material upon which to build such a tale."

I knew this of course, but I urged that we could use our imaginations, draw the story out of thin air, so to speak. It was useless. Nordhoff was not interested; and so, after his death, I resolved to go ahead with the story on my own. I will not enlarge upon this attempt. It is enough to say that many a time in the course of it I was in despair. I gave it up half a dozen times and then, grimly, returned to it. I knew that failure would be the result, but I was bound to reach THE END somehow. I was particularly depressed in the autumn of 1949, at the time when I left Tahiti for Honolulu. I had only ten chapters finished. I had written my daughter, Nancy, of my predicament, and she had replied: "Dad, come on up here. Nick and I have provided you with the finest pair of grandsons that ever were. I will guarantee that with their collaboration you will reach 'The Far Lands' well before the time for you to go to Grinnell." That settled it. I made the hastiest of preparations, for the monthly plane was expected two days later and I was by no means sure there would be another one. I kissed Sarah (my wife) good-by — she was to join me in the spring, if she found a way of coming. And so, with a suitcase in one hand and my briefcase containing the ten chapters of *The Far Lands* in the other, I boarded the old Catalina of the short-lived Trapas Line, for the Cook Islands, Samoa and Fiji.

This was the first time I had ever flown over the sea and the experience was one never to be forgotten. We had glorious weather throughout the voyage to Fiji, flying at around 8000 feet most of the way and at an average cruising speed of 125 miles per hour, which was that of our old Spad pursuit ships of World War I. We left Tahiti at ten in the morning and arrived at Aitutaki, in the Cook Group, by midafternoon. We spent the night there and took off

early the following morning for Samoa where an hour was spent while our gas tanks were filled. Then a course was set for Nandi airport in Fiji where we landed early in the evening. We passed over the entire Fiji Archipelago, and as we crossed the channel between the islands of Levuka and Viti Levu, I could see, in the imagination, Captain William Bligh and his men in the *Bounty's* launch, creeping along far below us on the 3600-mile voyage to Timor, in the Dutch East Indies. I spent the night at Nandi airport, and at one o'clock the following afternoon took off by a Pan-American plane for Honolulu where we landed at eight o'clock the next morning. And there were Nancy and Nick and my two little grandsons waiting to meet me. An hour later we were at their home which fronts a glorious beach of white sand bordering the great lagoon at Lanikai. I still have my old boyhood conception of distance, and the fact that I was able to go from Tahiti to Hawaii in a little more than twenty-four hours' actual flying time seemed in the nature of a miracle to me.

Another miracle was the fact that Nancy's prediction as to how smoothly work would go, with the help of two small collaborators, was fulfilled. Day after day I sat on the beach at Lanikai with Jamie — named after me — not yet six months old, on my lap, and little Nick, in his second year, playing in the sand near by. Jamie had a way of throwing out his hands and wiggling his fingers as though he were saying: "Grandpa, that's my suggestion. Take it or leave it." And Nick, who liked to get into my shoes and parade before me in them, was indeed, a perfect collaborator. He was as brown as a Polynesian and took the place of Hina's first child, in my story. I had only to shut my eyes for a moment to behold, in the imagination, the great double-hulled sailing ships of the Tongan Clan spreading out in a wide arc so as to cover as much sea as possible as they proceeded on their quest for the Far Lands of Maui which they had been seeking for more than twenty generations; and they reached their goal — insofar as my story of their quest was concerned — four months and two weeks after my arrival at Oahu. Never before, in my

writing career, had I been able to work so fast. I say nothing about my hopes for the story. Nordhoff was right: it *was* an impossible task. Nevertheless, I did my very best to make my dreams for it come true. I failed, of course, but I have at least this satisfaction: if I were to try again, half a dozen times over, I don't believe I could have bettered it.

I had the great advantage, while writing the latter part of the story, of being able to consult from time to time with Dr. Peter Buck, director of the Bishop Museum, in Honolulu. Dr. Buck was a friend of twenty years' standing and had often visited Tahiti in connection with his lifelong anthropological researches connected with the origin and the history of the Polynesian race and their migrations of centuries ago. His book, *Vikings of the Sunrise,* is wholly concerned with their great voyages eastward, and what he has discovered, or surmised, as to the routes taken, the destinations reached, and the approximate centuries when the voyages were made, is, in my opinion, as near the truth as can be known, or ever will be known, concerning them.

Far be it from me to assert that Dr. Buck would approve, from the scientific point of view, of my story, now that it is written. But he did encourage me to go on with it. One day I felt particularly frustrated because of the lack of source material to draw upon. He said, "Norman, you are not preparing a scientific paper to be read before a group of ethnologists and anthropologists. You are writing an imaginative tale. Well, then, use your imagination. Why worry about the facts? There are none, or practically none, available. Insofar as I know, you are the first man who has attempted a story of one of the ancient Polynesian voyages from a purely imaginative point of view. I think it is well worth going on with." He smiled as he added: "You will, certainly, come far from the truth, but none of us can check up on you."

It was thanks to Dr. Buck that I found an ancient Polynesian name for this great Mother of Oceans. I could not, of course, use

"Pacific," for the Polynesians had discovered and peopled many of the remotest islands and archipelagoes centuries before Magellan was born. Dr. Buck suggested an ancient Maori name: Te-Moana-nui-a-Kiwa — The Great Sea of Kiwa, and that was just what I wanted.

I doubt whether anyone, in whatever line of endeavor, is conscious of a deeper feeling of relief at the completion of a task than that of a writer when, after months of stewing and fussing over a book, he writes THE END on his last page of manuscript. I had been thinking so long about "The Far Lands of Maui" that it seemed to me the manuscript of this tale had been weighing me down for years, although I had spent little more than a year in the actual writing of it. When, at last, I was free of it, I felt as the Ancient Mariner must have felt when the body of the Albatross slipped from his neck and fell like lead into the sea. I hoped that *The Far Lands* would not sink in this manner in a sea of public indifference, but at the moment I didn't much care what happened. I was relieved of my burden and before me was the happy prospect of the 40th Commencement Anniversary at Grinnell of the Class of 1910. I have heard a good many college alumni — usually graduates of great universities — say that there is nothing more boring and depressing than a college class reunion, but I didn't feel so about mine. I looked forward to it with the keenest interest, and the event of it more than fulfilled my happiest anticipations.

I had expected to leave Hawaii for the U.S.A. as soon as the book was finished, for I wanted to be in Iowa by mid-April when the hepaticas would be pushing up through the dead leaves on my Hill, east of town. But my wife was to join me in Hawaii, and as luck would have it she was not able to come at the time planned because the monthly plane service from Noumea to Tahiti to Fiji "folded up" soon after I left the island. My wife was compelled to wait for a cargo ship to carry her to Fiji and she came on from there to Honolulu by plane. "In-laws" are, sometimes, barely tolerated in the homes of their married sons or daughters, and I had remained four and a half months

as the guest of Nancy and Nicholas Rutgers, Jr., and my two small grandsons. I had had no intention of remaining anything like that long. My plan was to spend two or three weeks at the outside, and then go on to Santa Fe, New Mexico to finish my book. But Nick is a son-in-law in a thousand, and both he and Nancy begged me to stay on with them until the book was finished. I had never stayed with anyone longer than two weeks but I could feel in my bones that they truly wanted me to and so I did; and when my wife came the visit was prolonged for another two weeks. By the time we reached San Francisco I knew that it was too late to see the hepaticas on my Hill, so I delayed my departure for Iowa. We went to Los Angeles to see our son, Conrad, a student at the University of Southern California. Conrad was to graduate from the U.S.C. in June, and I thought his Commencement was at the end of that month and had planned to be there at that time. I was greatly taken aback when he told me that Commencement at the U.S.C. was during the first week in June, the same time as that at Grinnell.

What was I to do: miss my 40th class reunion or my own son's graduation exercises? I was not long undecided. Conrad said: "Don't worry, Dad. Go to Grinnell. Mother can stay with me, but we won't, either of us, attend the U.S.C. Commencement."

"You won't go to your own Commencement services?" I asked.

He shook his head. "They don't mean a thing at the U.S.C. There are seven thousand members in this year's class. They send us our degree by mail."

I remembered how hard I had tried to persuade Conrad to have his collegiate education at Grinnell. Had he done so I could have attended my 40th class reunion and his graduation ceremonies at the same time. But he had spent all of his school years in California, in order to be as near his parents as the Pacific would permit. As a result, all of his friends and his interests were in California. He looked down his nose at my suggestion that he attend Grinnell. "What? A little fresh-water college out in the Middle West?" The idea didn't appeal

to him and I had no wish to send him against his will. But I could not avoid comparing my feeling about Grinnell with my son's feeling about the great educational factory of which he is now an alumnus.

Upon returning to San Francisco, about ten days before I planned to leave for Iowa, I found a letter awaiting me, with THE PRESIDENT'S OFFICE GRINNELL COLLEGE in the upper left-hand corner of the envelope. The letter read:

DEAR NORMAN HALL: —

I am happy to inform you that the College wishes to confer upon you the honorary degree of Doctor of Literature on your 40th Commencement Anniversary in June. Will you please send us your height, your approximate weight, and the size of your hat so that we can have a suitable cap and gown ready for you? My heartiest congratulations.

Sincerely yours,
SAMUEL N. STEVENS
President

The size of my hat is, customarily, #7, but one of 8¼ would have perched precariously on the top of my head at the moment when I read President Stevens' letter.

Me, a Doctor of Literature, even an honorary one? The announcement was incredible. I could scarcely grasp the sense of President Stevens' letter even as I held it in my hand. My immediate reaction was, "There goes all of my anticipated pleasure in our 40th reunion," for how could I have a free mind with this prospect looming up before me? Perhaps speeches were required of the recipients of academic honors? The thought that this might be the case gave me a feeling of panic: I might have been the high school graduate of 1904, sitting on the platform at the Methodist church, repeating over and over in thought: "One hundred years ago the morning broke . . ." as he awaited his turn to orate about "The Nineteenth Century: the Eighth Wonder of the World." It is strange how the memory of youthful experience stays with one throughout all the

years to come. Ever since the night of "The Eighth Wonder" I have had a horror of speaking in public, which my brief experience in lecturing just after World War I only accentuated. I wrote to President Stevens begging him to postpone giving the degree until our 50th Commencement Anniversary when I might have done a little more to merit it. In reply he said that the arrangements had already been made and the Commencement programs printed. "But you need not worry about your pleasure in this Commencement being spoiled," he added. "There are no speeches to be made. Nothing is required of the recipient of an honors degree except a gracious smile when he receives it; and even this is not obligatory." It was a great relief to be assured of this. I resolved to put aside all further thought of the matter, or, at least, to bury it as deeply as possible in the depths of consciousness.

By the time a man has entered his sixties, he knows beyond dispute that his greatest gains in life are the friendships made during the course of it, and what friendships are more lasting than those made in youth? The Grinnell Commencement was only a week distant as I set out for Iowa, with the lightest of hearts: I seemed to have dropped four decades off my shoulders. I knew that I would see there, Bill Ziegler (the "Dear William" of the unpublished *Letters from Louisburg Square*); Chester Davis, my old Chapin-house roommate; Harry Brundage, Morton Clark, Bob Lindsay, Pat Murphy, Murray McMurray, Cyril Carney, and dozens more whose friendship, in youth, had been kept in the best of repair by means of our forty-year-old Letter.

Still loyal to railway trains, I made the journey from California to Iowa by "The City of San Francisco," a completely modern train, the last word in comfort, but it went far too fast for my liking. A brakeman on the train told me that their average speed was between eighty and ninety miles per hour, including stops. But what I most disliked was the whistle — if it may be called such — of the Diesel engine. This was the first time that I had traveled on a completely modernized

train, and it was hard for me to recognize it as a descendant of the steam-locomotive trains of boyhood.

The Northwestern Railway does not pass through my home town. The nearest point is at Ames where the Iowa State Agricultural College is located, and there I was met by my older brother's son who is also named after me, so that I have a nephew and a grandson to keep the woodshed poet's memory alive after he has gone from the earth. And my nephew, Jimmy, is married to Barbara Black, the oldest daughter of my boyhood friend, Elmer Black, who still lives in Colfax. Thus, sometimes, a pair of old friends have their associations strengthened and renewed in the lives of their children. Jimmy was a mere child when I returned home from World War I. Little could I have guessed, at that time, that a quarter of a century later, he himself would be a soldier in France from the time of the Normandy invasion until the so-called end of the war, or that his baby brother who followed him would be killed there with another of my nephews, my sister Dorothy's oldest boy who was in the Air Service. I well remember seeing these children together, in the summer of 1919, and thinking, as I tossed them up in my arms, "God be thanked! These children will never know the meaning of war!"

It was a glorious May morning when I met Jimmy at Ames. "Now drive slowly, Jimmy," I said; "not over thirty. I want to look around and smell around."

"Okay, Uncle Norm," he replied. A few moments later when we came to a beautiful country home not far beyond the town he drew up at the side of the road and stopped. The roadside edge of the lawn was banked by lilac bushes in full bloom. Of all flowering bushes lilacs are my favorites. I left the car and drew some of the branches down to my face, and, as I did so, a meadow lark perched on a telephone wire overhead gave his call, so filled with the joy of living and the beauty of Mother Earth in the prairie country. "I arranged this for you in advance," Jimmy said. "Welcome to Iowa!"

My brother, Fred, and his wife, still lived in our old house near

the summit of Howard Street Hill, in Colfax. The house was as it used to be, except that the porch was larger and the walls covered with a kind of composition shingle. I regretted this latter change; I liked the old overlapped siding, but my brother told me that the house was three times as warm, in the wintertime, as it had been in the old days. The view over the beautiful farming country north and west was just as it had always been.

When the greetings were over I was ready to set out for my Hill which held so many happy associations connected with boyhood and youth. My sister-in-law said, "Norm, I wouldn't go out there if I were you."

"I know; it's too late for the hepaticas, but there will be a few May-apple blossoms left," I replied.

"Don't go!" she urged.

"Why not?" I asked, and my heart misgave me as I put the question. "They haven't cut off the old timber?"

"Worse than that," my sister-in-law said. "The Rock Island has straightened their track, east of town. You'll be horrified when you see the result."

I wish that I had heeded her advice, but I wanted to see for myself. It was an appalling sight. A great V-shaped cut had been made through the hill from top to bottom. The old linden tree I had loved so much had been at the summit of the cut. Even the trees on either side of the hill had been destroyed. I could scarcely believe in it even as I looked at it.

My friend, Nordhoff, used to say: "Hall, never return to a place where you have known true happiness." In our many long talks, either on his veranda in the district of Punauiia, or mine in Arué, we sometimes discussed this matter. I didn't agree with him. I contended that the places to avoid were those where one had been unhappy, and that happy memories could never be destroyed by a return to the old haunts concerned with them. But now, as I looked at the ruin of my Hill, I realized that I had returned once too often. Nevertheless, I

still have it, in memory, just as it was in boyhood and youth. The stench of burned Diesel oil from all the Rock Island trains that pass and are yet to pass through it can never destroy, for me, the fragrance of the hepaticas that once grew on its slopes.

My brother and his wife were invited out somewhere that evening. They wanted me to go with them, but I begged off, preferring to "moon around" by myself, at home. I know what Nordhoff would have done in that situation: he would have gone with his relatives; or, if he had remained at home, he would have brought out a bottle of Scotch. He could not bear old memories, either of places or of people whom he had dearly loved; and to return to a place where he had been happy caused him the deepest anguish. He loved music but would not listen to it if it had for him any associations with the past. Many a time he would walk out of my beach house if I chanced to play anything, on my phonograph, which had such associations. This was hard for me to understand, but I learned, eventually, never to play the phonograph when he was present.

I have what must be called a shallower nature; or, perhaps, to flatter myself, I might say that I am tougher-minded than Nordhoff was. As mentioned earlier, I loathe man-made changes, but I can except the inevitable ones that come to all of us with the passage of years with the resignation that one must acquire if one is not to become a miserable and embittered old man. It was comforting to feel so strongly the presence of my father and mother in the old house. I could hear my father singing one of his favorite songs, "I Dreamt That I Dwelt in Marble Halls," as he climbed the steps carrying a bucket of water from the one hydrant in the cellar; and I could see my mother sitting at the dining-room table, and hear the faint scratching of her pen as she wrote the wonderful letters to her grown-up and far-scattered children. My sister-in-law had made one great improvement in the house: the wall between the sitting room and parlor had been removed making one room of them. But the old pictures on the walls were still there. One was the beautiful print of the mid-ocean

seascape I had brought for my mother from Boston, in the spring of 1914; and there were two others I had given her later; an interior view of Rheims cathedral, which had in it the stillness and sacredness and majesty of that ancient church; and that well-known picture called, I believe, "The Lone Wolf"; at any rate, a lone wolf is shown standing in the dusk of a winter evening at the summit of a hill, looking down over the snow-covered landscape toward the lighted windows of a farmhouse in the valley. And there were two portraits, of Longfellow and Tennyson, that used to hang in my old room at 713 Main Street, in Grinnell.

Strangely enough, I had forgotten, temporarily, the voice of the hall door until I opened it to go up to bed in my old north room; but as it swung on its hinges I heard the old familiar squeak that had lost its shrillness with the passage of years but the timbre of its voice was just what it should have been for a door that had opened and shut countless thousands of times since the days of its youth. I recalled my sister Dorothy's wish that I should honor the door we loved so much, whose hinges had never been oiled since the house was built; and so, with her suggestion for a beginning, sitting at the little table where in the winter of 1915–1916 I had written *Kitchener's Mob*, I wrote the following verses:

THE OLD HALL DOOR

The old hall door, the Halls' hall door
Squeaks as it did in days of yore.
What is the life of a hall-door squeak?
Day after day, week after week,
Year after year, for two generations
Going on three, the Hall relations
Near and remote, their neighbors and friends
From the old home town to the farthest ends
Of the U.S.A., have heard its hinges
Giving their nerves so many twinges;

Making them wince, and sending shivers
From the lobes of ears to teeth and livers.
"How can they stand that piercing squeak?"
They must have thought, too polite to speak.

But the Halls so loved their old hall door
That led from the parlor to upper floor,
And the eloquent hinges from which it hung
Shrilly greeting both Hall and Young,
That never a single drop of oil
Or dab of grease was allowed to spoil
A voice they loved for its very shrillness
In joy or sorrow, health or illness.

It shrieked "Sweet dreams!" when they went to bed.
(The Halls should know what their hall door said.)
It moaned, "Oh, ow!" when they went away;
"Gee Weetchy!" it cried on the happy day
When one of them came from far or near:
A jubilant squeal, so loud and clear
That the Sharpes and Luthers and other neighbors
Would wince and halt in their household labors
And peer from windows to see who'd come;
What son or daughter it welcomed home.

In eighteen-ninety, or thereabout,
When my mother was toting me in or out,
Or it may have been, upstairs to bed,
Something rang in my infant head.
It wasn't a passing train I heard:
(Some years later my blood was stirred
By whistles of the trains); it wasn't the shrill
Blast of the north wind over the hill,
Making the old house reel and rock;
Or the high-pitched whir of the sitting-room clock.

I am as sure as a man can be
Who thinks he remembers life at three
That the sound, not consciously heard before,
Was the youthful voice of the Halls' hall door.

We were *all* young, then — both house and door,
Parents and children, with several more
Yet to be born to hear the squeak.
Maybe the door had learned to speak
Only that night. But this is flat:
It never was silent after that.

Years later, a pair of growing boys
Would try to steal in without a noise
Some nights, all for their parents' sake.
They were thoughtful boys and disliked to wake
Parents having a well-earned rest;
And, at night, a quiet return was best.

So, furtively holding their shoes in hand,
They would tiptoe into the house, and stand
Listening, there in the dining-room,
Dim in the starlight-filtered gloom.
"Hooray! So far, so good!" they'd think.
The sitting-room was as black as ink,
For, close outside, was a linden tree.
It didn't matter, for they could see
Better than cats, on the darkest night,
And darkness itself gave a kind of light
To their mother's piano of ebony wood,
And showed where the chairs and tables stood.

On through the parlor, hearts athrob,
To the old hall door. They turn the knob
Ever so gently . . . Piercing screams:
"Oh ow! Gee-weetchy! Sweet dreams! Sweet dreams!

Gee-weetchy-oh-weetchy! You're late, my boys!
Don't waken your parents or make a noise!"
And parents would waken, as parents will,
And every neighbor on Howard Street hill
Would wince and waken, and note the hour
When, in a house by the water-tower
Those boys, despite their noiseless tread,
Were foiled again, on the way to bed,
By the faithfully-faithless old hall door.

And now, alas! I'm at home once more,
Thinking of many a yesteryear
And the human voices I used to hear
In days as dead as the unicorn.
"Is this the house where I was born?"
I thought, and sadly shook my head.
"Well, I guess it's time for bed."

Old footsteps trod the upper floors;
I heard them, thinking not of doors
As I turned the knob. A plaintive moan
Was heard in the hall, by the Hall alone,
Faintly stirring the silence there.
I paused, one foot on the bottom stair.
No more, from the voice I long had loved?
With a gentle hand I gently shoved.
Slowly it swung, and the tardy guest
Heard, "Sweet dreams!" and the old protest:
"But, Normie, what will your mother say,
Your coming home so late, this way?"

It was later, far, than a door could know,
But only the silence told it so.

Epilogue

EDWARD WEEKS

JAMES NORMAN HALL began the writing of these memoirs in the spring of 1948. He had been looking for a spare trunk to give to a friend who was leaving Tahiti and needed an extra piece of baggage, and in his search came upon an old suitcase which he had brought from his home in Iowa years ago. It contained several diaries hopefully begun but not persevered with, notebooks filled with his earlier verse, college photographs, and the program of the Colfax High School Commencement for June, 1904. Hall decided to write a brief sketch of that Commencement night and of how his brother Harvey nearly ruined his recitation. But once the door of memory was opened, it was a book, not a sketch, which emerged.

Jim wrote of his boyhood and youth with the freshness and savor of a spring morning: his battle with his old enemy, Diffidence, his determination to travel to the more remote corners of the earth, and his secret aspiration to win recognition as the Hawkeye Poet, once again possessed his mind.

It was Jim's intention that the chapters recollecting his boyhood, his education at Grinnell, and his social work in Boston should comprise the first volume of his autobiography. But I argued against this on the grounds that there were too many local allusions, and what was more embarrassing, that the "Woodshed Poet," as he called himself, had included far, far too many of his youthful derivative effusions. I urged him to leave these chapters as they were for the time

being, and to go on to the more adventurous phases of his career. His services as a machine gunner with the Royal Fusiliers, 1914–1916, his experiences as a pursuit pilot in the Lafayette Escadrille, his return to Paris from a German prison camp, and his meeting with Charles Nordhoff which led to their first collaboration in Paris in 1919, then the agreement which took them to Tahiti, where under singular circumstances they wrote together their finest books — these were the major events in Jim's literary career, and I wanted them told, together with the account of his youth, in one all-encompassing volume. He finally agreed.

"I think that you are quite right in saying that the Memoirs should appear in one volume," he wrote from Tahiti, September 18, 1949, "so, at your suggestion, I will put aside once more further work on my Polynesian migration tale, 'The Call of Maui,' and go on with the reminiscences. I may find that I can work on the two manuscripts at the same time, but in any case I will give the Memoirs the first call on my time. . . .

"Now that Nordy is dead, I write in a vacuum, so to speak. There is, actually, no one here to whom I can appeal for criticism and advice, and as I read over my stuff I often get deeply discouraged and disheartened. I wish that you might have time to give me some criticism in detail."

I sent him suggestions and encouragements as the new chapters came in, and I also went to Ellery Sedgwick, his senior and very dear counselor for advice. Jim was troubled to know what to do about his earlier semi-autobiographical novels, *Kitchener's Mob, High Adventure,* and *Flying with Chaucer,* which told of his experiences, first as a machine gunner, then as a pursuit pilot in the First World War. He did not relish the idea of quoting these earlier works. "If I am not to leave great lacunae in the narrative it seems to me that I will have to find a different manner of writing what has already been written, a mature method of approach, speaking of the spiritual effect of brute incident upon the character of a young man and how it

moulded his later life. But would this be interesting enough to the general reader who usually wants to know of the adventures themselves rather than the effect of them upon character?"

I assured him that it would. The work progressed steadily into the spring of 1950, and it began to look as if it might run to fifty chapters. We both realized that a vast amount of cutting would have to be done if we were to hold the text within the compass of even a large volume. I had expected that we would work this out together, and we began to do so when Jim came on to Boston in mid-June of that year. He was in buoyant spirits, fresh from the happiness of his Fortieth Reunion and the unexpected pleasure of his Honorary Degree. He did mention something about his left leg, how it had gone numb on his plane flights eastward, and how it had hurt him a little when he climbed to his beloved haunts on Beacon Hill. He told me he was to have a checkup at the Massachusetts General Hospital, but whatever anxiety I felt was lost sight of in our luncheons at the Tavern.

The Memoirs were now two-thirds along. I told Jim of my confidence that we had here the makings of one of the finest books he had ever written, and Jim, who was always embarrassed by praise, told me of the troubles he had been encountering in the later chapters, chief of them the difficulty of trying to tell how he and Nordhoff worked together.

"Gosh, Ted," he said, "do you really think people will be interested in reading about a thing like that? A journalist came out to Tahiti a few years ago and tried to do a story about us, but Nordy made a joke of it. I wish I didn't have to go into it now." There were personal reasons for this. Nordhoff had died in 1947, and at his going Jim lost the banter, the tough realism, and the criticism which Nordhoff had supplied to their teamwork in their most productive years. To write of their collaboration was to write of grief, and it was also to touch on a fact which Jim in his modesty — and he was the most modest author I have ever known — could hardly bring himself to mention.

Collaborations, even one bound by such reciprocal trust as this, are unlikely to last for long on an even basis, and although the friendship between these two never wavered, I feel that in fairness to Hall, Nordhoff would wish me to say that from *Botany Bay* on the creative imagination which powered their novels was largely Jim's.

But at the outset the partnership was very definitely on a fifty-fifty basis, and so it continued through their most productive years. Because Jim never finished the chapter depicting their collaboration on the *Bounty,* perhaps I should round it out with what I know as the editor of their books.

In 1920, in their first year of residence in Tahiti, they joined forces to write a travel book, *Faery Lands of the South Seas.* Then, as Hall has told, for seven years they went their separate ways — Hall as essayist and poet, Nordhoff an incipient novelist who was beginning to find his strength in his books for boys.

In 1927, Nordhoff suggested that they write together a war story for boys based on their experiences in the Lafayette Escadrille. Up to this point I doubt if either had averaged as much as $2500 a year from his writing, but *Falcons of France* proved to be a success, and now with the farsighted, tonic encouragements of Mr. Sedgwick they prepared for their first major venture in fiction. The idea for a novel about the mutiny on the *Bounty* had occurred to Hall as far back as 1916 when he was browsing in a Paris bookstore. Their problem was not what story to tell but how to tell it. Their first task was to project themselves into the British Navy at the time of Nelson, and this they did by assimilating the mass of eighteenth-century literature which was shipped out to them from London. They read the contemporary accounts of Captain Bligh and of his 3600-mile voyage in an open boat, which made him the Lindbergh of his day; they read of the court martial and of the confessions of the mutineers which were sent to them in photostats from the Admiralty; they read and were shocked — Hall in particular — by the brutal discipline which then reigned in the Royal Navy. Imperceptibly this absorption of the lucid, ordered

prose of the eighteenth century began to set a style common to them
both.

Their next step was to make a thematic division of the source ma-
terial. Hall was to be responsible for the scenes which took place in
England; he would describe Midshipman Byam; depict the remodel-
ing of the *Bounty* which resulted in such crowded quarters below
deck (the warship had been assigned to bring breadfruit plants from
the South Seas to the West Indies); he would draw the portrait of
Captain Bligh with his raging discipline, and of Fletcher Christian,
the acting lieutenant, who tried to intercede; Hall was to take the ship
on its outward voyage until it dropped anchor at Tahiti. Then Nord-
hoff took over. Nordhoff was to be responsible for all the Polynesian
chapters, and, of course, the development of Byam's love affair with
Tehani; he was to show how the Mutiny was sparked by the brutality
of Captain Bligh, and of how the sparks were first subdued and then
inflamed by the days ashore at Tahiti; he was to describe the events
leading up to the Mutiny, and the fight which was to leave the mu-
tineers in command of the ship and Bligh with eighteen loyalists
adrift in the open boat. Then the novel was to swing back to London
to the trial of the mutineers sometime later, and here Hall would be
in command. So much for theory.

But as the book came to be written these boundaries tended to dis-
appear. In their work room at the Aina Paré, they would read aloud
the chapters to each other, and there were frequent interruptions.
Jim was the romantic, the poet, who kept pausing to describe and to
muse; Nordhoff was the narrator who kept the story driving ahead,
and it was inevitable that they should work in and out of each other's
sections as their spirits prompted. Thus in the chapter where Byam
surprises Tehani at the pool, it was Nordy who went too fast and
Hall interposed. It was not enough that Byam should see her in her
loveliness; they must swim together, and there must be a challenge
before the surrender. The scene could not be taken swiftly, and in
the end it was Hall who wrote it. This process of interruption speaks

for the absolute confidence they had in each other, and explains why it was so difficult for either one of them to initial throughout the portions for which he was personally responsible in the *Bounty* trilogy and in *The Hurricane*. In *The Hurricane*, for instance, which I speak of with particular fondness, the count shows that Nordhoff wrote eight chapters, Hall, seven, and two were written jointly.

When they had finished the writing of the *Mutiny on the Bounty*, and the manuscript had been dispatched to Boston, it was natural that they should tell the sequel, the strange and violent story of what happened to the mutineers after Captain Bligh and his eighteen loyal men had been set adrift. The mutineers were left in possession of the *Bounty*, and were under the nominal command of Fletcher Christian, acting lieutenant, and the instigator of the Mutiny. After two unsuccessful attempts to settle on the Island of Tupuai, the mutineers returned to Tahiti where they parted company. The more indolent remained ashore. But Mr. Christian with eight of his own men and eighteen Polynesians (twelve women and six men) embarked in September 1789 for an unknown destination. For eighteen years no word was heard of them. Then in February, 1808, the American sealing vessel, *Topaz*, in need of water sent a long boat ashore to the supposedly uninhabited Pitcairn Island, and there on the plateau discovered the remnants of Christian's colony, a colony of many women and many children presided over by the last surviving Englishman, the patriarch, John Adams.

The story of what happened on Pitcairn was a blend of legend and imagination, and the team had a hard time in writing it. It was a sanguinary story, for there were too few women for peace. When the mutineers had deposited their stores, livestock, guns, and ammunition on the uplands of Pitcairn, they destroyed the ship and locked themselves in, and then the inevitable antagonism broke out between the whites and the natives, between those who had wives and those who wanted them. This led in time to a race riot in which every man in the place fought for his life and only one sur-

vived. Nordhoff and Hall had elected to tell the story by omniscience, and as the story pursued murder after murder the narrative became both bloody and repetitive. When they had finished 65,000 words, Nordhoff threw up the sponge. He sent the manuscript to me, and expressed their disgust with it when he wrote: "The thing has interfered with my sleep for three months past; it is the finest story, and the most nearly impossible to tell, that I have ever come across. I believe old Shakespeare himself would have had to reflect for a moment or two before sitting down to dash it off."

I mulled over that fragment for several months. As it stood, it was as the boys knew pretty hopeless: too full of violence and bloodshed for either interest or sympathy. And then walking to the office one morning I had a happy clue. I had been thinking of the American ship and of what a surprise it must have been to the boatswain when with his crew he toiled up to the top of the Pitcairn plateau, there to be greeted by the incredible colony. There must have been a feast, and afterwards the white-bearded patriarch must have told the American sailors how they all got there, and what happened to Christian and the others. He would have told only as much of the final tragedy as he would have seen before he was wounded and hidden by the women, and his telling of it would of course have been softened by time and by loyalty.

I outlined all this in my next letter to Tahiti, the idea appealed to them, and the team later went on to reshape and rewrite *Pitcairn's Island*.

Meantime having despaired of *Pitcairn*, they had gone on to do a short book, the story of that hazardous, long-suffering trip in the open boat which brought out the best of Bligh's leadership as the cruise of the *Bounty* had brought out the worst. Here they had the meager details of his log, supplemented by that of knowledge of the islands through which he had threaded his way, — and the imagination to project the enormous courage and suffering which was endured in that frail boat of twenty-three feet, with a beam of six feet, nine

inches. This time they told the story through the eyes and mind of a young surgeon who would be best calculated to know every change in the behavior and psychology of the suffering seamen.

This, or something like this, is what I believe Hall would have written had I been able to persuade him to round out the chapter which was still incomplete at his death. This is one partial omission; and there are two others which I am sure he had in his mind to supply: a reference to his long and touching friendship with Robert Dean Frisbie, and a passage of affection in which he would speak as he spoke so often in his letters of his happiness with Conrad, his son, and Nancy, his daughter, and of the great help Sarah had been to him.

But I am sure Jim knew he was writing against time, and I am equally sure that he reached ahead in his mind, as authors do, to write the final chapter, the account of his last visit to Grinnell and his old home. That he meant to be the ending, and if there were details still to be fitted in, they would come as may.

Friendship was the mainspring of this singular collaboration, and how the two complemented each other has been beautifully summed up by Mr. Sedgwick in these words:

What a contrast, those two young men! Nordhoff slightly scornful, very ambitious, Hall modest to a fault; Nordhoff skeptical and distrusting, Hall with no formulated belief but trusting absolutely in good. Both had a compelling sense of beauty; but for Nordhoff it was the beauty of strength and the outward world, for Hall the fairness of the inner, poetry and dream. Nordhoff was strikingly handsome in those days, a young David straight as a javelin, with aristocratic features and a manner that showed friendliness was not to be imposed upon. Hall wore a homely pleasantness about him reminding one, in spite of his soldiering abroad, of the good earth of his father's farm. Nordhoff had his inhibitions, too, but he was full of confidence and too eager to let doubts raise their interrogating

heads. As he sat smiling in his chair, you knew that Hall's ambition was some lonely, lovely haven where he could dream out his dreams."

Jim died on July 6, 1951. On July 23 I received from Walter G. Smith, who had long been an inmate of his household, a letter telling of the Island's grief.

DEAR MR. WEEKS:

I am sure I do not deceive myself in the belief that a brief account of the last days of your dear friend and my dearest friend, Jimmy Hall, from one who has the facts at first hand — many of them from personal observation — will not be without interest for you.

These days of the obsequies and mourning have been so poignantly moving that I don't know whether I can collect my thoughts, but I will do my best.

While death came with almost appalling suddenness, it was not altogether unexpected, at least by his doctors and myself. When Hall was visiting his married daughter in Honolulu the forepart of last year he for the first time experienced some peripheral vascular disorder. Due to the stoppage or partial stoppage of circulation in the left leg, resulting in numbness in the member, walking became difficult, and indeed impossible for any considerable distance. Perhaps you remember that when he was in Boston last summer he entered the Phillips Hospital, I believe it was, and underwent a thorough examination. He then for the first time became aware of his malady of the circulatory system, that it was an affection difficult of treatment, and that about the only thing he could do to ameliorate the situation was to engage in long and tedious exercises and manipulations of the toes. (This, incidentally, he found difficult to do, and if ever he adopted the advice he had long since abandoned it.)

His physical status remained unchanged until he returned to Tahiti the fall of last year and during most of the first half of this year. But he almost certainly had symptoms that warned

him or at least gave him a premonition of trouble ahead. For one day a couple of months ago he called his wife to his side and said he wished to talk with her as to what should be done in case of his death. He wanted no mourning or weeping or wailing. On the contrary he desired that the natives of the district should assemble and sing their songs, songs that he so loved, and not alone their songs of sadness, but also their joyous himines, and especially those of a humorous character. He wished that wine and food be furnished to them, and that they be regaled to their hearts' content. Mrs. Hall, as any wife would, at first refused even to listen to him, but he was so insistent that she heard him out and finally succeeded in diverting his thoughts into other channels. But the significance of this was not lost on the wife, and thereafter she kept him under watchful and loving attention practically from hour to hour. She had doctors visit him under the guise of friendship — everybody in Tahiti was a friend of James Norman Hall — and advise her what course to follow in case of unfavorable eventualities. He himself never repined or complained, but spoke sometimes of the enforced restriction upon his walking activities, and in a semi-humorous vein, said he supposed it would some day be necessary to amputate his left leg.

The first outward symptom of further marked deterioration in his bodily condition came about twelve days ago. Walking to a friend's house in the near neighborhood he suddenly discovered that there was a numbness in his right lower leg, indicating that the vascular trouble was spreading, with accompanying functional disability. He was obliged to return to his home by automobile.

From here on there was change only for the worse. At first there was only additional inconvenience, as far as observation went, for as I have said if he suffered or had other adverse symptoms he concealed them. He always insisted on smoking, and generally drank a couple of old-fashioneds a day, except when friends dropped in, in which case the number would be enhanced. But in the two weeks before the end, there were ev-

idences that he was losing ground almost daily. He had distressing attacks with considerable pain in the upper chest region, sometimes two or three nights in succession, and once or twice also during the day. The condition came to a climax with terrifying suddenness. The night of July 4–5 he passed in comparative comfort. Two doctors had talked with him the afternoon of Wednesday, the 4th; either by ruse or insistence on the part of Mrs. Hall, he had been daily under the observation of his medical friends. Always he insisted he was "all right," and never willingly saw a doctor. The night of July 5th when he went to bed there was a rather general hope that perhaps he had passed the present crisis of his malady. But, alas for hopes! by 2 o'clock next morning he was lying cold in death.

About midnight Mrs. Hall was heard crying aloud for help. I myself, living near by, heard her, and awakened her cousin, who hurried to the aid of the grief-stricken wife. Dr. Andrea de Balmann, who had been Hall's chief medical adviser in the past weeks, was at once telephoned for. She arrived in less than half an hour, and at once saw the case was hopeless. To relieve his suffering and distress, which was acute, she administered an opiate, and thereafter until his death a couple of hours later, when asked if he was in pain he answered no, but that he found it hard to breathe. The doctor endeavored to take his blood pressure, which had been excessively high in recent weeks, but her instrument failed to register any pressure at all. What had happened was that there had been a complete collapse of the coronary arterial system and of the heart itself. He lingered on for two hours, until finally with a few short gasps, and then, after a pause, another gasp or two, life left the body. Dr. de Balmann remained till the last moment, and then for another couple of hours in the endeavor to comfort the almost frantic widow. Death had occurred at 2 o'clock the morning of Friday, July 6th.

The body having been washed and clothed, it was carried to what is known as the beach house, on the very shore of the Pacific Ocean, within a few yards of the lapping waves. Here

it rested on a low couch for nearly thirty hours, and until the moment it was carried away for burial. During the whole of this time Mrs. Hall sat beside and at the head of the corpse. Her distress was naturally acute and painful to witness, but was retained within decent bounds.

Before daylight had broken over the scene, neighbors and friends from all around the island began to gather in numbers which steadily increased all day long. They came with sympathy for the widow and to pay their respect to the dead. Flowers were sent in great abundance, and by nightfall the floor of the main chamber of the beach house was almost carpeted in floral beauty. A magnificent wreath was sent by the government, on telegraphic direction of Governor Pettibon, who at the moment was voyaging on the other islands of the group. That evening a short service was conducted by the head pastor in Tahiti of the Protestant church.

Hall lies buried in an almost incredibly lovely spot, on the slope of a steep hill immediately behind his home, backed by a grove of ironwood (casuarina) trees, and directly overlooking Matavai Bay, where Captain Bligh brought his ship, the "Bounty" to anchor in thirteen fathoms. More than once, standing on that hill, Hall has pointed out to me almost the exact spot where Bligh dropped anchor, and always remarked, "You are now gazing on historic territory." It was his dearest wish that his remains should be interred on this beautiful spot, so hallowed with memories of his and Charles Nordhoff's masterpiece "Mutiny on the Bounty." I think it not far-fetched or fanciful to say that in these days another Vailima has been established, and that many a pilgrim will in future years visit the hill called by the Tahitians Ferai. It belongs to the Hall family, and undoubtedly will remain in their possession.

The interment took place the morning of Saturday, July 7th. Early that morning the body had been coffined. Mourners in great numbers had arrived, filling and surrounding the beach house. His favorite melodies were sung by the Arué church choir, and as the body was carried out to the hearse his greatly

loved Andante from Dvořák's New World Symphony was softly
played from a record. The first stage of the last journey was
to the temple at Otu-aiai, a famous peninsula near-by where is
situated the tomb of King Pomre. Here a short service was con-
ducted by the local pastor. The sad journey was then resumed.
At the entrance to the steep road leading to the hill Ferai the
coffin was again removed from the hearse. The young men of
the Arué Football Club had insisted that theirs should be the
privilege of carrying the coffin to the actual scene of burial. Ac-
cordingly, they harnessed themselves to the casket, which they
said afterwards they found surprisingly light, and marched away
with slow steps up the rugged hillside. They were followed by
several hundreds of mourners, all afoot, save for a few old and
infirm people, all clad in white, as is the custom on this island.
As it wound slowly up the hillside, here shaded by trees, there
in the strong sunlight, or again in dappled luminance where
the foliage was not so thick, the procession was astonishingly
beautiful . . . A short service was said at the graveside. The
sécretaire général of the colony — representing the absent gov-
ernor — and other high officials of the administration, as well as
the British and Chinese consuls, were amongst those present.
There were several addresses in eulogy of Hall, the most no-
table being that of the famous native orator, Teriieroo, Chief of
the district of Papenoo, who recalled his services in the war of
1914–1918, spoke of his fame as an author, but particularly
emphasized his constant readiness to aid the distressed and con-
tribute generously to whatever might be for the benefit of the
local inhabitants.

Singularly impressive had been the two days outpouring of
native grief and love, the display of respect and admiration for
a lost friend. But to me at any rate the highest, the most poign-
ant moment of all came the evening of the day of the burial.
It had been intimated to Mrs. Hall that the choirs and the
parishioners of the district of Arué and the adjacent district of
Pirae, all Tahitians, wished to assemble and in song and speech
take their final farewell of the departed. Accordingly, these peo-

ple, to the number of about eighty, almost all of the laboring class, with their pastors gathered in the beach house. For the ensuing three and one-half hours there poured forth, as from a brook that goes on forever, address after address, in which I am told there was practically no repetition of thought or phrase, in eulogy of him to whom they were saying goodbye forever. Women as well as men arose — in all to the number of about thirty — and each in the smoothly-flowing Tahitian tongue, expressed his or her feelings. These addresses were interspersed with songs, not all songs of mourning — far from it; but it was all just as Hall would have had it. So rollicking became the atmosphere at one time that a young girl leaned over and whispered to me: "If Papa Hall" — he was universally known to the natives as Papa — "If Papa Hall were here he would say that the Fete of July 14th had already commenced." But if the singing became joyous in tone, not so the speech. This was uniformly grave. An address by a young workman of Arué particularly affected Mrs. Hall. As translated to me, a rough paraphrase of his main thought may be expressed in these words: "We all knew and loved Papa Hall. He was one of us in his interest in our sports and our other activities. We knew him especially as a *kind* man, a simple man, to whom the interests of the poorest were more important than those of the rich and comfortable. No one ever in vain approached him with a request for aid. These things I knew and we all knew. But today my eyes are opened. When I look upon that cushion upon which are pinned his medals and decorations from the leading governments of the world, I for the first time realize that we have had living amongst us a great man. I know now, but never knew before, that in our midst dwelt a hero."

With my best regards, Mr. Weeks, and sympathetic condolences in our mutual loss, I remain sincerely yours

WALTER G. SMITH

The grave faces the Northward as well as Matavi Bay where the *Bounty* dropped anchor. This was Jim's favorite lookout, the place

where he and Nordhoff used to sit discussing their work. Here there is to be a bronze plaque inscribed:

JAMES NORMAN HALL

April 22, 1887 — July 6, 1951

Look to the Northward, stranger,
Just over the hillside, there
Have you in your travels seen
A land more passing fair?

Index